JOE'S
BOOK

Joseph Ward (handwritten)

Fall 2003 (handwritten)

From the Wadsworth Series in Production

Albarran, Alan B., *Management of Electronic Media*, 2nd ed.

Alten, Stanley, *Audio in Media*, 6th ed.

Armer, Alan A., *Writing the Screenplay*, 2nd ed.

Craft, John, Frederic Leigh, and Donald Godfrey, *Electronic Media*

Eastman, Susan Tyler, and Douglas A. Ferguson, *Broadcast/Cable/Web Programming: Strategies and Practices*, 6th ed.

Gross, Lynne S., and Larry W. Ward, *Electronic Moviemaking*, 4th ed.

Hausman, Carl, Philip Benoit, and Lewis B. O'Donnell, *Modern Radio Production*, 5th ed.

Hausman, Carl, Lewis B. O'Donnell, and Philip Benoit, *Announcing: Broadcast Communicating Today*, 4th ed.

Hilliard, Robert L., *Writing for Television and Radio*, 7th ed.

Hilmes, Michele, *Only Connect: A Cultural History of Broadcasting in the United States*

Hilmes, Michele, *Connections: A Broadcast History Reader*

Kaminsky, Stuart, and Jeffrey Mahan, *American Television Genres*

MacDonald, J. Fred, *Blacks and White TV: African-Americans in Television Since 1948*, 2nd ed.

MacDonald, J. Fred, *One Nation Under Television: The Rise and Decline of Network TV*

Mamer, Bruce, *Film Production Technique: Creating the Accomplished Image*, 2nd ed.

Meeske, Milan D., *Copywriting for the Electronic Media*, 3rd ed.

Viera, Dave, *Lighting for Film and Electronic Cinematography*

Zettl, Herbert, *Sight Sound Motion*, 3rd ed.

Zettl, Herbert, *Television Production Handbook*, 7th ed.

Zettl, Herbert, *Television Production Workbook*, 7th ed.

Zettl, Herbert, *Video Basics*, 3rd ed.

Zettl, Herbert, *Zettl's VideoLab 2.1*

Management of Electronic Media

Second Edition

Alan B. Albarran
University of North Texas

WADSWORTH
THOMSON LEARNING

Australia ▪ Canada ▪ Mexico ▪ Singapore ▪ Spain ▪ United Kingdom ▪ United States

WADSWORTH
THOMSON LEARNING

Radio-TV-Film Editor: Karen Austin
Assistant Editor: Nicole George
Editorial Assistant: Mele Alusa
Executive Editor: Deirdre Cavanaugh
Publisher: Clark Baxter
Executive Marketing Manager: Stacey Purviance
Marketing Assistant: Neena Chandra
Senior Project Manager: Cathy Linberg
Print/Media Buyer: Tandra Jorgensen
Permissions Editor: Joohee Lee

Production Service: Gretchen Otto, G & S Typesetters
Copyeditor: Carolyn Russ
Cover Designer: Ross Carron Design
Compositor: G & S Typesetters
Printer: R. R. Donnelley and Sons, Crawfordsville

Wadsworth / Thomson Learning
10 Davis Drive
Belmont, CA 94002-3098
USA

For more information about our products, contact us:
Thomson Learning Academic Resource Center
1-800-423-0563
http://www.wadsworth.com

International Headquarters
Thomson Learning
International Division
290 Harbor Drive, 2nd Floor
Stamford, CT 06902-7477
USA

UK/Europe/Middle East/South Africa
Thomson Learning
Berkshire House
168-173 High Holborn
London WC1V 7AA
United Kingdom

Asia
Thomson Learning
60 Albert Street, #15-01
Albert Complex
Singapore 189969

Canada
Nelson Thomson Learning
1120 Birchmount Road
Toronto, Ontario M1K 5G4
Canada

Library of Congress Cataloging-in-Publication Data
Albarran, Alan B.
 Management of electronic media / Alan B. Albarran.—2nd ed.
 p. cm.
 Includes bibliographical references and index.
 ISBN 0-534-56191-8
 1. Mass media—Management. I. Title.
P96.M34 A4 2001
302.23'068—dc21
 2001026515

This book is dedicated to the memory of
my former broadcast management professor, mentor,
and friend, Dr. C. A. "Ace" Kellner

Contents

3 ## Ethics of Management 51

6 Managing Personnel 123

7 Understanding Markets and Audiences 149

8 Programming: Strategy and Distribution 181

12 The Internet and Electronic Media Management 277

Preface

The electronic media industries experienced sweeping changes during the 1990s. Driven by technological, economic, regulatory, global, and social forces, these changes have had a dramatic impact on management in the radio, television, cable, and telecommunication industries.

Just a decade ago, media managers faced a very different set of challenges. There was less competition for audiences and advertisers. Regulators imposed many guidelines, including those that prevented multiple ownership of stations within the same market and cross-ownership among broadcasters, networks, cable operators, and telephone companies. The potential of new communication technologies, such as broadband distribution, digital television, and direct broadcast satellites, was not understood. Electronic mail, fax machines, and the Internet had little meaning for electronic media managers.

Today, media managers face a unique and rapidly changing environment. Competition is intense. Technology has created convergence among media industries, blending computers, programming, and distribution systems. Mergers and acquisitions have changed the makeup of the key players who operate networks, station groups, and cable companies. The elimination of regulatory barriers, the growth of strategic alliances and partnerships among media companies, and a global marketplace for entertainment and information have all contributed to the changing managerial environment.

Managers no longer manage a single operation. In many markets, electronic media managers may be responsible for several radio stations or two television stations. Given this hectic environment, multitasking has become a common characteristic of media managers. Coupled with structural changes, management of individual employees has changed in many ways, led by the changing composition of the workforce. The growth of ethnic populations, the presence of more women in the workforce, and new skills required of media employees have changed organizational cultures. Employees no longer must make an appointment to see their supervisor; in most organizations they simply send an email. Downsizing has produced leaner organizations and a more hectic pace.

This textbook is designed to help you understand the changing contemporary world of electronic media management. Though targeted primarily toward undergraduate and graduate students, this book will also be useful to media managers and practitioners. It focuses on domestic (U.S.) managerial topics, but where applicable, global issues are introduced. Every effort has been made to make the information not only relevant and timely but also understandable.

Chapter Review

Management of Electronic Media begins with an overview of electronic media in society. Chapter 1 introduces you to the main industries that make up the electronic media and also presents the various functions, skills, and roles of electronic media managers.

Chapter 2 examines the types of strategic alliances and partnerships found across the electronic media, with a particular emphasis on mergers and acquisitions. This chapter includes a discussion of factors influencing the formation of alliances.

Chapter 3 centers on ethics in electronic media management. This chapter examines types of ethics, ethical norms, and situations in which ethics are challenged in the management of electronic media organizations.

Chapter 4 provides a discussion of management theory by examining the three schools of management thought. Contemporary managerial theories and their application to the electronic media are presented in this chapter.

Chapter 5 details the importance of financial management in an electronic media organization. The chapter includes sections on budgeting, financial statements, financial ratios, and financial analysis.

In Chapter 6, you will learn about personnel management by looking at recruitment, selection, orientation, and termination of employees. This chapter also covers the use of performance reviews and legal aspects of managing people.

Identifying target markets and audiences is the focus of Chapter 7. Readers will gain an understanding of the different types of markets, market structure, and the increasingly important use of audience research.

Programming strategies and distribution are discussed in Chapter 8 in the context of the radio, television, and cable industries, at both the national and local levels.

Marketing, an important business skill, is discussed in Chapter 9. You will find an introduction to basic marketing principles and strategies, along with information on marketing to advertisers and the role of promotion in marketing campaigns.

Chapter 10, one of two completely new chapters in this edition, is devoted to news and newsroom management. News plays an increasingly important role in the electronic media, and this chapter examines the importance of news and managerial topics related to managing the news department.

While the Federal Communications Commission remains the single greatest influence on telecommunications policy in the United States, all three branches of government and a host of other federal agencies impact the regulatory process. Chapter 11 reviews these influences and their impact on management.

Chapter 12, the other chapter new to this edition, is devoted to a discussion of the Internet and electronic media management. The Internet is being used in a variety of ways by electronic media organizations; this chapter reveals how management uses the Internet to complement and expand traditional lines of business.

Each chapter begins with an overview summarizing its contents. At the end of each chapter, you will find case studies that you can use to stimulate thought and discussion on various management topics. Most of the case studies in this second edition are new. Many cases put you in the role of an electronic media manager, requiring you to perform in a decision-making environment.

Throughout the book, tables and charts present data and other statistical information pertinent to each chapter. A glossary of key terms used in the text is also included for easy reference.

Acknowledgments

The second edition of this book is the product of years of experience and my interactions with a variety of media practitioners—first as an employee, then as a manager, and finally as a media educator and

consultant. In my own professional career, I have been fortunate to work with many good managers, first in the radio industry and later in television. Each of them in some way helped form my ideas about media management, as expressed in this work.

Many industry professionals have shared insight and advice to make this a contemporary and realistic book. In addition to the electronic media professionals who contributed to the first edition, this second edition benefited from insight gained from a number of other professionals. My thanks go to David Strickland (KTRK-TV), Dan Halyburton (KLIF/KPLX), Gary Corbitt (WJXT-TV), Brian Ongaro (Clear Channel Communications), and other professionals whom I have met through my involvement with the Broadcast Education Association.

WFAA-TV and the Belo Corporation provided a 1999 summer faculty internship that gave me unfettered access to a number of their managers. At WFAA, my thanks go to Kathy Clements-Hill, Dave Muscari, Connie Howard, John Irving, Cathy Reese, David Johnson, Beaven Els, Jim Glass, Deidre Davis, Steve Kennett, Nick Nicholson, Vic Savelli, David Walther, Sarah Smith, Vince Patton, Eric Goodner, and Danny Manly for spending hours answering questions. At the Belo corporate offices, my thanks go to Jack Sander, Cathy Creany, Flory Bramnick, John Miller, and Sherri Brennen. I also am grateful to Jamie Aitken and Steve Ackermann of TXCN. A big thank-you to Sherry Koeninger for organizing my internship experience.

A number of reviewers examined various chapters and made valuable suggestions that improved this book. My sincere thanks to Maria Williams-Hawkins, Ball State University; Bruce Klopfenstein, University of Georgia; Peter Ensel, SUNY–Plattsburgh; Sylvia Chan-Olmsted, University of Florida; Edward L. Morris, Columbia College–Chicago; Ted Carlin, Shippensburg University; and Cathy Perron, Boston University.

I am very grateful to Karen Austin, my editor at Wadsworth, for her advice, friendship, and patience throughout the preparation of this second edition. Karen is a true professional and a pleasure to work with, and I appreciate all of her encouragement, support, and enthusiasm for this project.

I am blessed with a loving family that has unselfishly supported my research and writing over the years. To my wife Beverly and my daughters Beth and Mandy, I offer my sincere gratitude and love.

Thanks also to my mother, Jean Albarran, for her support. I also appreciate the support of my faculty and staff in the Department of Radio, Television and Film at the University of North Texas.

In conclusion, this book is dedicated to the memory of the man who taught me the most about electronic media management—my former professor and mentor at Marshall University, Dr. C. A. "Ace" Kellner. Ace passed away in November 1996, his beloved wife Toni just after Christmas that same year. I miss both of them greatly. We grew to be close friends after his retirement, and I had the opportunity to visit the Kellners several times in their Florida home during the 1980s and 1990s. One of the greatest joys in my life was having him see the first edition of this book. He was so proud and honored to have the book dedicated to him. My only hope is that the second edition of this book will be helpful to students and inspire them to reach their full potential in life as Ace inspired me to do.

Alan B. Albarran
University of North Texas

Abbreviations and Acronyms

ABC—American Broadcasting Company
ACT—Action for Children's Television
AE—Account Executive
AM—Amplitude modulation
AOL—America Online
AQH—Average quarter hour
AR&D—Audience research and development
AT&T—American Telephone & Telegraph
AWRT—American Women in Radio and Television
BCFM—Broadcast Cable Financial Management Association
CAB—Cable Advertising Bureau
CBS—Columbia Broadcasting System
CEO—Chief Executive Officer
CHR—Contemporary hit radio
CNN—Cable News Network
CPM—Cost per thousand
CPP—Cost per point
DAB—Digital audio broadcasting
DARS—Digital Audio Radio Services
DBS—Direct broadcast satellite
DMA—Designated Market Area
DOJ—Department of Justice
DSL—Digital subscriber line
DTV—Digital Television
DVD—Digital Video Disc
EAS—Emergency Activation System
EBS—Emergency Broadcast System
EEO—Equal employment opportunity
EEOC—Equal Employment Opportunity Commission
EMRC—Electronic Media Ratings Council
ESPN—Entertainment Sports Programming Network
FAA—Federal Aviation Administration
FBC—Fox Broadcasting Company
FCC—Federal Communications Commission

Fin-Syn—Financial interest–syndication rules
FM—Frequency modulation
FRC—Federal Radio Commission
FTC—Federal Trade Commission
GI—Gross impressions
GM—General Manager
GRP—Gross rating points
GSM—General Sales Manager
HBO—Home Box Office
HDTV—High definition television
HH—Households
HR—Human Resources
HUT—Households using television
IAB—Internet Advertising Bureau
ISP—Internet Service Provider
IXC—Interexchange carrier
LAPS (test)—Of literary, artistic, political, or scientific value
LEC—Local exchange provider
LMA—Local marketing agreement
LSM—Local Sales Manager
LUR—Lowest-unit-rate
MBO—Management by Objectives
MCI—Microwave Communications, Inc.
MFJ—Modified Final Judgment
MMDS—Multipoint multichannel distribution services
MSO—Multiple system operator
MSTV—Maximum Service Television
MTV—Music Television
NAB—National Association of Broadcasters
NATPE—National Association of Television Program Executives
NBC—National Broadcasting Company
NCTA—National Cable Television Association
NHI—Nielsen Homevideo Index
NHSI—Nielsen Hispanic Station Index
NHTI—Nielsen Hispanic Television Index

NMMS—Nielsen Metered Market Service

NMS—Nielsen New Media Services

NPV—Net present value

NSI—Nielsen Station Index

NSM—National Sales Manager

NSS—Nielsen Syndicated Services

NTI—Nielsen Television Index

NTIA—National Telecommunications and Information Administration

PAX—Paxnet television network

P & L—Profit and loss

PCS—Personal communication services

PD—Program Director

PDA—Personal digital assistant

PEG—Public, educational, and government channels

PICON—Public interest, convenience, or necessity

P-O-M-C—Planning, organizing, motivating, controlling

PPM—Portable People Meter

PPV—Pay-per-view

PSC—Public service commission

PTAR—Prime-time access rule

PUC—Public utility commission

PUR—Persons using radio

PV—Present value

RAB—Radio Advertising Bureau

RADAR—Radio's All Dimensional Audience Research

RBDS—Radio broadcast data system

RBOC—Regional Bell operating company

ROR—Rate of return

RTNDA—Radio-Television News Directors Association

SBC—Southwestern Bell Corporation

SMATV—Satellite Master Antenna Television

SMSA—Standard metropolitan statistical area

SPJ—Society for Professional Journalists

SRDS—Standard Rate and Data Service

STV—Standard television

TCI—Tele-Communications, Inc.

TQM—Total quality management

TSA—Total Survey Area

TSL—Time spent listening

TVB—Television Bureau of Advertising

TVHH—Television households

UHF—Ultrahigh frequency

UPN—United Paramount Network

USTA—United States Telephone Association

VALS—Values, attitudes, and lifestyles

VHF—Very high frequency

VIP—Viewers in Profile

VNR—Video news release

WB—Warner Brothers network

WWW—World Wide Web

Managing in the Electronic Media

In this chapter you will learn

- The basic characteristics of the radio, television, cable, and telecommunications (telephone) industries
- The demands placed on electronic media managers by audiences, advertisers, and owners
- The levels of management found in the electronic media
- The skills, functions, and roles of electronic media managers

As an introductory look at the subject of electronic media management, consider the following scenarios that managers might encounter in a hypothetical top-50 market.

- The second-quarter budget projections are down for one of four group-owned radio stations in the same market. Advertising revenues fell 10 percent below expectations. The station has been particularly weak at attracting new business. The General Sales Manager knows that to reverse the trend a stronger emphasis on developing new business accounts must be initiated immediately, beginning with the hiring and training of two new account executives.

- Retransmission consent negotiations with a popular local broadcast station are at an impasse. The Operations Manager of the local cable system faces a tough decision. If an agreement is not reached by midnight tomorrow night, the Operations Manager will have to pull the station from the existing channel lineup. This would anger many members of the audience, leading to possible subscription

loss to DBS services. The manager is calling a strategy meeting with department heads to discuss contingency plans.

- Conflicts continue among the department heads of a network-affiliated TV station over the role of the station's Web site. The news department sees the primary purpose of the Web site as an extension of news and information, while the promotion department sees it as a vehicle for marketing and electronic commerce. The programming, research, and sales staffs all have their own ideas as to the role of the Web site. The conflict is expected to take up most of the day's department head meeting.

- The most recent radio ratings book is out, and for the third consecutive period the high-salaried morning show host has produced lower numbers, especially among female listeners. The Program Director faces pressure from the General Sales Manager and the GM to improve the station's ratings. The host is resistant to changes in his program.

- Ratings for the 6:00 and 10:00 P.M. newscasts continue to be strong, but a new sweeps month is less than 3 weeks away. The News Director, Program Manager, and Promotions Manager are finalizing strategies to maintain their number one position and will later report to the General Manager.

- The local telephone company has finalized plans for a new marketing campaign directed to customers, offering one-stop shopping for video, data, and voice applications. But consumers may be resistant to switching from their current Internet Service Provider (ISP) and cable operator. The Marketing Director must develop a realistic business plan detailing projections and anticipated revenues (losses) for the new initiative.

As these examples illustrate, management in the electronic media involves a number of individuals coordinating many different responsibilities on any given day. One can define management in numerous ways. In this text, **management** is defined as a process by which individuals work with and through other people to accomplish organizational objectives. This book centers on management in the **electronic media**—defined here as the radio, television, cable television, and telecommunications (telephone) industries. As you will see, management is not a static concept but a dynamic process involving

many different skills such as decision making, problem solving, creativity, negotiation, and interpersonal relations.

This book examines electronic media management in the 21st century—an era marked by rapid change, media convergence, industry consolidation, and a heavily competitive environment. There is nothing easy about being an electronic media manager in such an environment. A good manager must balance the needs of owners, employees, and the audiences they serve in a time of unprecedented challenge.

An Overview of Electronic Media in Society

The electronic media occupy an important place in American society. In addition to providing audiences with a variety of entertainment and information products, the electronic media influence culture and help define social reality (McQuail, 1994). The electronic media also function as an important component of the economic system. In the United States, the majority of firms engaged in the electronic media operate in the private sector and thus deliver their content and services for profit (Albarran, 1996). As in any other business, managers in the electronic media must maintain efficient, profitable operations for their owners.

The electronic media pervade society. As consumers continue to exhibit an insatiable appetite for information and entertainment, levels of media usage reflect this trend. Television viewing, radio listening, and Internet surfing dominate leisure activity in U.S. households (see Figure 1-1). Audiences can access digital and analog information and entertainment content via cable television and direct broadcast satellite (DBS) subscriptions, VCR and DVD ownership, the Internet, and other types of video services such as multipoint multichannel distribution services (MMDS) and satellite master antenna television (SMATV). Media managers must respond to the needs of their customers, recognizing that their audience has many choices for entertainment and information content.

Several demands—for information and entertainment by the audience, for profits by stockholders and owners, and for access by advertisers—place managers of electronic media facilities in a challeng-

FIGURE 1-1

**Average Daily
Media Usage in
U.S. Households
(as of January 2000)**

NOTE: Television viewing
reflects average household
viewing per day, while radio
listening and Internet usage
reflect individual time spent
per day. From "TV Viewing
in Internet Households,"
Nielsen Media Research,
available online at www
.nielsenmedia.com and
Radio Advertising Bureau,
available online at
www.rab.com.

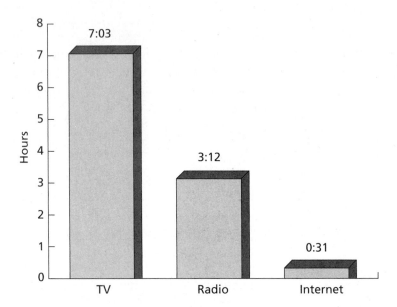

ing position as they try to serve the needs of the market along with
the needs of the marketplace. This balancing act is made all the more
difficult by constant changes in technology, regulatory issues, social
issues, and consumer tastes and preferences.

At this point, I should clarify exactly what electronic media com-
panies do. All such companies engage in certain types of activities.
Sherman (1995) identifies four separate but interrelated activities: de-
velopment, production, distribution, and exhibition. **Development** is
concerned with new technological innovations. Technology stimu-
lates the growth of the electronic media and improves the quality
of media consumption. Advances in digital technology and streaming
media are but two examples of current technological innovations in
the electronic media. As you will see further on, technology continues
to change the nature of the media business and the way society uses
the media.

Production consists of the manufacture of both **hardware** and
software for the electronic media. Hardware includes television and
radio receivers, satellite dishes, and compact disc (CD) and DVD
players. Software includes such products as television and radio pro-
grams, recordings, and advertising messages.

Distribution, the focus of Chapter 7, is concerned with getting products to consumers. Today many forms of distribution are available, ranging from the traditional broadcast networks to satellite-delivered services and the Internet. Improved means of distribution, in the form of fiber optic lines and digital compression, increase channel capacity and promote interactivity in video programming.

The fourth activity, **exhibition,** is the part of the process where the consumer uses the product. The pervasiveness and portability of electronic media hardware means that exhibition can occur at any time and place. This flexibility has added to the challenge of reaching targeted audiences, since consumption of media content can take place in the home, in the car, at work, or during a workout.

Though the electronic media share similar activities, each industry has unique characteristics. The following sections will illustrate the similarities and differences by offering a contemporary look at the principal electronic media industries.

Radio

The grandparent of the electronic media industries, radio, formally began in the United States during the 1920s. The radio industry established many practices for the rest of the electronic media by introducing the sale of hardware (receivers), the marketing of commercial time (advertising), the practice of networking, and the distribution of programming to audiences. Radio broadcasting consists of two types of services, AM and FM, with digital audio broadcasting (DAB) available through subscription services.

AM Radio AM radio consists of 107 channels operating between 535 and 1705 kilohertz (kHz). AM channels are restricted to 10 kHz of channel space, which severely limits the quality of the AM signal. The actual channel assignments begin at 540 kHz and repeat every 10 kHz. Because the signals are transmitted via amplitude modulation, that is, by varying the amplitude of the radio wave, the transmissions became known as AM radio. In 1982 the Federal Communications Commis-

sion (FCC) authorized AM stereo service but refused to set a technical standard for receivers and transmitters (Klopfenstein & Sedman, 1990). AM stereo never really matured, and few stations broadcast in AM stereo.

In awarding licenses to AM stations, the FCC established four classes of service (Classes A, B, C, and D) to ensure that everyone would have access to radio broadcasting. Class A stations are the most powerful, operating as **clear channels** during evening hours, which means they have exclusive rights to their assigned frequency beginning at sunset. From a management perspective, the clear channel stations represent the best class of AM stations in the country. Class B or secondary channels are also strong stations but must defer to the power and direction of the more dominant Class A stations. Class C stations are best thought of as regional operations, while Class D or local stations are usually restricted to a local geographical area and operate at levels of transmitter power even lower than that of the Class C stations.

Approximately 38 percent of all the radio stations in the United States are commercial AM radio stations. By the year 2000 approximately 4,783 AM stations were broadcasting. Research indicates that AM listeners are for the most part older than FM listeners and that AM listening accounts for a smaller share of all radio listening. The most popular formats on AM radio include news and talk, sports, and niche music formats (for example, Spanish, Big Band, and Oldies).

FM Radio The FM radio channels operate at a much higher frequency than their AM siblings, between 88 and 108 megahertz (MHz). Each channel is allocated 200 kHz for broadcasting, approximately 20 times larger than an AM channel, giving FM the potential for outstanding quality. The wider channel capacity allows FM stations to offer ancillary services such as Muzak for music programming in stores, providing another source of revenue.

FM channel assignments begin at 88.1 MHz and continue through 107.9 MHz. **FM** stands for **frequency modulation,** meaning the frequency of the radio wave is varied while being transmitted. FM broadcasting also differs from AM in that the signals follow the curvature of the earth. The height of the station's antenna and the power of the transmitter affect the range of coverage.

The FCC also uses a classification system (Classes A, B, C, and D) for FM stations, based on the height of the antenna and the transmitter's power. Class A stations are limited to a power of 3 kilowatts (kw) and a range of 15 miles. Class B stations can operate up to a power of 50 kw and a 30–40 mile range. Class C, clearly the most attractive from an ownership perspective, can broadcast up to 100 kw with a range of 60 or more miles. Class D stations were originally classified as low-power (less than 10 watts) radio stations usually assigned to universities or religious organizations. In 1980, the FCC began eliminating Class D stations by forcing them to raise power or share frequencies with others.

One other interesting aspect of the FM band is the portion of the service reserved for educational and noncommercial use. All stations assigned a frequency between 88.1 and 91.9 MHz operate as noncommercial stations. These stations are typically licensed to a college, university, religious organization, or, in some cases, a high school. Though these stations are not permitted to accept advertising, they may engage in underwriting for programming and on-air fund drives. Here you will find programming from National Public Radio and American Public Radio, as well as the alternative music formats found on most college radio stations.

In 2000 approximately 5,766 commercial stations and 2,066 noncommercial stations were operating on FM channels in the United States, representing 62 percent of all radio stations. FM came of age during the 1970s and surpassed AM in total listeners. Today the FM band is dominated by music formats (adult contemporary, country, urban, and contemporary hits), although sports and talk programming have an increasing presence on FM channels.

The major radio group owners are listed in Table 1-1. Clear Channel and Infinity dominate radio ownership, followed in size by a number of smaller companies.

DAB Another class of radio service is **digital audio broadcasting (DAB)**. This service offers CD-quality sound to radio. DAB is primarily available as a subscription service. While the technology is available to offer digital broadcasting via the radio industry, the costs to convert existing radio transmitters and studios to digital are prohibitive. Further, the audience would need new digital receivers to capture dig-

OWNER BY RANK	STATIONS OWNED
Clear Channel Communications	1,018[a]
Infinity (Viacom)	187
ABC Radio (Disney)	52
Cox Radio	83
Entercom Communications	98
Citadel Communications	207
Emmis Communications Corp.	274
Cumulus Media Inc.	118
Radio One Inc.	51
Susquehanna Radio	29

[a] The number of stations owned by Clear Channel will decline to approximately 830 stations following divestiture of a number of stations as required by the FCC in approving the merger between Clear Channel and AMFM Inc.

NOTE: Station acquisitions regularly affect the data included in this table. Consult trade publications such as *Broadcasting & Cable* to locate ownership changes/updates. Adapted from "Special Report: Top 25 Radio Groups," *Broadcasting & Cable,* September 18, 2000, pp. 50–62, and other trade publications/Web sites.

ital signals. Neither the industry nor the audience is clamoring for a change to digital broadcasting.

In 1994, the FCC authorized **Digital-Audio Radio Service (DARS),** which would provide several channels of digital audio programming to consumers on a national basis. DARS debuted in 2001. The radio industry is concerned the new service could siphon away local listeners. The success of DARS will depend on many factors, including the willingness of consumers to acquire the reception hardware needed to receive the signals, the quality of the programming, and the cost of the service.

Television

Though the television industry began in the postwar years of the 1940s, it did not grow significantly in the United States until the 1950s. In 1952, the FCC ended a 4-year moratorium on television licensing known as the "TV freeze." The freeze allowed the nascent industry to solve technical problems and geographical station assign-

ments. An important outcome of the freeze was the addition of 70 channels (from 14 to 83) in the **UHF** (ultrahigh frequency) band to complement the existing **VHF** (very high frequency) band of 12 channels (from 2 to 13). Unfortunately, the UHF signals required higher power and were more subject to interference problems than their VHF counterparts.

The UHF stations languished for several years because the FCC failed to require manufacturers of television receivers to include the UHF reception technology until 1964. For that reason VHF stations dominated TV for many years in much the same way FM dominates AM radio today. As cable television emerged in the 1970s, UHF stations found parity with VHF signals in cable households. Both types of service (VHF and UHF) could be received with ease by cable with no differences observed in the quality of the signal.

Networks developed quickly in television after years of refinement in the radio industry. The three big networks—ABC, CBS, and NBC—each acquired early TV stations to form the basis for their network TV operations. These stations are known as *network owned and operated stations* (**O & Os**) and are the most profitable TV stations in the world. Other stations that carry network programs are called **affiliates.**

ABC, CBS, and NBC serve approximately 200 affiliates each, while Fox serves around 175. The other networks (UPN, WB, and Pax) have a smaller affiliate base. Affiliates play an important role in the network through the **clearance** or acceptance of network programming and advertising in return for **compensation** (cash payments). The exchange of clearance for compensation has enabled the network-affiliate relationship to survive for many years, but compensation is being reduced by many of the networks.

The mid-1980s saw upheaval in the television industry. Two of the three networks came under different ownership as Capital Cities Communications Inc. bought ABC and became Capital Cities/ABC, and General Electric acquired RCA and the NBC network. CBS fought off a takeover attempt by Ted Turner. Meanwhile, Rupert Murdoch purchased the former Metromedia television stations to form the flagship stations of the Fox Broadcasting Company (Auletta, 1991).

In early 1994, the upstart Fox network shook the television industry by securing the rights to the National Football League's national conference (NFC) games, which had aired on CBS for years

(Jensen & Carnevale, 1994). Fox added to the upheaval in May of that year by announcing that New World Communications would be switching all 12 of its television stations to the Fox network, secured by a $500 million investment from Fox. Ten of the 12 stations were in the top-50 markets; CBS, NBC, and ABC were suddenly without affiliates in several markets. The announcement triggered a mad scramble during the summer of 1994 by all the networks to enter long-term affiliation agreements.

Two new national television networks began broadcasting in January 1995. United/Paramount (UPN), a venture between the Chris-Craft and Paramount television stations, debuted along with Warner Brothers, a new network from Time Warner Entertainment. Both UPN and Warner Brothers started out with a very limited prime-time schedule.

The summer of 1995 brought further changes to the network television industry. The Walt Disney Company acquired Capital Cities/ABC. One day later, Westinghouse announced plans to acquire CBS. Westinghouse would later change the name of the merged company to CBS.

Further consolidation activity in the television industry was fueled by the passage of the 1996 Telecommunications Act, which increased the percentage of national audience reach from 25 to 35 percent. This allowed TV groups to acquire more stations. The networks were particularly aggressive buyers, adding several new stations to their existing portfolios.

In 1999, Paxnet became the seventh national broadcast network. Built around stations assembled by Lowell "Bud" Paxson, the new service offered family-oriented programming. By the end of 1999, NBC had acquired a significant financial interest in Paxnet. In October 1999, a merger between Viacom and CBS was announced. In January 2000, America Online announced plans to purchase Time Warner, parent of the WB network. The AOL–Time Warner merger signaled a new era of alliances between Internet companies and traditional media companies.

You will find a listing of the major television groups in Table 1-2. Note that five of the top six groups (Tribune the exception) have ownership interests in a broadcast network.

Approximately 561 VHF stations and 682 UHF stations make up the commercial television industry in the United States. Another 373 TV stations operate as public or educational stations. The major-

TABLE 1-2

Top 10 Television Group Owners in the United States as of April 23, 2001 (rankings based on percentage of national audience reached)

OWNER BY RANK	STATIONS OWNED
Fox Television Stations, Inc.	31[a]
Viacom	238
Paxson Communications Corp.	69
Tribune Broadcasting Co.	23
NBC (General Electric)	13
ABC (Disney)	10
Univision	25
Gannett Broadcasting	22
Hearst-Argyle Television	33
Sinclair Television	62

[a]Number of stations Fox will own if merger with Chris-Craft Television Group is approved by the FCC.

NOTE: Station acquisitions regularly affect the data in this table. Consult trade publications such as *Broadcasting & Cable* to locate ownership changes/updates. Adapted from "Special Report: Top 25 Television Groups," *Broadcasting & Cable,* April 23, 2001, pp. 59–80. Groups are ranked based on the percentage of national audience reached.

ity of the 1,616-plus television stations operate on a 24-hour schedule, 7 days a week. According to Nielsen, the average household watches television more than 7 hours a day (TV Viewing, 1999).

Cable

The contemporary cable television industry bears little resemblance to the early cable industry, which started primarily as a retransmission medium for broadcast signals in areas where geography limited reception. The major difference for customers between the broadcast and cable industries involves cost of service. To receive broadcast signals, one must first obtain a receiver. To receive cable programming, one must purchase a subscription in order to receive the signals, usually via **coaxial cable** or a hybrid combination of coaxial and fiber optics, and then select the types of service desired.

Early cable systems were limited in their capacity; many could handle only a few channels. Eventually, capacity increased through the use of set-top converters and improvements in transmission. The

TABLE 1-3

Major U.S. Cable Networks

SERVICE	ESTIMATED SUBSCRIBERS (IN MILLIONS) AS OF DECEMBER 1999
TBS Superstation	77.0
Discovery Channel	76.4
ESPN	76.2
USA Network	75.8
C-SPAN (Cable Satellite Public Affairs Network)	75.7
TNT (Turner Network Television)	75.6
FOX Family Channel	74.0
TNN—The Nashville Network	73.9
Lifetime Television	73.4
CNN (Cable News Network)	73.0
A&E Television Networks (A&E)	73.0
The Weather Channel	72.0
QVC	70.1
The Learning Channel (TLC)	70.0
MTV: Music Television	69.4
American Movie Classics	69.0
CNBC	68.0
Nickelodeon/Nick at Nite	67.0
VH1 (Music First)	65.6
ESPN2	64.5

NOTE: Cable Television Developments, NCTA, 1999. Available online at www.ncta.com

development of digital compression has allowed modern cable systems to expand their capacity.

In addition to offering over-the-air broadcast channels, cable systems offer a mixture of popular satellite-delivered cable networks (Cable News Network, ESPN, MTV, USA), superstations (WTBS, WGN, WWOR), premium services (HBO, Showtime), and pay-per-view (PPV) services. You will find a listing of the major cable networks in Table 1-3. Locally, cable systems usually designate a few channels for public, educational, and governmental use. These are called **PEG channels.**

Most cable systems also sell **insertion advertising** to local businesses, whereby local commercials appear on national cable networks. The cable industry produces a variety of revenue streams: the selling of local advertising, subscriber fees, high-speed Internet services, equipment rental (remote control devices and converter boxes),

TABLE 1-4

Top U.S. Multiple System Operators (MSOs)

MSO	ESTIMATED SUBSCRIBERS (IN MILLIONS) AS OF MAY 1, 2000
1. AT&T Broadband & Internet Services	16.40
2. Time Warner Cable	12.70
3. Charter Communications	6.13
4. Cox Communications, Inc.	6.10
5. Comcast Cable	5.71
6. Adelphia Communications	4.99
7. Cablevision Systems, Inc.	3.13
8. Insight	1.43
9. Mediacom	.74
10. Cable One	.74

NOTE: "Special Report: Top 25 Cable Operators," *Broadcasting & Cable,* May 1, 2000, pp. 24–48.

and premium/PPV programming receipts. The larger cable companies (for example, AT&T and Time Warner) are pursuing plans to offer telephony (telephone) services.

According to data supplied by the Cable Advertising Bureau, 80 percent of the nation's 100.8 million television households subscribe to cable (*U.S. Penetration, 2000*). To serve this large number of subscribers, the number of systems has grown from 2,490 in 1970 to 10,700 in 1999. A company that owns more than one cable system is called a **multiple system operator (MSO)**; Table 1-4 provides a list of the top MSOs. AT&T and Time Warner are the two largest; together they account for over 29 million cable subscribers. Cable consolidation escalated during the 1990s. Larger companies began **clustering** systems together as companies sought to group large numbers of subscribers and potential subscribers together geographically.

Telecommunications

The term **telecommunications** has become a blanket term for business enterprises engaged in communication-related activities involving the telephone, the telegraph, data services, switching equipment, and

TABLE 1-5

Market Shares of U.S. Interexchange (Long-Distance) Carriers (based on total revenues)

COMPANY	MARKET SHARE
AT&T	44.5%
MCI/WorldCom	26
Sprint	9.7
Others	19.8

NOTE: Original FCC data listed MCI and WorldCom market shares separately before their merger was approved. They have been combined in this table. From *Long Distance Market Shares, Fourth Quarter 1998,* by J. Zolnierek, K. Rangos, and J. Eisner, March 1999, Industry Analysis Division, Common Carrier Bureau, Federal Communications Commission. Available online at www.fcc.gov/ccb/stats

terminal equipment. In this text, the term represents three major segments of the telephone industry and their relationship to the electronic media: the **interexchange** or long-distance market, the **local exchange** market, and the **wireless** or cellular market.

For decades, little competition existed in the telecommunications industry. In 1982, American Telephone & Telegraph (AT&T) settled a long-standing antitrust suit with the Department of Justice, resulting in divestiture of 22 **regional Bell operating companies (RBOCs)** and the opening of the interexchange (long-distance) market to competition by 1984. The consent decree, known as the Modified Final Judgment (MFJ), designated the markets in which AT&T and the RBOCs could compete and established a new era in telecommunications competition.

Interexchange Service

Prior to divestiture, AT&T was the leading provider of long-distance service in the United States. In 1984, AT&T's share of the long-distance market was approximately 90 percent. In the years that followed, AT&T's market share of total revenues fell dramatically as competition was introduced. AT&T's primary competitors in the interexchange market are MCI/WorldCom (two companies that merged in 1998) and Sprint. In 1999, MCI/WorldCom and Sprint announced plans to merge, but regulators later rejected the merger because of antitrust concerns. Table 1-5 lists the primary interexchange carriers and their respective market shares based on total industry revenues.

Local Exchange Service After the Bell breakup, the 22 RBOCs were collapsed into 7 regional companies and assigned local service in over 160 regional calling areas. The 7 firms were NYNEX, Bell Atlantic, Bell South, Ameritech, SBC (formerly Southwestern Bell), U.S. West, and Pacific Telesis. The 1996 Telecommunications Act eliminated many of the restrictions put into place by the MFJ, and companies began to acquire one another. SBC bought Pacific Telesis and, later, Ameritech. Bell Atlantic acquired NYNEX and the largest independent outside the old Bell system, GTE. Upstart telecommunications firm Qwest acquired U.S. West. At the beginning of the 21st century, only three of the original RBOCs remained: Verizon (formerly Bell Atlantic), SBC, and Bell South.

Interest in the Electronic Media The telecommunication companies have a strong interest in the electronic media, particularly in the distribution of video programming. The telephone companies see the distribution of video signals as a natural extension of their primary business of transmitting voice and data. As well, the phone companies have already established digital-switching technology to convert analog content into a digital system for high-speed transmission.

Ultimately, the telecommunications industry wants to offer one-stop shopping for business and consumer communication services. The range of services could include voice applications using both wired and wireless technology, high-speed Internet access through digital subscriber lines (DSL), and broadband video service. The telcos (telephone companies) will compete heavily with the cable and satellite industry to be the primary communications provider of choice.

Management in the Electronic Media

Having examined the role of electronic media in society and the characteristics of the radio, television, cable, and telecommunications industries, we will now turn to management of the electronic media

industries. The remainder of this chapter examines the levels of management found in the electronic media and reviews the skills, functions, and roles managers play in their daily activities.

Levels of Management

A common misconception many individuals have regarding management is that there is one person—THE MANAGER—who leads an organization. Clichés such as "The buck stops here" suggest that a single leader makes all the decisions in an organization. In reality, managers are found at many levels within organizations, and this is true for the electronic media industries. Different managers serve to complete a variety of tasks within an organization.

Consider a single radio station with five management positions. The Program Director is responsible for the on-air sound of the station. The General Sales Manager is charged with the responsibility of advertising sales. A Traffic Manager coordinates the scheduling of commercial advertisements and other program material. The Chief Engineer makes sure everything works properly from a technical standpoint. The General Manager monitors and continually evaluates the entire operation and reports to the station owners. As managers, each individual has specific areas of responsibility, supervises one or more coworkers, and contributes to the overall performance of the organization.

While titles vary, there is wide agreement that most organizations support three levels of management. A study involving over 1,400 managers found that the responsibilities of first- or lower-level managers, middle managers, and executives at equivalent levels were similar, regardless of the type of organization (Kraut, Pedigo, McKenna, & Dunnette, 1989).

The activities of **lower-level managers** center on supervising others and monitoring individual performance. Such would be the case with a Program Director who evaluates the on-air personalities of a radio station, or a Local Sales Manager who monitors advertising sold by a staff of local account executives. **Middle managers** typically plan and allocate resources and manage the performance of smaller groups. An example of a middle manager in the electronic media would be a General Sales Manager, who must coordinate the activities of the sales department at both the local and national levels. Top-level or **executive managers** monitor the entire organizational envi-

FIGURE 1-2

Management Skills, Functions, and Roles

Skills	Functions	Roles
Technical Human Conceptual Financial Marketing	Planning Organizing Motivating Controlling Facilitating Communicating Negotiating	Leader Representative Liaison

ronment, identifying internal and external factors that impact their operation. General Managers for TV, radio, cable, and telecommunications facilities must keep pace with such diverse factors as local business economics, social trends, the regulatory climate in Washington, and the internal activities of their respective operations. As these examples illustrate, one encounters different responsibilities at different management levels. Although specific tasks and duties vary as a manager moves through these levels, all managers share certain skills, functions, and roles. *Management skills* refers to the basic competencies needed by electronic media managers. *Management functions* refers to the tasks that managers perform. *Management roles* refers to the different roles managers adopt as they interact with different constituencies, such as employees, owners, consumers, and peers. Figure 1-2 charts the various skills, functions, and roles of managers in the electronic media.

Management Skills

Management theorists (see Hersey & Blanchard, 1996) identify three broad areas of skills needed in the management process: technical, human, and conceptual. To this list they add two other skills crucial to successful media management: financial skills and marketing skills.

Technical Skills Electronic media managers need a technical understanding of their operations, for technology and innovation constantly impact the communication industries. While technological advancements make it impossible to keep up with all the changes taking place, managers still need basic competencies in such areas as equip-

ment operation, signal transmission, program distribution, and computer applications. The ability to provide hands-on training is an important managerial skill, since employees usually have greater respect for managers with technical expertise.

Human, or People, Skills Employees see no other area as clearly as a manager's people skills. Most managers identify this area as the single most important skill in the process of management (Hersey & Blanchard, 1996). Successful managers in the electronic media exhibit strong interpersonal skills and are particularly adept at leading and motivating employees. Electronic media managers need to be dynamic, visionary, and motivated in order to lead their operations effectively and create a spirit of cooperation and participation among all employees.

Conceptual, or Problem-Solving, Skills Managers must understand the complexities of the internal and external environment and make decisions based on sound judgment. Because change is constant in the electronic media, managers must be able to respond quickly to changes in the environment—whether the changes concern audience tastes and preferences, technology, or employee relations. Electronic media managers must deal with a variety of issues and solve problems efficiently.

Financial Skills Industry consolidation, staff turnover, and a heavily competitive environment place incredible demands on media managers to be increasingly conscious of the bottom line. Managers need strong financial skills to establish and maintain budgets, meet revenue projections, and deal with budgetary contingencies. Understanding financial statements, ratio analysis, capital budgeting, depreciation and amortization methods, and break-even analysis is critical (see Chapter 5).

Marketing Skills With so many options available for the content of entertainment and information, managers need a strong understanding of marketing. They must know how to position their product(s) effectively and know what vehicles to use to create awareness. Un-

FIGURE 1-3

**Skills Across
Managerial Levels**

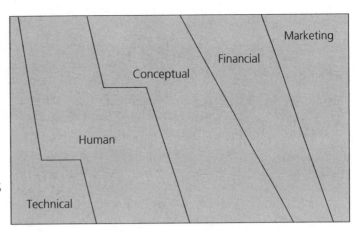

derstanding how to use the four Ps of marketing—price, product, promotion, and place—in interactions with consumers as well as advertisers is an invaluable management skill (see Chapter 9).

Though these skills are common to all managers in the electronic media, the degree of skill required at different managerial levels varies. For example, at the entry level of management technical skills are needed daily, while executives are likely to use conceptual and financial skills more regularly. Human skills are crucial at every management level. Figure 1-3 illustrates how these skills vary across levels.

Managers can develop skills via continuing education, experience, and attendance at managerial seminars and workshops (Bigelow, 1991). Regardless of how they learn, managers in the electronic media need *some* knowledge in all five areas. Finding individuals with this range of expertise is a continuing challenge for the electronic media industries.

**Management
Functions**

A frequently asked question in the study of management concerns management functions: What do managers do? One of the earliest investigations into management functions came in 1938 with Chester Barnard's (1968) book, *The Functions of the Executive*. Barnard identifies three managerial functions: (1) providing a system of organizational communication, (2) procuring proper personnel, and (3) formulating and defining the purposes and objectives of the organization.

FIGURE 1-4

The P-O-M-C Managerial Model

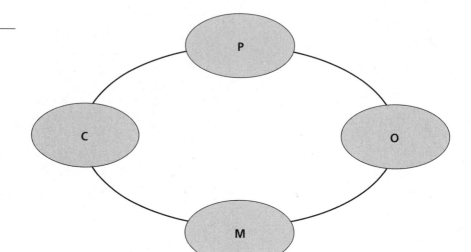

Henri Fayol was another major influence in the study of management functions. Fayol (1949) was a French theorist who specified the functions of planning, organizing, commanding, coordinating, and controlling (referred to as the POC[3] model). Later management scholars replaced commanding and coordinating with motivation, thus forming the P-O-M-C model of management (see Figure 1-4). Many management books show a heavy bias toward the Fayol model (Carroll & Gillen, 1987). But do managers spend most of their time planning, organizing, motivating, and controlling? Many studies have examined management functions to determine if the classical functions theorized by Fayol still exist.

One study (Mintzberg, 1975) found that most of the P-O-M-C functions form part of the folklore that inaccurately describe management. Mintzberg identified ten managerial functions. Other studies (Hales, 1986; Kotter, 1982) have questioned the validity of the classical management functions. One writer claims that acquisitions and divestitures, reductions in personnel and levels of hierarchy, and an increased use of performance-based rewards have created a new managerial work environment with different management functions (Kanter, 1989).

These studies present a conflicting view of management functions. Which functions actually occur in the daily activities of electronic media managers? An integrated approach, combining both

classical and modern perspectives, is perhaps the most reasonable way to describe management functions in the electronic media.

Media managers are involved in planning, organizing, motivating, and controlling, but they also exhibit three other important functions in managing their organizations: facilitating, communicating, and negotiating.

Planning Planning involves establishing organizational objectives and providing others with the resources needed to accomplish their tasks. Both short- and long-term objectives need to be established in the planning process. Both managers and employees should share in the creation of objectives. There are three criteria for such objectives: (1) They should be written, (2) they should be quantified in some way, and (3) they need to be dated, either with a specific deadline or an implementation date (Reaves, 1983). These criteria not only make objectives concrete but also provide a specific timetable for completion.

Organizing In the electronic media, the organizing function specifies who is responsible for completing organizational objectives. Most electronic media operations still use specific units or departments (such as operations, sales, engineering, and news) to handle individual responsibilities. Individual departments need their own planning objectives, budget, and staff to meet necessary goals, which then allows upper-level managers to concentrate on other activities. Managers of individual departments are linked to the overall structure of the organization to create a holistic environment. Tensions may arise between individual departments over the best way to address problems. When this occurs, managers must mediate and resolve the situation efficiently.

Motivating Motivating employees to a high level of performance directly helps any organization accomplish its goals. On the other hand, if motivation is low, productivity suffers. Certain positions in the electronic media need less management than others in this regard because the incentives are built in. For example, audience feedback, ratings, and public recognition drive talent positions, while commissions motivate account executives. For other areas, such as production, research, and engineering, motivation can be an important

managerial function. Numerous theories on motivation exist (see Chapter 4), but many studies yield similar findings: Employees want managers to recognize them for their individual achievements and contribution to the organization, and they want opportunities for continued growth and advancement (Buckingham & Coffman, 1999; Herzberg, 1987).

Controlling As a management function, control involves several areas of responsibility: (1) giving feedback to other managers and employees, (2) monitoring the progress toward completion of organizational objectives, and (3) making changes as situations demand. Feedback takes many forms: written, verbal, or electronic (such as email). A common criticism of managers is that they do not offer enough feedback to employees to let them know how they are performing. Positive feedback also helps motivate employees.

Monitoring is another essential control function. Managers must keep tabs on the progress of organizational objectives and help solve related problems. Finally, the ability (and at times courage) to make changes is an important control mechanism. Ultimately, such changes impact other personnel and perhaps even lead to their termination. While managers must be sensitive to the needs of their employees, they must also keep the goals and objectives of their operations in mind.

Facilitating As facilitators, managers must empower their employees with the needed resources to complete organizational tasks. These resources may include personnel, money, or equipment. The facilitator function is most prominent at the executive and middle levels of management. For individual units to function, managers must provide more than just moral support. They must articulate the needs of their unit when they develop a budget (see Chapter 5) and seek additional resources as needed on an ongoing basis.

Communicating A function that permeates all areas of management is communication. Managers in the electronic media have many ways to communicate with employees, who need and expect managers to keep them abreast of information important to their jobs. Formal lines of communication include newsletters, memos, and per-

formance reviews. But informal lines of communication are also important. As in any field, managers should not stay isolated in an office on the phone or in front of a computer screen during working hours. Managers who regularly visit employees in studios, offices, and other workstations establish a participatory climate beneficial to the organization. Managers encourage communication from employees by granting access in diverse ways—through voice and electronic mail, regular meetings in which ideas and concerns are shared, and an open-door office policy as opposed to visiting with employees only by appointment.

Negotiating All electronic media managers serve as negotiators in a variety of situations. For instance, negotiation with employees may involve salary and benefit packages, contracts for talent, bargaining with guilds or unions, and requests from low- and mid-level managers for new personnel. In program acquisition, the fees for copyrighted material, license fees, news services, and local productions are all negotiable. Equipment needs often constitute a third area of negotiation. Managers must often bargain for the price of expensive items, such as transmitters and production equipment. Similarly, advertising prices are determined by the available supply of commercial inventory and the demand by advertisers. Other forms of negotiation may involve owners, regulators, community leaders, business organizations, and audience members. In all types of negotiation, managers attempt to seek the best possible solution for their operations.

Management Roles Management roles are those behaviors associated with or expected of managers. In the electronic media, managers perform a variety of tasks and wear many hats in completing these tasks.

Studies on managerial roles vary in their findings. One study identifies three types of roles managers take on in their daily environment: interpersonal, informational, and decisional (Mintzberg, 1975). Interpersonal roles are concerned with leadership, while informational roles address communication. Decisional roles, as expected, involve decision making.

Other theorists (Hersey & Blanchard, 1996) suggest four managerial roles: producing, implementing, innovating, and integrating. Producing is concerned with aspects of production, with developing

products equal to or better than those of competitors. Implementing involves organizing, coordinating, and controlling. Innovating emphasizes information and decision making, and integrating involves the human/social system.

This information can be synthesized to provide a contemporary approach to understanding the roles of electronic media managers. Three roles best reflect the daily activities of media managers: leader, representative, and liaison. Each role is discussed below.

Leader Managers are expected to provide effective leadership for their individual department and organization. Being a good leader involves accepting responsibility for the organization as well as for its employees. Adapting to change, making decisions, maintaining open lines of communication, and leading others to the completion of goals are essential qualities of strong leaders.

Representative Managers in the electronic media serve as representatives in many settings. To the public and local community, electronic media managers serve as figureheads in a variety of contexts. The General Manager may serve on community boards. The News Director may be asked to speak to a high school or college class. The Sales Manager represents the station to a number of clients. Managers also represent various trade and professional organizations, such as the NAB, NCTA, National Association of Television Program Executives (NATPE), and the Radio Television News Directors Association (RTNDA), to name but a few. Tasks in these organizations may involve serving on committees, consulting with state regulators, and working with lobbyists.

Liaison Because of increasing consolidation in the media industries, the majority of the radio, television, and cable operations in the United States are owned by groups or corporations such as those listed in Tables 1-1, 1-2, and 1-4. Executive-level managers serve as important liaisons to the parent company. Accountable to the parent organization, managers regularly report on progress and problems in their operations. In turn, managers filter information from the parent

company back to their individual staffs. As expected, this role demands strong communication and negotiating skills.

This discussion of management levels, skills, functions, and roles indicates that electronic media managers are unique and talented individuals who can work with and through other professionals to accomplish organizational objectives.

Summary

This chapter began by introducing two terms used throughout the book: (1) *management,* defined as a process through which individuals work with and through other people to accomplish organizational objectives, and (2) *electronic media,* used in this text to represent the radio, television, cable television, and telecommunications (telephone) industries. Electronic media management in the 21st century functions in an era marked by rapid change, emerging philosophies, and a competitive environment.

The electronic media occupy an important place in society through the dissemination of information and entertainment. Electronic media managers attempt to balance the needs of the marketplace with the public's insatiable appetite for media content amid changes in technology, regulatory issues, and social trends.

Though electronic media companies all engage in development, production, distribution, and exhibition, each industry has unique characteristics. The radio industry consists of AM and FM broadcasting, with digital services emerging as a third form of broadcasting. The television industry continues to be dominated by the broadcast networks, which provide programming to their affiliates. Cable television is a multichannel source of programming consisting of broadcast signals, satellite-delivered networks, premium services, pay-per-view, and PEG channels. The telecommunications industry consists of the long-distance or interexchange market, the local exchange market, and the burgeoning wireless market.

In the electronic media, management occurs on different levels and involves a variety of skills, functions, and roles. Management requires unique and talented individuals who can work with and through other people to accomplish organizational goals.

CASE STUDY	**A Management Opportunity**

Jill Preston had distinguished herself as a detail-oriented and relentless television reporter for three different stations in various size markets. While in college earning a degree in broadcast journalism, Jill wrote for the campus newspaper and interned at the local newspaper, working primarily with print reporters covering city hall. After graduation, Jill landed a position as an entry-level reporter at a small-market TV station, where she remained for 2 years. She then moved on to a medium-market position that lasted 1 year.

Jill's career moves took her to markets of increasing size, until she took a job as an investigative reporter in a top-20 market. Her talents for reporting caught the attention of her current News Director, and when the Assignments Editor's position opened 18 months after her arrival, Jill was given the opportunity to move into management.

Jill jumped at the chance to accept a managerial role, knowing she could influence the style and breadth of coverage at the news department. As Jill began her duties, she soon found herself in conflict with most of the news staff. She wanted to be thought of as a manager, but she could not ignore her instincts as a street reporter. She found herself trying to be too controlling over her reporters, failing to give them the freedom she had valued as a reporter.

Frustrated, Jill sought the counsel of her News Director and immediate supervisor, John Williams. "What you are experiencing is not that unusual," said Williams. "Moving into management takes time to adjust. Most of us were never trained to be managers. It is something we grow into. The best advice I can offer is to think about the type of manager you want to be and how you want to relate to your fellow employees. Then work on improving your managerial capabilities."

Jill realized she had not really thought about the type of manager she wanted to be before assuming her new role. She vowed to think more seriously about her new role and the type of leader she aspired to become.

Imagine yourself in Jill's predicament. Picture yourself in a similar situation. What type of manager do you think you would be if given the opportunity to move into a managerial role? What management skills do you currently have? Which skills need improvement? What management functions are you ideally suited for? Which functions are you least suited for? What managerial roles are you the most—and least—comfortable with?

| CASE STUDY | **CHOOSING A NEW MANAGER** |

Jim Jacobs owned five small- and medium-market stations throughout the Southeast. Jim tended to be a hands-off owner, vesting control of each station in the General Manager of each of his properties. His style had paid off over the years; most of his GMs were extremely professional, producing good profits and strong ratings.

Earlier in the month, the GM of his smallest property tendered his resignation after 11 years on the job to become a group Vice President for a large radio company. The search for a new GM had yielded three viable candidates. Jimmy Smith was an account executive at a nearby station. Only 2 years out of college, Smith held a bachelor of arts degree in communications and a master's degree in business administration. Everyone believed Smith was a rising star, but his young age and minimal experience were concerns.

Bob Parsons was just the opposite. Parsons had been in radio nearly 30 years. In his mid-50s, Parsons had not gone to college, but he had years of experience in a number of positions in radio. He knew the business but reflected an older management style and philosophy.

Kathleen Johnson was the third candidate. She began working at the station after graduation from college. Johnson was an internal candidate; she had been with the station for nearly 6 years and currently served as the station's General Sales Manager. Jacobs endorsed Johnson's candidacy, although she had only been the station's GSM for 6 months and had little track record as a manager.

Which one of these three candidates would you recommend to Jacobs? Think about how each would view management and evaluate the strengths and weaknesses each would bring to the position. If you were Jacobs, what would you do?

 ### InfoTrac College Edition

For new information on the topic of management, use InfoTrac College Edition. Use the following terms for subject and keyword searches: management, media management, management practices.

 Web World

The following Web sites offer detailed information on the latest electronic
media industry trends and happenings:
National Association of Broadcasters (www.nab.com)
National Cable Television Association (www.ncta.com)
Radio Advertising Bureau (www.rab.com)
Cable Television Advertising Bureau (www.cabletvadbureau.com)
United States Telephone Association (www.usta.org)
Federal Communications Commission (www.fcc.gov)
Broadcasting & Cable Magazine (www.broadcastingcable.com)

References for Chapter 1

Albarran, A. B. (1996). *Media economics: Understanding markets, indus-
tries, and concepts.* Ames, IA: Iowa State University Press.

Auletta, K. (1991). *Three blind mice: How the TV networks lost their way.*
New York: Vintage Press.

Barnard, C. I. (1968). *The functions of the executive* (30th anniversary ed.).
Cambridge, MA: Harvard University Press.

Bigelow, J. D. (Ed.). (1991). *Managerial skills: Explorations in practical
knowledge.* Newbury Park, CA: Sage.

Buckingham, M., & Coffman, C. (1999). *First, break all the rules. What
the world's greatest managers do differently.* New York: Simon and
Schuster.

Cable television developments. (1999). Washington, DC: National Cable
Television Association. Available online at http://www.ncta.com

Carroll, S. J., & Gillen, D. J. (1987). Are the classical management functions
useful in describing managerial work? *Academy of Management Re-
view, 12,* 38–51.

Fayol, H. (1949). *General and industrial management* (C. Storrs, Trans.).
London: Pittman.

Hales, C. P. (1986). What do managers do? A critical review of the evidence.
Journal of Management Studies, 23(1), 88–115.

Hersey, P., & Blanchard, K. H. (1996). *Management of organizational be-
havior* (7th ed.). Englewood Cliffs, NJ: Prentice-Hall.

Herzberg, F. (1987). One more time: How do you motivate employees? *Har-
vard Business Review, 67*(5), 109–117.

Jensen, E., & Carnevale, M. L. (1994, May 25). Fox proves it's ready to play
in the big leagues. *The Wall Street Journal,* pp. B1, B4.

Kanter, R. M. (1989). The new managerial work. *Harvard Business Review, 67*(6), 85–92.

Klopfenstein, B. C., & Sedman, D. (1990). Technical standards and the marketplace: The case of AM stereo. *Journal of Broadcasting and Electronic Media, 34*(2), 171–194.

Kotter, J. P. (1982). What effective general managers really do. *Harvard Business Review, 60*(6), 156–167.

Kraut, A. J., Pedigo, P. R., McKenna, D. D., & Dunnette, M. D. (1989). The role of the manager: What's really important in different management jobs. *The Academy of Management Executives, 3*(4), 286–293.

McQuail, D. (1994). *Mass communication theory* (3rd ed.). Newbury Park, CA: Sage.

Mintzberg, H. (1975). The manager's job: Folklore and fact. *Harvard Business Review, 53*(4), 49–61.

Reaves, C. (1983). *The theory of 21.* New York: M. Evans and Company.

Sherman, B. (1995). *Telecommunications management* (2nd ed.). New York: McGraw-Hill.

Special Report: Top 25 Multiple System Operators. (1999, May 24). *Broadcasting & Cable,* 34–42.

TV viewing in Internet households. (1999). Nielsen Media Research. Available online: http://www.nielsenmedia.com.

U.S. penetration of cable programming tops 80 million for the first time ever. (2000, April 10). Available online: http://www.cabletvadbureau.com/00News/041000news.htm [Accessed May 24, 2000].

Zolnierek, J., Rangos, K., & Eisner, J. (1999, March). *Long distance market shares, fourth quarter 1998.* Washington, DC: Industry Analysis Division, Common Carrier Bureau, Federal Communications Commission. Available online: http://www.fcc.gov/ccb/stats

Strategic Alliances and Partnerships

In this chapter you will learn

- How technological, regulatory, global, and social forces are driving change across the electronic media industries
- What a strategic alliance is and the types of strategic alliances found in the electronic media industries
- Why there are so many mergers and acquisitions across the communication industries
- How strategic alliances and partnerships affect the process of management

The first chapter of this text provided an introduction to the electronic media industries and a micro overview of the various functions, skills, and roles required of contemporary media managers. This chapter examines at a more analytical level the macro aspects of the electronic media industries. A macro examination is critical to your understanding of management of the electronic media because the media industries are in a constant state of change and transition.

Mergers, acquisitions, and a variety of strategic partnerships and ventures are redefining the major companies participating in the media industries. Interestingly, a competitor in one market may be a partner in another market. This chapter considers these changes and how they are affecting the structure and management aspects of the electronic media.

A number of forces, functioning both independently and interdependently, have led to a state of chaotic change across the media

industries during the 1990s. Technological change and regulatory, global, and social forces are the four converging areas driving much of the change (Albarran, 1998), as discussed in the following paragraphs.

Technological Forces

The electronic media industries are technology-driven, utilizing technology to meet the demands of production, distribution, and exhibition. The 1990s will be remembered as the decade that fueled the transition of the media industries from an analog-based experience to a digital environment. The process of moving to a digital world means that any type of media content (voice, text, graphics, audio, video, or film) can be converted to a digital format, using the binary code symbols of 0s and 1s to encode analog material (Negroponte, 1996).

The transition to a digital environment and its potential encouraged the integration and convergence of the personal computer, telephone, and television into a single device (see Steinfield, Baldwin, & McVoy, 1996). Broadband has become the term used to indicate the transmission of digital content over a high-speed, high-capacity network that is seamlessly linked to the Internet. Some television content will eventually be delivered in a high-definition format superior to standard television service. Digital television will not only offer a richer viewing experience but an interactive experience as well to those who desire more than passive viewing.

With technology changing so rapidly, it is anyone's guess as to exactly how the media industries will be affected. A few assumptions seem clear, however. First, the transition to a digital world will take time, as with diffusion of any technology. Many households will continue to receive television in a standard or analog format for several years. Over time, though, digital sets with higher resolution and interactive features will permeate the marketplace.

Consumption for many people will continue to take place using existing receivers. Through the use of a video card, some users will access television via their personal computer. The Internet's ability to stream media (see Chapter 12) will be enhanced by the development of broadband digital networks. Customers will access broadband networks via a cable modem or DSL line, a satellite dish, or possibly

through a wireless device such as cellular phone or personal digital assistant.

In short, technological change will continue to impact the media industries as well as society. Management guru Peter Drucker claims that "No one can manage change" (Drucker, 1999). Electronic media managers must accept that technological change is a way of life and keep their efforts centered on remaining competitive and efficient in their operations.

Regulatory Forces

The 1996 Telecommunications Act removed a number of regulatory hurdles across the radio, television, cable, and telecommunications industries (see Chapter 11). This sweeping regulatory act took years to bring to fruition and led to numerous changes. Ownership limits were relaxed for broadcasting, and changes in cross-ownership rules allowed cable operators and telecommunication companies to merge.

As a result of the 1996 Act, the radio, cable, and telecommunications industries have been dramatically restructured. A number of mergers and acquisitions have taken place, resulting in a high degree of industry consolidation (see Albarran, 1998; Albarran & Dimmick, 1996; Bagdikian, 2000). The end of the 1990s featured a robust economy, low interest rates, and a regulatory environment conducive to change.

The beginning of the 21st century showed little decline in potential merger activity, as America Online announced plans to merge with Time Warner, Clear Channel Communications completed its acquisition of AMFM Inc., and the French utility and media player Vivendi planned to merge with Seagram/Universal.

Global Forces

Global forces can best be understood by recognizing that the media industries produce goods and services that can be marketed around the globe. The unification of the European Economic Community, the development of the Pacific Rim as an economic force, and the passage

of NAFTA (the North American Free Trade Agreement) have opened up new markets for trade and commerce, including the electronic media.

Many domestic markets in the United States are already saturated, in that 99 percent of all households have both a radio and television receiver, 96 percent have a telephone, 85 percent have a VCR, and 68 percent subscribe to cable. However, this is not the case in the international arena. Regions outside the United States offer great opportunity for business expansion and development.

A number of media powers are emerging in the regions of the world known as the triad, consisting of North America, Western Europe, and Japan/Pacific Rim (Albarran & Chan-Olmsted, 1998). Disney, Viacom, and AOL/Time Warner have become global media players. In Europe, Bertelsmann (Germany), Vivendi/Seagram (France), and Telefonica (Spain) are major players, while Sony and News Corporation are the leading companies operating out of the Pacific Rim. In short, globalization of the media is continuing in the early part of the 21st century, reflecting the fact that media companies compete in a global marketplace for content, goods, and services.

Social Forces

Society is also changing, not only in terms of demography but also in regard to the impact of the converging technological, regulatory, and global forces described above. Regarding demography, population data indicate that American society is growing older as the large baby boomer group approaches retirement age. From an ethnic perspective, the United States is changing as well. Demographers agree that the Latino population is the fastest growing minority group in the country and will likely overtake African Americans early in the 21st century as the largest minority group. Growth trends suggest the Anglo population will no longer be the majority ethnic group sometime between 2040 and 2050.

Interest and excitement about the Internet have driven more and more households to purchase computers and Internet access, leading to a society that is capable of receiving news and entertainment in both the offline and online worlds. Computers seem to be in every public sphere possible, from libraries and airports to Internet cafés

and churches. Traditional media usage has been impacted by the adoption of personal computers and Internet surfing, adding to the challenge of measuring media audiences and their activities.

Individuals are using the Internet for a myriad of purposes, ranging from email and e-commerce to virtual chat groups that share information about any type of topic. Still, not every segment of American society can afford a personal computer, nor access to the Internet. Politicians must address this social policy challenge in order to avoid developing a society divided into two segments, one that is information rich while the other is information poor.

These technological, regulatory, global, and social forces are driving change across the communications industries. From a management perspective, creating new partnerships among media companies has become a standard practice of doing business. These partnerships are designed to create the synergy possible between two companies (for a good discussion on synergy, see Turow, 1992). *Synergy* suggests that two different entities will operate more efficiently as one business than separately (Davidson, 1985). The remainder of this chapter will provide a context for understanding these synergies and changes. First, we will look at the types of strategic alliances found across the electronic media industries. Next, we will review merger and acquisition activity among media companies. The chapter concludes with a discussion on how alliances and merger activity impact electronic media management.

Strategic Alliances and the Electronic Media Industries

A recurring trend affecting all businesses is the formation of strategic alliances, especially among media companies and industries. But what is a strategic alliance? Which activities constitute strategic alliances? The following paragraphs introduce the topic.

What Is a Strategic Alliance? In this text, a strategic alliance is defined as an association designed to provide benefits for each of its members. Media organizations use alliances for such purposes as sharing capital and costs, providing access to new markets, increasing shareholder value, and reducing risk. Alliances may be formed when a company wants to gain access to new geographic markets, exercise control over existing markets, or

share risks in developing new products and technology (Gates, 1993; Lewis, 1990).

Strategic alliances take many forms. Among the most common examples are mergers and acquisitions, joint ownership, joint ventures, and formal and informal cooperative ventures. Lorange and Roos (1992) offer a theoretical examination of strategic alliances, ranging from those involving total internalization of one company by another (such as mergers and acquisitions) to those occurring on an open, free market (such as informal cooperative ventures). An alternative approach considers the degree of interdependence among the companies involved. Informal alliances require low interdependence among firms, while mergers demand high interdependence (Lorange & Roos, 1992).

Alliances can also be formed within industries (intra-industry) or between industries (inter-industry). For example, the consolidation that has taken place since 1996 in the radio industry is representative of intra-industry activity. Conversely, the merger between America Online and Time Warner is an example of an inter-industry alliance, joining a new media company known for its leadership in the Internet business with a traditional media company engaged in television, cable, motion pictures, and print.

Over time, alliances between companies may prove to be unstable and ultimately fail. For a strategic alliance to succeed, several criteria should be considered. Clearly the proposed alliance should be in a complementary business, and the companies involved must have similar business strategies (Cullen, 1999). Companies need clear expectations and agreement about the resources each company will commit, as well as compatible management styles. Alliances should be avoided if one partner would dominate the other (Gates, 1993).

Strategic planning among all parties should drive the basis of an alliance. Further, such planning should involve an objective evaluation of each business activity, the target market, the competitive advantages and disadvantages drawn from the alliance, and strategies to implement the alliance. Without this comprehensive examination, the alliance may suffer.

During the 1990s, the use of strategic alliances in the electronic media increased as companies reached out to one another to share rewards and risks in a variety of strategic partnerships. The following sections identify key categories of alliances dominating the media news in the early part of the 21st century.

Alliances to Develop and Market Programming and Content

As costs of producing programming have skyrocketed, many companies have entered into partnerships to share production and distribution costs. Increasingly, television program production companies are seeking partners to share costs and rewards. The shared expertise that results is helpful in creating new types of content and targeting programs toward specific demographic groups.

Alliances to Expand Domestic and Global Markets

Most media alliances have the goal of developing or expanding into new markets, at both the domestic and global levels. These types of alliances can occur at various stages of development—production, distribution, or exhibition (see Chapter 1). By expanding their market, alliance partners hope to increase brand loyalty for media products and capture greater market share.

Alliances to Develop Broadband Technology

The development and diffusion of broadband technology is driving many partnerships and alliances across the electronic media. The costs of developing the actual network, in reality a collection of high-speed, high-capacity digital networks, are beyond the scope of any single company. One research firm estimates that as many as 30 companies are involved in the development of broadband networks, in the United States and around the world (Interconnect, 2000).

Alliances to Develop Interactive Television

Interactive television will be a reality prior to the complete transition to DTV in 2006, ushering in a new era of television consumption. Numerous companies are engaged in developing interactive television, sion, with AOL and Microsoft the leading players. Interactive TV holds opportunities for numerous partnerships, whether in the creation of interactive content or in the production and distribution of the set-top boxes and hardware required for active audience participation.

As evidenced by these categories of strategic alliances, there is a great deal of business activity across the communications industries. When one ponders the development of both a domestic and a global system of interactive broadband networks and multiple distribution systems, the potential for media-related businesses appears unlimited. Of all types of strategic alliances, mergers and acquisitions are perhaps the most interesting to examine.

Mergers and Acquisitions

As strategic alliances, corporate mergers and acquisitions continually redefine the electronic media industries, both domestically and globally. Several mergers have resulted in huge media conglomerates, raising concerns among citizen groups and regulators over such issues as concentration of ownership and the free exchange of ideas (Bagdikian, 2000).

Here is a brief chronology of several major transactions involving media companies that have taken place just since 1997, when the first edition of this text was published.

- In the radio industry, a series of mergers led to the development of two huge companies—Clear Channel Communications and AMFM Inc. The companies announced plans to join in 1999, with the merger complete in the fall of 2000, creating the world's largest radio company. Once the merger was complete, the new Clear Channel owned over 1,000 radio stations and was the biggest single owner of billboards in the world.

- In the television industry, CBS announced plans in the spring of 1999 to acquire program developer King World, owner of some of the most successful syndicated programming in the country (*Oprah Winfrey, Wheel of Fortune, Jeopardy, Inside Edition*). Within a few months, Viacom announced a merger with CBS. In September 2000, Fox announced it was buying the complete television assets of Chris-Craft Industries (12 stations).

- The cable industry changed dramatically with AT&T's acquisition of all of TCI, the largest MSO in the cable industry. Charter Communications spent in excess of $11 billion to acquire a number of cable companies to become the third largest MSO in the country behind AT&T and Time Warner. Clustering of cable operations became more widespread as operators tried to strengthen their local presence by acquiring smaller cable companies adjacent to their main areas of operation.

- In the telecommunications industry, the original seven regional Bell operating companies (RBOCs) created after the breakup of AT&T in 1984 were reduced to four companies by the summer of 2000: Verizon (formerly Bell Atlantic), SBC (formerly Southwestern Bell), Bell South, and Qwest Communications. In the long-distance market, MCI and Worldcom merged, but they were unsuccessful in their effort to also merge with Sprint. Deutsch Telecom, the Ger-

man telecommunications giant, tried to buy U.S. West but lost in its bid to Qwest.

- In the Internet industries, America Online (AOL) announced plans to acquire Time Warner in January 2000. Telefonica, the Spanish telecommunications giant, acquired Lycos. Mindspring and Earthlink merged to become the second largest ISP behind AOL. Yahoo held talks regarding a merger with News Corporation.

- At the global level Seagram Universal, owner of Universal studios and a major recording company, was set to merge with Vivendi, the French company and owner of Canal Plus. Bertelsmann AG, the largest publisher of books in the world and the owner of BMG records (formerly RCA), continued its aggressive acquisition strategy with U.S. publishing companies.

Why So Many Mergers?

Why have we seen such a flurry of mergers and acquisitions involving media companies? Several factors have contributed to this phenomenon. Ozanich and Wirth (1998) explain that the level of domestic mergers and acquisitions has varied over time. In general, macroeconomic conditions (for example, changes in interest rates and inflation), variation in the methods used to determine the value of a company, and increasing sources of capital have driven mergers and acquisitions.

Ozanich and Wirth (1998, p. 95) claim that strong business performance in the media sector, barriers to entry for new competitors, technological convergence, and relaxation of regulatory policy have fueled merger activity. In all cases, the authors claim that prospects for growth should be the primary reason to seek a merger.

Given these factors, one can expect more mergers and acquisitions in the years ahead as companies begin to position themselves in one of two ways. First, some companies have chosen to emphasize the hardware or distribution side of the media business. In this sense, hardware refers to the actual radio, television, and cable operations as distributors of media content. In the television industry Fox, Viacom, Disney, and NBC reach well over 90 percent of all TVHH through their combination of affiliates and owned and operated stations. In cable, AT&T and Time Warner are the leading distributors of multichannel programming. In radio, Clear Channel and Infinity hold dominant positions with their ability to reach thousands of consumers sought by advertisers.

TABLE 2-1

Linkages Between Television Networks and Movie Studios as of April 2001

PARENT COMPANY	NETWORK	STUDIO LINKAGES
Walt Disney Company	ABC	Disney
		Buena Vista
		Miramax
		Hollywood Pictures
Viacom	CBS/UPN	Paramount
Time Warner	WB	Warner Brothers
		Castle Rock
		New Line Cinema
News Corporation	Fox	20th Century Fox
General Electric	NBC	none

NOTE: Compiled from various sources by the author.

Further concentration of ownership is anticipated, especially in the television industry. The FCC is required to review its ownership rules annually as part of the 1996 Telecommunications Act. The networks and other large owners want the audience reach cap for television stations to increase to at least 50 percent from the current 35 percent of the national television audience. The FCC also must annually review media cross-ownership regulations, which currently prevent a newspaper and television station from merging. The clustering of cable systems will continue, along with more acquisitions in the radio industry, though perhaps not at the pace of the torrid 1990s.

A second trend centers on the development of content—the creation and sale of programming, both for broadcast purposes and through interactive technologies such as the Internet and interactive TV. Companies such as Viacom, Disney, and Fox are established content machines, especially with their ties to studio properties (see Table 2-1). While NBC has been successful in leveraging its content into the cable world with CNBC and MSNBC, the lack of a studio partner has continually raised speculation that NBC may be a takeover prospect for another media power.

As discussed in the previous paragraphs, a handful of media conglomerates have the financial strength to pursue a hybrid strategy, involving both distribution and content. Disney, Time Warner, and News Corporation are the major players in this category. Their financial strength gives these three entities even more power across the media industries.

As a form of strategic alliances, mergers and acquisitions will continue to affect the electronic media. But how do strategic alliances affect the process of management, especially at the micro level where day-to-day management takes place? The final section of the chapter examines this question.

Implications for Management

Change among the media companies has many implications for the process of management. Three such changes likely to appear in all media industries are (1) managerial knowledge of more than one industry, (2) the ability of managers to engage effectively in multitasking, and (3) a need for managers to balance the needs of the marketplace and the public.

The rise of strategic partnerships requires managers to know not only their own specific operation but their partner's operation as well. This is particularly true in cross-industry partnerships, such as telco-cable alliances and broadcast television–cable/DBS/Internet distribution systems. To keep up with rapidly changing technology, managers will need to learn new information quickly, using a variety of means—from reading the trade publications of the partner's industry to attending conferences and workshops for continuing education.

Managers must also be able to balance many responsibilities at once—a skill referred to as multitasking. As discussed in Chapter 1, managers need a variety of skills to accomplish their duties. Handling the range of responsibilities resulting from strategic partnerships will particularly challenge managers in the electronic media. They must be willing to delegate responsibilities to other parties and carefully monitor their progress. Above all else, multitasking will require managers to have excellent organizational and communication skills. Further, successful managers will need to handle the pressures of work, family obligations, and other personal activities in an orderly manner.

Last, but not least, managers will have to balance the needs of the marketplace with those of the audiences in new ways. This dichotomy has long existed in the mass media, for all radio, television, and cable operations are businesses and as such, they operate to produce profits for their owners and stockholders. At the same time, the responsibility to serve the public remains an important component of

the electronic media. By nature, many alliances require heavy investments of time and money by the companies involved. There is substantial pressure to produce profits with these new alliances. Managers who can successfully balance the relationship between multiple ownership and public needs and wants will be extremely valuable to their operations.

While these changes apply to all the electronic media, each of the major industries discussed in this book presents unique characteristics in terms of how strategic alliances will impact their stations and systems. To provide some specific information on how management may be affected by strategic alliances, we will focus on the impact on managers of radio, television, and cable systems, using likely scenarios.

Radio Managers involved in supervising a cluster of radio stations in a single market have a great deal of responsibility in trying to manage each individual station offered in the market. In the case of a large market, a single General Manager may be responsible for as many as eight stations operating under one roof. No doubt, a major challenge lies in differentiating stations from one another to attract a wide range of listeners and advertisers. By appealing to different demographic groups, stations can strategically position themselves in the marketplace, serve different audiences, and maximize market share.

Another challenge lies in generating revenues from each operation not only to meet but also to exceed expenses. In this, the manager must carefully monitor revenue projections on a weekly and monthly basis for each station. In larger markets revenue data is supplied on a daily basis, even broken down by hours of the day. If the station is not producing its share of the revenues, management must be willing to take the necessary corrective action to bring the station back to a profit-producing mode.

Coordination among the various departments represents yet another challenge for managers. A single department may have to handle duties for several different formats—local talent or satellite. Managers must make certain each area has an adequate staff with the necessary resources to complete their tasks. Proper coordination works hand in hand with clear lines of communication among the various units, yet another responsibility of management.

Finally, the manager must monitor the relationship of each department to the audience and community it serves. This is accom-

plished in many different ways, from reviewing research collected via audience ratings, focus groups, and the station's Web site, to responding to listener phone calls, letters, emails, and face-to-face interactions. Only by understanding the audience and its needs can a manager effectively run any radio station, let alone a cluster.

Managing radio stations can be challenging and time-consuming. Radio managers must be skilled in many areas, be able to delegate tasks and responsibilities to middle managers, and effectively coordinate operations in order to meet their many challenges.

Television TV station managers also face many challenges as the result of strategic alliances and partnerships. Television stations have been allowed the opportunity to own duopolies since 1999, provided that the combinations are VHF-UHF. The change in the television duopoly rule was the primary motivation for Fox (News Corp.) to acquire the Chris-Craft television station group. The stations owned by Chris-Craft complemented the existing operations Fox held in its station portfolio.

TV managers also have been forced to deal with the transition to digital broadcasting (DTV) and the advent of high-definition television. The FCC mandated a move to DTV by the year 2006 but allowed broadcasters to keep their existing analog channels to prepare for the move to digital. This controversial decision angered policymakers, who felt broadcasters were being given valuable spectrum for free without any incentive to move toward faster adoption of the DTV format.

By the fall of 2000 about 40 TV stations had converted to digital capability, while the rest of the industry seemed in no rush to convert to digital. Concerns over the technology standards established for digital TV and the lack of consumer interest in acquiring HDTV receivers left many broadcasters in a quandary over how to proceed in moving toward the digital platform.

The move to a digital signal does offer opportunities for television broadcasters to engage in datacasting, as well as multicasting of traditional NTSC signals. With a digital channel, it is possible to send one signal of rich, high-quality HDTV or several channels of NTSC signals (currently 4–6 based on available digital-compression techniques), some of which could be devoted to datacasting, delivering services like paging, text-based information, or other specialized applications. Datacasting offers new revenue potential for TV broad-

casters, who find themselves in fierce competition for local advertising dollars and declining network compensation (Ducey, 1999).

TV stations could offer HDTV signals during prime-time hours, while devoting daytime hours to traditional TV programs on some channels and datacasting services on one or two other channels. Or stations could simply broadcast the entire day in the HDTV format, although the shared model using a combination of hours devoted to standard or NTSC television (STV) and DTV seems most likely.

Like their colleagues in radio, television station managers will need to be skilled in multitasking and able to coordinate a variety of tasks and responsibilities as many take on management of more than one station in a market. Likewise, dealing with changes in the type of distribution (STV/DTV/HDTV) raises implications for programming, promotion, and marketing.

Cable The cable industry finds itself in a very strong position compared to the broadcast industries, primarily in its ability to generate multiple revenue streams. For years, the cable industry has drawn revenues from subscriptions, equipment rental, premium services, and pay-per-view events. By the end of the 1990s, new revenue streams were opening up via digital cable, cable modems, and telephony service.

Digital cable service adds $10–12 a month extra to the consumer's cable bill, giving consumers yet another tier of program services. Due in part to reduced prices for premium channels, digital cable subscriptions are expected to increase from 9.8 million households in 2000 to 38.6 million households in 2005 (NCTA, 2000).

Cable modems, offering high-speed broadband Internet access, proved to be another lucrative revenue stream for the cable industry. Early in 2000, cable modems were diffusing at a faster rate than digital subscriber lines, available to customers for around $40 a month. Efforts to provide cable telephony service appear to be paying off, with 40 states approving applications by cable operators to provide telephone service.

The cable industry finds itself in a unique position to partner with a variety of companies to develop a variety of interactive TV ventures, particularly targeting the emerging digital tier. Still, cable managers will face continuing pressure from competitors, whether manifested in the form of DBS operators like Direct TV and EchoStar, or other cable-like providers in the form of local telephone companies, MMDS and SMATV.

Summary

Strategic alliances and partnerships offer a number of new opportunities and challenges for the electronic media, their managers, and the public. Technological, regulatory, global, and social changes are redefining the electronic media industries, resulting in evolving business practices and new opportunities.

Strategic alliances take many forms. Among the most common are mergers and acquisitions, joint ownership, joint ventures, and formal and informal cooperative ventures. Companies often form alliances in order to gain access to new geographic markets, exercise control over existing markets, and share risks in developing new products and technology. Mergers and acquisitions significantly changed the makeup of many media industries during the 1990s.

In the radio industry, mergers have led to clustering of radio operations in many local markets. In the broadcast television industry, the ability to engage in duopoly ownership and new methods of distribution, such as digital television and HDTV, have set the stage for numerous partnerships. The cable industry has found new revenue streams through digital cable, cable modems, and cable telephony and stands ready to gain a foothold in the emerging interactive TV industry.

Strategic alliances have expanded the role of managers, who need orientation and understanding of other industries in which they are engaged in order to build strategic relationships. The ability to handle multiple tasks in different distribution environments is an important requirement. Finally, managers must be able to balance the needs of owners and stockholders with those of audiences.

| CASE STUDY | **Local Alliances** |

Mark Elliott became the new group manager of a cluster of six radio stations in a top-30 Midwestern market when his company acquired four other stations in that market. Elliott's company, Janus Broadcasting, now owned four FM and two AM stations in a market of 23 total stations. More importantly, Elliott's combined stations controlled about 35 percent of the radio advertising revenue in the market, with four stations targeting the lucrative 18–34 demographic.

Elliott and his aggressive sales staff wanted to link up with retailers throughout the market to offer a number of opportunities for the retailers to reach new customers and the stations to create new listeners. Several projects were underway, including joint sponsorship on-air as well as on the station's Web sites; a cooperative venture with the local newspaper to promote joint newspaper-radio marketing efforts; and seminars on radio advertising to educate businesses that were currently not advertising on any radio station.

At the weekly staff meeting, Elliott praised the efforts that had been taken to date but encouraged his staff—especially the programming, promotion, and sales managers—to identify potential partnerships with local television stations and the local cable operator. "We are missing some opportunities here," said Elliott. "With five television stations in this market, and none of them owned by any of our radio competitors, let's figure out some cooperative arrangements that might benefit both of our operations. And don't forget about the cable operator, which has nearly 60 percent of the TVHH as customers. I want you to brainstorm and see what sort of ideas you come up with regarding potential partnerships that we could use to enhance both parties."

Working individually or in small groups, generate ideas on possible strategic alliances your station group and the TV and cable operators might consider that would enhance each operation at the local level. Ideas could be related to programming, advertising, or promotional alliances.

| CASE STUDY | **Developing New Markets** |

In 1995, a San Antonio television station started a local 30-minute program highlighting the many interesting and unique aspects of the state of Texas. *Texas Trails and Tales* became such a popular program that it was syndicated on several stations across the state.

Two years ago, your company decided to expand the program into other states in which you owned television stations. To date, clones of *Texas Trails* can be found in the states of California, Florida, Georgia, and Virginia— each of course with a separate name and host. Overall, the programs have been gaining strength in each market, and in California and Florida the local programs are starting to be syndicated among other stations in the states.

Recognizing the value of the program and its local nature, station managers have now focused on expanding ancillary markets for the programs in each

state. At a recent planning session, three potential ventures seemed to offer the most potential.

1. Begin a partnership with a professional designer to develop a Web site that would feature streaming media excerpts from past programs and clips not seen in the original broadcasts. Ideally, consumers could use the Web site in planning vacations or for general reference.

2. Market the program to cable systems within each state, particularly those with local-origination channels. This would expand the reach of the program and provide more exposure.

3. Enter a partnership with a specialty manufacturer to develop a companion book, a videotape, and other merchandise (for example, T-shirts, caps, and maps) to market to retailers in each state. Link these efforts to the station's Web site to develop an e-commerce revenue stream.

Discuss the types of strategic alliances possible for each of these ideas. For example, in developing the Web site, would it be better to enter a joint venture with a proven company, or simply hire a consultant to create the site, thereby retaining full ownership of the product?

Which types of alliances would work best with each situation? Explain how you made your decision in each case.

InfoTrac College Edition

For new information on the topic of strategic alliances across the electronic media, use InfoTrac College Edition. Use the following terms for subject and keyword searches: electronic media, strategic alliances, strategic partnerships, mergers, mergers and acquisitions.

Web World

The following Web sites offer information on various types of business activities, including strategic alliances and partnerships.

Business Resources and Publications
The Wall Street Journal (www.wsj.com)
Hoover's Online (www.hoovers.com)
Business Week (www.businessweek.com)
Broadcasting & Cable (www.broadcastingcable.com)

Electronic Media (www.emonline.com)
The Economist (www.economist.com)

Research and Investment Companies
Veronis, Suhler & Associates (www.veronissuhler.com)
BIA Research, Inc. (www.bia.com)

References for Chapter 2

Albarran, A. B. (1998). The coalescence of power: The transformation of the communication industries. In R. G. Picard (Ed.), *Evolving media markets: Effects of economic and policy changes* (pp. 8–24). Turku, Finland: Economic Research Foundation for Mass Communication.

Albarran, A. B., & Chan-Olmsted, S. (1998). *Global media economics: Commercialization, concentration, and integration of world media markets*. Ames, IA: Iowa State University Press.

Albarran, A. B., & Dimmick, J. (1996). Concentration and economies of multiformity in the communication industries. *Journal of Media Economics 9*(4), 41–50.

Bagdikian, B. (2000). *The media monopoly* (6th ed.). Boston: Beacon.

Cullen, J. B. (1999). *Multinational management: A strategic approach*. Cincinnati, OH: South-Western College Publishing.

Davidson, K. (1985). *Megamergers*. Cambridge, MA: Ballinger Publishing Company.

Drucker, P. F. (1999). *Management challenges for the 21st century*. New York: Harper Collins.

Ducey, R. V. (1999). Internet + DTV broadcasting = UN − TV. Available online: http://www.nab.org/Research/topic [Accessed September 28, 2000].

Gates, S. (1993). *Strategic alliances: Guidelines for successful management*. New York: The Conference Board, Inc.

Interconnect. (2000, April 10). *Arthur Andersen's weekly news summary for the technology, media and communication industries*. Available via subscription email from ArthurAndersen.com.

Lewis, J. (1990). *Partnerships for profit: Structuring alliances*. New York: Free Press.

Lorange, P., & Roos, J. (1992). *Strategic alliances: Formation, implementation, and evolution*. Cambridge, MA: Blackwell Publishers.

NCTA. (2000, June 13). Cable television year end review. Available online: http://www.ncta.com [Accessed October 24, 2000].

Negroponte, N. (1996). *Being digital.* New York: Knopf.

Ozanich, G. W., & Wirth, M. O. (1998). Media mergers and acquisitions: A communications industry overview. In A. Alexander, J. Owers, & R. Carveth (Eds.), *Media economics: Theory and practice,* 2nd ed. (pp. 95–107). Mahwah, NJ: Lawrence Erlbaum Associates.

Steinfield, C., Baldwin, T. S., & McVoy, D. S. (1996). *Convergence: Integrating media, information & communication.* Thousand Oaks, CA: Sage.

Turow, J. (1992). The organizational underpinnings of contemporary media conglomerates. *Communication Research, 19*(6), 682–704.

Ethics of Management

In this chapter you will learn

- The role ethics plays in managerial decision making
- Norms consulted in making ethical decisions
- How organizations and individuals use ethical codes of conduct and mission statements to define ethical principles
- Common ethical issues faced by media management
- How to implement an ethics program in an electronic media organization

Electronic media managers make numerous decisions every working day. Their decisions often involve routine activities such as budget approval, personnel matters, and marketing and promotion plans. However, not all decisions can be made easily. Certain situations force managers to confront their own system of morals and values. Consider the following examples based on actual events.

- Several car chases covered live by television news crews in the Southwestern United States end in tragedy. In one incident the suspect takes his own life. In another incident the suspect is gunned down by police after brandishing a weapon at officers.

- A national supermarket chain's image is damaged by a network newsmagazine report that the chain sold tainted meat. The story was compiled using hidden cameras worn by employees hired by the network to infiltrate the supermarket's workforce.

- A zealous reporter, anxious to get a story about illegal dog fighting, steals videotape from a subject's car that contains footage of dogfights involving pit bull terriers. The reporter is later arrested and charged with a misdemeanor.

- A study by the University of Miami finds one in five news directors claims some controversial stories are not being covered for fear a lawsuit may be filed against the station.

- *The Jerry Springer Show,* a controversial syndicated talk show, admits that on some broadcasts fights between people appearing on the show were staged and acted out prior to being broadcast.

These examples illustrate just a few of the challenging ethical situations confronting electronic media managers. Obviously, there are several possible solutions to each of these situations, and a discussion would yield many different answers. How would you handle each of these cases if you were the manager? Chances are you would depend on your own understanding of what is right and wrong, consider the alternatives, and respond accordingly. The study of ethics can help us by providing the means to make difficult moral choices that confront us in our professional and personal lives.

What Is Ethics?

Derived from the word *ethos,* the study of ethics began nearly 2,500 years ago in ancient Greek society. Ethics is concerned with basic questions about what is right and what is wrong, and it involves the character and conduct of individuals and institutions (Jaska & Pritchard, 1994). Day (2000) defines ethics as a branch of philosophy dealing with the moral aspects of life.

Ethics reflects a society's norms about what is morally right and wrong. On an individual level, ethics provides one's own understanding of proper conduct based on principles and rules that one considers important. Many laws in a society are derived from the ethics and ethical values regarding acceptable behavior (see Limberg, 1989).

There are many ways to study ethics (Jaska & Pritchard, 1994). One approach employs empirical methods to describe the particular moral values of a group or society. Another area of study, known as normative ethics, is concerned with understanding which values are

the most relevant to a society. Ethics can also be examined in terms of organizations and the codes of ethics they adopt. Finally, one may also study personal ethics. This chapter is most concerned with the role of ethics in decision making among electronic media managers, an area bridging organizational ethics and personal ethics.

Ethical Decision Making in the Electronic Media

There is no universally accepted code of ethics in the electronic media. An organization may adopt its own code of ethics, which may be written or simply implied. Wherever group or organizational ethics codes exist, conflicts may arise between the organization's approach and the individual's moral beliefs.

Furthermore, the types of ethical situations vary by departments. For example, in newsrooms the ability to address decisions quickly and responsibly is an important skill. Marketing, promotions, and public relations personnel face different ethical situations because they must be creative as well as competitive in dealing with audiences and advertisers. Programmers, producers, writers, and directors reveal their own sense of ethics through the production of media content. The General Manager attempts to balance the needs of the market (owners, stockholders, and other competitors) and the public in the ethical situations electronic media organizations face on a daily basis.

Christians, Rotzoll, and Fackler (1997) identify five ethical duties of mass media employees at all levels of management and non-management, as well as all types of institutions:

1. *Duty to self.* Media professionals need individual integrity and the strength to follow their conscience. Balancing career objectives with other duties can be challenging.

2. *Duty to the audience.* When deciding on a particular course of action, the audience, subscribers, or other supporters must be considered. How will the decision affect the audience?

3. *Duty to employer or organization.* Responsible employees have a sense of obligation to their employer. Duty to the firm may outweigh individual duty in certain situations. What is the impact of one's decision on the organization?

4. *Duty to professional colleagues.* We often consider obligation and loyalties to professional colleagues when we make ethical decisions. To what extent does duty to professional colleagues affect such decisions?

5. *Duty to society.* Many issues call into question our duty to society. In broadcast journalism, individual rights to privacy and confidentiality often arise. Media content that contains scenes of sex and violence also directly concerns society. To what extent does duty to society affect other professional duties and loyalties?

Hosmer (1991) explains that though the ethical problems management faces are thought to be simple, in most cases they are complex. Decision making is a challenging process for many reasons. Hosmer lists five factors that complicate the making of ethical decisions by managers:

1. *Ethical decisions have extended consequences.* Managerial decisions go beyond immediate or first-level consequences. Decisions affect others throughout the organization and society.

2. *Ethical decisions have many alternatives.* Few decisions involve a simple yes or no. Managers must consider all options when making an ethical decision. For electronic media managers, the pressures of time and deadlines can limit a careful analysis of each possible alternative.

3. *Ethical decisions often have mixed outcomes.* Ethical decisions often produce both benefits and costs that managers may or may not foresee. The easiest ethical decisions involve only one outcome but are rare.

4. *Most ethical decisions have uncertain consequences.* Rarely are managerial decisions free of risk or doubt, with clear-cut alternatives. Usually managers cannot foretell the full consequences of an ethical decision.

5. *Ethical decisions have personal implications.* Ethical decisions are intertwined with the values, beliefs, and other personal qualities of managers. In most cases, managers face personal benefits and costs in the ethical choices they make.

Ethical norms provide a means of making informed decisions. In the following section, several ethical norms used in making moral decisions are presented.

Norms Used in Moral Decision Making

Ethical norms form the basis of many of our individual and societal beliefs. One can define ethical norms as a set of theories derived from the study of ethics and ethical principles. Ethical norms are useful because they provide a philosophical foundation from which to analyze ethical situations and make intellectually defensible judgments (Day, 2000).

Seven ethical norms are widely used in the study of ethics (see Christians, Rotzoll, & Fackler, 1997; Day, 2000; Jaska & Pritchard, 1994). These norms are the golden mean, the Judeo-Christian ethic, the categorical imperative, utilitarianism, egalitarianism, relativism, and social responsibility theory (see Table 3-1).

TABLE 3-1

.**Comparison of Ethical Norms**

NORM	SOURCE	MAIN IDEA
The Golden Mean	Aristotle	Avoid excess and extremes, seek moderation
The Judeo-Christian Ethic	The Bible	Respect and dignity for all persons.
The Categorical Imperative	Immanuel Kant	Act on those principles that can be applied universally.
Utilitarianism	John Stuart Mill	When faced with a moral decision, seek the solution that will bring the greatest happiness to the greatest number.
Egalitarianism	John Rawls	Adopt a veil of ignorance when making ethical decisions. The veil will allow unbiased and impartial decisions.
Relativism	John Dewey Bertrand Russell	Each individual determines his or her own course of ethical decisions as each encounters different situations. (Gave rise to the study of situational ethics.)
Social Responsibility Theory	The Hutchins Commission	Journalists generally make decisions that serve society in a responsible manner. Decisions are made with good intentions.

NOTE: Compiled by the author from various sources.

The Golden Mean The Greek philosopher Aristotle suggested the golden mean, which stresses moderation as opposed to extremes or excess. Aristotle believed that an individual could achieve strong moral character, but he or she would necessarily face difficult choices. By adopting a middle position, one could avoid both excess and deficiency (Day, 2000).

Principles of the golden mean are evident today, especially in journalistic practices in the media. For instance, the principles of balance and fairness in reporting are built on the golden mean. Maintaining objectivity in covering and reporting the news is another way to practice the golden mean.

The Judeo-Christian Ethic The Judeo-Christian ethic appears in phrases from the Jewish and Christian scriptures, such as "Do unto others as you would have them do unto you" and "Love thy neighbor as thyself." The Judeo-Christian ethic illustrates respect and dignity for all people based on a universal love for God. In making ethical decisions based on this norm, one would consider how the decisions would impact others.

Programming that degrades or demoralizes certain groups, especially women and minorities, violates the Judeo-Christian ethic. For instance, numerous studies of television programming (see Gerbner, Gross, Morgan, & Signorielli, 1994) confirm that the television world differs greatly from the real world, with certain segments of society over-represented (e.g., police officers, doctors, and lawyers) and others almost nonexistent (children and the elderly). In 1999, the National Association for the Advancement of Colored People (NAACP) successfully pressured the major broadcast networks to provide greater diversity among the characters in prime-time television programming and to add more minorities in such critical job functions as writing and producing.

The Categorical Imperative German philosopher Immanuel Kant established the categorical imperative during the 18th century. Kant believed that ethical decisions are derived from a sense of moral duty, or the *categorical imperative*, which is based on principles underlying individual actions. In making moral decisions, we must seek what would be acceptable to all members of society. In other words, those principles we can apply comfortably to all situations will lead us to the right decision.

The categorical imperative is concerned more with the process of making an ethical decision than with the outcome. In using this

norm, electronic media managers must determine which course of action would be the most morally defensible to the most people.

Utilitarianism The writings of John Stuart Mill established the philosophy of utilitarianism during the 19th century. Mill claimed that when faced with moral decisions, one must consider which actions will result in the most happiness for the greatest number of people. This maxim is often referred to as "the greatest good" approach to decision making. Unlike Kant's categorical imperative, utilitarianism is more concerned with the consequences of an ethical decision than with the process of decision making. Democratic societies often identify with Mill's ideas, in that the concept of a majority rule also emphasizes the notion of the greatest good for the greatest number of people.

Given this norm, Program Directors would consider which type of programming would best serve the needs of the majority of the public. News Directors would focus on stories the public needs or wants to know about. Sales Managers might approach clients whose products and services provide a benefit to audiences.

Egalitarianism Based on the work of John Rawls, egalitarianism asserts that everyone must be treated equally and fairly when we form ethical judgments. Rawls introduced a concept known as the *veil of ignorance* to illustrate his ideas. The veil of ignorance is a hypothetical construct. By "wearing" a veil when considering a decision, an individual can eliminate possible biases or discrimination and therefore treat all persons in an equal manner. Without the veil of ignorance, minority viewpoints and those representing weaker points of view may be ignored or overlooked. The veil allows decisions to be made impartially, without cultural biases (Day, 2000).

You could apply this norm to electronic media management in several ways. For example, in the presentation of news, all sides must be presented fairly and accurately. Employment practices must maintain employee diversity. Relationships with advertisers should be conducted fairly without showing preference to larger clients.

Relativism The works of John Dewey and Bertrand Russell best exemplify the philosophy of relativism. Relativists believe that what is best for one is not necessarily what is best for another, even under similar situa-

tions. Each individual decides what is best from his or her viewpoint and does not judge others' decisions. The relativist position has given rise to the study of *situational ethics*, which examines ethical decisions in individual situations.

Program Directors are among the practitioners most likely to follow situational ethics. In radio, the PD must decide the types of music to be played on a station. Questionable lyrics or content should be carefully scrutinized, rejected, or restricted, if necessary, depending on the audience. In television, Program Managers determine which types of syndication programs to use, as well as which types of network programs to clear. When confronted with a potentially controversial program, the manager must evaluate it and its impact on the local audience.

Social Responsibility Theory

During the 1940s, the Hutchins Commission on the Freedom of the Press examined the American mass media (Day, 2000). The commission found that journalists and other practitioners generally make responsible decisions that serve society (Tucher, 1998). The commission's findings gave rise to the theory of social responsibility. The commission recognized that though individuals in the media cannot correctly determine the exact impact of their decisions, they make them with good intentions.

Though social responsibility theory originated in the newspaper industry, it easily applies to the electronic media. All managers who engage in responsible behavior and expect the same type of behavior from all employees act on this norm. Exhibiting responsible behavior through programming and other areas can also enhance the spirit of trust between an electronic media facility and its audience.

Deontological and Teleological Ethics

Ethical norms often fall into two broad categories of philosophical thought: those concerned with the *process* of making decisions based on established principles and those concerned with the *actions* or *consequences* of decisions. The former category is referred to as deontological ethics, the latter as teleological ethics.

Deontological ethics is best reflected in the works of Kant, who emphasized the idea of duty in making ethical judgments. In fact, the prefix *deon* in deontologist is derived from the Greek word meaning duty. Because deontological theories are not concerned with out-

comes, followers of those theories are often referred to as nonconsequentialists (Day, 2000). Deontological theories examine both the intent and the motives of actions.

On the other hand, teleological theories are primarily concerned with consequences and the ability to make the best possible decisions. Ethically correct decisions are those that produce the best consequences. Utilitarianism, with its maxim of "the greatest good," is the best example of a teleologically based ethical theory. Though teleological theories do not ignore the process of making decisions, they do emphasize efforts to produce the best possible decisions through a careful examination of each alternative and its impact on others.

Ethical Codes and Mission Statements

Ethical codes of conduct and mission statements are two ways electronic media practitioners and companies publicly define their business values. Codes of ethics tend to be associated with professional organizations such as the Radio-Television News Directors Association (RTNDA) and the Society for Professional Journalists (SPJ). Mission statements are created by companies to define exactly what the company does (the "mission") and to reflect the organization's sense of values.

Codes of Ethics Codes of ethics are written statements, often presented as creeds that define conduct for an organization and its members. These codes are usually controversial. Proponents claim that codes of ethics avoid the problems of individual interpretations of matters of moral judgments, while opponents assert that codes are a form of self-censorship and are often too vague and general to address moral issues effectively (Black & Barney, 1985–1986; Day, 2000; Vivian, 1999).

Several professional codes of ethics exist in the electronic media industries. The most prominent media-related organizations that have formulated professional ethical codes include the Society of Professional Journalists, the American Society of Newspaper Editors, the Radio-Television News Directors Association, the Advertising Code of American Business, the Associated Press Managing Editors, and the Public Relations Society of America. The National Association

of Broadcasters at one time produced separate codes for radio and television stations, but the codes were declared unconstitutional in 1982 (see Limberg, 1989). The RTNDA code of ethics is presented in Table 3-2.

TABLE 3-2

Example of Ethical Code

CODE OF ETHICS AND PROFESSIONAL CONDUCT OF THE RADIO-TELEVISION NEWS DIRECTORS ASSOCIATION

The Radio-Television News Directors Association, wishing to foster the highest professional standards of electronic journalism, promote public understanding of and confidence in electronic journalism, and strengthen principles of journalistic freedom to gather and disseminate information, establishes this Code of Ethics and Professional Conduct.

PREAMBLE Professional electronic journalists should operate as trustees of the public, seek the truth, report it fairly and with integrity and independence, and stand accountable for their actions.

PUBLIC TRUST: Professional electronic journalists should recognize that their first obligation is to the public.

Professional electronic journalists should:

- Understand that any commitment other than service to the public undermines trust and credibility.
- Recognize that service in the public interest creates an obligation to reflect the diversity of the community and guard against oversimplification of issues or events.
- Provide a full range of information to enable the public to make enlightened decisions.
- Fight to ensure that the public's business is conducted in public.

TRUTH: Professional electronic journalists should pursue truth aggressively and present the news accurately, in context, and as completely as possible.

Professional electronic journalists should:

- Continuously seek the truth.
- Resist distortions that obscure the importance of events.
- Clearly disclose the origin of information and label all material provided by outsiders.

Professional electronic journalists should not:

- Report anything known to be false.
- Manipulate images or sounds in any way that is misleading.

TABLE 3-2 continued

CODE OF ETHICS AND PROFESSIONAL CONDUCT OF THE RADIO-TELEVISION NEWS DIRECTORS ASSOCIATION

- Plagiarize.
- Present images or sounds that are reenacted without informing the public.

FAIRNESS: Professional electronic journalists should present the news fairly and impartially, placing primary value on significance and relevance.

Professional electronic journalists should:

- Treat all subjects of news coverage with respect and dignity, showing particular compassion to victims of crime or tragedy.
- Exercise special care when children are involved in a story and give children greater privacy protection than adults.
- Seek to understand the diversity of their community and inform the public without bias or stereotype.
- Present a diversity of expressions, opinions, and ideas in context.
- Present analytical reporting based on professional perspective, not personal bias.
- Respect the right to a fair trial.

INTEGRITY: Professional electronic journalists should present the news with integrity and decency, avoiding real or perceived conflicts of interest, and respect the dignity and intelligence of the audience as well as the subjects of news.

Professional electronic journalists should:

- Identify sources whenever possible. Confidential sources should be used only when it is clearly in the public interest to gather or convey important information or when a person providing information might be harmed. Journalists should keep all commitments to protect a confidential source.
- Clearly label opinion and commentary.
- Guard against extended coverage of events or individuals that fails to significantly advance a story, place the event in context, or add to the public knowledge.
- Refrain from contacting participants in violent situations while the situation is in progress.
- Use technological tools with skill and thoughtfulness, avoiding techniques that skew facts, distort reality, or sensationalize events.
- Use surreptitious newsgathering techniques, including hidden cameras or microphones, only if there is no other way to obtain stories of significant public importance and only if the technique is explained to the audience.
- Use the private transmissions of others only with permission.

continued

TABLE 3-2 *continued*

CODE OF ETHICS AND PROFESSIONAL CONDUCT OF THE RADIO-TELEVISION NEWS DIRECTORS ASSOCIATION

Professional electronic journalists should not:

- Pay news sources who have a vested interest in a story.
- Accept gifts, favors, or compensation from those who might seek to influence coverage.
- Engage in activities that may compromise their integrity or independence.

INDEPENDENCE: Professional electronic journalists should defend the independence of all journalists from those seeking influence or control over news content.

Professional electronic journalists should:

- Gather and report news without fear or favor, and vigorously resist undue influence from any outside forces, including advertisers, sources, story subjects, powerful individuals, and special interest groups.
- Resist those who would seek to buy or politically influence news content or who would seek to intimidate those who gather and disseminate the news.
- Determine news content solely through editorial judgment and not as the result of outside influence.
- Resist any self-interest or peer pressure that might erode journalistic duty and service to the public.
- Recognize that sponsorship of the news will not be used in any way to determine, restrict, or manipulate content.
- Refuse to allow the interests of ownership or management to influence news judgment and content inappropriately.
- Defend the rights of the free press for all journalists, recognizing that any professional or government licensing of journalists is a violation of that freedom.

ACCOUNTABILITY: Professional electronic journalists should recognize that they are accountable for their actions to the public, the profession, and themselves.

Professional electronic journalists should:

- Actively encourage adherence to these standards by all journalists and their employers.
- Respond to public concerns. Investigate complaints and correct errors promptly and with as much prominence as the original report.
- Explain journalistic processes to the public, especially when practices spark questions or controversy.
- Recognize that professional electronic journalists are duty-bound to conduct themselves ethically.
- Refrain from ordering or encouraging courses of action that would force employees to commit an unethical act.

TABLE 3-2 *continued*

CODE OF ETHICS AND PROFESSIONAL CONDUCT OF THE RADIO-TELEVISION NEWS DIRECTORS ASSOCIATION
• Carefully listen to employees who raise ethical objections and create environments in which such objections and discussions are encouraged. • Seek support for and provide opportunities to train employees in ethical decision-making. In meeting its responsibility to the profession of electronic journalism, RTNDA has created this code to identify important issues, to serve as a guide for its members, to facilitate self-scrutiny, and to shape future debate.

NOTE: Reprinted with permission of the Radio-Television News Directors Association.

Many professions use a code of ethics. Professional associations of doctors, lawyers, and psychologists have developed codes of ethics that are enforced by the associations; people found guilty of ethical misconduct can be completely removed from the profession. A distinguishing feature of codes relating to the mass media industries is their lack of enforceability. Many people criticize the lack of enforceable codes, as well as the lack of a universal code of ethics, in the media.

Mission Statements

Many electronic media organizations have followed the lead of other major corporations in creating mission statements, which identify an organization's purpose and values. While not a code of ethics, a mission statement publicly displays the inherent values of an organization. Warner and Buchman (1991) explain that these statements are an important source of pride and self-esteem for media employees; a mission statement instills confidence in employees by clearly and succinctly defining the purpose and focus of the company.

Hitt (1990) suggests that a mission statement is the responsibility of every manager in an organization. An acceptable mission statement defines the purpose of an organization, focuses on the product or service the organization provides, responds to the needs of various publics with interests in the organization, provides direction for making decisions and taking other actions, and energizes all employees. Finally, mission statements should be enduring but not resistant to change.

Table 3-3 lists the values and operating principles for Belo Corp., based in Dallas, Texas. Belo owns several television stations and pub-

TABLE 3-3

BELO VALUES	BELO OPERATING PRINCIPLES
Integrity	Build common understandings
Excellence	Apply our values
Fairness	Be accountable
Sense of Purpose	Practice respect and candor
Inclusiveness	Work as a team

NOTE: From Belo Corp., 2001. Used with permission.

lishes a number of newspapers. Note that the statement of Belo's values and operating principles identifies areas of conduct that exemplify the corporation's ethical conduct.

Ethical Issues in Media Management

Many ethical issues arise in electronic media management. This section will focus on four areas that clearly affect managerial decision making.

Serving the Market or the Marketplace

Natural conflicts arise over the ability of electronic media firms to serve the market as well as the marketplace (McManus, 1992). Radio and television stations are required to serve the public interest, without benefit of the guidance provided by the rules and guidelines that existed pre-deregulation. Thus, the burden is on management to define what is in the public's interest. The removal of requirements for community ascertainment (gathering of information on issues of concern to the community), the Fairness Doctrine, and requirements for news and public service programming quotas gives managers more latitude in determining their own course of action in serving the public.

Critics of deregulation contend that the media are no longer concerned with meeting the needs of the audience. This criticism is perhaps valid for some media facilities, but not across the board. Many broadcasters are actively involved in serving their communities through various types of outreach programs, recognizing that localism is the major difference between their service and that of competitors.

Even so, broadcasters have an obligation to their owners and stockholders to maintain a profitable business. Electronic media companies are not in business to lose money. The push for profits, however, can create pressures that may override the needs of the audience. Ethical issues arise when business interests eclipse other obligations (Day, 2000).

Dan Halyburton, a Group Vice President with Susquehanna Radio, claims that a good manager can effectively serve the needs of the public and the needs of the market, although it is a continuing balancing act. According to Halyburton, the key is to stay actively involved with the community in a variety of different ways—and to act responsibly toward the audience.

Controversies over Programming Managers in the electronic media are often confronted with ethical questions related to programming because it is the most visible activity of electronic media companies (see Chapter 8). Most programming controversies in television relate to sex, violence, and children's programming.

Sexual Content The amount of sexual content in television programs continues to generate concerns from audience members, religious organizations, and educational groups such as PTAs. Programs such as *NYPD Blue* have regularly featured partial nudity. Sexual situations are a regular part of many daytime soap operas. Many cable channels tend to be much more liberal in their use of sexual content than the broadcast networks.

Violence Decades of studies have shown that television programming contains excessive violence (Gerbner, Gross, Morgan, & Signorielli, 1994). While the networks have moved away from programs that feature gratuitous violence, some violent content remains. As with programs that feature sexual content, managers must determine which programs the audiences they serve will accept. Violence in society, such as the rash of public school shootings that escalated during the late 1990s, refocused attention on television and film violence and its potential effects on adolescents.

Children's Programming Advocates for quality children's television have bemoaned the lack of good children's programming since the

1960s. In spite of the Children's Television Act of 1990, controversies remain.

Programming controversies may cause conflicts between a manager's personal ethics and those of the organization. For example, a manager of a network-affiliated TV station may have personal moral objections to a program offered by the network. However, the station will in many instances allow the program to air so that the station will remain in good standing with the network and those advertisers who have purchased time during the broadcast. In such a case, the manager has chosen duty to the organization and customers over his or her personal duty.

Ethics in News and Public Affairs In the reporting of news and public affairs, many types of ethical concerns confront news managers and GMs. As in the case of serving both the needs of the market and the needs of the marketplace, a great deal of pressure exists to remain competitive and be the first to report a major news event. Economic pressures come into play for news departments as they strive to win the news ratings wars against other stations. Here are some of the most common areas of ethical questions.

Questions of Truth and Accuracy One of the most important virtues of a society, telling the truth, is reflected in many ethical codes and creeds. Truth establishes trust, credibility, and integrity among media institutions. Because every effort must be made to present accurate coverage in all news and public affairs programming, reporters and editors must carefully verify all facts. The staging of news events or other dramatic re-creations can mislead the audience, and many news organizations avoid dramatizations.

Questions of Privacy The public's right to know should not impinge on another person's right to privacy. News managers must be certain that coverage of individuals occurs because of its newsworthiness. Several areas of news reporting have been given special treatment by the media, for example, instances of rape or sexual assault (a generally accepted code of ethics prohibits the naming of victims), sexual orientation of potentially newsworthy individuals, identity of people affected by certain diseases (such as AIDS), details of suicides, identity

of juvenile offenders, and treatment by the media of people suffering from personal tragedies. Managers should also question the use of secret cameras and other recording devices to get a story.

Conflicts of Interest Generally, journalists should avoid situations that produce a conflict of interest, compromising their ability to cover a story properly. Managers may face situations where reporters are offered gifts or other considerations that could impair their ability to report a story accurately. Personal relationships may develop with news sources in a way that creates a conflict of interest. Paying sources for information, or "checkbook journalism," raises similar concerns (Day, 2000).

Confidentiality of Sources When a reporter promises anonymity to a source, confidentiality becomes a concern. Reporters are sometimes asked to reveal their sources of information; in extreme cases, reporters have been jailed for refusing to divulge the names of their sources. Many states have adopted provisions known as *shield laws*, which protect reporters from having to reveal the names of confidential sources to either courts or investigative agencies. News managers are sometimes caught between a reporter's effort to maintain confidentiality and external forces demanding the information.

Pressures from Advertisers In news stories, corporations and businesses often receive attention. In some cases, such businesses are also advertising clients of the station or network. Advertisers typically object if a story is presented in a negative manner. For example, the infamous *Dateline* program that featured the rigged explosion of a General Motors truck resulted not only in a lawsuit against NBC but also in the potential loss of a major advertiser. The lawsuit was eventually dropped, NBC apologized for the incident, and GM remained a client.

Ethics in Sales The sales or marketing department also faces a range of ethical questions. In their analysis of ethics in sales, Warner and Buchman (1991) offer a list of ethical responsibilities. Their five levels of accountabil-

ity, in order of importance, are consumers (audience), conscience, commercial media, customers (advertisers), and the company.

Responsibility to the Audience As with their journalistic counterparts, media sales departments must maintain the truth in all commercial announcements. The audience wants messages it can believe; to provide false messages violates trust and destroys credibility.

Responsibility to One's Conscience Responsible to themselves, salespeople should exhibit good ethical behavior. Salespeople with strong ethical principles will be received as professionals, enhancing their self-confidence and self-esteem.

Responsibility to Other Commercial Media Because media sales professionals represent the industry in which they work, they exert a great deal of influence in the local market through their actions. Sales professionals who criticize other competitors so as to gain more business exhibit little respect for other media and engage in negative selling, which ultimately undermines them.

Responsibility to Advertisers Sales professionals enter into a relationship of trust with the clients they serve. They come to know a great deal about a client's outlook on advertising, budget, goals and objectives, and primary competitors. Such information is privileged, between only the client and the salesperson. Further, salespeople have an obligation to serve the needs of the client with the campaigns they propose. Finally, sales professionals should avoid making promises they cannot keep to advertising clients.

Responsibility to the Organization In addition to serving clients, sales professionals have specific obligations to their employers. Because electronic media advertising is an intangible product, the sales professional becomes an extension of the product offered by the company and should therefore act responsibly. Sales professionals also have an obligation to help maximize revenue and should therefore

strive to balance the needs of the clients they serve with the needs of the organization.

Implementing an Ethics Program

As this chapter illustrates, ethical decision making in the electronic media can be a complicated and challenging process involving many aspects of the organization and different types of practitioners. Companies that have adopted a plan or program to help guide them through ethical dilemmas deal with ethical issues better than others.

Good companies and their managers do more than simply talk about ethics. They take steps to address ethical issues routinely and make ethical principles an integral part of their practices. For companies who have not considered implementing a program of ethics, Hitt (1990) offers a four-step plan applicable to any organization.

1. *State the mission.* Each company should have a mission statement that clarifies the purpose of the organization, not only for employees but also for external publics.

2. *Clarify the values of the organization.* Good companies exemplify good values. Communicating the values that the organization considers important is just as critical as stating the mission of the organization. Whether included in the mission statement or presented separately, values should be clear and understandable, because they communicate a great deal about the company's attitude toward ethics.

3. *Create a code of ethics.* A written code of ethics, ideally found in the employee handbook, clarifies the company's position on ethical principles. The code requires the commitment of the entire organization. Promoting professionalism and credibility, a code of ethics helps the company manage employee conduct and organizational change. The code should be written in everyday language, with a positive tone.

4. *Develop an ethics program.* Hitt (1990) offers several pointers for implementing an ethics program. Complete the necessary basic in-

formation (mission statement, values, and code of ethics). Orient all new employees to the ethical principles of the company. Conduct ethics seminars for all levels of management, using participatory decision making. Take time to discuss ethical issues in management and staff meetings. Maintain an open-door policy with all employees regarding ethical concerns. Finally, regularly evaluate your ethics program much as you would any other managerial program (at least yearly).

Summary

Electronic media managers and practitioners are often required to make decisions that challenge their personal morals and values. The study of ethics helps by providing some means to make difficult moral choices that confront us in our professional and personal lives. Ethics, a branch of philosophy concerned with the basic questions about what is right and wrong, is based on principles and rules that define proper conduct for both individuals and society.

In the electronic media, ethical decision making varies by managerial levels and individual units. Though no universal code of ethics exists in the electronic media, scholars have recognized that media professionals have five areas of ethical duties: duty to self, duty to the audience, duty to the employer, duty to professional colleagues, and duty to society. Ethical decisions by managers often have extended consequences, multiple alternatives, mixed outcomes, and personal implications.

Several ethical norms provide a foundation on which to make ethical decisions. These include the golden mean, the Judeo-Christian ethic, the categorical imperative, utilitarianism, egalitarianism, relativism, and social responsibility theory. Some norms examine the process of making ethical decisions; this is called *deontological* ethics. Norms concerned with the consequences of ethical decisions are called *teleological* ethics.

Ethical codes of conduct and mission statements are two ways electronic media companies publicly define their business values. Professional organizations tend to produce ethical codes while organizations or companies usually offer mission statements.

Ethical issues in media management cover a range of subjects. Such issues often arise in efforts to serve both the public and the marketplace, media programming controversies, the reporting of news and public affairs, and the sale of media advertising.

Implementing an ethics program is an essential step in making ethics an important part of any organization. To have a successful ethics program, organizations should state their mission, clarify their values, establish a written code of company ethics, and formulate an active program that involves all employees and receives regular evaluation.

CASE STUDY	**Dealing With A Major Advertiser**

WCIT-TV, Channel 6, has had a strong reputation in the local market thanks to its award-winning news department. Over the years, a regular feature called *The Investigative Team* has focused on in-depth investigative reporting. Over the years the "I-Team" has uncovered corruption in many different arenas: the local school board, kickbacks to local politicians, and a scam by supermarket employees to defraud companies offering coupons to consumers.

In recent weeks, the I-Team has focused on automobile repairs. Several auto dealers were targeted (based on complaints to the local Better Business Bureau) to determine if the centers were recommending unneeded repairs for vehicles.

A female reporter took a vehicle to five auto dealers. The car needed minor repairs—replacement of a spark plug and a tire with badly worn treads, and replacement of some brake fluid. A local mechanic checked out the car prior to the investigation and determined there were no other problems.

All of the dealerships determined the car needed a tune-up as well as a new tire. Three of the dealerships suggested purchasing anywhere from two to four tires to ensure proper balance and efficiency while driving. The fourth dealer noted the car needed some brake fluid. The fifth dealer claimed the car needed an entirely new brake job and replacement of the brake master cylinder. Total cost for the brake system—nearly $1,000!

As routinely done, the I-Team reporters went back to each dealer to confront the manager with video evidence. The fifth dealer, All-American, was the primary target for the investigation. The manager at All-American denied any wrongdoing and ordered the reporters to leave.

The report was scheduled to air as part of a series on customer abuses and rip-offs in auto repairs starting the following Monday. On Friday afternoon, the attorney for All-American Automotive, Tony Larson, called the station to talk to the Local Sales Manager, Paul Corey.

"Mr. Corey, I'll get right to the point," said Larson. "All-American Automotive is very concerned about the story by your news team and its impact on the business. We don't feel the station was being professional by using hidden tactics to find out about our business. In any event, the owners have terminated the manager of the shop and the mechanic who ran the estimate on your news vehicle."

Corey listened but was confused. "That's fine, Mr. Larson, but what does that have to do with my department—don't you want to talk to the News Director?"

Larson continued, "No, Mr. Corey. You see, your reporter didn't know this, but All-American Automotive is part of a larger company you know quite well—Banner Enterprises, which includes Banner Motors and the Banner Auto Parts chain of parts stores around the city. As I understand, Banner Enterprises is one of your personal accounts. Banner purchases nearly $200,000 worth of advertising each year on your station. Mr. Banner wanted me to communicate to you that if this report, which directly and publicly admonishes All-American Automotive, runs on your station, there is little chance that your station will be able to secure any more advertising dollars from Banner Enterprises. Thanks for your time, Mr. Corey." Larson hung up.

Corey quickly organized a meeting with the General Manager and the News Director to discuss the problem. What should the station do? How might the desired decision differ between the News Director and the Sales Manager? Should the station kill the I-Team report or run the story as planned? What would the loss of the client mean to the station? How would the decision to kill the report damage the reputation and credibility of the news department? If you were the manager of this station, what would you do?

| CASE STUDY | **DEFINING THE MISSION OF A MEDIA FACILITY** |

Your company, Progressive Media Inc., recently completed the acquisition of its tenth radio station, WCFG-FM, in a top-30 Southern market. The station has been programming a classic rock format, beginning with the syndicated morning show of a popular shock jock. Ratings indicate the station attracts less than 12 percent of the population.

Your company will change the format at the end of the month to a country format, targeting younger adults, that will be more moderate and more appealing to advertisers in the market, many of whom hold very conservative values.

Progressive Media has a generic corporate mission statement and requires each station to develop a statement that reflects the local audience it serves. As the new manager of the station, one of your duties is to develop a mission statement for your operation that also reflects the values of your organization.

How would you go about determining what should be included in your mission statement? Which community leaders might you consult? Prepare a draft of the statement for your station as a starting point for discussion.

| CASE STUDY | **WEEKEND ANCHOR IN TROUBLE** |

Brad Hutchinson is the weekend news anchor at WWES-TV in a top-15 Midwest market. Hutchinson, a single, handsome man in his mid-30s, has anchored the weekend news at WWES-TV for 2 years.

Hutchinson is extremely popular in the ratings, especially with female viewers. He has a reputation as a ladies' man, attending a number of social and community events with a variety of women. Hutchinson also is known for being a party guy when he is off-duty, enjoying nightlife at local dance clubs and bars.

One Tuesday evening, News Director Pat Albright received a telephone call from a reporter covering city hall and the police department. Brad Hutchinson had been arrested earlier in the evening in a sting operation along with another person. Allegedly, they were trying to buy cocaine from an undercover police officer. The reporter learned that Hutchinson was in the car as a passenger and the other suspect did the talking in trying to

make a deal. Hutchinson was considered an accomplice in the operation, resulting in his arrest.

The next day, Albright schedules an appointment with you as GM to discuss the Hutchinson situation. How should the station handle this incident? How might it impact the community's view of the anchor and the station? What ethical principles should be considered in this case? What would you do if you were the manager?

InfoTrac College Edition

For new information on the topic of ethics, use InfoTrac College Edition. Use the following terms for subject and keyword searches: ethics, media ethics, ethical norms, ethical principles, journalism ethics.

Web World

The following associations offer information related to media ethics and ethical principles:
Radio-Television News Directors Association (www.rtnda.org)
The Poynter Institute (www.poynter.org)
The Freedom Forum (www.freedomforum.org)
Society for Professional Journalists (www.spj.org)

Other Web sites:
(www.fullerton.edu/les/ethics_list.html) Ethics on the Web site contains a number of useful links.
(www.journalism.sfsu.edu/www/ethics.html) A good site with numerous links to other Web sources on media ethics.
(www.truthinmedia.org) An organization that has accuracy and truth in media as its primary goal.
(www.pbs.org/mediamatters) Companion Web site to the PBS television series.
(www.uta.fi/ethicnet) EthicNet. Sources of information related to European media ethics.

References for Chapter 3

Black, J., & Barney, R. D. (1985–1986). The case against mass media codes of ethics. *Journal of Mass Media Ethics, 1*(1), 27–36.

Christians, C. G., Rotzoll, K. B., & Fackler, M. (1997). *Media ethics: Cases and moral reasoning* (5th ed.). New York: Longman.

Christians, C. G., Schultze, Q. J., & Sims, N. H. (1978). Community, epistemology and mass media ethics. *Journalism History, 5*(2), 38–67.

Day, L. A. (2000). *Ethics in media communications: Cases and controversies* (3rd ed.). Belmont, CA: Wadsworth.

Gerbner, G., Gross, L., Morgan, M., & Signorielli, N. (1994). Growing up with television: The cultivation perspective. In J. Bryant & D. Zillmann (Eds.), *Media effects: Advances in theory and research* (pp. 17–42). Hillsdale, NJ: Lawrence Erlbaum Associates.

Hitt, W. D. (1990). *Ethics and leadership: Putting theory into practice.* Columbus, OH: Battelle Press.

Hosmer, L. T. (1991). *The ethics of management* (2nd ed.). Boston: Irwin.

Jaska, J. A., & Pritchard, M. S. (1994). *Communication ethics: Methods of analysis* (2nd ed.). Belmont, CA: Wadsworth.

Limburg, V. E. (1989). The decline of broadcast ethics: U.S. v. NAB. *Journal of Mass Media Ethics, 4*(2), 214–231.

McManus, J. (1992). Serving the public and serving the market: A conflict of interest? *Journal of Mass Media Ethics, 7*(4), 196–208.

Tucher, A. (1998). The Hutchins Commission, half a century on—I. *Media Studies Journal* (Spring/Summer) 48–55.

Vivian, J. (1999). *The media of mass communication* (5th ed.). Needham Heights, MA: Allyn and Bacon.

Warner, C., & Buchman, J. (1991). *Broadcast and cable selling* (2nd ed.). Belmont, CA: Wadsworth.

4

Theories of Management

In this chapter you will learn

- Why management is considered a process
- The contributions of the classical school of management
- The contributions of the human relations school of management
- The contributions of the modern school of management

In Chapter 1, management was defined as a *process* in which individuals work with and through other people to accomplish organizational objectives. But what does it mean to say management is a process? How has the study of management evolved over time? Has management always been theorized as a process? This chapter examines these questions by focusing on the concept of management as a process and reviewing theories of management and their applicability to the electronic media.

Management as a Process

The term **process** describes a series of actions or events marked by change. Most of the time, the word process is used to define a continuous operation in which many things are happening simultaneously. Management is often considered to be a process because of its ongoing state of operation. Using process to describe electronic media management is especially appropriate.

Radio, television, and cable services operate 24 hours a day, 7 days a week, 365 days a year. Programming content changes daily, as does advertising. As discussed in Chapter 1, development, production, and distribution require the many skills, functions, and roles of managers in the electronic media. Further, electronic media management must deal with changing consumer tastes and preferences as well as social, regulatory, and technological trends.

Management in the electronic media is not a static concept but a dynamic, evolving process. However, management has not always been thought of in these terms. In the next section, you will review different approaches to the study of management, from its formal beginnings to its most recent theories.

Approaches to Management

To understand contemporary approaches to the study of management, one should review the major historical contributions to management theory. Serious study of management began near the start of the 20th century, in the United States and abroad. This interest began at the same time as the development of the electronic media in American society. I have grouped the characteristics of the different approaches to management into *schools,* the earliest of which is referred to as the classical school of management.

Classical School of Management

The classical school of management (late 1800s through the 1920s) is associated with the industrial revolution, which marked a shift from agrarian-based to industrial-based societies. This philosophy of management centered primarily on improving the means of production and increasing productivity among workers. Three different approaches to management, developed in three different parts of the world, represent the classical school: scientific management in the United States, administrative management in France, and bureaucratic management in Germany.

Scientific Management Scientific management presented a systematic approach to the challenge of increasing production. This ap-

proach introduced several practices, including determination of the most effective way to coordinate tasks, careful selection of employees for different positions, proper training and development of the workforce, and introduction of economic incentives to motivate employees. Each part of the production process received careful scrutiny toward the end of greater efficiency.

Frederick W. Taylor, a mechanical engineer by profession, is referred to as the father of scientific management. In the early 20th century, Taylor made a number of contributions to management theory, including the ideas of careful and systematic analysis of each job and task, and identification of the best employee to fit each individual task.

Scientific management also proposed that workers would be more productive if they received high wages in return for their labor. This approach viewed the worker mechanistically, suggesting that management could guarantee more output if better wages were promised in return. Later approaches proposed that workers need more than just economic incentives to be productive. Nevertheless, many of Taylor's principles of scientific management are still found in modern organizations, such as detailed job descriptions and sophisticated methods of employee selection, training, and development.

Administrative Management Henri Fayol, a French mining executive, approached worker productivity differently from Taylor. Fayol studied the entire organization in hopes of making it more efficient. As discussed in Chapter 1, Fayol (1949) introduced the POC³ model, which detailed the functions of management. To aid managers in the planning, organizing, commanding, coordinating, and controlling functions, Fayol established a list of 14 principles of management (see Table 4-1). Fayol recognized that management principles must be flexible enough to accommodate changing circumstances. In that sense, Fayol was among the first management theorists to recognize management as a process. Fayol's management functions and principles are still widely used in contemporary business organizations.

Bureaucratic Management In Germany, sociologist Max Weber focused on another aspect of worker productivity—organizational structure. Weber (1947) theorized that the use of an organizational hierarchy or **bureaucracy** would enable an organization to produce at

TABLE 4-1

Fayol's 14 Principles of Management

1. Division of work—Work should be divided according to specialization.
2. Authority and responsibility—The manager has authority to give directions and demand compliance along with appropriate responsibility.
3. Discipline—Respect and obedience is required of employees and the firm.
4. Unity of command—Orders should be received from a single supervisor.
5. Unity of direction—Similar activities should be under the direction of one leader.
6. Subordination of individual interest to general interest—Interests of a single employee do not outweigh those of the organization.
7. Remuneration of personnel—Wages are to be fair and equitable to all.
8. Centralization—Each organization must find the level of centralization of authority needed to maximize employee productivity.
9. Scalar chain—There is a line of authority in an organization, usually from top to bottom.
10. Order—All necessary materials should be located in the proper place for maximum efficiency.
11. Equity—Fair and equitable treatment is needed for all employees.
12. Stability of tenure of personnel—Adequate time should be allowed for employees to adjust to new work and skills demanded.
13. Initiative—The ability to implement and develop a plan is crucial.
14. Esprit de corps—A spirit of harmony should be promoted among personnel.

NOTE: Adapted from *General and Industrial Management,* by H. Fayol, 1949, London: Pittman.

its highest level. Weber called for a clear division of labor and management, a strong central authority, a system of seniority, strict discipline and control, clear policies and procedures, and careful selection of workers based primarily on technical qualifications. Weber's contributions to management are numerous, manifested in such visible practices as organizational flow charts, job descriptions, and specific guidelines for promotion and advancement.

The classical school of management concentrated on ways to make organizations more productive. Management was responsible for establishing clearly defined job responsibilities, maintaining close supervision, monitoring output, and making important decisions. Individual workers were thought to have little motivation to do their tasks beyond wages and other economic benefits. These ideas would be challenged by the next major approach to management.

Human Relations School of Management

The notion that workers were motivated only by economic factors began to be challenged by management scholars in the 1930s and 1940s, giving rise to the human relations (or behavioral) school of management. The human relations school recognized that managers and employees were in fact members of the same group and thus shared in the accomplishment of organizational objectives. Further, employees had needs other than just wages and benefits; with these needs met, workers would be more effective and the organization would benefit.

Many theories relating to the behavioral aspects of management arose in this era. A number of the theories represent a **micro** perspective—that is, they center on the individual rather than the organization. Important contributors include Elton Mayo, Abraham Maslow, Frederick Herzberg, Douglas McGregor, and William Ouchi. Their contributions to the human relations school are discussed in the following paragraphs.

The Hawthorne Studies Perhaps the greatest influence on the development of the human relations approach to management was the work of Harvard business professor Elton Mayo. In 1924 the Western Electric Company investigated the impact of illumination (lighting) on productivity in Hawthorne, Illinois. Efficiency experts at the plant used two different groups of workers in an experiment. A control group worked under normal lighting conditions while an experimental group worked under varying degrees of illumination. As lighting increased in the experimental group, productivity went up. However, productivity in the control group also increased, without any increase in light.

Mayo and a group of associates were called in to investigate and expand the study to other areas of the Hawthorne plant. After a year and a half of study, Mayo concluded that the productivity of the workers was affected more by the human aspects of their work than by the physical conditions of the plant. In other words, the increased attention and interaction with supervisors led to greater productivity among employees. Workers felt a greater affinity to the company when they felt that managers showed interest in the employees and their work.

The term **Hawthorne effect** has come to describe the impact of management attention on employee productivity. Mayo's work rep-

FIGURE 4-1

**Maslow's Hierarchy
of Needs**

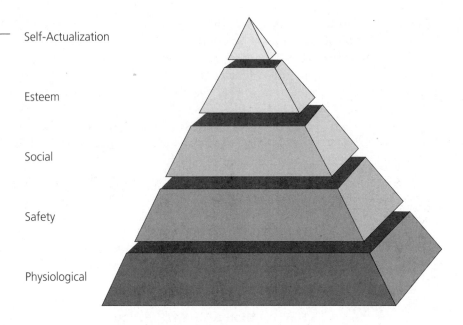

Self-Actualization

Esteem

Social

Safety

Physiological

resents an important benchmark in the development of management thought, in recognizing that employees have social as well as physical and monetary needs. In this era new insights were developed into ways that management could identify and meet employee needs as well as motivate workers.

Maslow's Hierarchy of Needs Psychologist Abraham Maslow contributed to the human relations school in the area of employee motivation. Maslow (1954) theorized that employees have a series of needs that one can organize into a hierarchy. As one level of needs is met, other levels of needs become important to the individual; as these levels are met, the progression through the hierarchy continues.

Maslow's hierarchy comprises five areas of needs: physiological needs, safety, social needs, esteem, and self-actualization (Figure 4-1). Physiological needs are for the essentials of physical survival—food, water, shelter, and clothing. Safety or security needs are satisfied only after the basic physiological needs are met. Safety concerns the need to be free of the threat of physical danger and to live in a predictable environment. Social needs include the need to belong and be accepted by others. Esteem can be thought of in terms of both self-

TABLE 4-2

Herzberg's Motivation and Hygiene Factors

MOTIVATORS The job itself	HYGIENE FACTORS Environment
Achievement	Policies and administration
Recognition	Supervision
Challenging tasks	Working conditions
Responsibility	Interpersonal relations
Growth and development	Money, status, security

NOTE: *Management of Organizational Behavior* (7th ed., p. 70), by P. Hersey and K. H. Blanchard, 1996, Oxford, England: Butterworth-Heinemann Ltd. See also *Work and the Nature of Man,* by F. Herzberg, 1966, New York: World Publishing Company.

esteem (feeling good about the self) and recognition from others. Self-actualization is the desire to become what one is capable of being—the idea of maximizing one's potential.

The utility of Maslow's hierarchy lies in its recognition that each individual is motivated by different needs. Further, Maslow theorized that individuals respond differently throughout the life cycle. Further, some people may have dominant needs at a particular level and thus never move through the entire hierarchy. In any case, Maslow's motivational theory suggests that managers may require different motivational techniques to motivate people according to their needs.

Herzberg's Hygiene and Motivator Factors Frederick Herzberg, another psychologist, studied employee attitudes through a series of intensive interviews to determine which job variables made workers satisfied or dissatisfied. Herzberg (1966) identified two sets of motivating factors: hygiene or maintenance factors, and motivators (Table 4-2).

Hygiene factors represent the work environment. They include not just technical and physical conditions but also such factors as company policies and procedures, supervision, the work itself, wages, and benefits. **Motivators** involve aspects of the job such as recognition, achievement, responsibility, and individual growth and development. Herzberg called this second set of factors motivators to reflect the positive impact they have on employee satisfaction.

Herzberg's hygiene factors have some similarities to the three lower levels (physiological needs, safety, and affiliation) of Maslow's

hierarchy, while the motivator factors represent the two upper levels (esteem and self-actualization). From a management perspective, Herzberg's work suggests that managers must recognize a dual typology of employee needs—both the hygiene factors and the need for positive motivation—in order to maintain job satisfaction.

Theory X and Theory Y While the work of Maslow and Herzberg advanced the importance of motivation in management, industrial psychologist Douglas McGregor (1960) noted that many managers still clung to traditional managerial assumptions that workers had little interest in work and lacked ambition. McGregor labeled this style of management **Theory X,** which emphasized such tactics as control, threat, and coercion to motivate employees.

McGregor offered a different approach to management, which he called **Theory Y.** Under Theory Y, managers did not rely on control and fear but instead integrated the needs of the workers and those of the organization. Employees could exercise self-control and self-direction and develop their own sense of responsibility if given the opportunity. The manager's role in Theory Y centers on matching the talents of the individual with the proper position in the organization and providing an appropriate system of rewards.

With its emphasis on human needs, McGregor's analysis of Theory X and Theory Y further developed the ideas associated with the human relations school. Interestingly, traits of both Theory X and Theory Y are observable in many business organizations.

Theory Z William Ouchi (1981) used characteristics of both Theory X and Theory Y in contrasting the management styles of American and Japanese organizations. Ouchi claimed that U.S. organizations could learn much from the Japanese model of management, which he called **Theory Z.**

Like Theory Y, Theory Z cites employee participation and individual development as important components of organizational growth. Interpersonal relations between workers and managers are stressed in Theory Z. However, Ouchi also drew from Theory X, in that management makes the key decisions in an organization, and a strong sense of authority must be maintained.

A common criticism of Theory Z is that it fails to recognize cultural differences between U.S. and Japanese firms and how these dif-

ferences are manifested in business organizations and management efforts. Nevertheless, aspects of Theory Z can be found in many electronic media organizations in such areas as employee training, various types of fringe benefit programs, and lines of communication with managers (which tend to be more direct).

The human relations school launched a significant change in management thought as the focus moved away from production to the role of employees in meeting organizational goals and objectives. In particular, the ideas of creating a positive working environment and attending to the needs of the employees represent important contributions of the human relations school to the management process.

Modern Approaches to Management

By the 1960s, theorists began to integrate and expand elements of the classical and human relations schools. This effort, which continues into the 21st century, has produced an enormous amount of literature on modern management thought. In this section, I focus on several areas that illustrate the diverse range of the modern school of management: management effectiveness, leadership, systems approaches to management, and total quality management (TQM).

Management Effectiveness The classical and the human relations schools share productivity as a common goal, although they disagree on the means. The former proposes managerial efficiency and control, while the latter endorses employee needs and wants. However, neither approach really takes into account the importance of *effectiveness,* the actual attainment of organizational goals. In both the classical and human relations schools, effectiveness is considered a natural and expected outcome.

Some modern management theorists have questioned this assumption. Management theorist Peter Drucker (1973) claimed that effectiveness is the very foundation of success for an organization, much more critical than organizational efficiency. To this end, Drucker (1986) developed **Management by Objectives (MBO)**, which involves a particular type of interaction between managers and individual employees. In an MBO system, middle- and senior-level managers must identify the goals for each individual area of responsibility and share these goals and expectations with each unit and employee. The shared objectives are used to guide individual units or departments and serve as a way management can monitor and evaluate progress.

An important aspect of the MBO approach is the agreement between employees and managers regarding performance over a set period of time. In this sense, management retains external control while employees exhibit self-control over how to complete individual objectives. The MBO approach has further utility in that one can apply it to any organization, regardless of size. Critics of the MBO approach contend it is time-consuming to implement and difficult to maintain in organizations that deal with rapidly changing environments, such as the electronic media. Nevertheless, one can find traits of MBO in the electronic media, particularly in the areas of promotion, marketing, and financial planning, where performance objectives are carefully established and monitored.

Leadership The relationship between management and leadership represents a second area of modern management thought. Considered a broader topic than management, *leadership* is commonly defined among management theorists as "the process of influencing the activities of an individual or a group in efforts toward goal achievement in a given situation" (Hersey & Blanchard, 1996, p. 94). While leadership is not confined to management, there is wide agreement that the most successful organizations have strong, effective leaders. Most organizations contain both formal and informal leaders, both those in recognized managerial positions and those not in such positions but who show wisdom and experience.

Although a number of leadership models and theories exist, I center on the work of Warren Bennis (1994), who has spent a majority of his life studying leadership in organizations. Bennis claims that leadership consists of three basic qualities: vision, passion, and integrity. In terms of vision, leaders have an understanding of where they want to go and will not let setbacks or obstacles deter their progress. Passion is another trait of a good leader: a person who loves what he or she does and enjoys doing it. Integrity is made up of self-knowledge, candor, and maturity (Bennis, 1994, pp. 40–41).

Bennis adds that good leaders also exhibit curiosity and daring. Curious leaders never stop learning about their organization. They also are willing to take risks and are not afraid of failure. Leaders look upon mistakes as a way to learn.

Bennis makes several distinctions between someone who is a manager versus someone who is a leader. To Bennis, the leader innovates, while a manager administers. Leaders offer a long-range per-

spective, while managers exhibit a short-range view. Leaders originate, while managers imitate. The author argues that most business schools—and education in general—focus on narrow aspects of training rather than on development of leadership qualities.

Systems Approaches to Management The systems approach to management follows a **macro** perspective; that is, the entire organization is examined, and the study includes the environment in which the organization operates (Schoderbek, Schoderbek, & Kefalas, 1985). Organizations are similar to one another in that they are engaged in similar activities involving **inputs** (e.g., labor, capital, and equipment), **production processes** (the conversion of inputs into some type of product), and **outputs** (e.g., products, goods, and services). In the systems approach to management, organizations also study the external environment, evaluating feedback from the environment in order to identify change and assess goals.

Organizations are not isolated entities; they interact interdependently with other objects and organizations in the environment. The systems approach recognizes the relationship between the organization and its external environment. Though managers cannot control this environment, they must be aware of environmental factors and how they may impact the organization. For an application of systems theory applied to electronic media management, see Covington (1997).

A related approach to systems theory is the resource dependence perspective developed by Pfeffer and Salancik (1978). An organization's survival is based on its utilization of resources, both internal and external. All organizations depend on the environment for resources, and media industries are no exception (Turow, 1992).

Much of the uncertainty organizations face is due to environmental factors. As Pfeffer and Salancik (1978) state,

> Problems arise not merely because organizations are dependent on their environment, but because this environment is not dependable . . . [W]hen environments change, organizations face the prospect either of not surviving or of changing their activities in response to these environmental factors (p. 3).

Organizations can alter their interdependence with other organizations in one of two ways: (1) by absorbing other entities or (2) by

cooperating with other organizations to reach mutual interdependence (Pfeffer & Salancik, 1978). Mergers and acquisitions, vertical integration, and diversification are strategies organizations use to ease resource dependence.

Systems theory and the resource dependence perspective help one understand the relationship of the electronic media to other societal systems. The media industries do not operate in isolation but form part of a larger system that also includes political, economic, technological, and social subsystems. Because systems approaches are concerned with responding to and interpreting environmental influences on the organization, electronic media managers at the executive level (General Managers) may find these approaches to management useful.

Total Quality Management Another modern approach to management theory is total quality management (TQM), which one might best describe as a series of approaches to emphasizing quality in organizations, especially in regard to producing products and serving both external and internal customers (Weaver, 1991). In TQM, managers combine strategic approaches to deliver the best products and services by continuously improving every part of an operation (Hand, 1992). While management implements and leads TQM in an organization, every employee must be responsible for quality. Used effectively, TQM helps an organization maintain a competitive edge.

A number of management scholars have contributed to an understanding of TQM, which is widely used. Considered the pioneer of modern quality control, Walter Shewart originally worked for Bell Labs, where early work focused on control charts built on statistical analyses. Joseph M. Juran (1988) and W. Edwards Deming (1982) contributed to Shewart's early work, primarily with Japanese industries. Deming linked the ideas of quality, productivity, market share, and jobs; Juran contributed a better understanding of planning, control, and improvement in the quality process. Other important contributors to the development of TQM include Philip Crosby, Armand Feigenbaum, and Karou Ishikawa (Kolarik, 1995).

The popularity of TQM in the United States increased during the late 1970s and early 1980s, when U.S. business and industry were suffering from what many industrial experts labeled declining quality. Organizations adopted quality control procedures and strategies

to reverse the negative image associated with poor-quality products. TQM is still used as a way to encourage and demand high quality in the products and services produced by organizations. TQM has many areas of potential application in the electronic media, from the actual production of media content and advertising to the use of mission statements and public relations activities.

Management in the 21st Century How will management thought evolve in the 21st century? Perhaps one of the best sources for insight is Peter Drucker, one of the preeminent management scholars of the past century. Drucker calls for a new management model, as well as a new economic theory to guide business and industry (Drucker, 2000). Drucker claims that schools have become antiquated, failing to prepare people for the new managerial environment.

In examining management challenges for the 21st century, Drucker (1999) argues that, given the sweeping social, political, and economic changes affecting the world at the end of the 20th century, there are few certainties in management and strategic thinking. Drucker states that "one cannot manage change . . . one can only be ahead of it" (1999, p. 73). Drucker claims managers must become change leaders, seizing opportunities and understanding how to effect change successfully in their organizations.

Clearly, electronic media managers would agree with Drucker that in order to be successful, the ability to cope with change and use it as a competitive advantage is critical. The challenge is how to embrace change successfully. A critical change issue for managers in the 21st century is determining when to focus on the external environment and when to focus on the internal environment.

At the end of the day, management is still concerned with working with and through other people to accomplish organizational objectives. In a sweeping study of some 400 companies and 80,000 individual managers across many industries, Buckingham and Coffman (1999) identified four key characteristics of great managers. Great managers were those who were particularly adept at selecting the right talent, defining clear expectations, focusing on each individual's strengths, and helping them find the right fit in the organization. The authors' findings have particular implications for electronic media management, helping to focus attention on the importance of quality employees in meeting organizational objectives.

Management and the Electronic Media

The different approaches to management reflected in the classical, behavioral, and modern schools all have limitations regarding their direct application to the electronic media industries. Although the classical school emphasizes production, its understanding of management functions, skills, and roles remains helpful. The human relations school makes an important contribution by emphasizing the needs of employees and proper motivation. And the modern approaches clarify managerial effectiveness and leadership while also recognizing the interdependency of media and other societal systems.

The changing nature of the communication industries precludes the adoption of a universal theory of electronic media management. The complex day-to-day challenges associated with managing a radio, television, cable, or telecommunications facility make identifying or suggesting a central theory impossible. Further, the variability of electronic media firms in terms of the number of employees, market rankings, qualitative characteristics, and organizational culture requires individual analysis of each operation to discern what style of management will work best.

At best, an amalgamation of approaches drawn from the classical, behavioral, and modern schools of management seems the most beneficial. Management is a constant, ongoing process subject to refinement and change. One manager sums it up as follows: "The only way to determine which approach to management works best for you is to actually manage and find out for yourself" (D. Tincher, personal interview, March 1994).

Summary

In this chapter, the term *process* is used to describe a series of actions or events marked by change. Management is often considered to be a process because of its ongoing state of operation. However, management has not always been conceptualized in dynamic terms. Three schools of management thought have evolved. Some approaches center on the organization as a whole (macro approaches) while others focus on interaction between individual managers and employees (micro approaches).

The classical school of management was concerned with improving the means of production and productivity of workers. The major contributors to this school were Frederick W. Taylor, who developed scientific management; Henri Fayol, the founder of administrative management; and Max Weber, who developed bureaucratic management.

The human relations (behavioral) school focused on the needs of employees in meeting organizational goals. The important contributors include Elton Mayo (Hawthorne studies), Abraham Maslow (hierarchy of needs), Frederick Herzberg (hygiene and motivator factors), Douglas McGregor (Theory X and Theory Y), and William Ouchi (Theory Z).

The modern school of management appeared in the 1960s and continues today. Contributions to the modern school include studies on managerial effectiveness and management by objectives (Peter Drucker); leadership (Warren Bennis); and systems approaches to management in the form of general systems theory and the resource dependence perspective, total quality management, and management thought at the beginning of the 21st century.

The changing nature of the electronic media industries and their complex structures preclude the use of a general theory or set of guidelines for management. At best electronic media managers draw from all three schools in developing their own management styles and adapt as new situations and experiences warrant change.

| **CASE STUDY** | **Just What Kind of Manager Are You?** |

It has been 8 years since you graduated from college with a degree in communications. During that time you toiled for several radio stations in a variety of programming and production positions before moving into sales as an account executive.

You have became one of the station's strongest account executives, always meeting your quotas and goals on time. During the past 3 years, you achieved the highest billings of any AE at the station. Life has been good, but it is about to change.

Gene Michaels, your supervisor and Local Sales Manager, invited you to lunch, where he informed you that he has accepted a position as a General Sales Manager with another radio group and has recommended

that you be named the new Local Sales Manager. "I realize that a position in management was not what you thought this lunch was about, but it is a great opportunity for you to apply your skills as an AE in more of a mentoring role to develop other strong salespeople like yourself."

Flattered by the recommendation, you nevertheless are apprehensive about a move into sales management. You have experienced various management styles in your career, but never before have you been asked to develop one of your own.

Based on your understanding of the different schools of management you have encountered in this chapter, how would you describe your managerial philosophy? Would it be more representative of the classical, behavioral, or modern school? What sort of expectations would you have about yourself—and the people who report to you? Finally, how would you measure your success as a manager in your new role?

| CASE STUDY | **Cable System Management Styles** |

As the Operations Manager for the local cable operator, all the department heads (programming, engineering/technical, sales, and office) report to you on a regular basis. You have just received the initial budget request for next year from each unit, which also includes a summary of employee productivity in each area. The difference in employee evaluations caught your attention, noted by the following excerpts:

Jane Sadler, Programming. "The employees are hard-working individuals but could function better as a team. The level of detail needed in our unit is not as sharp as it could be. Our primary goal is to develop more of a team approach to our work and make sure the left hand knows what the right is doing."

Ralph Winslow, Technical/Engineering. "We have dealt with unusually high turnover in our area. New employees think they know everything, but they really know very little. They don't have much motivation. We offer a good salary and benefits, but it doesn't seem to matter to these people. Next year I would like to identify a stronger group of employees who care more about their jobs."

Ruth Cook, Sales. "Our staff is small, but we have had a great year. Our incentive-based sales program has created a lot of friendly competition among the sales staff, and local advertising is up 62% over last year. I am confident that if we can add two more people to our staff they will not

only pay for their salaries, but add to our bottom line as well. Our staff understands that when they are successful, everyone here is successful."

Carol Gaines, Office. "Our employees, most of them in the customer service area, deal with a number of frustrated customers every day. It can be a demanding and negative experience, but our staff is handling it very well. The regular training workshops offered by the company on new strategies to deal with customer service issues have really paid off. Work on developing employees in other areas such as accounting, traffic, and general administrative areas is also paying good dividends. The quality of our unit continues to improve, and we hope to build upon our success next year."

Reviewing these comments, how would you characterize the management philosophies exhibited by each of these midlevel managers? If you were the Operations Manager, what suggestions would you offer on ways to improve their units?

 InfoTrac College Edition

For new information on the topic of management theories, use InfoTrac College Edition. Use the following terms for subject and keyword searches: management, theory, management and theory, business theory.

References for Chapter 4

Bennis, W. (1994). *On becoming a leader.* Reading, MA: Addison-Wesley Publishing Company.

Buckingham, M., & Coffman, C. (1999). *First, break all the rules: What the world's greatest managers do differently.* New York: Simon and Schuster.

Covington, W. G. (1997). *Systems theory applied to television station management in the competitive marketplace.* Lanham, MD: University Press of America.

Deming, W. E. (1982). *Out of crisis.* Cambridge, MA: Productivity Press.

Drucker, P. F. (1973). *Management: Tasks, responsibilities, practices.* New York: Harper & Row.

Drucker, P. F. (2000, January 1). Interview. *The Wall Street Journal,* p. R34.

Drucker, P. F. (1986). *The practice of management.* New York: Harper & Row.

Drucker, P. F. (1999). *Management challenges for the 21st century.* New York: Harper Collins.

Fayol, H. (1949). *General and industrial management.* (C. Storrs, Trans.) London: Pittman.

Hand, M. (1992). Total quality management—One God but many prophets. In M. Hand and B. Plowman (Eds.), *Quality management handbook* (pp. 26–46). Oxford, England: Butterworth-Heinemann Ltd.

Hersey, P., & Blanchard, K. H. (1996). *Management of organizational behavior* (7th ed.). Englewood Cliffs, NJ: Prentice Hall.

Herzberg, F. (1966). *Work and the nature of man.* New York: World Publishing Company.

Juran, J. M. (1988). *Juran on planning for quality.* Cambridge, MA: Productivity Press.

Kolarik, W. J. (1995). *Creating quality.* New York: McGraw-Hill.

Maslow, A. H. (1954). *Motivation and personality.* New York: Harper & Row.

McGregor, D. (1960). *The human side of enterprise.* New York: McGraw-Hill.

Ouchi, W. G. (1981). *Theory Z: How American business can meet the Japanese challenge.* Reading, MA: Addison-Wesley.

Pfeffer, G., & Salancik, G. (1978). *The external control of organizations: A resource dependence perspective.* New York: Harper & Row.

Schoderbek, P. P., Schoderbek, C. D., & Kefalas, A. G. (1985). *Management systems: Conceptual considerations* (3rd ed.). Plano, TX: Business Publications.

Taylor, F. W. (1991). *The principles of scientific management.* New York: Harper & Brothers.

Turow, J. (1992). *Media systems in society: Understanding industries, strategies, and power.* New York: Longman.

Weaver, C. N. (1991). *TQM: A step-by-step guide to implementation.* Milwaukee, WI: Quality Press.

Weber, M. (1947). *The theory of social and economic organization.* (A. M. Henderson and T. Parsons, Trans.). New York: Free Press.

Financial Management

In this chapter you will learn

- Basic aspects of financial management
- The process of budgeting in an electronic media organization
- An approach to analyzing common types of financial statements
- Analytical tools used in financial analysis

All firms that own electronic media facilities operate with a common financial goal—to earn a profit on the products and services they offer. Even noncommercial entities, such as public broadcasting stations, must keep revenues ahead of expenses. Commercial radio and television stations, cable systems, and telecommunication companies are businesses. And in business, success is measured primarily by **the bottom line**—the amount of profit or loss that remains after one deducts expenses from revenues. Owners of electronic media properties want to protect their investment and receive a favorable return. To do this, owners turn to managers for assistance and expertise in meeting fiscal goals.

Probably no other management task is more universal than the administration and decision making associated with creating budgets and controlling revenues and expenditures. While many tasks and responsibilities are delegated, the manager remains directly responsible for financial matters. In most electronic media facilities, this person is the General Manager (GM) or some other senior manager who makes

the important decisions that affect profit or loss. Those preparing for a career in management must clearly understand the role of financial management.

What Is Financial Management?

To properly manage the finances of an organization, managers use **financial management,** which involves systematic planning, monitoring, and control. Though *planning* involves many areas, it mainly concerns developing budgets based on revenue history and expense projections. In planning, one also creates new personnel positions and establishes timelines for the upgrading and replacement of expensive items such as equipment, vehicles, and computer systems.

Monitoring takes place through managerial review of financial statements and other reports that measure the efficiency of an organization. Later in the chapter, you will learn more about two types of financial statements—income statements and balance sheets—commonly used in business. Managers need to be familiar with the content of financial statements and be able to interpret and evaluate them.

Finally, *control* can take many forms, from authorizing purchases to establishing internal policies and procedures. Control of fiscal policy helps eliminates ambiguity in an organization's financial matters. General managers work together with middle managers to administer individual budgets and evaluate performance.

Meeting Financial Goals

Financial management is needed not only to maintain fiscal control but also to meet the financial goals of owners and investors. Setting financial goals is a complicated process affected by many factors beyond the control of managers and owners. Managers must consider (1) the state of the economy (both local and national), (2) technological change, (3) regulatory issues, and (4) audience tastes and preferences. Change in any one of these areas can influence the financial performance of an electronic media facility.

Take a television station, for example, that is faced with many challenges to its financial planning. First, with a flourishing local economy, competition for local advertising is generally strong. But if the economy falters, the station will be affected since advertising is one of the first things many businesses reduce or eliminate to control costs. Second, the need to upgrade equipment for local production may mean a sizable increase in the operating budget. Third, if the FCC enacts new policies requiring broadcasters to offer free commercial time for political candidates, this reduces the amount of commercial inventory available to advertisers. Finally, the audience may respond negatively to a redesigned news set or a new anchor. If the audience erodes significantly, change will be necessary.

One can establish financial goals in many different ways, ranging from revenue projections to cost-cutting methods. Ideally, the process involves both senior-level management and owners, with some flexibility needed from both for unknown contingencies. As you will see, financial success can be measured in many different ways—via profit or loss, profit margins or investor appreciation. Every organization needs financial goals in order to maintain growth.

Implementing Financial Management

The manager works closely with other personnel in administering the finances of an electronic media facility. The number of personnel involved varies, depending on the size of the organization. In small firms (fewer than 15 employees) a bookkeeper or traffic manager may handle most of the financial transactions. Medium-sized firms may have an accounting or business department employing several people. Larger firms (more than 50 employees) often have a Controller—a midlevel manager who, along with his or her staff, supervises all accounting functions and prepares reports and other materials for the General Manager. Regardless of the size of the unit, other duties beyond basic accounting functions include banking, billing, collections, payroll and personnel obligations, tax payments and purchasing.

Electronic media organizations are capital-intensive, consisting of a number of expensive resources. The amount of equipment, personnel, and other materials (such as programming) needed to operate a radio, TV, cable, or telecommunications facility represents an in-

vestment of hundreds of thousands of dollars. The money that flows into a media organization, through advertising and other types of revenue, can reach staggering proportions. To maintain control over the constant flow of revenue and expenses, electronic media facilities use accounting systems to keep track of all financial transactions.

Computerized accounting systems help in monitoring financial performance. Before high-powered desktop computers, accounting was handled through manual entry. Today several accounting software systems offer a wide range of features and options. Many programs combine spreadsheet, database, and even personnel operations. Among the systems used by electronic media firms are Great Plains, PeopleSoft, Oracle, Computer Associates, J. D. Edwards, JDS, and Bias (S. Kennett, personal communication, 1999). A typical system tracks revenues and expenses, coordinates commercial inventory and billing (commonly referred to as traffic), provides forecasts, and produces different types of reports. Managers must understand the features of the computer system and how to access information, making computer literacy an important skill one should obtain in pursuing a career in management.

Budgeting

Managers need budgeting in order to achieve established financial goals and objectives. Budgeting is usually an annual process in which management projects anticipated revenues and expenditures for the firm for the following 12 months. Once the final budget is approved and implemented, managers monitor performance at regular intervals (weekly, monthly, and quarterly) using various financial statements. Keep in mind that the business year may differ from the calendar year because companies are allowed to designate their own fiscal year for tax purposes; that is, the fiscal year does not necessarily go from January through December.

Creation of the actual budget follows a specific organizational procedure, and all managers usually participate in budgeting. By clearly understanding the financial goals of the corporate owners, managers at all levels can work as a team toward the completion of specific financial objectives.

Setting Priorities and Goals in Individual Departments

Department heads (middle and lower-level managers) normally submit a tentative budget for approval to the Controller and General Manager based on the individual department's priorities and goals. Though some departments will have similar needs (such as upgrading computers), others will have unique ones. The engineering department may require diagnostic equipment while the marketing department may request new sales assistants for the following year. Each manager conducts a careful review of past performance of her or his individual unit, considering not only revenues and expenses but also equipment, personnel, and other needs.

Departmental budgets are usually established with some set of parameters provided by the Controller and General Manager. Depending on the economy and the financial condition of the organization, managers may be asked to limit the overall increase of their budget requests to a certain percentage or to cut expenses by a certain percentage of the previous year's budget. The submission of a departmental budget is usually accompanied by a report that summarizes the budget and justifies each expense.

Capital Budgeting

Major expenses, such as the replacement of equipment, involve a separate budgeting process called **capital budgeting** (Eckhart, 1994), defined here as the long-range planning, evaluation, and selection of projects covering more than one fiscal cycle. Managers use capital budgeting techniques to evaluate large purchase decisions. Most firms have more opportunities than resources for investing in long-term projects. Capital budgeting allows management to evaluate projects that will increase the value of the firm.

Compiling the Budget

The General Manager, working with the Controller or other financial manager, compiles the budget requests from each department. In some cases, these requests exceed company goals. The General Manager can reject any budget items deemed unreasonable. In compiling the overall budget, though, the General Manager should explain to the department heads what areas of their proposed budgets are being cut or modified.

The General Manager must also evaluate capital expenditures requested by individual departments. He or she prioritizes these requests and, through the use of capital budgeting techniques and other

analysis, determines which projects (if any) can be pursued over the next calendar year.

Once the budget is finalized and approved by the General Manager, it becomes the blueprint for monitoring financial performance. Department heads and the General Manager meet regularly with the Controller and other financial managers to determine steps to curb overspending and encourage savings.

Budgetary Flexibility

Successful budgets contain some degree of flexibility. The uncertainty associated with any business or industry, particularly the electronic media, requires such flexibility. Most media managers account for this uncertainty by designating a percentage of the budget as a reserve account to cover emergencies or unexpected contingencies.

Forecasting

Budgets also help managers project estimates of future revenues and expenses. This part of financial management, known as **forecasting,** usually covers long periods of time such as 3, 5, or 10 years. Forecasting can be challenging, because many unknown factors influence business conditions, such as the strength of the local economy, competition, changes in technology, regulatory decisions, and changes in demography and social trends. Despite these limitations, internal forecasting remains an important tool in long-term financial planning.

Monitoring Financial Performance

To monitor and evaluate the financial performance of a business, management uses different financial statements and reports. But where does this information come from? All financial transactions are recorded in computerized journals and ledgers; this information is then summarized and reported in financial statements. The individual entries or **postings** are completed using a computer software program.

Typical journals include a cash receipts journal, cash disbursements journal, sales journal, and general journal. Ledgers usually consist of accounts receivable, accounts payable, the payroll ledger, and the general ledger. See Table 5-1 for a description of each of the journals and ledgers used in financial accounting. Information from the general ledger is used in preparing the main types of financial state-

TABLE 5-1

Journals and Ledgers

JOURNAL	DESCRIPTION
Cash receipts journal	Record of all moneys received; identifies the payer and type of account.
Cash disbursements journal	A record of all moneys paid out by the organization; should include expense categories. Totals posted to the general ledger on a regular (monthly) basis.
Sales journal	Record of all advertising sales, including name of client, contract number, date, amount, and name of advertising representative.
General journal	Record of all noncash transactions not included in any of the other journals. Includes such items as depreciation, amortization, accruals, etc.

LEDGER	DESCRIPTION
Accounts receivable	Record of all moneys owed the organization by clients. Dated entries indicate which accounts are paid on time and which are delinquent.
Accounts payable	Record of all payments to creditors for both short- and long-term liabilities.
Payroll ledger	Record of all payroll disbursements for both hourly and salaried employees.
General ledger	Record of all transactions posted from other journals and ledgers for entry into appropriate accounts. Transactions to general ledger usually posted monthly.

ments: the balance sheet, the income statement, and the statement of cash flows.

Balance Sheet The **balance sheet** summarizes the financial condition of a firm at a particular point in time, allowing one to compare its condition at given times. It consists of three sections: assets, liabilities, and owner's (or stockholders') equity (see Figure 5-1). The term *balance* is used to indicate that a firm's assets are equal to the total liabilities plus owner's equity:

Assets = Liabilities + Owner's Equity

FIGURE 5-1

Balance Sheet

NOTE: Reprinted courtesy of the Broadcast Cable Financial Management Association (BCFM).

BROADCASTING COMPANY
Balance Sheet
As of _____

ASSETS	This Year	Last Year
Current Assets:		
Cash and cash equivalents		
Marketable securities		
Accounts receivable, less allowances		
Program rights—current		
Prepaid expenses & deferred charges		
Other current assets	_____	_____
Total Current Assets		
Property, plant, and equipment at cost		
Less: accumulated depreciation		
Net Property, Plant, and Equipment		
Program rights—long-term		
Other non-current assets		
Intangible assets, net of amortization	_____	_____
Total Assets	======	======

LIABILITIES AND STOCKHOLDERS' EQUITY

	This Year	Last Year
Current Liabilities:		
Accounts payable		
Notes payable		
Accrued expenses		
Income taxes payable		
Program rights payable—current		
Other current liabilities	_____	_____
Total Current Liabilities		
Long-term debt		
Deferred income taxes		
Program rights payable—long-term		
Other non-current liabilities		
Total Liabilities		
Stockholders' equity:		
Capital stock		
Paid-in capital		
Retained earnings		
Treasury stock	_____	_____
Total Stockholders' Equity	_____	_____
Total Liabilities and Stockholders' Equity	======	======

Assets represents the value of anything owned by a firm. **Liabilities** represents obligations to others, or money the firm owes. **Owner's equity,** or net worth, refers to the financial interest of the firm's owners. Each of these terms is further detailed in the following subsections.

Assets Assets fall into three categories: current assets, fixed assets, and other assets. **Current assets** are usually considered first when one discusses assets, because they represent items that one can convert quickly into cash. Sometimes thought of as liquid assets, current assets include cash, money market accounts, marketable securities, accounts receivable, notes, and certain types of inventories (including equipment items such as cable modems and remote control devices, unsold advertising time, and programming).

Fixed assets are assets held for a long time that one cannot convert to cash as quickly as current assets. Land and property are the best examples of fixed assets. All types of equipment found in offices and studios, vehicles, and even antenna systems at broadcast stations represent fixed assets.

Other assets are primarily thought of as intangible assets. For most businesses, other assets consist of such things as patents, trademarks, copyrights, goodwill, and any prepaid expenses such as taxes, interest, or insurance. In the electronic media, several important assets fall into this category, including the FCC license, network contracts for affiliated stations, and the franchise agreement for cable systems. Programming and advertising contracts are also considered assets. Finally, **goodwill** deserves separate mention because of the importance of the electronic media to society. Goodwill refers to an organization's public record. Electronic media organizations increase their goodwill with the community by becoming involved in the community and maintaining a positive identity.

Tax regulations require all companies to dispose of the value of their fixed and other assets over time through **depreciation** and **amortization.** Fixed assets are depreciated; intangible assets are amortized. Both methods allow firms to deduct a portion of the overall cost of the asset over the life of the asset. These concepts are discussed more fully later in the chapter.

Liabilities The second part of the balance sheet reflects the various financial obligations of the organization. Liabilities that can be elim-

inated in one year or less are considered current liabilities; long-term liabilities represent obligations of one year or more.

Current liabilities include accounts payable, taxes (including franchise fees for cable operators), payroll expenses (including social security and other types of withholding taxes), and commissions payable. Yearly program contracts and music licensing fees, if applicable, are also considered current liabilities. Long-term liabilities include bank debts (loans) and mortgages on properties and structures.

Owner's Equity The third and final component of the balance sheet consists of the owner's equity or net worth. Besides the owner's initial investment in the firm, owner's equity includes earned income (called retained earnings) that has not been disbursed. This part of the balance sheet reports the amount of common and preferred stock held by the owners of the company.

Income (P & L) Statement The **income statement**, also called the **operating statement** or the **profit and loss (P & L) statement**, charts a firm's financial activities over a set period of time—usually a week, month, or quarter. The P & L statement differs from the balance sheet in that **revenues** and **expenses** are reported along with the appropriate profit or loss. While the balance sheet compares how a firm operates from one time period to the next, the P & L statement identifies where changes in the financial condition of the firm took place. See Figure 5-2 for a sample P & L statement.

Revenues vary among electronic media organizations. For radio and television stations, most revenues come from advertising sales (local, regional, national, and political) and network compensation (if applicable). Cable systems derive revenues from several sources, including subscriber fees, premium channel subscriptions, PPV events, advertising, and equipment rental in the form of cable modems, cable converter boxes, and remote controls. Telecommunication facilities draw revenues primarily from business and consumer users, as well as local and regional advertisers (e.g., the yellow pages). For all of the electronic media, the Internet is viewed as offering additional revenue streams.

Expense categories vary among the media industries. Broadcast stations cluster expenses into the following categories: general and administrative, programming and production, news, sales, engineering, and advertising and promotion. Cable systems report expenses in

BROADCASTING COMPANY
Statment of Operations

As of _____
(Date)

MONTH:_____ YEAR-TO-DATE

Actual	Budget	Last Year		Actual	Budget	Last Year
			OPERATING REVENUE			
			Local			
			National			
			Network			
			Production			
			Other Broadcast			
_____	_____	_____	Misc. Revenue	_____	_____	_____
			Gross Revenue			
			Less:			
_____	_____	_____	Commissions	_____	_____	_____
			Net Revenue			
			OPERATING EXPENSES			
			Technical			
			Programming			
			News			
			Sales and Traffic			
			Research			
			Advertising			
			General & Admin.			
_____	_____	_____	Depr. & Amort.	_____	_____	_____
_____	_____	_____	Total Op. Expenses	_____	_____	_____
_____	_____	_____	Op. Profit (Loss) Before Taxes	_____	_____	_____
_____	_____	_____	Provision for Taxes	_____	_____	_____
======	======	======	Net Income	======	======	======

FIGURE 5-2

**Statement of
Operations**

NOTE: Reprinted courtesy
of the Broadcast Cable
Financial Management
Association (BCFM).

areas that include general and administrative, capital equipment, programming, technical expenses, and marketing. Similar to those of cable, the major expense groups of telecommunication companies include general and administrative, capital expenses, technical expenses, and marketing. Other expense categories found in all electronic media organizations include Internet (Web site) development and marketing, depreciation, amortization, and interest expenses.

Statement of Cash Flows

Maximizing cash flow is an important goal of all businesses (Capodanno, 1994). Managers use the **statement of cash flows** (Figure 5-3) to track the flow of money in an organization. This statement summarizes the sources and uses of the cash flows in an operation and presents the beginning and ending cash balances. Notice in Figure 5-3 that a statement of cash flows falls into three sections: (1) cash flows from operating activities, (2) cash flows to or from investment activities, and (3) cash flows to or from financing activities.

Managing cash flow is difficult. Several strategies are used to enhance cash flow. Increasing revenues while controlling expenses will produce more cash for an organization, as will efficient collection of outstanding client accounts, lowered taxes, and efficient management of accounts payable (Capodanno, 1994). Cash planning also helps maximize cash flow. By planning cash needs in advance, managers allow excess cash to shift into interest-bearing accounts (e.g., a money market account). For example, if a station has moneys available in another account, transferring the money to an interest-bearing account produces additional cash and larger cash flows.

In the electronic media, managers use cash flows to determine the value of a broadcast station or cable system; that is, as cash flow increases, so does the value of the business. Sales prices for electronic media properties are routinely based on some multiple of annual cash flows. For example, if a radio station has an annual cash flow of $2 million, a multiple of 8–10 would suggest the station is valued at $16 to $20 million.

Other Financial Statements

In addition to the widely used balance sheet, income statement, and statement of cash flows, firms use other financial statements to monitor their financial condition. These include the statement of changes in owner's equity, the statement of retained earnings, the statement of changes in financial position (also called the funds flow statement), and statements related to specific projects, such as special program-

FIGURE 5-3

Statement of Cash Flows

NOTE: Reprinted courtesy of the Broadcast Cable Financial Management Association (BCFM).

STATEMENT OF CASH FLOWS

Years Ended . 20_____ 20_____

CASH FLOWS FROM OPERATING ACTIVITIES:

Net Income

Adjustments to Reconcile Net Income to Net Cash
Provided by Operating Activities:
 Depreciation & Amortization
 Deferred income taxes
 Decrease/(increase) in receivables
 Decrease/(increase) in inventories
 Decrease/(increase) in deferred costs
 Decrease/(increase) in accounts payable & accruals
 Payments for program rights*
 Additions/(reductions) to other deferred items

Net cash provided by operating activities

Cash Flows from Investing Activities:
 Purchase of property, plant, and equipment
 Proceeds from sale of property, plant, and equipment
 Purchase of marketable securities
 Redemption of marketable securities
 Reductions/(additions) to other assets

Net cash (used) provided by investing activities

Cash Flows from Financing Activities:
 (Decrease)/increase in short-term debt
 Proceeds from long-term debt
 Payments to retire long-term debt
 Proceeds from common stock issued
 Purchase of treasury shares
 Dividends paid

Net cash (used)/provided by financing activities
Net increase/(decrease) in cash and cash equivalents
Cash and cash equivalents at beginning of year

Cash and Cash Equivalents at End of Year

Supplemental Disclosures of Cash Flow Information:
 Cash paid during year for:
 Interest (net of amounts capitalized)
 Income taxes

* Program rights may alternatively be treated as follows:
- Program rights amortization—Operating (add back to net income)
- Purchases of program rights—Reduction of cash (may be either operating or investing)

ming. Extensive discussion of these financial statements lies beyond the scope of this chapter; if you desire further information, I encourage you to consult accounting textbooks.

Financial Analysis

To fully understand financial management, you should have a basic knowledge of the tools used in financial analysis. Concepts presented in this section include the time value of money and a discussion of future value, present value, and net present value (used in capital budgeting); ratio analysis; and break-even analysis. There is also an expanded discussion of depreciation and amortization.

Time Value of Money

The **time value of money** is a concept basic to all financial analysis. Over time, the value of money changes. For example, if we save money in an asset that produces interest, our money will increase over some time period. Likewise, inflation has a way of decreasing the value of money. Prices for most products tend to rise over time, thus reducing the value of money.

Because it affects a range of managerial decisions, the time value of money is an important concept for managers to understand. The time value of money is affected by interest rates. Likewise, the time value of money depends on whether we are talking about money in your possession (cash on hand) or money to be paid in the future.

An example can clarify these concepts. A retail chain decides to purchase advertising from a television station. After the station processes the order, the client is billed. Typically a client has 30 to 60 days to pay upon receipt of the invoice. The advertising order, which becomes part of accounts receivable on the balance sheet and part of the revenues on the income statement, represents a flow of cash to be paid at a future date. But what is the value of this order?

Present Value of Money Financial managers use a tool known as **present value** to determine the value of cash flows. To calculate the present value, you need three numbers: the sum of the cash flow(s), a present value factor, and the current interest rate available for investment purposes. The *cash flows* represent the amount of money to

be paid to the station at specific time intervals. *Present value factors* are found in many finance manuals (e.g., Sherman, 1982). The *interest rate* represents the rate of return available to the station if the total amount of money could be invested immediately.

The present values of a series of cash flows can be added together to determine the value of an order. For example, a station bills a client for $3,000 of advertising, with $1,000 payable at the end of 1 month and the remaining $2,000 payable at the end of 2 months. Assume a 10 percent interest rate. You calculate the present value of each of the cash flows and simply add them together to find the sum:

TIME	CASH FLOW	PRESENT VALUE FACTOR WITH A 10% INTEREST RATE	PRESENT VALUE
1	$1,000	.9917	$ 991.70
1	$2,000	.9835	$1,967.00
			Present value using .10

This example shows that the present value of $3,000, to be received two time periods from now, at an interest rate of 10 percent, is $2,958.70. Present value analysis tells us that money received today is worth more than money received at a later time period. It also explains why financial managers must monitor accounts receivable closely. The longer it takes to collect money from an account, the lower the value because of the effects of inflation and interest rates on the value of a dollar.

Net Present Value and Capital Budgeting Earlier in the chapter, you learned about capital budgeting, which involves projects that span more than 1 year. In capital budgeting situations, costs and benefits are spread over time. One widely used technique in evaluating capital budgeting projects is the **net present value (NPV)** method (Bierman & Smidt, 1988).

The NPV is a direct application of the present value (PV) concept. Using NPV, one discounts the present value of the cash flows of

a project at a particular rate. The rate used is analogous to an interest rate, or the cost of borrowing money. The discounting process focuses on the present value of future sums of cash inflows and outflows. The NPV is the sum of the present values of the cash benefits subtracted from the present values of the cash outlays. If the NPV is positive (greater than or equal to zero), the project should be accepted. If the NPV is negative (less than zero), the project should be rejected. The NPV method allows managers to compare multiple projects in capital budgeting decisions.

For example, a cable television system is considering a capital budgeting project that will allow faster processing of high-speed Internet connections. The equipment will cost an initial $12,500, but it is expected to produce positive cash flows of $10,000 and $5,000 over the next 2 quarters. Assuming a 7 percent discount rate, what is the NPV of this project?

QUARTER	CASH FLOW	PRESENT VALUE FACTOR WITH A 7% DISCOUNT RATE	PRESENT VALUE (CASH FLOW × PV)
0	$ (12,500)	1.000	$ (12,500)
1	$ 10,000	.9346	$ 9,346
2	$ 5,000	.8734	$ 4,367
		Net present value =	$ 1,213

The initial cash outlay of $12,500 is enclosed in parentheses to indicate a negative number. It is multiplied by 1.0 because at time zero there is no discount; the money represents an outflow of cash. The $10,000 and $5,000 cash flow amounts are discounted using a present value factor at an interest rate of 7 percent. Because the NPV is positive, management may adopt the project unless a competing project presents a higher NPV.

Future Value of Money Money that is not immediately needed, such as excess cash in accounts, can be invested to earn additional moneys. Investing takes into account the **future value of money**—how much the money will be worth at some point in the future.

For example, let us assume our television station has $100,000 not needed for day-to-day cash flow. By investing this money in an interest-bearing account, the station can earn interest on the original $100,000 (the principal amount), which increases the cash flow of the station. To determine the future value, you need the amount of the original investment, the number of time periods invested, and the available interest rate.

Normally, a time period is thought of as 1 year, although other time periods could be used (quarter, month, or day). To determine the future value of the $100,000 at the end of 2 years with a 7 percent interest rate, we use the following formula:

$$FV = PV (1 + r)^n$$

where PV stands for the present value of the investment ($100,000), r the interest rate and n the number of time periods. To calculate,

$$FV = \$100,000 (1 + .07)^2$$
$$FV = \$100,000 (1.1449)$$
$$FV = \$114,490$$

By investing $100,000 over 2 years at a 7 percent interest rate, the money will grow by nearly $14,500.

Compounding The previous example illustrates another important feature about the time value of money—the power of **compounding.** Compounding has a dramatic effect on investing because interest is earned on *both* the original investment and the interest it accumulates.

Compounding can also tell us how long it takes for an investment to double using the "rule of 72." To determine how long it takes for an investment to double in value, divide 72 by the interest rate. If the interest rate is 12 percent, then we have the following:

$$T = (72/r) = (72/12) = 6$$

where T is the time period and r is the interest rate.

The investment will double in 6 years at an annual 12 percent interest rate if we do not withdraw any of the money during this time.

This section of the chapter has introduced basic concepts used by managers in understanding the time value of money. You should recognize that this discussion presents only a brief introduction to the concepts of present value, net present value, and future value. If you

want more information, you should consider additional readings or courses in managerial finance.

Ratio Analysis

Ratio analysis refers to the **financial ratios** and margins managers use to compare their firm's financial history to that of other companies or to industry averages (Albarran, 1996). Ratios measure liquidity, debt, and capitalization, all of which one can usually calculate with information drawn from financial statements.

Liquidity refers to a firm's ability to convert assets into cash. **Liquidity ratios** include the quick ratio, the current ratio, and the acid test ratio. Ideally, liquidity ratios produce at least a 1.5 to 1 ratio of assets to liabilities. *Debt ratios* measure the debt of a firm. One kind, the leverage ratio, is calculated by dividing total debt by total assets. The lower the number, the better. Another common debt measure, the debt-to-equity ratio, comes from dividing total debt by total equity. The debt-to-equity ratio should be no larger than 1. *Capitalization ratios* deal with the capital represented by both preferred and common stock. Two ratios are common: dividing preferred stock by common stock and dividing long-term liabilities by common stock. Table 5-2 lists the formulas for the ratios most commonly used to evaluate electronic media firms and industries.

Growth measures calculate the growth of revenue and assets over time; they also document historical trends. For each growth measure, the previous time period is subtracted from the current time period, whereupon this number is divided by the previous time period (see Table 5-3). Financial growth is important to any business, and the stronger these measures, the better for the firm or industry examined. These measures include growth of revenue, operating income, assets, and net worth. *Operating income,* a variable used in both growth and performance ratios, refers to the operating profit (or loss) of a firm before allocating money for taxes.

Performance or *profitability measures* measure the financial strength of a company or industry. Low profitability measures indicate high liabilities, low revenues, or excessive expenses. Included in this set of measures are return on sales, return on assets, return on equity, price-earnings ratio, and profit margins (see Table 5-4).

TABLE 5-2

Common Financial Ratios

LIQUIDITY RATIOS	
Current Ratio	$\dfrac{\text{Current Assets}}{\text{Current Liabilities}}$
Acid Test Ratio	$\dfrac{\text{Liquid Assets}}{\text{Current Liabilities}}$
DEBT RATIOS	
Leverage Ratio	$\dfrac{\text{Total Liabilities}}{\text{Total Assets}}$
Debt-to-Equity Ratio	$\dfrac{\text{Total Liabilities}}{\text{Total Equity}}$
CAPITALIZATION RATIOS	
	$\dfrac{\text{Total Shares of Preferred Stock}}{\text{Total Shares of Common Stock}}$
	$\dfrac{\text{Long-Term Liabilities}}{\text{Total Shares of Common Stock}}$

TABLE 5-3

Common Growth Measures

Growth of revenue
$$\frac{(\text{Current Period [mo, qtr, yr] Revenue}) - (\text{Previous Period Revenue})}{\text{Previous Period Revenue}}$$

Growth of operating income
$$\frac{(\text{Current Period [mo, qtr, yr] Operating Income}) - (\text{Previous Period Operating Income})}{\text{Previous Period Operating Income}}$$

Growth of net worth (owner's equity)
$$\frac{(\text{Current Period [mo, qtr, yr] Net Worth}) - (\text{Previous Period Net Worth})}{\text{Previous Period Net Worth}}$$

Growth of assets
$$\frac{(\text{Current Period [mo, qtr, yr] Assets}) - (\text{Previous Period Assets})}{\text{Previous Period Assets}}$$

TABLE 5-4

**Performance and
Profitability Measures**

PROFITABILITY MEASURES	
Return on Sales	$\dfrac{\text{Operating Income}}{\text{Total Revenues}}$
Return on Assets	$\dfrac{\text{Operating Income}}{\text{Total Revenues}}$
Return on Equity	$\dfrac{\text{Operating Income}}{\text{Owner's Equity}}$
Price-Earnings (PE) Ratio	$\dfrac{\text{Market Price of a Share of Common Stock}}{\text{Earnings Per Share}}$
PROFIT MARGINS	
Cash Flow Margin	
	$\dfrac{\text{Cash Flow (After-tax net profit + interest, depreciation, amortization)}}{\text{Net Revenue (Revenues – operating expenses)}}$
Net Profit Margin	$\dfrac{\text{Net Profit (Revenues – expenses and taxes)}}{\text{Total Revenues (Sales)}}$

Break-Even Analysis

All companies operating for profit ask themselves how much revenue they need to break even. Stated another way, how many units of a good (such as advertising time) must they sell to earn a profit? To answer these questions, managers need a clear understanding of the cost structures of their business.

Costs are usually examined in two categories. Fixed costs represent fixed inputs such as buildings, land, and equipment. Variable costs, such as the cost of labor, programming material, and supplies, necessarily change over time. Fixed costs and variable costs added together equal total costs.

For example, assume a network-affiliated television station in a top-50 market has total costs of $250,000 in an average month. In order to break even, the station must generate a minimum of $250,000 per month through the sale of advertising and network compensation. If the station receives approximately 5 percent of this

FIGURE 5-4

Break-Even Analysis

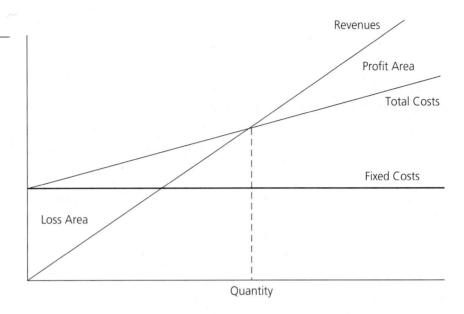

amount, or $12,500, in the form of network compensation, then advertising must provide the remaining $237,500. If national advertising through the station's representative firm (see Chapter 8) generates another $25,000 in an average month, then $212,500 must be generated through local advertising. If the station's local inventory (number of unsold units) consists of 500 commercial announcements, each slot must be sold at an average price of $425 in order to break even. If inventory falls to 250 spots per week, the average price will have to double, to $850 per spot.

Break-even analysis is easier to understand when presented graphically. Figure 5-4 illustrates the break-even point for a firm. Notice that the point where revenues and total costs intersect is the break-even point. The area below this point represents a loss for the firm, while the area beyond it represents a gain. The break-even point, usually referred to as a quantity (Q), may represent something different for different kinds of businesses, such as the number of advertising units sold for a radio or TV station or the number of subscriptions for a cable system.

Break-even analysis must be conducted within a particular time frame (month, quarter, or year) to have meaning. As a tool for man-

agers, break-even analysis is useful in setting projections for sales and other revenue-producing streams.

Depreciation and Amortization

Earlier in this chapter you were introduced to the concepts of depreciation and amortization as a way to deduct the costs of certain assets. The Internal Revenue Service allows companies to depreciate over time the costs of tangible assets such as equipment, buildings, automobiles, and land. Assets are depreciated according to particular categories that represent the life of the asset. Currently, tax laws allow the taxpaying entity to depreciate assets over 3, 5, 7, 10, or 15 years. However, tax laws are modified regularly, so always check to see if new regulations have altered depreciation methods.

Amortization is similar to depreciation, with one important exception: It deals with a firm's intangible assets, such as programming contracts. Two common methods used in amortization are the *straight line method* and the *declining value method* (Von Sootsen, 1997). In the straight line method, the same value is deducted for each run of a program series. If a station paid $50,000 for five runs, 20 percent, or $10,000, will be amortized each run through the end of the contract. The declining value method assumes most of the value of the program is found in the initial runs; in this case the first run is charged a higher percentage than the second, third, and later runs. Table 5-5 illustrates the differences between the straight line and the declining value methods. Recognize that each method results in the same amount of money being amortized; the difference lies merely in the way one calculates it. Straight line offers a fixed deduction every year, while declining value deducts the costs at a faster pace. Tax strategies dictate which method to use; if a firm needs additional tax deductions in the near term, it would use the declining value method.

Depreciation and amortization represent non-cash expense items on the P & L Statement (Figure 5-2). On the statement of cash flows, depreciation and amortization are added back to net income to determine the cash provided by operating activities (Figure 5-3).

As you can see, financial analysis utilizes a number of analytical tools to provide various types of information. By understanding the

TABLE 5-5

**Comparison of
Amortization
Methods**

In the following example, a television station has paid $50,000 for a program series to be used for 5 years. Using the straight line method, the same value is deducted each year. The declining value method assumes that most of the value of the program is found in the initial runs, so the first year is charged a higher percentage than later years. The same amount of money is amortized regardless of the method used.

YEAR	STRAIGHT LINE	DECLINING VALUE
1	$10,000	$20,000
2	$10,000	$15,000
3	$10,000	$10,000
4	$10,000	$5,000
5	$10,000	0
Total	$50,000	$50,000

concepts used in financial analysis, managers are better equipped to make decisions that will ultimately benefit their firms.

Reporting Financial Performance

Owners and stockholders of electronic media companies need timely information on the financial performance of their investments. Reporting financial performance is thus the final step in the cycle of financial management. Reports to owners and stockholders vary by company; the most common reports are executive summaries, quarterly reports, and annual reports.

Executive summaries are concise reports that one can read quickly to gain an overview of a firm's financial progress. An executive summary is a condensed version of a larger report, usually prepared by management for owners and members of the board of directors. Rather than containing detailed financial statements, it consists of a series of bullet points that explain the financial condition of a firm.

Quarterly reports, provided for both owners and stockholders, highlight progress from the previous quarter and explain any changes in the financial stability of the firm. Such reports contain financial

statements, the most common being the P & L statement for the quarter. Stockholders may receive quarterly reports along with any dividends.

Annual reports are provided for owners and stockholders, as well as public and university libraries and potential investors. Though ultimately the responsibility of the chief executive officer (CEO), annual reports are compiled from all segments of the firm and thus involve general managers and lower level managers. Of the three reports, the annual report offers the most detailed information about a company, and thus it is prepared with care and precision.

Another important aspect of reporting financial performance concerns the role of auditors. Usually certified public accountants (CPAs), auditors verify the accuracy of the financial data provided by the firm. An auditor's statement of verification is found in every annual report and some quarterly reports. To maintain accuracy and credibility, General Managers normally arrange for auditors to examine the journals and ledgers at least once a year.

Summary

Managers of an electronic media facility must know how to handle its finances. Such management involves planning, monitoring, and control in order to meet financial goals. Managers work with other personnel, such as a Controller in large firms, to administer financial management.

Budgeting, one of the most important components of financial management, should involve the General Manager, Controller or other financial officers, and other managers. Budgeting consists of establishing revenue and expense projections as well as capital budgeting needs.

Monitoring of financial performance is accomplished through the posting of individual transactions in various journals and ledgers and the compiling of different financial statements and reports. Widely used financial statements include the balance sheet, the income or P & L statement, and the statement of cash flows.

In financial analysis, managers use a variety of tools to gain additional insight into the financial performance of a firm. Managers should be familiar with several concepts, including the time value

of money, ratio analysis, break-even analysis, and depreciation and amortization.

Reporting on financial performance is the final step in the process of financial management. Reports vary by company, with the most common reports consisting of executive summaries, quarterly reports, and annual reports. Auditors are used in the preparation of quarterly and annual reports to verify the accuracy of financial data.

· CASE STUDY | Purchasing A Radio Station?

As a group owner of a number of small-market stations, the Helzberg family is always looking for opportunities to grow the family's radio business. Several offers have been tendered from larger groups to buy the family company, but the Helzbergs have resisted the offers. Through a business acquaintance, John Helzberg, the President and CEO, has learned of a station that may be for sale in a market about 75 miles away. Helzberg asks you, the group's Controller, to check out the financials of the station.

Mr. Helzberg arranges a meeting in his office. "I believe I can buy this station at ten times cash flow along with taking over the debt. Cash flow is about $500,000 per year, and they owe another $250,000 in debt, so the station will go for about $5.5 million, maybe less, depending on negotiations." Helzberg adds, "They won't let me see all the books until I make a contract offer. I do have a recent balance sheet from the station's accounting firm. Will you review this statement and give me your thoughts on the financial condition of this station?"

Using the following balance sheet, calculate liquidity, debt, and capitalization ratios as well as a growth-of-assets ratio using the formulas in Tables 5-2 and 5-3. Using the data from your calculations, offer Mr. Helzberg your evaluation of the station.

**KBNR-FM
BALANCE SHEET,
MAY 31, 2002**

ASSETS	THIS YEAR	LAST YEAR
Current Assets:		
Cash/Marketable Securities	$27,000	$29,000
Accounts Receivable	12,000	18,000
Prepaid Expenses	15,000	15,000
Total Current Assets	$54,000	$62,000
Property, Plant, Equipment		
Less Depreciation	35,000	40,000
Intangible Assets	5,000	5,000
Total Assets	$94,000	$107,000

LIABILITIES AND OWNER'S EQUITY		
Current Liabilities:		
Accounts Payable	$18,000	$21,000
Notes Payable	5,000	4,000
Income Taxes Payable	11,000	11,000
Total Current Liabilities	$34,000	$36,000
Long-Term Debt	50,000	60,000
Total Liabilities	$84,000	$96,000
Owner's Equity:		
Common Stock	7,000	8,000
Retained Earnings	3,000	3,000
Total Owner's Equity	$10,000	$11,000
Total Liabilities and Owner's Equity	$94,000	$107,000

CASE STUDY **ANALYZING AN INCOME STATEMENT**

From the following sample income statement, calculate six ratios using the information in Chapter 5. What does this information tell you about the

financial condition of this station? What factors may have contributed to KAAA-TV's successful bottom line for the year?

Ratios to be calculated:

1. Return on sales
2. Cash flow margin
3. Net profit margin
4. Growth of revenue
5. Growth of operating income

KAAA-TV
DECEMBER 31, 2002
YEAR-TO-DATE

	ACTUAL	BUDGET	LAST YEAR
Operating Revenue			
Local	$28,500	$26,000	$20,500
National	17,080	15,000	12,290
Network	4,800	3,600	2,400
Political	200	250	1,000
Production	170	160	190
Misc. Revenue	550	600	600
Gross Revenue:	$51,300	$45,610	$36,980
Less Commissions	(5,140)	(4,600)	(3,690)
Net Revenue	$46,160	$41,010	$33,290
Operating Expenses			
Technical	$2,058	$2,400	$1,600
Programming	4,870	5,000	3,000
News	4,720	4,800	3,800
Sales and Traffic	5,300	5,400	4,800
Research	1,004	1,250	1,008
Advertising and Internet	1,500	2,000	1,600
General & Administrative	5,972	6,600	6,300
Depreciation & Amortization	1,550	1,550	1,752
Total Operating Expenses	$26,974	$29,050	$23,860
Operating Income Before Taxes	$19,186	$11,160	$9,430
Provision for Taxes	(5,512)	(3,248)	(2,640)
Net Income	$13,674	$8,612	$6,790

NOTE: All figures in thousands.

InfoTrac College Edition

For new information on the topic of financial management, use InfoTrac College Edition. Use the following terms for subject and keyword searches: finance, managerial finance, accounting, depreciation, amortization.

Web World

The following Web sites offer useful information related to electronic media financial management:
Broadcast/Cable Financial Management Association (www.bcfm.com)
National Association of Broadcasters (www.nab.com)

References for Chapter 5

Albarran, A. B. (1996). *Media economics: Understanding markets, industries and concepts.* Ames, IA: Iowa State University Press.

Bierman, H., & Smidt, S. (1988). *The capital budgeting decision: Economic analysis of investment projects* (7th ed.). New York: Macmillan.

Capodanno, B. (1994). Cash flow measures and reports. In A. Gordon (Ed.), *Understanding broadcast and cable finance* (pp. 109–116). BCFM Press.

Eckhart, R. (1994). Capital expenditure budgeting and controls. In A. Gordon (Ed.), *Understanding broadcast and cable finance* (pp. 102–108). BCFM Press.

La Greca, P. (1994). Introduction to financial systems. In A. Gordon (Ed.), *Understanding broadcast and cable finance* (pp. 3–9). BCFM Press.

Picard, R. G. (1989). *Media economics.* Beverly Hills, CA: Sage.

Sherman, M. (1982). *Comprehensive compound interest tables.* Chicago: Contemporary Books.

Von Sootsen, J. (1997). Domestic syndication. In S. T. Eastman & D. A. Ferguson, *Broadcast/cable programming strategies and practices* (5th ed., pp. 66–96). Belmont, CA: Wadsworth.

6

Managing Personnel

In this chapter you will learn

- All aspects of personnel management, from recruitment of employees to termination of employment
- Key federal laws designed to protect employees
- The role of unions in the electronic media
- How demographic changes affect the makeup of the workforce
- How organizational structure is changing in many media organizations

At the beginning of this book, management is defined as a process in which individuals work with and through other people to accomplish organizational objectives. Personnel management is an essential part of the management process of any industry, but particularly the electronic media, which employs people with a wide variety of creative and technical talents.

The quality of personnel at an electronic media facility often determines its ability to achieve success. Indeed, employees are the most important asset of any organization. Through careful selection, orientation, training, compensation, and benefit programs, and by providing a safe and responsible working environment, managers can directly impact the success of their organization. Managers who fail to properly manage human resources are constantly forced to deal with problems related to turnover, low morale, and inefficient performance.

This chapter begins with a discussion of personnel management, including aspects of recruitment and hiring, training, performance reviews, and promotion and termination. The second section discusses legal issues involving personnel. Finally, you will find a discussion of changes in organizational structure and their impact on communication between management and employees.

Personnel Management

Several individuals manage personnel in an electronic media organization. Department heads or middle managers who are responsible for individual units recommend the number of individual positions needed to accomplish their unit's tasks. **Force field analysis,** a technique developed by the social psychologist Kurt Lewin (1951), can help managers determine this number.

Force field analysis considers driving and restraining forces as variables that impact effectiveness (Hersey & Blanchard, 1996). Briefly, *driving forces* are positive forces, such as increased earnings, praise from a supervisor, and competition. Restraining forces inhibit the driving forces. They can range from employee apathy and hostility to poor equipment. Used in the electronic media, force field analysis is a tool that helps managers properly diagnose their environment.

Department heads usually recommend hiring (or terminating) individual employees, determine wages, consider vacation and other leave requests, and conduct performance reviews at least once a year. Department heads also provide for the training and development of employees within their unit.

In most operations, the General Manager reviews and approves personnel matters such as hiring and termination, salary levels, and other departmental priorities as requested by the department heads. The GM also makes sure the organization adheres to all legal guidelines regarding personnel, especially in the areas of hiring and compliance with all applicable labor laws. When required, the GM handles negotiations with various craft guilds and unions that represent employees. Most medium- and large-market organizations will have a personnel manager or human relations (HR) manager who maintains records on all employees. The Personnel Manager's responsibilities may include monitoring recruitment for individual positions (dead-

lines, interview schedules, and so forth), arranging job training, establishing benefit programs, monitoring changes in labor laws and collective bargaining agreements, educating employees on issues such as sexual harassment, and working with the General Manager on setting wages and salaries for the organization.

As new and existing positions open up, managers must identify and properly select qualified new personnel. One of the most important tasks in personnel management, hiring must be handled efficiently and in compliance with federal, state, and local employment guidelines.

The Hiring Process To hire an employee for a new or replacement position, managers need effective recruitment strategies to identify a qualified pool of applicants. Finding potential new employees involves a variety of internal and external approaches. Here are a few of the more common means of recruitment:

- *Recruiting internally.* One of the fastest and easiest ways to recruit personnel is through internal job postings on company bulletin boards, in newsletters, through electronic mail or by other forms of communication. Recruiting from within helps build morale among existing employees by showing that management wants to help employees advance.

- *Job fairs.* Job fairs have become an increasingly efficient way to gather a large number of applicants for non-talent positions. Job fairs can be conducted on a local, state, or national basis. Usually, prospective candidates are allowed to attend job fairs for free and can interact with representatives involved in hiring.

- *Applications on file and unsolicited applications.* Most electronic media organizations maintain application files for several months to a year from candidates who were not hired for a previous opening or who submitted unsolicited applications.

- *Advertising.* Job announcements in local newspapers work well to fill certain types of positions, while advertisements in trade publications such as *Broadcasting and Cable, Electronic Media, Radio and Records,* and *Cablevision* offer positions requiring particular skills and training. The Internet has evolved into a major source for recruiting for many positions in the electronic media.

- *Employment agencies.* Normally found locally, these agencies can be a good source for a number of positions requiring clerical, technical, and general business skills.

- *Consultants and headhunters.* Commonly used to find upper-level managers, executives, and talent, these firms usually charge a substantial fee for their services.

- *Colleges, universities, and other educational outlets.* Excellent sources for entry-level positions include 4-year colleges and universities with programs in broadcasting, radio-TV-film, telecommunications, journalism, and so forth, and graduate programs emphasizing communications, business administration, marketing, and engineering.

- *Word of mouth.* Personal contacts within an organization can alert a potential employee to an opening. *Networking,* the practice of establishing contacts with media professionals, is a common practice in the electronic media.

- *Internships.* Another important source for entry-level positions, college interns are usually near graduation and may show promise for full-time employment.

- *Other sources.* Recommendations from other employers, situation-wanted ads in trade publications, and advice from professional organizations and local civic organizations can all help managers fill positions.

Once the recruitment process has been completed, the selection process begins. Often, a potential candidate will express interest in a position by providing a brief cover letter and a résumé, as well as an audition tape for a talent position. Companies may also require an applicant to complete a formal application for employment. Such applications usually ask for current information (such as address and phone number) as well as the candidate's educational background, employment history, skills and qualifications, and personal references. They also may inquire about immigration status, criminal records, or pending criminal or civil charges. Policies concerning nondiscrimination are also provided in the formal application.

Prior to the interview stage, employers often seek out additional information on the top applicants. This may involve verifying educational and employment histories and contacting personal references.

Applicants sometimes overstate their qualifications on the application; a check to verify dates and responsibilities will determine if the applicant has provided accurate information.

The high mobility of personnel in the electronic media may hamper efforts to gather information about former employment, particularly if previous managers have moved on to other positions. Employers may hesitate to divulge much information about former employees. In fact, because of possible legal action by the candidate, some companies refuse to provide any details of previous employment beyond the job title, dates of employment, and responsibilities.

Interviewing

Once managers have selected the top candidates for a position, they normally arrange interviews between the candidates and the company. For the applicant, the interview provides an opportunity to visit the facility, meet prospective coworkers and managers, get a better understanding of the position and its responsibilities and learn about the philosophy of the organization. For the employer, the interview provides the important interpersonal link to the hiring process (see Table 6-1). Résumés, tapes, personal Web sites, references, and other sources of information can only tell you so much about an applicant. Meeting the applicant face-to-face can resolve many questions about the applicant's motivation, personal qualities, and interest in the position.

Time-consuming for both parties, interviewing can also be expensive. Some companies use highly structured interview procedures, while others may use a semistructured or completely unstructured process (Kaiser, 1990). The employer should clarify the type of interview procedures that will be used as well as the time required. When an applicant is brought in from out of town, the company normally pays for all travel expenses associated with the interview.

More than one interview may be required. The initial interview may be conducted with the Personnel Manager, followed by another interview with the actual supervisor for the position. Interviews may be arranged with other appropriate personnel as deemed necessary, especially for managerial and talent positions. For example, in the hiring of news personnel for a TV station, most General Managers prefer to interview the final candidates for key anchor/reporter positions along with the News Director and other news managers.

TABLE 6-1

**A Few Common
Interview Questions**

QUESTION	WHAT THE EMPLOYER HOPES TO LEARN
1. What do you know about our company?	Did you prepare for the interview? Did you do your homework?
2. Why should we consider you for this position?	Are you confident in your abilities? What does the company gain by hiring you?
3. What are your strengths and weaknesses?	Companies expect honesty in answering this question. You should be able to articulate what you are best at and areas you are working to improve.
4. What do you want to be doing 5 years from now?	Are you goal directed? Or will you be satisfied with an entry-level position?
5. What other job experiences have you had?	Have you held a job before? How long have you been working? Did you get along with others?
6. What people have been important influences in your life?	People quick to credit others often work well with others and are not driven by ego.
7. Are you a self-starter?	Can you work alone and without direct supervision? If not given a task, are you the type of person who will take the initiative to find something to do?
8. What are your interests apart from work?	Hobbies, activities, and other interests indicate people who are well rounded and can manage time and work.

Some openings may require a skill assessment as part of the interview process. This assessment is especially needed for office and production-related positions. Many companies also evaluate a candidate's communication skills (both verbal and written) and conduct other types of performance and aptitude examinations as well. Regardless of the type of interview, the employer should explain clearly the details regarding the interview and the time required. If the employer does not volunteer this information, the candidate should ask for the information in order to be properly prepared. Many companies also require a drug test before an offer of employment can be made.

The interview process ends when a candidate accepts an offer of employment. Negotiating the terms of employment often forms part

of this final step, particularly for talent positions and managerial openings (Pinkley & Northcraft, 2000). Generally, the higher the pay, the more extensive the negotiations over salary and other perks offered to the employee, depending on the type of position. These perks may include the use of a company car, profit sharing or stock options, extra vacation time, travel allowances, or membership in a local health or country club. An agent or attorney may represent high-salaried performers during final negotiations. Regardless of the type of position, both the employer and the candidate should maintain a professional manner throughout the negotiation process.

Orientation Introducing the new employee to company policies and other personnel is commonly referred to as the orientation process. Orientation should occur during the initial days of employment. The amount of time needed varies depending on the type of position. A new Account Executive's orientation period may last a month, while orientation for a clerical employee may last a day or less.

As with interviews, orientation procedures differ from company to company. A Personnel Manager may instruct the new employee on various policies and procedures concerning such matters as office hours, overtime compensation, sick leave, leave of absence, vacation, substance abuse, and personal appearance. The Personnel Manager or Business Manager will also take care of all paperwork necessary to enroll the new employee in company-sponsored benefit programs such as health and dental insurance and retirement plans, as well as payroll deductions for state and federal taxes, health insurance, and so on. Many companies also require new employees to sign a form claiming they will not accept either payola or plugola, which is illegal compensation from an outside source to promote a particular good or product.

Many companies provide an employee handbook or similar document that explains in detail company policies and procedures regarding personnel. This document should include specific information on nondiscrimination in employment, promotion and advancement, performance reviews (discussed later), available benefit programs, disciplinary actions, and formal grievance procedures. All employees should become familiar with the contents of the employee handbook, and employers should provide updates as necessary when company policies or provisions are modified.

The Department Manager or supervisor is responsible for orienting the new employee to the specific tasks associated with his or her position. Ideally, the interview process has already offered a realistic preview of the job, thus minimizing the time needed for orientation. In fact, when new hires have not been fully informed of the duties and expectations associated with the position, frustration usually occurs. Studies refer to this experience as an *unrealistic job preview* (Jablin, 1984; Wanous, 1980). Unrealistic job previews can hurt the organization because they tend to place new employees in a negative environment, affecting their motivation and outlook on their new job. Companies should make sure that all employees clearly understand their positions before they actually begin work.

Managers may need to include training in the orientation process. When new employees have little direct experience with a specific task or must work with new equipment, their training needs are obvious. Veteran employees who accept a new position may also need some training, particularly if they move to a new department. One professional trainer (Rollins, 1991) offers managers the following points for a proper training experience.

- *Approach training with a proper attitude.* Too many managers look negatively on training.

- *Plan out the new employee's first day.* Careful planning will ease the transition for the new hire.

- *Consider using a training outline.* This ensures that all relevant points will be covered during the session.

- *Allocate enough time for training of the new employee and avoid interruptions.* Let other staff members know you will be involved in training.

- *Discuss company philosophy, not just policy.* New employees want to know the reasons behind company policy, and training is the best time to discuss them.

- *Utilize outside training resources.* Use as needed to supplement internal training activities.

Managers should also promote ongoing development activities for all employees, such as in-house workshops and seminars; meetings of professional associations, both local and national; and credit courses at educational institutions. Development activities provide

continuing education and growth for the workforce, as well as many benefits to management.

Performance Reviews

An important part of each employee's overall growth and development is the **performance review,** which should be conducted at least once a year. The department supervisor usually conducts this review; departmental managers have their reviews with the General Manager or other immediate supervisor. Like the interview, review procedures vary from company to company. The performance review allows the employer to identify areas where the employee is particularly weak or strong. It also allows the employee to give candid feedback to the employer. A review not only evaluates job performance but also serves as the basis for salary adjustments, merit pay, and promotion.

Employers should initiate performance reviews. Sometimes employees are asked to provide written information about their own performance during the past year, highlighting important information concerning particular projects and outcomes. The actual review is conducted in person, and written copies of each evaluation should be offered to the employee, with the original copy placed in the employee's file.

At the review, the supervisor will discuss the employee's job performance during the past year, noting relevant strengths and weaknesses in an open and honest exchange. The employee should be allowed to discuss his or her feelings about the evaluation given by the supervisor, particularly as to areas of disagreement. At all times, the review should focus on the specifics of the job and the actual performance of the employee. Further, managers should establish ample time for each review and enough privacy to avoid interruptions.

Employees who believe they have been evaluated improperly or unfairly should be offered an appeal process through which they can challenge the review. These procedures should be outlined in the employee handbook. The employer must make sure all performance reviews are conducted with proper procedures and focus on relevant task-oriented responsibilities. Failure to do so can result in legal challenges by the employee against the manager and the company. Here are some management guidelines for successful performance reviews.

- *Allow enough time for the review and eliminate interruptions.*

- *Stay calm and be objective.*

- *Be helpful to the employee. Point out areas where performance is poor and offer ideas for improvement.*

- *At all times be honest.*

- *State opinions clearly, and do not confuse opinions with facts. As a supervisor your opinions are not relevant in a review.*

- *Avoid using other employees as an example of positive performance.*

- *Concentrate only on the employee's performance and expectations.*

- *Do not stress deficiencies that are hard to overcome.*

- *Make sure any discussion of behavior is job related.*

- *Offer specifics and avoid euphemisms. Examples can help clarify important points.* (Reising, 1991, p. 18)

Promotion Positive performance reviews and good working habits often pave the way for promotion. For example, a news reporter with a strong track record may be offered promotion to a weekend anchor position. Internal promotion is common in the electronic media, both within the organization and within the larger parent company. Promotion is critical to advancement in the electronic media; most professionals find it necessary to move up from market to market to achieve their career goals.

Recall in Chapter 1 the high percentage of corporations involved in ownership of the electronic media. As such, many promotions, especially among managerial positions in larger markets, involve individuals moving from market to market rather than within the same operation. For example, a TV station's General Manager may be promoted from one of the parent company's medium-market stations to a larger market. One often finds that managers in the top markets have served in smaller and medium markets with the same company.

Increasingly, many electronic media organizations have reduced the number of personnel over the past few years. Typically, this takes one of two forms. **Downsizing** has become very common due to industry consolidation, especially in radio. As multiple operations are combined under a single owner in a market, the need for separate office, engineering, and programming staffs are reduced. **Outsourcing** has also been adopted by electronic media organizations. Outsourc-

ing involves hiring an outside firm or individual to handle specific functions. Some of the more common areas of outsourcing in electronic media involve Web page maintenance, computer repair, engineering support, and office and custodial staffing.

Retaining good employees is a continuing priority for managers. Providing adequate training and promotion from within the company will help promote an atmosphere of loyalty to the organization, which in turn can help reduce the high costs associated with job turnover.

Termination

One type of turnover that occurs regularly in the electronic media is termination. Employees may voluntarily leave a company to work for another facility or to pursue a different vocation. In some cases, they may be forced to leave.

Managers use disciplinary action to correct employee behaviors detrimental to the organization. The employee handbook should clearly spell out behaviors detrimental to the employee's performance. Common problems include failing to be at work on time, excessive absences or tardiness without excuse, engaging in employment with another company without permission, inability to follow instructions, and contributing to a work environment that is hostile to other employees.

Whenever taking disciplinary action, management should document all charges in writing and notify the employee of the action. Managers have an obligation to try to prevent disciplinary problems by keeping open lines of communication with all workers (Hughes, 1989). They should deal with problems quickly and not allow them to develop into larger problems. Some companies use a probationary period of between 30 and 90 days to address disciplinary problems with employees. It should be understood that repeated disciplinary problems will lead to dismissal. Because they apply to all employees, disciplinary policies and procedures must not be used unfairly or to discriminate.

Managers should take actions to encourage positive performance rather than to create a threatening work environment. However, in some situations, managers may have to fire employees. Though grounds for termination vary among organizations, certain actions often result in immediate dismissal. These include possession, use, or sale of illegal drugs; unauthorized alcohol consumption; pos-

session of a weapon or firearm; theft; insubordination; indecent behavior; repeated acts of sexual harassment or racism towards other employees; any crime resulting in a felony charge; and any continuous disciplinary problems.

The decision to terminate an employee must be made carefully. To avoid possible legal ramifications, managers must carefully follow all proper procedures. They should review the employee handbook as well as the employee's personnel file to be certain that the reasons for termination follow company policy and have been clearly documented. You can see how crucial it is for managers to document all notices, warnings, and other actions involving the employee, as well as areas where the employee has performed positively (Pardue, 1990).

A termination can also be caused by consolidation. Changes in ownership often cause a turnover of station personnel. A drop in ratings or changes in the local economy may also lead to cuts in personnel. Ideally, companies facing layoffs will help former employees find new employment, not just provide them with a severance package. Employers may help arrange for new job training, employment counseling, and other programs as a part of the termination process.

Part-Time Employees

Electronic media companies usually employ a number of part-time employees in a variety of capacities requiring production, clerical, or technical skills. Important to the success of an organization, part-timers represent a challenge for managers. Because part-timers usually receive an hourly wage, as opposed to a salary, and receive few benefits, they may not feel like a true part of the organization. Managers should try to respond to the needs of part-timers with the same attention given to full-time employees and see that part-timers are integrated into all company-sponsored activities. Part-timers desiring advancement should also be considered for full-time positions as appropriate.

Interns

A large majority of electronic media companies offer internship opportunities through local colleges and universities. In most cases, interns work a limited number of hours for course credit alone, but some are paid. Like part-timers, interns make an important contribution to the operation and present another personnel challenge to management. Three ideas to facilitate a good internship program follow.

First, interns should not be selected haphazardly. Departments should develop selection procedures that focus on actual tasks. So the intern is not reduced to mundane tasks such as filing paperwork or making coffee, the company should offer specific responsibilities, making the experience positive for both parties. Second, interns should be evaluated similarly to other employees so the intern supervisor can point out strengths and ways to improve performance. This feedback can help students achieve their career goals. Third, only students enrolled in an actual credit course should be allowed to intern. Regular contact should be maintained with the educational institution regarding the intern's performance. In facilities that use a number of interns, management should designate one person as the contact for internship information and record keeping.

Working with Personnel

Because of demographic and other changes, managers in the electronic media currently encounter a diverse workforce. In the past, the electronic media workforce tended to be dominated by white men. Now, women and minorities make up an increasing percentage of employees in many contemporary electronic media organizations. Additionally, the workforce is aging. The baby boom generation continues to age and exit the job market.

A strong U.S. economy during the late 1990s resulted in record low unemployment for the country, causing employment shortages for many sectors of the economy. Conversely, when the economy declines, employment often tightens, resulting in fewer opportunities for part-time positions. The way people work and what they work at will also change as a result of social conditions.

How might these demographic changes impact managers? Consider the following situations. Many entry-level positions are likely to be filled by younger workers who have varied cultural backgrounds and who may speak English as a second language. Women with school-aged children and older citizens in early retirement continue returning to the labor force, many seeking part-time hours with flexible schedules. Two or more part-time employees may share the responsibilities of a single job on different hours or days. Employee training and development are ongoing activities for many organiza-

tions. Managers must therefore understand these changes in the labor force and sensitively address the needs of a diverse group of workers.

Successful managers will need strong leadership skills to cope with diversity and change among employees. As opposed to someone who just gives orders, the best managers will be able to motivate employees to achieve quality performance. A flexible attitude and approach to managing people with a variety of backgrounds will be critical in this endeavor.

Legal Issues in Personnel Management

Electronic media organizations must comply with many laws and regulatory guidelines regarding the hiring and treatment of their employees. One of the most important areas of responsibility concerns issues of equal opportunity and nondiscrimination in employment practices. Managers need to be familiar with the requirements of equal employment and affirmative action programs.

Equal Employment Opportunity (EEO) Guidelines

Employers are required by federal law to provide equal employment opportunities (EEO) to all qualified applicants without regard to race, color, gender, religion, or national origin. On January 20, 2000, the FCC adopted new rules regarding EEO. Previous requirements had been ruled unconstitutional in a 1998 federal court decision because the old rules imposed "de facto racial and gender hiring quotas on stations" (McConnell, 2000, p. 19).

The new rules required broadcast, cable, and multichannel video operators to widely disseminate information regarding all full-time job openings in order to reach all qualified applicants, especially women and minorities. From the outset, the new rules faced criticism and controversy, from both broadcasters and citizen groups (McConnell, 2000). In January 2001, a three-judge district court found that the rules created "pressure to recruit women and minorities," which "ultimately does not withstand constitutional review" (Shoptalk, January 17, 2001). In short, the rules were declared unconstitutional.

The decision leaves broadcasters and cable operators without any government-mandated rules regarding equal employment. While minority groups criticized the court's decision, broadcasters were pleased to be freed of regulatory obligations regarding the hiring of

personnel. Congress or the FCC may try to develop new rules for hiring, but until something is passed which can withstand judicial review, broadcasters and cable operators will enjoy more freedom in hiring decisions.

Sexual Harassment Related to issues of discrimination in the labor force is the continuing problem of sexual harassment. Awareness of sexual harassment became more common during the 1990s as a result of media coverage of high-profile sexual harassment cases. One must understand that sexual harassment can target men and women equally.

The Equal Employment Opportunity Commission (EEOC) offers guidelines that clarify the many different forms harassment can take. Unwanted sexual advances, requests for sexual favors, and other conduct of a sexual nature (either verbal or physical) constitute sexual harassment under one or more of the following conditions:

1. when submission to such conduct is either explicitly or implicitly a term or condition of an individual's employment

2. when submission or rejection of such conduct by an individual is used as the basis of employment decisions affecting the individual

3. when such conduct has the purpose or effect of unreasonably interfering with an individual's work performance or creating an intimidating, hostile, or offensive work environment. (29 Code of Federal Regulations [CFR] 1604.11 (a))

Sexual harassment is a serious problem not only for individuals but also for employers. In 1993 the Supreme Court ruled that employers may be held liable for monetary damages as a result of sexual harassment, even if employees suffer no psychological harm. The reason is simple—sexual harassment is against the law. Broadcast and cable operations may be held responsible for acts of sexual harassment committed by supervisory personnel or its agents even if the company has a written policy forbidding such conduct. Employers can also be held responsible if the conduct in question takes place between employees "when it knew, or should have known, of the conduct, unless it can show that it took immediate and appropriate corrective action" (29 CFR 1604.11 (d)).

Because of the detrimental impact sexual harassment has on the work environment, managers must do their best to prevent harassment from happening in the first place. In short, management must

(1) develop clearly defined policies that define and prohibit sexual harassment, (2) establish a communication program by which all employees are made aware of their rights, and (3) establish procedures for employees to report any violations or abuses of those rights (Pardue, 1992). Additionally, the employer should have a system for promptly investigating complaints, usually with the complainant's permission. Outcomes of the investigation should be properly documented, reported to both parties in question, and retained in case of legal action.

Managers need to recognize that victims of sexual harassment need much courage to come forward and report such conduct. Many acts of sexual harassment are believed to go unreported in the workplace because of embarrassment or fear of retaliation from the employer (Pardue, 1992). Likewise, managers must make sure that all allegations can be substantiated before committing to any action regarding an employee accused of such conduct. Dealing with sexual harassment demands careful, sensitive, and responsible actions on the part of management.

Other Labor Laws Managers need to know about a number of other labor laws. These laws are briefly reviewed in this section of the chapter.

- *Fair Labor Standards Act.* Requires employers to pay the federal minimum wage to employees. This act also addresses overtime compensation. Exempt from the provisions of this act are executive, administrative, and professional personnel, as well as outside salespeople.

- *National Labor Relations Act.* Enacted to establish workers' right to organize and engage in collective bargaining, and to create the National Labor Relations Board.

- *Equal Employment Act.* Prohibits discrimination based on race, color, gender, religion, or national origin in regard to employment. Established the EEOC and amended the Civil Rights Act.

- *Age Discrimination in Employment Act.* Prohibits discrimination with respect to employment for citizens between the ages of 40 and 70.

- *Equal Pay Act.* Guarantees that all employees with similar skills and qualifications will be paid the same wage. Prohibits wage discrimination under similar working conditions.

- *Americans with Disabilities Act.* Targeted to employers with 15 or more employees, prohibits discrimination against qualified individuals with disabilities who seek employment, promotion, compensation, training, and so forth. The law requires employers to provide reasonable accommodations for a disabled employee's needs.

- *Family and Medical Leave Act.* Companies with 50 or more employees must allow employees to take up to 12 weeks of unpaid leave on an annual basis to care for family members (children, parents, or other close relatives). This act requires the employer to hold the employee's job until return from leave of absence, without loss of benefits or seniority.

Laws and regulations relating to employment frequently change. Managers must keep abreast of new laws, amendments, and other modifications and how they will impact the organization.

Labor Issues: Working with Unions

Historically, laborers and employers have not always enjoyed a harmonious working relationship. Unions were initially organized to give workers a representative voice in dealing with management over issues of salary, benefits, and safe working conditions. Today, unions still exist for much the same purpose—to represent workers in negotiations with management and to procure fair and equitable wages and benefits for their members. Unions are funded by membership dues.

One can find many kinds of labor organizations throughout the electronic media. In general, guilds represent creative personnel while unions represent technical and engineering workers. The industry also refers to these distinctions as "above the line" (creative) and "below the line" (craft). Table 6-2 identifies the major trade unions and guilds in the electronic media.

Much union activity centers on the major networks and large markets such as New York, Chicago, and Los Angeles. However, unions may also exist in other areas, allowing employees to join a union or guild if they do not work near a major media center. Production technicians and engineering employees are often members of local unions.

TABLE 6-2

Examples of Unions and Guilds in the Electronic Media

MAJOR UNIONS AND GUILDS	TYPES OF MEMBERS
National Association of Broadcast Employees and Technicians (NABET)	Radio and television station employees in many areas
International Brotherhood of Electrical Workers (IBEW)	Broadcast and cable technicians as well as members in fields outside of electronic media
Communication Workers of America (CWA)	A number of technical employees in the cable and telecommunications industries
International Alliance of Theatrical and Stage Employees (IATSE)	Some radio and television technicians and engineers
American Federation of Television and Radio Artists (AFTRA)	Performers in live or taped radio and television programs and commercials
Screen Actors Guild (SAG)	Performers in motion pictures, television series, and commercials
Directors Guild of America (DGA)	Directors and assistant directors in radio, television, and stage performances
Writers Guild of America (WGA)	Writers for radio and television news, promotion, and continuity; graphic artists; researchers; and editors
American Federation of Musicians (AFM)	Radio and television musicians in live or recorded performances

Management's involvement with unions and guilds focuses mainly on negotiations over economic issues (e.g., wages and benefits) and working conditions (e.g., recognition of the union by management, grievance procedures, and job responsibilities). The heart of the negotiations, the union contract, binds union members and management for a specified period of time.

Collective bargaining describes the process of negotiation between union and management. Normally, each group uses a team of

individuals to handle negotiations. In large markets, a General Manager may be part of the management negotiation team, along with the station's legal counsel and other key members. Both local and national representatives and their attorneys represent the union.

Ideally, negotiations will lead to a new agreement mutually satisfying to both parties. When an agreement is not reached after a certain amount of time has passed, both parties may agree to accept either mediation or arbitration. The differences between mediation and arbitration are simple to understand, although the procedures used are often complex. Though a mediator suggests alternative solutions or proposes new approaches to resolve the conflict, his or her advice is not binding. On the other hand, arbitrators produce final decisions to which both parties must adhere. This is called *binding arbitration*.

Unions and management have an interdependent relationship. Management must recognize the needs of workers regarding wages and working conditions and respect the workers' right to organize. The union must recognize the responsibilities of management and respect management's obligations to its shareholders and the public. By working together in an atmosphere of mutual respect, unions and management can achieve common goals.

Structure, Communication, and Personnel

This final section explores changes in the hierarchical structure within media organizations and examines how these changes impact communication between management and employees.

Historically, media management texts have devoted considerable space to discussing the formal structure of a radio, television, or cable system through the use of a flow chart, similar to the one found in Figure 6-1. The flow chart graphically illustrates the vertical and horizontal relationships among units, workers, and managers, and suggests specific lines of demarcation in terms of duties and responsibilities.

This type of presentation, however, is problematic. Many companies have recognized that hierarchical structures no longer serve the efficient management of organizations. This phenomenon is known as **flattening.** Management consultant and author Tom Peters (1992)

FIGURE 6-1

Example of a Simple Flow Chart

explains that organizational work has evolved this way because of advances in technology, the emergence of a global marketplace for goods and services, and the need for efficiency in operations.

Peters adds that many organizations will resist changing to a more ambiguous and open structure; however, such change will be necessary for survival. Leaner structures, a continuing development and educational program for employees, and a move toward self-generated projects as opposed to departmental tasks are all traits of organizations that have moved beyond hierarchy.

Technology has forced many changes in organizational structure, opening up new lines of communication and interaction between managers and employees. Email has eased divisions between upper-level managers and employees, facilitating information exchange and prompt feedback. Employees with email have instant access to managers without having to arrange formal appointments. Similarly, voice mail, the fax machine, and other communication technologies have opened access between electronic media companies and the public. Information can flow up, down, and sideways in an open structure, virtually eliminating the former top-down flow of communication visualized in flow charts.

Though technology has eased employees' access to management, it will never replace the need for interpersonal relationships (see the discussion of the Hawthorne studies in Chapter 4). Managers still need to take the time to get to know their employees; interact with them during coffee breaks, lunch, and other times; publicly recognize them for their accomplishments; and work to develop a sense of camaraderie among all employees.

Nor will changing and more flexible organizational structures eliminate the need for promoting healthy employee relations by such methods as personal notes, company newsletters, bulletin boards, special recognition, company sports teams, annual picnics, and other traditional activities. Successful managers will integrate people skills and technological access for the benefit of all employees and the organization.

Summary

Employees are the most valuable asset of any organization. In the electronic media, the quality of the personnel directly affects the quality of the organization.

In most organizations personnel management is accomplished through several managers; larger operations may employ a personnel manager or human resources director. Personnel management involves many functions, including recruitment, selection, interviewing, hiring, training, performance reviews, promotion, discipline, and termination. Managing people involves dealing with wages, compensation, benefits, and other employee programs. Companies should provide an employee handbook that explains clearly all policies and procedures pertaining to employment.

Managers need to be familiar with major labor laws, especially those dealing with equal employment opportunities and sexual harassment in the workplace. An understanding of unions is also critical for managers in the electronic media.

Changes in demographic trends and organizational structure will continue to impact the management of personnel. Workers will represent ever more diverse backgrounds and cultures and will require nontraditional schedules. Organizations are transforming from a highly hierarchical structure to one that is more flexible and ambiguous.

Technology has made communication easier. Email and other communication tools have increased employee access to management. Nonetheless, interpersonal skills and traditional communication methods (memos, newsletters, bulletin boards, etc.) will remain important in promoting good employee relations.

CASE STUDY	**Personnel Problems at KMDT-TV**

KMDT-TV is a television station located in a top-30 market. Part of a group ownership of nine stations, KMDT-TV has operated since 1957, having enjoyed a long and successful relationship as a CBS affiliate. You were appointed Vice President and General Manager of KMDT-TV about a year ago.

During the past year you have come to know the employees and the other managers fairly well. Overall you have a good rapport with the station's managerial staff (some 10 members) and you feel good about your relationship with the employees (a total of 45, including both full- and part-time employees).

Following your regular Tuesday morning meeting with the managers, Jane Stovall, the Personnel Manager, asks to speak with you privately in your office. Stovall has been with the station for 6 years in a variety of capacities and in charge of personnel for the past 2 years.

"We have two separate personnel complaints that have come up, and both are serious and need immediate attention," she says. "One of them concerns the Chief Engineer and his lack of sensitivity towards other employees; the other concerns conduct that might be considered sexual harassment."

Stovall presents the available facts of each problem. Otis Wilson, who is Anglo, has been Chief Engineer for over 30 years. Otis is particularly gruff with new people. KMDT's position as a middle-market station has caused a lot of personnel turnover as employees join KMDT and then move up to larger markets. Otis does not deal well with change. Despite being an engineer, he is gregarious and likes to share his off-color jokes loudly with other employees. "The complaint received about Otis concerns the jokes, which often deal with minorities. The complaint said Otis regularly uses phrases such as 'jungle bunnies,' 'spics,' 'slant eyes,' 'jew-babies,' and 'fags.' We have a diverse staff, largely because of your commitment to hiring more women and minorities. In fact, 46 percent of our employees are women, and 24 percent represent various ethnic groups, including African Americans, Latinos, and Asian Americans."

The second problem concerns the Programming Department. "As you know, last week we appointed Bill Campo from our sister station to the position of Assistant Program Director, in line with Mike Hayes's recommendation. Well, it seems that Monica Davis, the programming staff

assistant, is very bitter that she did not get the position, suggesting that Mike passed her over because of a personal relationship that went sour." Puzzled by the comment, you ask what Stovall means.

"About 18 months ago, Mike and his wife were having problems, and they eventually separated. During the separation, Mike and Monica had an affair. Monica was and still is single. As far as I know she has had no other relationships with anyone at the station. In fact, the only reason the Mike and Monica affair became so well known was that they were observed by several staff members hugging and touching one another, and word moved around quickly. The affair soon ended. Mike and his wife later reconciled and began counseling. Monica seemed to take things in stride after the affair ended. Apparently Mike's marriage is holding up pretty well," says Stovall.

"Mike came into my office late yesterday, claiming that Monica is threatening to file a sexual harassment complaint against Mike and the station because she says that during their affair he suggested to her he would help her get a promotion in the department—and now she has been passed over. Mike denies that he ever made any sort of promise to Monica about a promotion during the affair. Further, he said that their affair only lasted about a month, and work was rarely discussed. It is interesting that until now, there has been no problem with either Mike or Monica in working together despite the affair and Mike's reconciliation. I am afraid, though, the fact that Monica is Anglo, Bill is Latino, and Mike is African American could somehow become an issue."

Stovall concludes her report. "Obviously, these matters need to be addressed. Because of the damaging nature of these complaints, we could be faced with two separate legal actions. My feeling is that both problems may be resolved with some decisive action. How do you want to handle these situations?"

As the VP/GM, you need to take action for each of these personnel problems. Offer a specific plan of action. Explain what you will do with each of these personnel matters, and how you will determine if the solutions you propose are working. Justify your responses.

CASE STUDY	DEALING WITH AN EMPLOYEE'S ILLNESS

As the Program Director for KKZZ-FM, Carrie Miller is responsible for the on-air staff and the overall sound of the radio station. KKZZ's afternoon drive personality, Lee Thomas, has been with the station for nearly 3 years and has produced steady and stable numbers.

During the past year, Thomas went through a nasty divorce, which brought about changes in his work habits. He frequently arrived at the station just prior to his 3:00 P.M. shift. Fellow employees found him to be moody at times; some days he would be happy and energetic, other days he would be surly and appear angry.

On Monday, midday announcer Sean Fuller stopped at Carrie's office after his shift. "Carrie, I don't want to talk about other employees, but Lee was in a bad mood when he arrived a few minutes ago. I am pretty sure he has been drinking heavily. And I don't think this is the first time this has happened."

Miller immediately went to the control room to confront Thomas. "Yeah, Carrie, I have been drinking. I am sorry. Guess I have been hitting the bottle pretty heavy lately. I just can't seem to stop."

If you were Miller, how would you handle this situation? Should Thomas be terminated? Does the station have an obligation to help Thomas deal with his drinking problem? What would you suggest?

InfoTrac College Edition

For new information on the topic of personnel management, use InfoTrac College Edition. Use the following terms for subject and keyword searches: personnel management, human relations management, management practices.

Web World

The following Web sites offer detailed information related to personnel management and topics discussed in this chapter:

FCC/EEO rules and regulations (www.fcc.gov/mmb/eeo)

Society for Human Resource Management (www.shrm.org)

Media Human Relations Association (www.shrm.org/mhra)

References for Chapter 6

Hersey, P., & Blanchard, K. H. (1996). *Management of organizational behavior* (7th ed.). Englewood Cliffs, NJ: Prentice Hall.

Howe, P. W. (1991, January–February). The 90's employee. *Broadcast Cable Financial Journal,* pp. 5–6.

Hughes, B. (1989, November–December). Employee discipline. *Broadcast Cable Financial Journal,* pp. 36–40.

Jablin, F. M. (1984). Assimilating new members into organizations. In R. N. Bostrom (Ed.), *Communication Yearbook 8* (pp. 594–626). Newbury Park, CA: Sage.

Kaiser, B. (1990, November–December). Hiring smart. *Broadcast Cable Financial Journal,* pp. 30–31.

Lewin, K. (1951). *Field theory in social science.* New York: Harper & Brothers.

McConnell, B. (2000, April 24). EEOuch! Stations want stay. *Broadcasting & Cable,* p. 19.

Pardue, H. (1989, November–December). Keys to EEO compliance for the broadcaster. *Broadcast Cable Financial Journal,* pp. 30–31.

Pardue, H. (1990, November–December). Legal and practical implications of employee termination. *Broadcast Cable Financial Journal,* pp. 32–33.

Pardue, H. (1992, March–April). Managing the sexual harassment problem. *Broadcast Cable Financial Journal,* pp. 12–13.

Peters, T. (1992). *Liberation management: Necessary disorganization for the nanosecond nineties.* New York: Knopf.

Pinkley, R. L., & Northcraft, G. B. (2000). *Get paid what you're worth.* New York: St. Martin's Press.

Reising, B. (1991, January–February). Tips for successful performance reviews. *Broadcast Cable Financial Journal,* p. 18.

Rollins, B. (1991, January–February). Don't miss the train. *Broadcast Cable Financial Journal,* pp. 8–10.

Sexual Harassment Rule, 29 C.F.R. Sec. 1604.11, Subtitle B, Chapter 14 (Sexual Harassment).

Shoptalk. (2001, January 17). Available online: http://www.tvspy.com/shoptalk.htm [Accessed January 17, 2001].

Wanous, J. P. (1980). *Organizational entry: Recruitment, selection and socialization of newcomers.* Reading, MA: Addison-Wesley.

Understanding Markets and Audiences

In this chapter you will learn

- The product and geographic dimensions that form electronic media markets
- The four types of market structure and their characteristics
- The sources and types of audience research data used by electronic media managers
- Key terminology used in analyzing audience data

All forms of electronic media share the goal of generating audiences. Radio stations use a variety of music and information formats geared to specific demographic groups. The way television stations target audiences depends on many factors, such as the type of station (network affiliate versus independent) and decisions to offer certain types of programming and available types of programming, such as news. Cable channels target specific audiences through programming such as MTV and ESPN and air mass-appeal channels such as TNT and USA. Even telecommunication carriers, such as AT&T, Verizon, and Southwestern Bell (SBC), target specific audiences in providing ancillary services—voice mail, caller ID, Internet access, call waiting, call forwarding, and the like—to supplement local and long-distance services.

To identify potential audiences, electronic media managers need a clear understanding of the markets in which they compete. They must define the markets as well as understand their characteristics or structures. Defining each market also helps managers develop programming, advertising, and branding strategies (see Chapter 9).

This chapter begins with a discussion of how to define a market, with a particular emphasis on media markets and their unique characteristics. After a review of the types of market structures, you will learn how an understanding of these structures helps managers analyze audiences. The next section focuses on the use of research data, in the form of audience demographic and psychographic information. You will find here the terms used in audience analysis along with a discussion of how managers use audience research data.

Defining the Market

In the electronic media, the terms *target market* and *target audiences* are sometimes used interchangeably. Though not exactly synonymous, both terms reflect the goal of reaching a specific type of audience. Specifically, media outlets try to attract enough of an audience to obtain a dominant share of a particular market. But what exactly is a market?

The term *market* is often associated with the study of economics. Economists define a **market** as a place where consumers and sellers interact with one another to determine the price and quantity of the goods produced. A market consists of sellers who provide similar products or services to the same group of buyers. In the electronic media, the sellers are the actual broadcast stations, cable channels, and telecommunication carriers offering their services to buyers, who are consumers or advertisers. The products include programming (content) and other services offered by the sellers.

Markets are also defined geographically. This is especially true for the electronic media, where markets are ranked according to the size of the population served (1–New York, 2–Los Angeles, 3–Chicago, etc.). Though labels for media markets are somewhat arbitrary, major markets are usually ranked 1–50; medium markets, 51–100; and small markets, above 100.

Many electronic media firms operate in a range of product and geographic markets. For example, News Corporation owns the Fox network and several television stations. News Corporation also has interests in cable programming (FXM, Fox News, and Fox Sports), newspaper and magazine publishing, and motion pictures (20th Cen-

tury Fox). A major player in several media markets, News Corporation encounters different competitors in each market, as well as different consumers.

Dual Product Markets

Media firms function in a **dual product market** (Picard, 1989). That is, while media companies produce one product, they participate in separate good and service markets. In the first market, the good may be a radio format, a television program, or a cable channel. The content is targeted to consumers, and consumption is measured in different ways. For instance, some types of media content, such as a premium cable subscription or DVD rentals, require the consumer to make a purchase. TV and radio content is available to anyone with a receiver.

The second market in which many media companies operate involves the selling of advertising. Advertisers, both local and national, seek access to audiences by buying time and space in various forms of media content. As the demand for advertising rises, companies can charge higher prices to increase revenues and profits. On the other hand, a drop in audience ratings or other media usage often causes a decline in advertising expenditures and a reduction in revenues. TV network rating periods, or *sweeps,* as the industry refers to them, are vital in determining advertising revenues. At the national level, each rating point represents millions of dollars. The network that wins a sweeps period (held in February, May, July, and November) will be able to charge more for future advertising than the network that finishes in third or fourth place. Local stations also benefit from a strong performance during the sweeps.

Geographic Markets

In addition to operating in a dual product market, electronic media companies operate in specific areas, or **geographic markets.** Some firms, such as radio, television, and cable networks, operate in a na-

FIGURE 7-1

**Product/Geographic
Market**

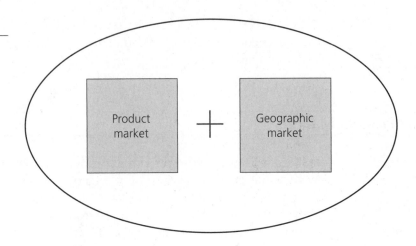

tional market; other companies, such as local radio and television stations, compete in a regional geographical area.

For radio and television stations, the FCC mandates the makeup of each geographical market by granting licenses to specific areas. In the cable industry, local municipalities award franchises that specify limits of operation. In both cases, the potential audience is limited to the geographic boundaries of the market.

Defining a media market involves combining the product and geographic aspects of the market (see Figure 7-1). This process identifies a specific market in which a media firm offers some or all of its products to advertisers or consumers. The number of sellers in a particular market—as well as the extent of the competition among suppliers for buyers—is affected by the characteristics of the market. Economists refer to these characteristics as **market structure.**

Market Structure

Though the structure of a market depends on many factors, several important criteria help identify the type of market structure (Scherer, 1980). These criteria include the concentration of buyers and sellers (producers) in the market, differentiation among products, barriers to entry for new competitors, cost structures, and vertical integration.

Concentration in the Market

The number of producers or sellers in a market explains a great deal about the degree of **concentration** in the market. A market is considered concentrated if revenues are controlled by a limited number of companies. For many years, the big three broadcast networks (ABC, CBS, and NBC) dominated the network television market. As cable television, other video technologies, and new networks (Fox, UPN, and WB) emerged, competition for viewers and advertisers increased.

Though concentration can be measured in various ways, two approaches are common in media industries. One method calculates the share of the market (using ratings data) reached by each competitor. Ratings data provide estimates of the degree of buyer concentration in the market. Highly rated programs attract a larger percentage of the audience, leaving smaller audiences for less popular content. Another method involves calculating the percentage of revenues (sales) controlled by the top four (or eight) firms. This type of measure is known as a *concentration ratio*. A market is considered concentrated if the four-firm ratio is equal to or greater than 50 percent, or if the eight-firm ratio is equal to or greater than 75 percent (Albarran, 1996).

Product Differentiation

Product differentiation refers to perceived differences among products. Because many media products can be substituted for one another, product differentiation is important in the electronic media. To establish such differentiation, radio stations offer unique formats, call letters and logos, on-air personalities, and Web sites. Marketing campaigns and technical facilities also establish differences in the minds of listeners. Television stations attempt to differentiate their local programming, especially in the area of news, from other stations. Broadcast networks and cable services attempt to distinguish themselves through their program offerings.

Barriers to Entry

Barriers to entry are obstacles new sellers must overcome before they can enter a particular market. In the electronic media, barriers often take the form of capital investment. The high-quality equipment, personnel, and programming resources needed to establish or purchase an electronic media facility require a formidable financial investment, in many cases reaching millions of dollars.

Sometimes barriers to entry involve regulatory policy. For example, the 1996 Telecommunications Act limited the number of radio stations a group or individual could own in a local market depending on the number of stations in the market. Further, the Act imposed limitations on the number of stations an owner could hold in a particular class (AM or FM) of stations.

Cost Structures

Cost structures are the costs involved for the production of products in a market. Total costs represent a combination of fixed costs—those needed to produce one unit of a product—and variable costs, such as labor and raw materials, which depend on the quantity produced. Industries with high fixed costs, such as cable television, often lead to concentrated markets. **Economies of scale** refers to the decline in average cost that occurs as additional units of a product are created. Economies of scale are important to businesses in an industry with high fixed cost. In contrast, the costs to establish an Internet Web site are much lower, giving electronic media companies a relatively low-cost distribution outlet for their products and services.

Let's consider the costs associated with producing a newscast for a local TV station. To produce a single evening newscast, the station must commit to the costs of staff, equipment, and other resources. By expanding and repurposing (also known as using the same content in different forms) the news operation to provide additional newscasts (early morning, midday, early, and late news), the average costs to produce each newscast declines, creating economies of scale. News can also be repackaged and streamed over a Web site. The station ob-

tains more local programming with little additional investment beyond that required for a single newscast.

Vertical Integration

Vertical integration occurs when a firm controls multiple aspects of the production, distribution, and exhibition of its products. For example, a movie produced by the Viacom/CBS–owned Paramount film studio eventually will be marketed to home video audiences through Viacom's Blockbuster outlets. The same movie will be scheduled on Viacom's premium services, Showtime and The Movie Channel. The movie may later be shown on the CBS or UPN network, or offered as a package of feature films to other broadcast or cable networks, or even local television stations. The Web site for the film may offer opportunities for merchandising and e-commerce applications. In each case, the company maximizes its revenue through several stages of distribution and exhibition.

One can better understand market structure by analyzing the number of producers and sellers in a market, the difference between products, barriers to entry, cost structures, and vertical integration (Caves, 1992). Four types of market structure have been identified, often referred to collectively as *the theory of the firm* (Litman, 1988).

The Theory of the Firm

The four types of market structure making up the theory of the firm are monopoly, oligopoly, monopolistic competition, and perfect competition. One can present them graphically as a continuum, with monopoly and perfect competition at opposite ends and oligopoly and monopolistic competition occupying interior positions (see Figure 7-2).

In a **monopoly,** a single seller of a product exists and dominates the market. A true monopoly offers no clear substitute for the product; a buyer must purchase the good from the monopolist or forgo the product altogether. Though monopolists establish the price of

FIGURE 7-2

**Four Types of
Market Structure**

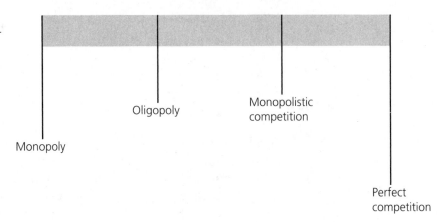

their product, not all buyers may demand the seller's product. If demand is weak, the monopolist will achieve limited market power. Barriers to entry are usually very high in such a structure.

In the electronic media, cable television service has historically represented a monopoly market structure. Many of the franchise agreements between the cable operator and the local government are exclusive arrangements that permit only a single cable operator to offer cable services in a given area. Cable's monopolistic position is threatened by competition from direct broadcast satellite systems and wireless cable operators and by the broadband potential of telephone companies.

As opposed to a monopoly, an **oligopoly** features three or more sellers of a product, which may be either homogeneous or differentiated. A market dominated by a few firms that hold a similar share is considered an oligopoly. Such firms are interdependent; that is, the actions of the leading firm usually affect the others. As such, these firms consider their actions in light of the impact on both the market and their competitors.

Broadcast television stations operate in an oligopoly market structure, as do the networks. Though competition for audiences and advertisers is strong, the product itself is relatively homogenous: situation comedies, dramas, movies, sports, news, talk, and so forth. Barriers to entry are significant in an oligopoly, but less so than in a monopoly. For example, the Fox network successfully entered the national television network market despite the fact that ABC, CBS,

and NBC held dominant positions with audiences, advertisers, and affiliates.

The third type of market structure, **monopolistic competition,** exists when many sellers offer similar products that are not perfect substitutes for one another. Barriers to entry are fewer compared to an oligopoly. Each firm attempts to differentiate its products to the consumer through various methods including advertising, promotion, location, service, and quality.

In a monopolistic competitive structure, price varies, with both the market and the individual firms impacting price decisions. Monopolistic competitive firms often lower prices in an effort to increase revenue. Among the electronic media the radio market resembles a monopolistic competitive structure, as does the market for syndicated television programming—although the former is headed toward more of an oligopoly structure as the industry consolidates.

In **perfect competition** many sellers and a homogeneous product characterize the market. No single firm dominates. Barriers to entry do not exist, and individual companies operate as price takers in that the market establishes the price for the product. There are no current examples of a perfectly competitive market structure in the electronic media.

Other Factors

Two factors that impact media markets and market structure are regulatory policies and general economic conditions in the market. Regarding *regulatory policies,* governmental bodies such as Congress, the courts, and the FCC can impact the structure of media markets through rulings and other actions. As mentioned previously, the 1996 Telecommunications Act reformed a number of rules regarding ownership in the broadcast industries. Increasingly, the Congress and the FCC have become more liberal about the number of media properties a single owner can hold.

Economic conditions refers to a number of economic factors that affect the general business cycle in local geographic markets across the country. As economic conditions fluctuate, they impact con-

sumers as well as businesses, including the electronic media. If the local economy begins to decline, consumers tend to spend more conservatively. If retail sales drop significantly, businesses may be forced to lower the amount of moneys spent on advertising, which in turn causes a drop in potential revenues for electronic media companies. The key economic indicators include the rate of inflation, local employment trends, retail sales, interest rates, measures of effective buying power, housing developments, and changes in tax laws. Periodicals such as the *Wall Street Journal* and *Business Week* help keep managers aware of current economic conditions. Managers also need to monitor the economic conditions of the markets in which they operate and be prepared to adapt to fluctuations in the business cycle.

Because managers must be aware of potential changes in the regulatory environment, most electronic media companies employ Washington attorneys to keep abreast of significant developments. Trade publications, such as *Broadcasting and Cable* and *Electronic Media,* also help managers monitor the evolving regulatory climate in Washington.

Understanding the characteristics of the dual product market and the types of market structure enables electronic media managers to better define the level of competition for the audiences they desire. However, targeting audiences involves more than just analyzing markets and market structure. It involves analyzing and using appropriate audience research data.

Audience Research and Analysis

The proliferation of media channels has led to an increasing reliance on research as a tool in audience analysis. Electronic media managers, programmers, and advertisers all need knowledge of the audience in terms of uses of and preferences for media content, but they also use knowledge of audience needs, motivations, and lifestyle characteristics.

Audience research is an ongoing activity among the electronic media. Radio and television stations need to know which types of programs successfully reach target audiences. Cable companies need to

understand the types of audiences that desire particular types of cable service—basic, expanded, or premium. Radio, TV, and cable advertisers monitor the effectiveness of commercials in selling products.

Managers in the radio, television, and cable industries routinely use three types of data to assist in decision making. **Demographic** research, the most familiar type, presents quantitative information on the media habits of audiences. **Psychographic** research goes beyond numeric information to offer qualitative data on audiences, such as lifestyle and buying patterns. Supplementing demographic and psychographic data, **geodemographic** research considers neighborhood characteristics by zip code.

Demographic Research Data

For many years, demographic research served most of the research needs of broadcast television and cable operators. Demographic research is best represented by audience ratings data, with which one can estimate the number of viewers and listeners in a variety of age and sex categories across different time periods, or **dayparts.** Radio data is normally reported for individuals, while television data is reported in terms of households and demographic groups.

Though age categories reported in demographic data vary, they routinely include the following segments: 2–11 (children), 12–17 (teens), and adult categories of 18–34, 35–54, 18–49, 25–49, 18+, 35+, 50+, and 35–64. When ratings are reported in newspapers and television programs such as *Entertainment Tonight,* only a single audience category (such as adults 18+) is given. Adult categories are also broken down by gender. Such categories allow for analysis of specific groups by program.

Managers use other demographic categories to supplement and expand age and gender breakdowns. Ethnic background has become much more important in recent years because of the growth of ethnic segments in the United States. African American households tend to watch more television than Anglo households (Albarran & Umphrey, 1993; Nielsen, 2000), and Latinos number among the most loyal members of the radio audience (Gerlin, 1993).

Income and education characteristics also help managers target audiences, especially because the two are often correlated. Other demographic data potentially useful in defining audiences are the number of individuals in the household, household ownership status, and occupation. Demographic information is very valuable because it describes the audience and specifies how many people are estimated to be watching or listening to a particular program at a given time.

Psychographic Research Data

Psychographics offer an alternative to demographic information by focusing on consumer and lifestyle characteristics like activities, opinions, interests, values, needs, and personality characteristics. More broadly based than demographic research, psychographic research is more challenging to interpret.

One popular form of psychographic research is VALS, an acronym for values, attitudes, and lifestyles research, developed by SRI Associates. The VALS research is based on an extensive survey instrument designed to gauge changes in individual lifestyles and values over time. VALS groups individuals into one of nine different categories, which range from "Emulators" and "Achievers," representing highly motivated, high-income households, to "Survivors" and "Sustainers," representing those striving to satisfy the basic human needs of food, clothing, and shelter.

Psychographic research involves a range of qualitative approaches. Among the more popular methodologies are focus groups, program testing, and call-out research. In a focus group, a small number of subjects are recruited to discuss a particular topic. A moderator leads the session, which is usually taped for further analysis. Focus groups are widely used in marketing research. In call-out research, a radio station or independent research firm calls households to find individuals in specific demographic groups. If a desired respondent is identified (say men, 18–35), the interviewer will ask the respondent to identify which types of music they would most likely listen to from a series of prerecorded segments. Because of its individual nature, psychographic research takes longer to gather and interpret, although the data often provide a richer source of audience information than quantitative data (Wimmer & Dominick, 2000).

Geodemographic Research

This particular area of research combines demographic and psychographic data with geographical locations or clusters (using postal zip codes and census data) to understand audience tastes and preferences. Developed in the 1970s, geodemographic research is used regularly in advertising and marketing to aim messages and products at specific geographic areas. Companies specializing in geodemographic media research include Claritas and Tapscan. In particular, radio stations use geodemographic information in larger markets to target specific clusters of listeners through the use of direct mailings, call-out research, and remote broadcasts. Good managers will recognize the value of using all three types of research information—demographic, psychographic, and geodemographic—to help them to analyze and target audiences.

Sources of Audience Research Data

Managers can access audience research from several sources. The most widely used sources are national research services. Other sources include industry and trade associations, professional consulting firms, and local research (in-house) departments. A summary of each of these areas follows. (For further information on audience research, see Ferguson, Meyer, and Eastman, 1997, and Wimmer and Dominick, 2000.)

Nielsen Media Research In the television industry, Nielsen Media Research, owned by the Dutch company VNU, offers a variety of services to its clients. The premier television ratings service, Nielsen tracks national viewing through the Nielsen Television Index (NTI). Nielsen also estimates viewing of syndicated programs with Nielsen Syndicated Services (NSS) and home video with the Nielsen Homevideo Index (NHI). The NHI service includes measurement of cable and pay cable services, VCRs, video discs, and other new television technologies (*Nielsen Report on Television*).

FIGURE 7-3

Nielsen Peoplemeter and Keypad

Reprinted by permission of Nielsen Media Research.

Other services include Nielsen New Media Services (NMS), Nielsen Hispanic Television Index (NHTI), and the Nielsen Hispanic Station Index (NHSI). Local television ratings are available through the Nielsen Station Index (NSI), used by television owners and advertising agencies. Nielsen has also moved into measuring Internet audiences, through Nielsen NetRatings.

Nielsen's national data is collected with the Nielsen Peoplemeter, a device that monitors audience viewing using a set-top box and a remote control keypad (see Figure 7-3). Through extensive sampling procedures, Nielsen chooses approximately 5,000 households, called **Nielsen families,** out of the nation's 100.8 million television households. Each individual in the household logs in with the keypad each time he or she watches television. The data collected from the Nielsen families are used in compiling the **overnight** ratings and other reports for subscribers.

Nielsen's local service uses a diary method to collect data. In an increasing number of medium markets, local metered service is also available. The data is especially important during the sweep periods. Every respondent in the household fills out a daily diary of television viewing, usually for a week. The diaries are then mailed to Nielsen,

which compiles the information into a summary report called the Viewers in Profile (VIP) (see Figure 7-4). The Nielsen Metered Market Service (NMMS) provides overnight ratings information to all local clients.

National Research Services for Radio

In the radio industry, local audience ratings come primarily from The Arbitron Company, a subsidiary of Ceridian Corporation. A former television ratings competitor of Nielsen, Arbitron dropped out of television at the end of 1993 to concentrate on radio. Arbitron reports ratings for every radio market in the country at least once a year, with major markets measured as many as 48 weeks out of a year.

Arbitron sends diaries to a carefully selected sample of the audience in each radio market. Respondents log their listening activity for 1 week and then return the diary to Arbitron for analysis. The usable information is compiled into a local market report or book, which is distributed to Arbitron's clients, most of whom are radio station owners, advertising agencies, and radio representative (sales) firms. An example of an Arbitron Local Market Report is found in Figure 7-5.

Arbitron has conducted experiments in the United Kingdom using a new technology known as the Portable People Meter (PPM) to measure radio audiences. The PPM is a passive data-gathering technology that allows a beeper-size device to monitor and record radio listening (see Figure 7-6). The device picks up encoded signals from radio stations, measuring individual time spent listening. At the end of the day, the PPM is placed in the docking station, where the data is downloaded to a central computer. It is then compiled with other data and used to provide ratings analyses. Early results of the technology indicate the PPM has good potential as a research tool but is an expensive technology to develop. Several more tests are planned to determine its feasibility as a new measuring device for radio listening.

The primary competitor to The Arbitron Company for local radio ratings is Strategic Media Research, which in 1992 began offering an alternative service known as AccuRatings. This service uses telephone coincidentals (interviews) rather than audience diaries to gather data, and claims to use larger samples in local markets than Arbitron.

Ratings for the national radio networks are reported in RADAR (Radio's All Dimensional Audience Research) compiled by Statistical

FIGURE 7-4 Sample Page from a Nielsen VIP Report. Reprinted by permission of Nielsen Media Research.

Sample Nielsen VIP Report page for DALLAS-FT. WORTH, TX, Monday 5:30PM – 7:30PM, showing DMA Household Ratings, DMA Ratings for Persons, Women, Men, and Child demographics.

Target Listener Estimates

Persons 12+

	Saturday 7PM-MID				Sunday 6AM-10AM				Sunday 10AM-3PM				Sunday 3PM-7PM				Sunday 7PM-MID			
	AQH (00)	Cume (00)	AQH Rtg	AQH Shr	AQH (00)	Cume (00)	AQH Rtg	AQH Shr	AQH (00)	Cume (00)	AQH Rtg	AQH Shr	AQH (00)	Cume (00)	AQH Rtg	AQH Shr	AQH (00)	Cume (00)	AQH Rtg	AQH Shr
KBFB-FM																				
WI '99	122	356	.3	4.0	27	132	.1	.8	93	390	.2	2.0	77	300	.2	2.1	22	120	.1	1.1
4-Book	118	339	.3	3.8	53	188	.2	1.6	111	430	.3	2.5	73	281	.2	2.0	35	155	.1	1.7
KDGE-FM																				
WI '99	148	628	.4	4.9	44	235	.1	1.3	139	671	.4	3.0	127	612	.3	3.4	91	372	.2	4.7
4-Book	138	598	.4	4.5	48	226	.1	1.5	132	629	.4	3.0	109	488	.3	2.9	80	367	.2	4.0
KDMX-FM																				
WI '99	77	448	.2	2.5	88	340	.2	2.6	155	722	.4	3.4	108	532	.3	2.9	83	383	.2	4.3
4-Book	113	569	.3	3.7	92	380	.2	2.8	172	820	.5	3.9	139	621	.4	3.7	94	421	.2	4.6
KDXX-AM																				
WI '99	35	113	.1	1.2	34	75	.1	1.0	42	95	.1	.9	34	102	.1	.9	21	75	.1	1.1
4-Book	17	59	.1	.6	25	58	.1	.8	36	83	.1	.8	18	48		.5	11	41		.6
KDXX-FM																				
WI '99	7	32		.2	19	57		.6	21	45	.1	.5	15	51		.4	10	31		.5
4-Book	18	59		.6	29	71	.1	.9	22	74	.1	.5	13	48		.4	10	46		.5
KEGL-FM																				
WI '99	170	588	.4	5.6	88	295	.2	2.6	162	629	.4	3.5	241	724	.6	6.4	116	439	.3	6.0
4-Book	181	620	.5	5.9	82	292	.2	2.5	174	639	.5	3.9	187	602	.5	5.0	102	403	.3	5.0
KESS-AM																				
WI '99	21	64	.1	.7	41	114	.1	1.2	57	166	.1	1.2	52	147	.1	1.4	18	64		.9
4-Book	39	119	.1	1.3	47	139	.1	1.4	57	168	.1	1.3	43	116	.1	1.2	25	73	.1	1.2
KFJZ-AM																				
WI '99					* 21	41	.1	.6	10	44		.2	* 22	33	.1	.6				
4-Book	**	**	**	**	18	40	.1	.5	18	56	.1	.4	13	28		.4	**	**	**	**
KGGR-AM																				
WI '99					* 26	44	.1	.8	11	37		.2	* 12	25		.3				
4-Book	**	**	**	**	**	**	**	**	**	**	**	**	**	**	**	**	**	**	**	**
KHCK-FM																				
WI '99	55	165	.1	1.8	33	145	.1	1.0	78	287	.2	1.7	60	212	.2	1.6	31	122	.1	1.6
4-Book	58	182	.1	1.9	25	99	.1	.8	65	208	.2	1.5	46	150	.1	1.2	28	115	.1	1.4
KHKS-FM																				
WI '99	207	938	.5	6.8	145	754	.4	4.3	256	1292	.7	5.6	187	912	.5	5.0	132	750	.3	6.8
4-Book	232	983	.6	7.6	180	705	.5	5.4	296	1315	.8	6.7	262	986	.7	7.1	167	724	.4	8.1
KHVN-AM																				
WI '99	28	77	.1	.9	254	535	.7	7.6	92	379	.2	2.0	102	240	.3	2.7	24	91	.1	1.2
4-Book	18	58		.6	199	488	.5	6.0	118	433	.3	2.7	97	218	.3	2.6	19	79	.1	.9
KKDA-AM																				
WI '99	19	46		.6	77	159	.2	2.3	80	198	.2	1.7	35	87	.1	.9	23	62	.1	1.2
4-Book	19	55		.6	74	159	.2	2.2	75	187	.2	1.7	27	66	.1	.7	14	35		.7
KKDA-FM																				
WI '99	394	1206	1.0	13.0	123	388	.3	3.7	158	647	.4	3.4	278	830	.7	7.4	195	591	.5	10.0
4-Book	357	1089	.9	11.6	167	483	.4	5.0	252	845	.7	5.7	282	788	.8	7.6	233	704	.6	11.4
+KKLF-AM																				
WI '99																				
4-Book	**	**	**	**	**	**	**	**	**	**	**	**	**	**	**	**	**	**	**	**
KLIF-AM																				
WI '99	32	100	.1	1.1	27	119	.1	.8	26	145	.1	.6	23	147	.1	.6	22	100	.1	1.1
4-Book	16	64		.5	46	147	.1	1.4	23	107	.1	.5	18	86	.1	.5	14	61		.7
KKZN-FM																				
WI '99	54	311	.1	1.8	15	81		.4	97	396	.3	2.1	86	337	.2	2.3	43	176	.1	2.2
4-Book	47	256	.1	1.5	27	126	.1	.8	85	368	.2	1.9	66	257	.2	1.8	34	158	.1	1.7

** Station(s) not reported this survey.
* Listener estimates adjusted for reported broadcast schedule.
+ Station(s) changed call letters – see Page 13.
4-Book: Avg. of current and previous 3 surveys.
2-Book: Avg. of most recent 2 surveys.

(continued)

FIGURE 7-5 Sample Pages from an Arbitron Local Market Report. Reprinted by permission of The Arbitron Company.

Target Listener Estimates

Persons 12+

Station / Daypart	Sat 7PM-MID AQH(00)	Cume(00)	AQH Rtg	AQH Shr	Sun 6AM-10AM AQH(00)	Cume(00)	AQH Rtg	AQH Shr	Sun 10AM-3PM AQH(00)	Cume(00)	AQH Rtg	AQH Shr	Sun 3PM-7PM AQH(00)	Cume(00)	AQH Rtg	AQH Shr	Sun 7PM-MID AQH(00)	Cume(00)	AQH Rtg	AQH Shr
+KXZN-FM																				
WI '99	11	11	**	.4	**	**	**	**	**	**	**	**	**	**	**	**	**	**	**	**
4-Book	**	**	**	**	**	**	**	**	**	**	**	**	**	**	**	**	**	**	**	**
KLTY-FM																				
WI '99	90	356	.2	3.0	217	1006	.6	6.5	205	972	.5	4.5	153	474	.4	4.1	84	268	.2	4.3
4-Book	75	328	.2	2.5	195	930	.5	5.9	172	868	.5	3.9	131	488	.4	3.6	63	323	.2	3.1
+KLUV-AM																				
WI '99	12	43		.4	12	53		.4	9	64		.2	12	58		.3	1	8		.1
4-Book	5	20		.2	12	33		.4	15	63		.4	26	67	.1	.7	7	22		.3
KLUV-FM																				
WI '99	97	497	.3	3.2	68	262	.2	2.0	155	701	.4	3.4	137	522	.4	3.7	46	224	.1	2.4
4-Book	93	433	.3	3.0	90	368	.3	2.7	181	725	.5	4.1	174	609	.5	4.7	66	297	.2	3.2
+KMEO-FM KNKI-FM																				
WI '99	26	120	.1	.9	40	150	.1	1.2	65	244	.2	1.4	47	174	.1	1.3	14	81		.7
4-Book	**	**	**	**	**	**	**	**	**	**	**	**	**	**	**	**	**	**	**	**
KOAI-FM																				
WI '99	88	350	.2	2.9	59	187	.2	1.8	138	528	.4	3.0	119	355	.3	3.2	92	234	.2	4.7
4-Book	108	394	.3	3.5	73	266	.2	2.2	159	529	.4	3.6	130	372	.3	3.5	92	301	.2	4.5
KPLX-FM																				
WI '99	102	388	.3	3.4	125	397	.3	3.7	183	567	.5	4.0	135	464	.4	3.6	107	394	.3	5.5
4-Book	100	394	.3	3.3	95	334	.3	2.9	168	561	.5	3.8	140	501	.4	3.8	74	305	.2	3.6
KRBV-FM																				
WI '99	118	384	.3	3.9	156	452	.4	4.6	105	404	.3	2.3	71	214	.2	1.9	43	161	.1	2.2
4-Book	115	343	.3	3.7	150	468	.4	4.5	116	464	.3	2.6	79	237	.2	2.1	78	257	.2	3.8
KRLD-AM																				
WI '99	70	199	.2	2.3	128	520	.3	3.8	115	492	.3	2.5	35	166	.1	.9	23	113	.1	1.2
4-Book	87	261	.2	2.8	143	522	.4	4.3	120	535	.3	2.7	76	271	.2	2.0	55	205	.2	2.7
KRNB-FM																				
WI '99	31	100	.1	1.0	19	69		.6	50	169	.1	1.1	58	121	.2	1.5	17	62		.9
4-Book	45	137	.1	1.5	24	66	.1	.7	36	138	.1	.8	38	106	.1	1.0	31	95	.1	1.5
KSCS-FM																				
WI '99	123	458	.3	4.0	159	630	.4	4.7	261	870	.7	5.7	158	508	.4	4.2	95	371	.2	4.9
4-Book	147	528	.4	4.8	158	562	.4	4.7	247	872	.7	5.6	166	566	.4	4.5	74	329	.2	3.6
KTCK-AM																				
WI '99	12	77		.4	23	135	.1	.7	66	322	.2	1.4	63	277	.2	1.7	16	99		.8
4-Book	14	78		.5	40	151	.1	1.2	74	268	.2	1.7	56	216	.2	1.5	22	103	.1	1.1
KTXQ-FM																				
WI '99	89	342	.2	2.9	73	249	.2	2.2	178	596	.5	3.9	136	362	.4	3.6	59	179	.2	3.0
4-Book	95	377	.2	3.1	51	186	.2	1.6	115	448	.3	2.6	108	358	.3	2.9	60	237	.2	2.9
KVIL-FM																				
WI '99	105	444	.3	3.5	128	475	.3	3.8	186	653	.5	4.1	202	617	.5	5.4	129	441	.3	6.6
4-Book	102	417	.3	3.3	150	529	.4	4.4	228	882	.6	5.2	245	735	.6	6.6	85	358	.2	4.2
KWRD-FM																				
WI '99	1	9			14	81		.4	13	81		.3	4	28		.1	2	9		.1
4-Book	9	27		.3	14	64		.4	7	42		.2	4	19		.1	8	22		.4
KXEB-AM																				
WI '99	9	50		.3	39	159	.1	1.2	70	226	.2	1.5	19	68		.5	2	9		.1
4-Book	**	**	**	**	**	**	**	**	**	**	**	**	**	**	**	**	**	**	**	**
KYNG-FM																				
WI '99	88	361	.2	2.9	106	369	.3	3.2	167	602	.4	3.6	120	419	.3	3.2	66	268	.2	3.4
4-Book	101	391	.3	3.3	80	287	.2	2.4	132	515	.3	3.0	133	428	.4	3.6	71	329	.2	3.5

** Station(s) not reported this survey. * Listener estimates adjusted for reported broadcast schedule. + Station(s) changed call letters – see Page 13. 4-Book: Avg. of current and previous 3 surveys. 2-Book: Avg. of most recent 2 surveys.

FIGURE 7-5 (continued) Reprinted by permission of The Arbitron Company.

Target Listener Estimates – Persons 12+

FIGURE 7-5 (*continued*) Reprinted by permission of The Arbitron Company.

Target Listener Estimates

	Saturday 7PM-MID				Sunday 6AM-10AM				Sunday 10AM-3PM				Sunday 3PM-7PM				Sunday 7PM-MID			
	AQH (00)	Cume (00)	AQH Rtg	AQH Shr	AQH (00)	Cume (00)	AQH Rtg	AQH Shr	AQH (00)	Cume (00)	AQH Rtg	AQH Shr	AQH (00)	Cume (00)	AQH Rtg	AQH Shr	AQH (00)	Cume (00)	AQH Rtg	AQH Shr
KZDF-FM																				
WI '99	10	38		.3	11	18		.3	9	34		.2	6	22		.2	3	6		.2
4-Book	10	28		.3	9	15		.3	12	30		.3	12	27		.3	9	22		.4
KZDL-FM																				
WI '99	6	34		.2	40	100	.1	1.2	31	66	.1	.7	23	48	.1	.6	4	15		.2
4-Book	10	44		.3	20	50		.6	23	63	.1	.5	18	47	.1	.5	9	31		.4
KZMP-AM																				
WI '99	13	28		.4	11	52		.3	25	51	.1	.5	18	37		.5	5	21		.3
4-Book	7	18		.2	12	29		.4	20	38	.1	.4	12	33		.3	5	14		.3
KZPS-FM																				
WI '99	126	509	.3	4.1	83	290	.2	2.5	217	720	.6	4.7	164	591	.4	4.4	74	346	.2	3.8
4-Book	113	445	.3	3.7	63	255	.2	1.9	145	574	.4	3.2	135	529	.4	3.6	63	290	.2	3.1
WBAP-AM																				
WI '99	28	139	.1	.9	179	579	.5	5.3	203	661	.5	4.4	77	294	.2	2.1	19	101		1.0
4-Book	45	183	.1	1.5	181	560	.5	5.4	171	542	.5	3.9	89	279	.3	2.4	29	118	.1	1.4
WRR -FM																				
WI '99	69	310	.2	2.3	56	280	.1	1.7	116	412	.3	2.5	106	384	.3	2.8	60	225	.2	3.1
4-Book	71	322	.2	2.3	59	249	.2	1.8	91	377	.2	2.0	91	318	.3	2.5	56	223	.2	2.8
TOTALS																				
WI '99	3041	9792	8.0		3360	10611	8.8		4590	14668	12.0		3749	10773	9.8		1942	6633	5.1	
4-Book	3073	9481	8.2		3340	10253	8.9		4441	13863	11.8		3713	10486	9.8		2044	6810	5.4	

** Station(s) not reported this survey. * Listener estimates adjusted for reported broadcast schedule. + Station(s) changed call letters – see Page 13. 4-Book: Avg. of current and previous 3 surveys. 2-Book: Avg. of most recent 2 surveys.

FIGURE 7-6

Photo of Arbitron Portable People Meter

Reprinted by permission of The Arbitron Company.

Research Inc. National advertisers and programmers use the RADAR report to determine the audiences of network radio services and nationally syndicated radio programs such as Dr. Laura, Howard Stern, and Rush Limbaugh.

Industry and Trade Associations

Another useful source of audience research data is industry and trade associations. Organizations such as the Radio Advertising Bureau (RAB), Cable Advertising Bureau (CAB), Television Advertising Bureau (TVB), and the Internet Advertising Bureau (IAB) offer many types of audience information. Specifically, each of these associations provides research data to help its members sell advertising.

The National Association of Broadcasters (NAB) provides several research sources for its clients. For instance, it publishes various types of research in the form of books, pamphlets, and reports funded by the NAB Office of Research and Planning. The National Cable Television Association (NCTA) also offers several publications on cable audiences and other industry statistics. Station representative firms such as Interep and Katz, as well as major advertising agencies such as McCann-Erickson and J. Walter Thompson, also provide

audience data. A useful publication for marketing research, *Standard Rate and Data Service* (SRDS), compares advertising rates and other information among various segments of the communication industries.

Consulting Firms

Many companies and individuals provide independent research and consulting. Some offer relatively specialized services, such as Audience Research and Development (AR&D), which focuses on television news. Though usually expensive to retain, professional research and consulting firms offer considerable expertise to their clients. You can find a listing of major research companies serving the electronic media in the annual *Broadcasting and Cable Marketplace* yearbook.

Internal Research Departments

Local or in-house research departments are becoming more common among the electronic media industries, especially in larger media markets. In-house research is generally used in conjunction with services provided by companies such as Nielsen and Arbitron to provide more detailed analyses on specific programs and audiences. Local research efforts can be expanded through joint projects with colleges and universities, often at very reasonable costs.

The increase in the number of individuals with education and training in research methods and data analysis has boosted the creation of local research departments. Research remains a strong growth area for employment in the electronic media industries.

Using Audience Data

Research helps managers identify the specific strengths and weaknesses of their operation, as well as those of their competitors. To make the best use of the many sources of audience research at their disposal, managers must understand ratings terminology and be able to interpret the data.

The two most common terms used in audience research are *rating* and *share*. A **rating** is an estimate of the number of people or households viewing or listening to a particular program, based on

some universal estimate. This universal estimate could be the entire national audience (as in the case of a broadcast network or cable channel) or a sample of a larger population in a local market. Regardless, the universal estimate must be clearly delineated. A common formula for a rating follows:

$$\text{Rating \%} = \frac{\text{Audience (Individuals or Households)}}{\text{Universal Estimate}}$$

Or stated another way:

$$\text{Rating \%} = \frac{\text{Number of Viewers or Listeners}}{\text{Total Viewer or Listener Population}}$$

A single rating point represents 1 percent of the population under examination. If a particular television program has a rating of 10, this means that 10 percent of the population is estimated to have watched the program. A rating of 28 means an estimated 28 percent of the population watched a particular program.

Share differs from a rating in that a share measures the percentage of the viewing or listening audience, based on the actual number of viewers or listeners, such as all television households (called Households Using Television, or **HUT**) or listeners (Persons Using Radio, or **PUR**) at a given time. Shares indicate how well a particular program or station is performing against the competition.

$$\text{Share \%} = \frac{\text{Audience (Individuals or Households)}}{\text{HUT or PUR}}$$

To see the difference between ratings and share, consider the following simple example. A three-station TV market has a population of 10,000 households (HH). A sample of 1,000 HH was used to estimate viewing of the local (6:00 p.m.) newscast. The sample found 200 HH viewing WAAA's newscast, while WBBB's audience comprised 150 HH and WCCC only drew 50 HH. Ratings and shares were calculated as follows.

In this example, the HUT level is derived by adding the number of households for each station together (200 + 150 + 50 = 400). That is, 400 HH out of 1,000 HH were watching television, while the remaining 600 HH or 60 percent were not watching television. Note that the rating and share numbers are usually expressed as whole numbers rather than percentages. Calculating the rating for WAAA

yields .20 (200 / 1,000 = .20), but the percentage is converted to a whole number (.20 × 100) when reported as ratings information.

Ratings are always smaller than corresponding shares because ratings consider the entire population with sets on or off, but shares take into account only the actual households or individuals using a particular medium. As such, share totals will usually equal 100 percent of the available audience; ratings will not. Interpreting the data is simple. For WAAA, a rating of 20 indicates that 20 percent of the total audience watches the WAAA newscast. However, for the time period, WAAA draws 50 percent of all available viewers to its newscast, indicating a strong position in the local news rankings.

Rating and *share* are the two most common terms used to understand audience data. Other terms used in radio estimates include average quarter-hour persons, rating, and share; cume (cumulative) persons and rating; exclusive cume rating; time spent listening; and turnover.

- **Average quarter-hour (AQH) persons** estimates the number of people listening to a radio station for at least 5 minutes in any given quarter hour. An AQH of 15,000 from 6:00 to 10:00 A.M. would mean that a radio station is estimated to reach an average audience of 15,000 persons during any quarter hour in that time period.

- **Average quarter-hour rating** is the AQH persons expressed as a percentage of the total population. Using the previous data, if there are 300,000 potential listeners in the market, then the AQH rating would be 15,000 / 300,000 = 5 percent, or 5 as it is usually reported.

- **Average quarter-hour share** is the AQH persons expressed as a percentage of the total audience actually listening. If there are 150,000 people listening to all radio stations between 6:00 and 10:00 A.M., then the AQH share would be 15,000 / 150,000 = 10%, or 10.

- **Cume persons** represent a radio station's cumulative audience, or the estimated number of individuals reached by a radio station. If cume persons total a given number, then that number of different listeners tuned in for at least 5 consecutive minutes during a given week. High cume persons indicate strong penetration of a market.

- **Cume rating** is an estimate of a station's reach, or the cume persons expressed as a percentage of the total population in a given week.

If there are 60,000 cume persons out of a population of 300,000, the cume rating would be 60,000 / 300,000 = 20 percent, or 20.

- **Exclusive cume rating** is an estimate of the percentage of the total population that listens to only one station over a period of time. For example, if 5,000 out of 60,000 cume persons listened to only one station, the exclusive cume rating would be 5,000 / 60,000 = 8.3 percent, or 8.3. Exclusive cumes estimate audience loyalty.

- **Time spent listening (TSL)** estimates the amount of time the average person listens to radio. To calculate TSL, use the following formula:

$$TSL = \frac{AQH \text{ Persons} \times \text{Number of QH in Time Period}}{\text{Cume Persons}}$$

- **Turnover** is an estimate of how many times the audience completely changes during a particular time period. You calculate turnover with the following formula:

$$Turnover = \frac{\text{Cume Persons}}{\text{AQH Persons}}$$

Ratings information is also used by sales and marketing to calculate other measures in determining advertising placement and effectiveness. These measures include gross rating points (GRP), gross impressions (GI), reach, frequency, cost per thousand (CPM), and cost per point (CPP). These terms and formulas are discussed in more detail in Chapter 9.

Market Terminology

Another set of terms represents the physical market for the radio and television industries. Arbitron and Nielsen both use the terms DMA and Metro to define media markets geographically. These terms are detailed below.

- **Designated Market Area (DMA)** consists of those counties where the heaviest concentration of viewing or listening of stations in the Metro area takes place. Each county can be included in only one DMA. Market rankings by Nielsen and Arbitron are based on the number of households in the DMA and are revised annually.

- **Metro** is the geographical area corresponding to the U.S. Office of Management and Budget's standard metropolitan statistical area (SMSA).

A Word Regarding Samples

Ratings information is obtained by gathering data from a **sample** of the audience or population. Because time and expense prevent gathering information from every member of a population, a sample is used to represent the larger group. Most companies involved in media research use probability or **random sampling** procedures to select a sample, which means every member of the population under study has an equal chance of being selected and represented in the study (Wimmer & Dominick, 2000). With data generated from a random sample, companies can estimate the viewing or listening preferences of a larger population.

Though the random sample is used regularly in audience research, nonprobability samples are often used in areas such as focus groups, auditorium testing, and call-out music research. A nonprobability sample means that not every member of the population under study has an equal chance of being selected, which prevents generalizing the data to a larger population. For more information on different types of samples, consult Wimmer and Dominick (2000).

Standard Error and Confidence Intervals

All ratings are only estimates of audience viewing and listening and are subject to a certain degree of error from sampling procedures (Beville, 1988). Research companies normally refer to this as a standard error or *standard error of the estimate*. Always expressed as a percentage, standard error is directly affected by the size of the sample and must be interpreted within a particular confidence interval, usually 95 percent.

Confidence interval means that 95 out of 100 times one can be sure the results will fall within a certain range. For example, if a television show has a rating of 21, with a standard error of 1.5, this means the true rating in the total population from which the sample was drawn would fall between 20.5 and 22.5 every 95 out of 100

times. Generally speaking, the larger the size of the sample and the more conservative the confidence interval (such as 95 percent or .05), the lower the standard error. Information on standard error and confidence intervals is always clearly explained in a ratings book, usually near the end of the report.

Ratings Accuracy

Managers must be concerned about the accuracy of the audience data to which they subscribe, as well as any research conducted for their facility by a professional research firm or consultant. Research vendors obtain accreditation from the **Electronic Media Ratings Council (EMRC),** an organization of research professionals drawn from several media-related fields. To ensure that the ratings data are accurate and objective, the EMRC examines the methodologies and procedures used in their collection.

If a firm or individual consultants are not a member of the EMRC, managers should take care before contracting research with them. Before hiring firms or individuals to conduct research, managers should check them out through references and other clients. In this regard, knowledge of ratings, research methodologies and procedures, and research terminology is helpful in scrutinizing research firms.

Research is expensive. Nielsen and Arbitron, the leaders in the television and radio industries, charge millions of dollars for their services to clients in major markets. Even smaller scale projects, such as focus group research for local markets or local call-out music research, can run several thousands of dollars per study. In short, managers must compare the cost of research with the benefits derived from the process.

Research Application

Good research can be applied and used in many creative ways. While most research data is naturally tied to programming and sales efforts, research also can be used very effectively in marketing and branding efforts (see Chapter 9).

Research can be misused as well. Inflating or misrepresenting the actual numbers, usually in efforts to secure advertising, is a serious ethical problem as well as grounds for legal action. Managers should stress the importance of using research data accurately and fairly at all times, especially in communication with clients and the general public.

Management must carefully analyze research results and then make decisions on how best to use the data in reaching audiences as well as the advertisers who desire those audiences. Used properly, audience research complements managerial decision making across the electronic media.

Summary

All companies in the electronic media are involved in reaching audiences. Radio, television, and cable attract audiences through different types of programming. Advertisers gain access to these audiences through the purchase of time and space. The interaction of audience members, media outlets, and advertisers forms a market in the electronic media.

The electronic media operate in a dual product as well as a geographical market. While electronic media companies distribute one product (programming), they also sell goods (advertising time) to advertisers. The geographic market is the physical boundary that affects the interaction of buyers and sellers in the market.

The number of buyers and sellers in the market, concentration, product differentiation, barriers to entry, cost structures, and vertical integration constitute the structure of the market. Four models of market structure are monopoly, oligopoly, monopolistic competition, and perfect competition. Regulatory policies and general economic conditions also affect the structure of a market.

In addition to understanding markets and market structure, media managers need to be familiar with different types of audience research data and tools of analysis. To understand audiences, electronic media companies use a combination of demographic, psychographic, and geodemographic data. Audience research data is available from national research services, industry and trade associations, professional firms, and local research departments. Because most types of

research are very expensive, managers must consider costs against perceived benefits.

Managers also need to be familiar with the various ratings terms and formulas. Used effectively, audience research augments managerial decision making involving programming, marketing, and promotional strategies.

CASE STUDY **Acquiring a Station**

Umphrey Broadcasting owns 26 radio stations, mostly in medium-size markets. The company has decided to expand its holdings by targeting stations among current markets for possible acquisition.

You are the manager of WZBR AM/FM, located in a top-40 southeastern market. WZBR-AM plays a traditional country-and-western format that draws audiences ages 50 and older, while the FM station programs a country format featuring more contemporary artists, attracting adults ages 35 through 54. There are seven other AM stations and seven other FM stations, for a total of 16 stations. Under FCC rules, in markets with 15–29 stations, a single owner may operate up to six stations, with a limit of four in the same class. The owners of Umphrey Broadcasting are interested in adding up to three FM stations to their station portfolio.

The owners have asked you to take a good look at the local market, the audience, and FM stations that are possible targets for acquisition. The owners want you to prepare a report on which FM stations Umphrey Broadcasting should consider acquiring, ranking the stations in order of preference.

Use the tables below and the material in this chapter to analyze the market. Be sure to consider such factors as demographic composition of the market and competition from other stations.

Existing Stations: Characteristics from Recent Ratings Report

AM STATIONS	FREQ.	FORMAT	AQH (00)	CUME P (00)	KEY DEMO
WABL	550	Sports Talk	140	410	M 25–54
WCDD	810	Country	45	101	M 50+
WDDG	930	Oldies	55	88	W 35–49
WGRC	1060	C/W	100	330	W 45+
WMMG	1420	Religious	23	51	W 35–49
WSST	1530	Country	33	44	M 45+
WXYV	1610	Gospel	26	47	W 35–54
FM STATIONS					
WABL-FM	92.7	Classic Rock	150	370	M 25–49
WGEO	94.1	Jammin' Oldies	101	350	M 18–35
WGRC-FM	98.7	Country	210	620	W 35–54
WMMG-FM	99.5	CHR	168	490	Teens
WRST	103.9	Soft Rock/AC	60	101	W 18–49
WXYV-FM	104.1	AC	75	100	W 25–34
WXXR	106.7	Spanish	38	67	W 18–34

Market Characteristics

POPULATION ESTIMATES	WOMEN	MEN	TOTAL
Total population	57,500	54,800	112,700
18–34	17,600	16,985	34,585
18–49	21,200	20,750	41,850
25–34	11,000	10,800	21,800
25–49	9,400	9,500	18,900
POPULATION ESTIMATES	**WOMEN**	**MEN**	**TOTAL**
35–54	7,600	7,300	14,900
55+	7,200	4,200	11,600
Teens 12–17	4,000	4,050	8,050
Children 2–11	2,300	2,100	4,300

(continued)

Market Characteristics (*continued*)

ETHNIC COMPOSITION		HIGHEST EDUCATION ACHIEVED	
Anglo	71%	College Graduate/Higher	45%
African American	13%	High School Graduate	69%
Latino	11%	Grade School	91%
Other races	5%		

OCCUPATION		HOUSEHOLD INCOME	
Professional	16%	Above $100,000	9%
White Collar	29%	$60,000–$99,999	16%
Blue Collar	27%	$30,000–$59,999	44%
Service Occupations	23%	Less than $30,000	31%
Unemployed	5%		

InfoTrac College Edition

For new information on the topic of audience research across the electronic media, use InfoTrac College Edition. Use the following terms for subject and keyword searches: audience research, sample, electronic media research, ratings, share, radio research, Internet research.

Web World

Here are some Web sites related to electronic media audience research:
The Arbitron Company (www.arbitron.com)
Nielsen Media Research (www.nielsenmedia.com)
Statistical Research, Inc. (www.sriresearch.com)
Jupiter Media Metrix (www.mediametrix.com)
Strategic Media Research (www.strategicmediaresearch.com)

References for Chapter 7

Albarran, A. B. (1996). *Media economics: Understanding markets, industries and concepts.* Ames, IA: Iowa State University Press.

Albarran, A. B., & Umphrey, D. (1993). An examination of television viewing motivations and program preferences by Hispanics, blacks, and whites. *Journal of Broadcasting and Electronic Media, 37,* 95–103.

Beville, H. M. (1988). *Audience ratings: Radio, television and cable* (2nd ed.). Hillsdale, NJ: Lawrence Erlbaum Associates.

Caves, R. E. (1992). *American industry: Structure, conduct, performance* (8th ed.). Englewood Cliffs, NJ: Prentice Hall.

Eastman, S. T., & Ferguson, D. A. (1997). *Broadcast/cable programming strategies and practices* (5th ed.). Belmont, CA: Wadsworth.

Ferguson, D. A., Meyer, T. P., & Eastman, S. T. (1997). Program and audience research. In S. T. Eastman & D. A. Ferguson, *Broadcast/cable programming: Strategies and practices* (5th ed., pp. 32–65). Belmont, CA: Wadsworth.

Gerlin, A. (1993, July 14). Radio stations gain by going after Hispanics. *The Wall Street Journal,* pp. B1, B8.

Litman, B. R. (1988). Microeconomic foundations. In R. G. Picard, M. McCombs, J. P. Winter, & S. Lacy (Eds.), *Press concentration and monopoly: New perspectives on newspaper ownership and operation* (pp. 3–34). Norwood, NJ: Ablex Publishing Company.

Nielsen Media Research. (2000). *2000 report on television.* New York: Author.

Picard, R. G. (1989). *Media economics.* Beverly Hills, CA: Sage.

Scherer, F. M. (1980). *Industrial market structure and economic performance* (2nd ed.). Chicago: Rand McNally.

Wimmer, R. D., & Dominick, J. R. (2000). *Mass media research: An introduction* (6th ed.). Belmont, CA: Wadsworth.

CHAPTER **8**

Programming: Strategy and Distribution

In this chapter you will learn

- The responsibilities of the program director in an electronic media facility
- Differences in the types of programming and strategies used in the radio, television, cable, and telco industries
- Issues of concern for program managers across the electronic media

Programming is a critical component of successful media management. Radio and television stations would have little attraction without the entertainment and information content they deliver to audiences. Similarly, satellites and cable channels would be meaningless without programming. Like management, programming in the electronic media is an ongoing process, reflecting changes in audience tastes and preferences and in distribution technologies.

The Program Director

The person actually responsible for programming in a radio or television station is the Program Director or Program Manager, a midlevel manager who reports directly to the General Manager. In the cable industry, the title Operations Manager identifies the person responsible for programming the system. In this chapter, the names

Program Director (PD) and *Program Manager* will represent the person responsible for programming across the electronic media.

In most cases, only a few employees work in the programming department. Radio stations in smaller markets may have only a single employee, the actual Program Director, while larger markets may also employ a program assistant. TV stations and cable systems employ an average of two to four people in their programming departments.

Most program directors have several years of experience, as well as a college degree. The paths to programming vary; many programmers have previous experience in a related area such as production or promotion. Program Directors are responsible for many management tasks, the most common of which are the following:

- *Program budgeting.* As discussed in Chapter 5, programming represents a major expense in the electronic media. Program Directors must have skills in creating and administering budgets, amortizing programming, and conducting break-even analysis.

- *Acquisition.* Programming comes from various sources. The PD's job is to acquire programs, usually in consultation with other managers. Programming can be produced internally, acquired from a network or other production company, or acquired in trade or barter. Acquisition involves negotiating with program producers and syndication distributors.

- *Scheduling.* Scheduling is the process of arranging programming to meet strategic goals and objectives. Numerous strategies and considerations are used in scheduling programming, the most important being how well the program will attract audiences and advertisers.

- *Evaluation.* Program managers use different types of research data (see Chapter 7), as well as other feedback, to evaluate programming. Evaluation determines whether or not a radio station will change format or a television show will be moved to another time period or even canceled.

- *Interpersonal skills.* The PD's many responsibilities involve interaction with other managers and station personnel, as well as the public at large. Strong verbal and written communication skills are needed, as well as the ability to work with others.

Because of the structural differences among the radio, television, and cable industries, programming and the strategies used to reach

audiences differ across the electronic media. In the following sections, you will learn about the specific ways each industry programs, beginning with the radio industry.

Radio Programming

Radio stations are commonly identified by the type of format they offer audiences. Popular radio formats across the United States include country, adult contemporary, news/talk, and contemporary hit radio (CHR), and variations of news, talk, and sports. Popular radio formats are listed in Table 8-1.

Selection of a station format should begin with a careful analysis of the marketplace. A good market analysis examines such factors as the number of other radio stations in the market and their formats, ratings of competing stations, demographic characteristics, and retail expenditures. Ultimately, format decisions often take one of two approaches: (1) Stations attempt to capture an existing audience from another station, or (2) stations develop a format to reach an audience not being targeted by a competitor.

Target Existing Audiences Advertisers desire certain types of audiences more than others. In radio, the 18–49 demographic is often desired. If one station has a large share of a key demographic group, such as women 18–49, another

TABLE 8-1

Popular Radio Formats

What are the most listened to radio formats in the United States? While popularity of formats varies from region to region and from one demographic group to another, one benchmark is to look at the share of stations that program a certain format. Listed below are the most popular formats by share of stations based on the most recent available data.

FORMAT	PERCENTAGE OF STATIONS
Country	24.8%
Adult Contemporary	14.4
News/Talk/Sports	13.3
Religious	10.1
Golden Oldies	8.5

NOTE: Adapted from *Communications Industry Forecast, 1999–2003,* by Veronis, Suhler, & Associates, 1999, New York: Author.

station may attempt to draw some female listeners away by using a similar format. Radio audiences tend to be fickle; they rotate stations in much the same way that television viewers do. One challenge in radio programming, besides identifying and targeting an audience, is maintaining that audience.

Develop a Niche An alternative approach to capturing another station's audience is to target an audience not currently being served by an existing station. Niche formats come in many different flavors, ranging from sports talk to ethnic formats on AM to jazz and classical on FM. Niche formats also represent challenges in terms of marketing and promotion; to be successful, niche formats are found most often in large (top-50) markets.

Format Variables In selecting a format, management must consider many other variables. Among the most important are

- *Technical aspects.* From a technical standpoint, FM stations are best suited for music formats, while AM stations tend to emphasize talk and information programming, as well as niche or specialty formats.

- *Local-air staff or satellite distribution.* Formats can be built around local personalities or provided by a syndicated satellite-delivered service, such as one of ABC's 24-hour networks. The PD should weigh the costs and benefits of local talent against those of a satellite service.

- *Commercial matter.* Stations must carefully determine how many minutes will be allocated to the sale of commercial time in both drive and non–drive time periods. Enough time must be provided for the station to meet expenses as well as hold listeners. Most music formats limit commercial matter to 8 to 10 minutes per hour.

- *Marketing and promotion considerations.* A format should have strong marketing and promotion potential, regarding both advertisers and audiences. Today, managers use *branding,* a marketing technique discussed in the next chapter, to help establish an identity for each station. Labels such as "classic rock," "jammin' old-

ies," and "news radio" are used in tandem with station call letters and frequency location to help build brand identity.

- *Wheel or "hot clock."* The PD is responsible for creating the actual format wheel or clock used as an on-air guide by station personalities. The wheel contains various categories of music, all commercial matter, and other programming material such as weather, traffic, and time announcements.

- *News and public affairs programming.* What (if any) will be the station's commitment to providing news and public affairs programming? When and how will these elements be programmed? Such elements help meet the public interest requirement of a licensee.

- *Selection of a network.* Though not required, many radio stations are affiliated with a national network so they can provide news and other program features. Network material is tailored to reflect the station's format and on-air sound. Table 8-2 provides a listing of the major radio networks.

Station management regularly evaluates format variables and modifies them as conditions warrant.

Generally speaking, the greatest concentration of radio listening takes place in the morning drive time hours of 6:00–10:00 A.M. followed by afternoon drive time (3:00–7:00 P.M.). Midday (10:00 A.M. to 3:00 P.M.) ranks third in terms of listeners, followed by nighttime (7:00 P.M. to midnight). Because of this, a radio station's highest-paid personalities are found during the morning hours. Stations build on the success of their morning program to attract audiences throughout the day.

Structurally, the radio industry continues to evolve. As discussed in Chapter 1, the 1996 Telecommunications Act removed all national limits on radio station ownership, leading to the formation of radio clusters in local markets. This has also impacted programming positions in local markets. If a group owner controls the maximum of eight stations in a local market, a single programming department can coordinate the formats across the group's stations. This eliminates the need for a separate PD for each station, saving expenses for the owner.

Another change concerns the anticipated entry of digital-based radio services to compete with AM and FM broadcasting. In 1995, the

TABLE 8-2

Representative National Radio Networks

ABC RADIO NETWORKS
ABC Radio Networks
Prime
Platinum
Genesis
Galaxy
ESPN Radio Network
Radio Disney
INFINITY BROADCASTING CORPORATION
Westwood One
CBS Radio
NBC Radio Network
Fox News Radio
CNN Radio
Metro Networks
CLEAR CHANNEL COMMUNICATIONS, INC.
AMFM Radio Networks
DIGITAL-AUDIO RADIO SERVICES (DARS) NETWORKS[a]
Sirius
XMRadio

[a]DARS services are available through subscription service and not part of over-the-air broadcasting

NOTE: Compiled by the author from various sources.

FCC allocated part of the radio spectrum to a new national satellite-distributed digital audio radio service (DARS). After much debate and planning, DARS services are expected to be offered in 2001 (Albarran & Pitts, 2001).

Though the industry continues to change, radio remains an important medium for audiences and advertisers. Radio is a daily companion for thousands. Advertisers use radio as a cost-efficient medium to supplement other marketing efforts. From a management perspective, radio still generates strong profit margins for stations with clear target audiences and good technical facilities.

Television Programming

To discuss programming in the television industry, one should differentiate between network-affiliated stations and independent stations. Network affiliates enter into contractual agreements with a network. Historically, this relationship has been based on compensation the networks paid affiliates to carry network programs. As programming costs have skyrocketed and audiences continued to decline due to the advent of cable, the nature of compensation has changed dramatically.

Today, a definite trend to end compensation is ongoing between the networks and their affiliates. In some cases, affiliates are now starting to sign long-term agreements with networks in which affiliates pay the network—a practice called **reverse compensation.** Another trend involves affiliates giving back advertising time to the networks in exchange for compensation. It will be interesting to observe how the relationship between networks and affiliates evolves in the coming decade.

Independent stations are those not affiliated with a broadcast network. They generate the bulk of their schedule through syndication, barter (discussed later in the chapter), and local production, such as news.

Program Directors in any kind of station can acquire several types of programming through first-run syndication, off-network syndication, ad hoc networks, and local production. Each of these areas is examined in the following paragraphs.

First-Run Syndication

As the name suggests, **first-run syndication** involves programs offered directly to local television stations, thus bypassing the national broadcast networks. When programs are successful, the penetration rate can quickly exceed 95 percent of all U.S. TVHH. Successful distributors of first-run syndication programming include Paramount (*Entertainment Tonight*), King World (*Wheel of Fortune, Jeopardy, Oprah Winfrey*), and Pearson Television (*Baywatch, Divorce Court*).

First-run syndication is often produced at a lower per-hour cost than network programs because of the high license fees required for the latter. Still, first-run programming contains a lot of risks. Success depends on many factors, including the national penetration of TVHH, marketing and promotion, and audience interest in the series.

Despite these concerns, popular series such as *Baywatch* and *Entertainment Tonight* clearly prove that first-run syndication is an attractive option for programmers.

Off-Network Syndication

Unlike first-run syndication, off-network syndication represents those series that have had a previous run on a network schedule. Ideally, a series should have a minimum of 100–150 episodes prior to entering the syndication marketplace, which allows a local station to run the series on a strip basis (5 days a week) a minimum of two runs per year. Prices for off-network syndication have soared in recent years, with network hits such as *Seinfeld* and *Home Improvement* earning millions in syndication. Popular off-network programs usually attract many bidders in local markets, increasing the costs for a profitable syndication product. Major markets have been known to pay millions of dollars for off-network programs; as market size drops, the cost declines.

Most program producers will finance programs at a deficit in order to get a program on the network schedule, with the hope of eventually recapturing the losses in the syndication marketplace (Von Sootsen, 1997). Situation comedies are the most attractive type of off-network syndication, as evidenced by the success of recent series such as *Seinfeld, Home Improvement, Friends,* and *Frasier.* Sitcoms are popular because of their half-hour format, which can be used in a variety of dayparts. Dramatic programs have found the best opportunities for syndication on cable, as opposed to local television stations, because the programs are longer and can target specific demographic groups cable channels want to reach. *NYPD Blue* and *The X-Files* helped the Fox FX network establish an audience brand, while TNT found success with reruns of *ER.*

Production companies providing first-run and off-network syndication depend heavily on barter in negotiations with local stations and cable networks. **Barter** refers to the practice of a program being acquired for broadcast with some commercial time already packaged in the program. For example, a number of programs are offered in today's program marketplace with one or two minutes of barter time included. The use of barter allows the distributor to be assured of an additional return on the program beyond the license fee. Though the buyer of the series (a TV station or cable channel) gives up some commercial inventory when accepting barter, the practice usually results

in lower programming costs. In most cases, programs must clear approximately 85 percent of all TVHH to make barter advertising successful (Moscow, 2000).

Ad Hoc Networks Programming of interest to a state or region may be produced as part of an **ad hoc network;** an ad hoc network consists of stations that affiliate in order to receive certain programming. For example, college sports events may be found on various regional networks that carry football or basketball games. Telethons, beauty pageants, and an occasional special series or production are other types of programming available through ad hoc networks.

Local Programming Local programming varies from station to station. Most local programming consists of news, sports, children's programming, public affairs programs, and an occasional series or special. In general, network affiliates are the most likely stations to have local news operations, although some leading independent stations also provide news. Local programming can be expensive to produce and, except in the case of news or sports, may not easily attract audiences and advertisers.

Networks and Programming The three major networks (ABC, CBS, and NBC) provide the greatest part of the program schedule of their affiliates—on average, 15 to 18 hours per day. Fox provides approximately 15 hours a week of prime-time programming. UPN, Warner Brothers, and Paxnet offer a limited prime-time schedule to their affiliates.

The increase in the number of networks symbolizes the importance of distribution and economies of scale in delivering television programming. The elimination of the financial interest and syndication rules has allowed the networks to own and distribute more programming. In recent years, many networks have become aligned with major film production companies to provide a continuous source of programming for distribution (ABC–Disney, Fox–20th Century, CBS/UPN/Viacom–Paramount, and WB–Time Warner). The marriage of production studios and networks creates a perfect union: The studios provide the programming (software) to be distributed through the networks (hardware).

Evidence of network ownership or interest in programming is reflected in the annual debut of fall television prime-time program

lineups. For example, in the fall of 2000, of the 37 new programs produced for prime time, 27 were owned or co-owned by one of the networks (Schlosser & McClellan, 2000). The top five producers for the fall 2000 season included 20th Century Fox (19 shows), Warner Brothers (18), Paramount (10), CBS Productions (10), and Disney (9) (Schlosser & McClellan, 2000).

To reach enough of an audience, networks need an affiliate base capable of reaching at least 90 percent or more of all TVHH. As more audience members are reached, the overall costs to produce and distribute programming decline. The networks engage in cooperative behavior, characteristic of an oligopoly market structure (see Litman, 1993). Advertising inventory and prices, compensation agreements, and license fees for programming acquired from production companies reflect areas of conduct agreement among the networks. Television ratings, promotional activities, and program quality represent areas that differentiate networks.

Network Program Strategies Television program managers use many strategies in the placement and scheduling of programming in different dayparts (see Eastman & Ferguson, 1997). In prime time, particular strategies are commonly used. The **lead-in** program strategy simply places the best program at the beginning of the prime-time schedule, in the hope that the audience will remain for other programs. **Hammocking** involves placing a new or weak television program between two established programs, at either the half-hour or the hour interval. The opposite of hammocking, **tent-poling** is a strategy to place a strong program between two new or weaker programs, to generate more of an audience before and after the middle program.

Counterprogramming involves targeting a different audience from that of competitors. On Monday nights in the fall, ABC draws male viewers with *Monday Night Football,* while NBC and CBS counter with programs geared toward women. **Stunting,** a practice usually limited to the sweeps, involves a deviation from the regular schedule. A series may air one or more times a week, feature crossover guests from another series, or be packaged as a movie or special.

These network strategies have been used for decades, although their value has come into question in recent years. With cable television in nearly 70 percent of all TVHH, and VCRs and remote control devices in over 80 percent of all TV households, it is increasingly

difficult to control audience flow. Further, audience members are not necessarily loyal to any particular network; instead, the audience watches specific programs.

Other Network Dayparts Dayparts outside of prime time are very important to the network, especially in terms of revenues. Daytime programming is much cheaper to produce than that of prime time. Further, though advertising rates and audience ratings are lower, the networks still generate strong profits from their daytime schedule. During non-prime-time hours, the networks generally strive for parity; that is, they try to equal one another in terms of audience ratings and affiliate reach (Sedman, 1997).

Overall, non-prime-time network programming consists of the following segments and approximate time periods:

- *Early morning* (7:00 A.M.–9:00 A.M.). This period is normally reserved for morning news and information programs such as *Today* and *Good Morning America*. These programs have fairly wide appeal to adults ages 18–49.

- *Daytime* (10:00 A.M.–4:00 P.M.). This time period features three main types of programming—talk, game shows, and soap operas—all targeting mainly female viewers.

- *Late night* (11:30 P.M.–1:00 A.M.). This has become a fierce battleground as David Letterman and Jay Leno fight for younger audience members (18–35) and *Nightline* attempts to reach older audiences (25–54) who want an alternative to talk shows.

- *Overnight* (1:00 A.M.–7:00 A.M.). This daypart has primarily been programmed by the news divisions as a way to obtain more programming from the expensive news operations, effectively lowering the cost per hour to produce local news.

- *Weekend mornings and afternoons*. Mornings have primarily been devoted to children's programming, although NBC adopted a different strategy in recent years with a push toward programming for young teens. Afternoons have usually been programmed with sports or sports magazine programs. The news departments for the networks carry a number of discussion programs on Sunday mornings; sports programs take over in the afternoon.

Local Affiliate Programming Because they receive the bulk of their schedule from the network, local affiliates actually have very few hours of programming decisions to make. Still, the hours programmed by the local PD are critical in terms of audience ratings and the ability to draw local revenues. The major time periods that local PDs must fill are as follows:

- *Early morning* (6:00 A.M.–7:00 A.M.). Stations may use this time for an early local newscast, children's programming, or religious programming.

- *Morning* (9:00 A.M.–10:00 A.M.). Talk programming has become the norm during this hour, either a syndicated talk show or a locally produced version.

- *Noon* (12:00 P.M.–1:00 P.M.). Stations in medium and large markets will likely program 30–60 minutes of local news in this time period.

- *Early fringe* (4:00 P.M.–8:00 P.M.). The most critical time period for the local station, this daypart encompasses both local and national news and leads into prime-time programming. Depending on market size, news may take up as much as 90–120 minutes of this daypart. Typically 4:00–5:00 P.M. is reserved for talk programming, first-run syndication, or off-network series. The prime access period of 6:30–8:00 P.M. consists of game shows, tabloid news programs, and more talk programs. Court programs became increasingly popular in the late 1990s as an alternative to game and tabloid programs.

- *Late fringe* (11:00 P.M.–11:30 P.M.). Traditional time period for late news or, in some cases, an off-network series.

- *Overnights* (varies). Stations carry a variety of programs overnight. In addition to network offerings, you may find syndicated programming, more talk shows, movies, or even infomercials.

- *Weekends*. Building around the network schedule can be tricky; local stations use movies, sitcoms, locally produced programs, and barter programs to fill in hours between network programs.

Local affiliate programming decisions are often made by the Program Director in conjunction with other department heads, such as sales and news, and the General Manager. In all dayparts, the PD at-

tempts to maximize the size of the audience with the programming and provide a strong lead-in to other shows. To accomplish this challenging task, PDs work several months in advance to acquire programming and to provide enough time for proper promotion and marketing of new material.

Independent Programming and Strategies Independent PDs face far greater obstacles than network PDs in attracting audiences. While the network provides many hours a day for programming, the independent, with fewer financial resources, must generate an entire schedule of programming. Today, most independents try to position themselves with a particular type of programming or counterprogram against network affiliates. Most independent programming consists of a combination of syndicated programs, movies, and sports.

Some independent stations have built a schedule around talk shows. This strategy is referred to as **stacking,** or programming a block of time with the same genre. Stacking can be used effectively with movie packages, situation comedies, and dramatic programs, in addition to talk shows. It can also be used as a counterprogramming tool to attract key demographic groups. For example, an independent may target younger audiences during access time by using a block of programs such as *Saved by the Bell, Sabrina, Full House,* and *Boy Meets World* as an alternative to newscasts offered by network affiliates.

In larger markets, an independent station will often attempt to secure local broadcast rights for professional baseball, basketball, or hockey games. Sports programming can be expensive, and it carries some risk. If the local team does well in the standings, good ratings usually follow; if the team falters, ratings may fall. Periodic labor strikes sour fan interest and create a scramble for programming to fill the time slots.

Some independents also program local news, although many stations have alternatively presented news at an earlier hour than other stations in the market. In the eastern time zone, this may mean offering a local newscast at 10:00 P.M. versus the traditional 11:00 P.M. time for network affiliates.

Independent stations will usually generate far lower ratings than network affiliates, but with a combination of successful positioning and counterprogramming strategies, the independent can usually gen-

erate enough audience to interest advertisers and earn profits. The fate of independent stations is not promising; with seven broadcast networks to choose from, there are now fewer than 100 true independent stations in the United States, down from about 500 in the pre-Fox television era.

Cable Programming

To the consumer, cable television is a series of services available at different **tiers** and prices. Basic cable service normally consists of local broadcast channels; public access, educational, and governmental (PEG) channels; and a limited number of cable networks. An expanded tier features many popular cable services, such as ESPN, CNN, MTV, Nickelodeon, USA, and TNT. The top cable networks are listed in Table 8-3. Premium services, such as HBO and Showtime, are individually priced on a monthly basis. Pay-per-view programming involves paying for material per event; popular genres include championship boxing, wrestling marathons, movies, and special events.

It should be noted that all of the cable programming services discussed in this section are also provided by other multichannel carriers, such as DBS carriers, MMDS and SMATV operators, and telephone companies. Because cable is the dominant distributor with nearly 70 percent of all households subscribing to cable, that term is used to describe the programming in a multichannel environment.

Programming in cable differs from that in broadcast television. At the system level, the PD negotiates with individual cable networks for system carriage, then arranges the various tiers of service offered to the public. Cable systems normally pay each network a set fee per subscriber (usually in cents) to carry the programming. Fees vary across systems and depend on the services obtained. Local system PDs must also allocate shelf space for local program services, PEG channels, and local origination channels as needed or required by the franchise agreement.

At the cable network level, programming decisions are made much in the same way as at a broadcast network, save for one key difference. Some cable networks are known for mass appeal programming (e.g., TBS, USA, and TNT) while other services are targeted

TABLE 8-3

Top Cable Networks, Ranked by Number of Subscribers (in millions)

TBS Superstation	78
Discovery Channel	77.4
USA Network	77.18
ESPN	77.11
C-SPAN (Cable Satellite Public Affairs Network)	77
CNN (Cable News Network)	77
TNT (Turner Network Television)	76.8
Nickelodeon/Nick at Nite	76
FOX Family Channel	75.7
Lifetime Television (LIFE)	75
TNN (Nashville Network)	75
A&E Television Networks (A&E)	75
The Weather Channel	74
MTV: Music Television	73.2
CNN Headline News	72.4
QVC	72.1
The Learning Channel (TLC)	72
CNBC	71
AMC (American Movie Classics)	71
VH1 (Music First)	68.3

NOTE: From Cable Television Developments, available online at www.ncta.com

toward various niches and smaller audience segments (e.g., Home and Garden Channel, Food Network, and The History Channel). Cable networks will put their strongest programming in prime time but will also look at counterprogramming opportunities and positioning strategies against the broadcast networks. For example, HBO offers several original series (*The Sopranos, Sex and the City,* and *Arli$$*) as part of its channel lineup. ESPN has obtained rights to several professional sports events. CNN programs *Larry King Live* every weeknight at 9:00. Programming strategies vary by cable network and type of service (advertiser supported, premium, or pay-per-view).

The proliferation of cable services has created a tremendous need for new and recycled programming. For example, mass appeal channels such as USA and TBS use a variety of off-network syndication programs to fill their schedule. Channels geared toward specific audiences have also generated demand for programming. ESPN and ESPN2 feature programming dealing with subjects such as personal health and fitness, fishing, auto racing, and running.

Cable networks also have a strong presence in the international market. A number of programming brands have extended into inter-

national markets. MTV has been very successful offering global versions of music television targeted to young audiences in Europe, Asia, and Latin America. CNBC has successfully launched European and Asian extensions of its business news services. CNN's launch of CNN International has helped establish the network as the world's most recognized news service.

Management Issues in Programming

An examination of programming in the radio, television, and cable industries illustrates the common concerns shared by program managers in acquiring, scheduling, and evaluating program content. These concerns about the future are discussed in the following sections.

Intense Competition for Audiences

Today audiences have many choices for both listening and viewing, consisting of traditional delivery systems (e.g., broadcasting and cable) and new delivery systems (e.g., DBS, wireless, and Internet). Audience shares will continue to fragment as new competitors emerge. In both radio and television, a range of new services, the majority of which will be digitally based, will lead to more programming options. Given this increasingly competitive environment, electronic media managers will have a tougher job maintaining existing market share.

Demand for More Research

So managers can better understand the audiences they serve, increasing emphasis is being placed on audience research. Audience fragmentation is increasing, necessitating data more detailed than just demographic ratings and shares. More lifestyle and psychographic research (see Chapter 7) will be needed to pinpoint specific attributes of the audiences served by individual programs. This will not only provide better efficiency for advertisers but also better targeting and program strategies.

Brand Development and Brand Extension

Audiences tend to watch programs, as opposed to watching channels. Programs that attract and hold audiences become recognizable brands for the networks on which they are distributed. All programmers are interested in building brand recognition for their programs, in extending those brands into other dayparts and in finding other opportunities to build audiences.

Rising Costs of Programming

High-quality programming is expensive to produce and distribute. All PDs share a concern about maintaining and controlling the costs of programming, both local and national. As costs increase, programming bears greater pressure to generate profits. This pressure is a common concern for local news operations, which often fail to produce enough revenue to cover their expenses.

One reason why reality programs, talk shows, and newsmagazines became more common television fare during the 1990s is that they are relatively cheap to produce, compared with sitcoms or dramas. In the radio industry, satellite music channels can often be acquired at a lower cost than employing an entire on-air staff. However, fees for sporting rights continue to rise. In general, increasing programming costs represents an area of common concern.

Regulatory Concerns

Regulators continue to express concern over certain types of media content, particularly programs featuring sexual and violent content. The introduction of the "V-Chip" technology, a provision of the 1996 Telecommunications Act, has been delayed for a number of political and logistical reasons. Voluntary program ratings have met with controversy as well, with NBC still refusing to rate its primetime programs.

Tragic school shootings in Arkansas, Washington, and Colorado and their resultant news coverage raised questions regarding journalistic standards and practices, ethics, and concerns over media content. Many critics feel television broadcasters have failed to live up to the programming requirements of the 1990 Children's Television Act. With the advent of digital channels near, policymakers and broadcasters have debated public interest requirements for television in a digital world.

Because of its pervasive nature, programming will continue to be scrutinized by the public and by politicians. Managers must be cognizant of the programming provided by their operations and ideally maintain the community's interests and needs at all times.

Utilization of the Internet

As the Internet continues to evolve, many questions are unanswered regarding how the audience may eventually use the Internet to receive programming. With both audio and video streaming technologies, audiences can receive programming now via the Web. But the limitations on bandwidth and modem speed, along with the limited size

of the screen for video programming, are major obstacles to wider adoption.

Interactive television is fast becoming a reality, blending the features of the Internet with traditional programming (see Chapter 12). But will consumers want to use a combination PC/TV device, or will they prefer to have two separate appliances—the computer and the television? The next several years will involve a great deal of trial and error, along with research, to better understand audience needs and wants and how best to adapt programming to meet those needs.

Programmers all agree that the Internet is changing how consumers ultimately access programming. But history demonstrates that as new forms of communication technologies are introduced to consumers, the "old" media find ways to adapt and coexist. For the near future, broadcasting and cable will continue to be the primary platforms most consumers choose to access media content.

Summary

Programming is vital to the success of an electronic media facility. The Program Director plays a major role by acquiring, scheduling, and evaluating programming in consultation with the General Manager and other department heads.

Among the electronic media, programming strategies differ. Radio stations build their programming around a specific format or type of presentation in combination with other programming elements. FM stations tend to be more music oriented while AM stations offer more information and niche formats.

Broadcast television programming consists of network programs, first-run syndication, off-network syndication, ad hoc networks, and local programming. Network affiliates program only a few hours a day, while independents must organize an entire schedule. Affiliates try to maintain audience flow between network offerings; independent stations use positioning and counterprogramming strategies to gain market share.

Cable and multichannel programming occurs on two levels. At the system level, the operator arranges programming among various tiers of service, using a combination of broadcast channels, cable networks, PEG channels, and local origination channels. Basic, expanded, premium, and pay-per-view are the typical tiers of many

cable systems. At the national level, cable networks tend to position themselves as either a mass appeal service or a niche service, targeting specific audiences.

Across the electronic media, program managers face similar concerns. Increasing competition means smaller audiences for many services and a greater reliance on accurate and improved research data. Rising programming expenses represent another area of concern, along with the possibility of future governmental regulation of programming. All programmers are wrestling with the challenges brought by the Internet and the opportunities it provides for increased program distribution and marketing.

| CASE STUDY | **Morning Drive: Local Talent or Syndication?** |

Shaun Stevens, Program Director of WKCQ-FM, a classic rock station (one of 15 stations) in a medium-size market (rank = 47), was faced with a difficult programming decision. Market consolidation had reduced the number of station owners in the market to four, with his station the only one maintaining a local ownership presence. For years WKCQ had retained a strong audience in the market, much of its success due to a stable staff of air personalities, among them morning man "Jumbo" Jim Elliott.

Elliott's numbers had started to slip the past couple of books, and while he still led in the important 18–49 female demographic, other demos were on the decline. Elliott had surprised Stevens the week before by announcing he was leaving the station to take an on-air position with a larger company in a top-25 market.

Replacing Elliott with an existing staff member was not an option as far as Stevens was concerned. While the rest of the staff were good, they were better suited to their respective time periods. Replacing Elliott would be a challenge, not only in finding the right personality, but also in attracting someone with the salary limitations imposed by the station's owner.

For the past couple of years at various radio trade shows and through the mail, Stevens had collected information on the growing number of syndicated morning radio programs. Going with a syndicated morning program had several advantages—and disadvantages.

A syndicated show would bring a professional sound to the station at an affordable price. It would be cheaper than hiring a new morning talent. There were some very good personalities offering a classic rock show via

syndication, and with no other syndicated morning shows in the market, Stevens felt he could build on the opportunity.

But going with the syndicated program would mean giving up local control. Yes, it was still possible to provide local news, weather, and traffic inserts, but the sound of the 4-hour morning shift would definitely not reflect the local community. Further, there was no guarantee the syndicated program—or a local replacement—could match or exceed Jumbo Elliott's numbers in morning drive.

Take the role of Shaun Stevens in this case. Consider the implications of staying with local talent versus adopting a syndicated program. Analyze the issues involved and render your decision.

CASE STUDY | ## Independent to Network Affiliate

KLWT-TV, channel 29, began operation in the Pacific Northwest during the late 1960s as an independent television station. The station's signal reached an estimated 135,000 TVHH. The market was predominantly Anglo, with a median household income of $31,000. The area was primarily rural, with forestry and agriculture the primary drivers of the economy. KLWT's transmitter was about 100 miles from the nearest "large" market, with little media competition save a suburban newspaper and three radio stations that served the region.

When the Fox Television network debuted in the 1980s, management had considered becoming part of the new network but passed at the opportunity. KLWT was primarily known for showcasing movies on its schedule, along with several older, off-network programs. The station carried no first-run syndication products or news.

The station's owners, Great Pines Broadcasting, had received several offers to sell the station since 1994, but the family-owned station did not want to sell. With programming costs continuing to rise, profit margins at the station began to shrink as more and more financial resources were allocated to prime time. After months of lobbying, Dan Byers, the station's Program Manager, convinced upper management it was time for KLWT to pursue network affiliation, which would provide a much needed prime-time schedule and allow the station to spend more money on other dayparts.

Byers had the luxury of selecting among three networks (UPN, WB, and Pax) for affiliation. In 1995, UPN and the WB network began operation, and in 1999, Paxson Communications started Pax Net, the seventh national

broadcast network. All three were interested in affiliating with KLWT. None of the three nets were offering any compensation, but they were providing much needed programming and an affiliate presence.

Byers faced two distinct challenges. The first was to recommend to management which of the three networks to affiliate with. The second challenge was to determine the best strategy for building a hybrid independent-network programming strategy with KLWT-TV.

Take the role of Byers, and conduct an analysis of the programming currently offered by UPN, WB, and Pax Net. Make a recommendation as to which network would be the best choice for affiliation. Next, develop a weekday daytime schedule in conjunction with the planned network prime-time lineup. Think about what audience strategies you could use to help maximize audience flow and build the station's profit margins.

CASE STUDY ## A Cable Programming Dilemma

Cathy Washburn serves as Operations Manager for Metro Cable in a Southeastern medium market with a population of 230,000 TVHH. Metro Cable was established in 1973 and currently has a 52 percent subscriber rate. Metro's physical plant is undergoing an upgrade to digital, which will take nearly 2 years to complete. Until the upgrade is finished, the system is programming its full capacity of 75 channels. Once the upgrade is in place, the system will offer over 300 channels, cable modem service, and other features.

In recent months, more and more new cable channels have debuted, causing a number of lineup changes that please some consumers and anger others. With over 220 available channels to draw from, Washburn has the challenge of deciding which services to offer on Metro's limited tiers.

DBS competition is new to the market but is already making a mark on Metro's leadership position. The DBS service offers subscribers up to 200 channels, along with Internet service and a number of special programming packages, mostly involving professional sports.

Walt Connell, the system General Manager, has asked Washburn to rethink the basic and expanded tiers of service and propose a new program lineup that will carry the system through the remainder of the upgrade period. "Remember, we have to keep eight channels on the basic lineup for the local TV signals and the public access channel. We also must keep our four premium services (HBO, Starz, Showtime, and Cinemax) and three PPV

movie channels, as they provide small but important revenues. That leaves us with 60 channels. Give me a proposal as to which channels you feel we should keep on the lineup at this time, recognizing we need to offer programming for a wide range of demographics and also to keep the customers from jumping to DBS."

Taking the role of Washburn, develop two tiers of service for the Metro customers. To obtain a comprehensive list of potential cable channel listings, consult the National Cable Television Association's Web site at http://www.ncta.com, as well as trade publications and local newspaper listings. Be prepared to explain why you chose certain services over others in establishing your system's programming.

 ## InfoTrac College Edition

For new information on the topic of programming across the electronic media, use InfoTrac College Edition. Use the following terms for subject and keyword searches: radio, television, programming, networks, cable television, satellites, syndication.

 ## Web World

Virtually all major programs, networks, producers, and distributors have Web sites. Here is a representative sample:

Broadcast TV and Radio Networks
ABC (www.abc.com)
CBS (www.cbs.com)
Fox (www.fox.com)
NBC (www.nbc.com)
ABC Radio Networks (www.abcradio.com)
Westwood One (www.westwoodone.com)

Cable Networks
MTV (www.mtv.com)
CNN (www.cnn.com)
ESPN (www.espn.com)
Discovery Channel (www.discovery.com)

Producers/Distributors
Viacom (www.viacom.com)

Industry Associations
National Association of Television Program Executives (www.natpe.com)
National Association of Broadcasters (www.nab.org)

References for Chapter 8

Albarran, A. B., & Pitts, G. G. (2001). *The radio broadcasting industry.* Boston: Allyn & Bacon Publishers.

Eastman, S. T., & Ferguson, D. A. (1997). *Broadcast/cable programming strategies and practices* (5th ed.). Belmont, CA: Wadsworth.

Litman, B. R. (1993). Role of TV networks. In A. Alexander, J. Owers, & R. Carveth (Eds.), *Media economics: Theory and practice* (pp. 225–244). New York: Lawrence Erlbaum Associates.

Moscow, S. (2000, January). Remarks at 2000 NATPE Educational Foundation luncheon, New Orleans, Louisiana.

NCTA cable television developments. Available online at http://www.ncta.com (accessed May 20, 2000).

Schlosser, J., & McClellan, S. (2000, May 22). Moneyphilia. *Broadcasting & Cable,* 16–20.

Sedman, D. (1997). Nonprime-time network television programming. In S. T. Eastman & D. A. Ferguson (Eds.), *Broadcast/cable programming strategies and practices* (5th ed., pp. 140–164). Belmont, CA: Wadsworth.

Veronis, Suhler, & Associates. (1999). *Communications industry forecast, 1999–2003.* New York: Author.

Von Sootsen, J. (1997). Domestic syndication. In S. T. Eastman & D. A. Ferguson (Eds.), *Broadcast/cable programming strategies and practices* (5th ed., pp. 66–96). Belmont, CA: Wadsworth.

Marketing

In this chapter you will learn

- The role marketing plays in the electronic media and the parties responsible for marketing
- Basic marketing strategies of segmentation, positioning, and branding
- The different types of advertising and their importance to the electronic media industries
- Terminology used in evaluating media advertising
- How promotion is used in marketing and the different types of promotion found in the electronic media

Electronic media companies are constantly engaged in marketing to different types of audiences, advertisers, agencies, representative firms, and suppliers. In Chapter 1 marketing was introduced as an essential skill needed by electronic media managers. As a business concept, marketing can be thought of as the ability of organizations to serve consumers' needs and wants for specific products (Ries & Trout, 1986a).

A business that understands the importance of marketing has two related goals: to generate new customers and to serve current ones. To accomplish these goals, businesses must be able to earn profits to stay in business. For successful marketing to occur, companies must be internally organized around common goals and objectives (Warner & Buchman, 1991). Marketing efforts follow the traditional

four Ps of marketing: product, price, place, and promotion, discussed in the following paragraphs.

The Four Ps of Marketing

The **product** consists of the actual good produced for customers, as well as the packaging of the product. Consumer research helps companies identify the types of products to offer. In the electronic media, test audiences regularly evaluate programming (the product) before it is scheduled to air. The success or popularity of a program is assessed after a broadcast through the use of audience ratings (see Chapter 7). Products change over time as audience needs change, affecting program genres. Reality programs were popular in the 1990s, but they lost favor with the audience. With the success of ABC's *Who Wants to Be a Millionaire?*, the prime-time game show genre experienced a revival beginning in 1999. The CBS program *Survivor* ushered in a new type of reality show.

Because it directly impacts the sale of a product, **price** is an important consideration in marketing. If two products are similar but one is priced much higher, most customers will purchase the other product. In the electronic media, managers make pricing decisions regarding advertising sales and rates for services such as cable television. Pricing decisions affect competitors, who must consider what price to charge in light of other prices available in the market.

Place is both the physical location at which the product is actually sold and the steps taken to distribute the product. Some manufacturers sell products directly to customers, while others distribute their goods through wholesalers and retailers. Decisions about place affect marketing strategy. For instance, broadcasting and cable represent traditional distribution vehicles. The Internet, wireless devices, and direct-to-home satellite dishes offer alternative ways to distribute programming to customers.

Promotion is a combination of activities that promote both awareness among consumers and the actual selling of products. Advertising is a major part of promotion. The electronic media serve the needs of many businesses by offering access to audiences through the sale of advertising. In turn, the electronic media use on-air promotion and their Web sites as well as advertising in other media (e.g., news-

papers, billboards, or transit media) to attract audiences to their programming (product).

Personnel in Electronic Media Marketing

Who is responsible for marketing in an electronic media facility? Most marketing tasks are coordinated across two units—sales and promotions—run by several individuals. The General Sales Manager (GSM), a midlevel manager, usually supervises the sales department. In some companies, other managers assigned to specific areas, such as a Local Sales Manager (LSM) and a National Sales Manager (NSM), assist the GSM. Each area has its own staff. The sales department serves primarily to market the station to potential advertising clients at the local, regional, and national levels.

A single midlevel manager supervises the promotions or creative services department. Larger operations may also employ an assistant manager. The size of the promotions staff varies with the size of the market; the larger the market, the larger the promotions staff. The promotions department is responsible for marketing the electronic media facility to audiences. Promotional staffs have increased in recent years with the emergence of the Internet as a marketing tool.

The sales and promotions managers work closely with the GM, programming (TV/radio stations), and operations (cable systems) departments to coordinate and manage all marketing activities. Because each area tends to overemphasize the importance of its individual unit, conflicts often arise, particularly between sales and programming. For example, programmers are quick to point out that it is programs that draw audiences, which in turn attract advertisers. Sales argues that advertising generates most of the revenues that pay for programs, salaries, and operations. In reality, the two units are interdependent and must therefore work together to benefit the organization.

Marketing involves a wide range of managerial responsibilities: strategic planning, targeting of specific audiences, design of advertising and promotional campaigns, and extending the organization's brand. According to Ries and Trout (1986a), marketing is a form of warfare, requiring participants to recognize opponents' strengths and weaknesses in order to successfully exploit or defend against them. In

the electronic media, the success of the warfare is usually measured in terms of audience ratings and market share.

Marketing Strategies

Successful marketing is a product of carefully planned strategies. Marketing-oriented electronic media companies may adopt many strategies. In this section, you will learn the three most common strategies used by businesses to market their products—segmentation, positioning, and branding—and their application to the electronic media.

Segmentation

Segmentation strategies target individual market segments (audiences). The goal of segmentation is to identify segments of the market not currently served and develop products to meet their needs. To be effective, the segment must be measurable, large enough to be profitable, and reachable (Runyon, 1980).

The electronic media provide many examples of segmentation strategies. In radio, ethnic formats can reach sizable segments not served by other competitors in large markets, particularly for stations targeting Latinos or African Americans (Brandes, 1995; Gerlin, 1993). Several cable channels have built on segmentation by airing channels such as MTV (teens/young adults), Univision (Latinos), BET (African Americans), and Lifetime and Oxygen (women).

Database marketing has refined segmentation strategies. Electronic media companies increasingly use database marketing to reach specific audiences (Scott, 1995). Database marketing involves building files of computerized information on audience members, then accessing the information as different needs warrant. One can compile the actual information in the database from various promotional activities or other means, and then supplement it with other databases such as population and demographic data.

Using database marketing in conjunction with the Internet, advertisers and electronic media firms can now better pinpoint and target consumers who use particular products and channels. With increasing channel capacity and distribution methods, segmentation strategies can become even more refined, leading to personalized mar-

keting and advertising messages. This is already happening with the development of "personal" radio available through the Internet (Albarran & Pitts, 2001). As interactive television diffuses, there is great potential for individualized messages via the PC/TV combination platform (Yang, 2000).

Positioning One of the most influential marketing strategies of the past 30 years, **positioning** is defined by Ries and Trout (1986b) as "what you do in the mind of the prospect" (p. 2). In other words, the product must be presented to consumers clearly. The authors contend that people are saturated with too many messages, limiting their ability to accurately recall information. Being the leader is important. Ries and Trout explain that people remember who is in first place, but often forget who is in second or third.

For electronic media organizations, positioning builds on a clear identity (brand) in the marketplace and establishes differences from competitors. In the electronic media, companies quickly embrace whatever top position they can, such as for certain demographic groups, whenever new ratings for radio and television stations are released. For example, Fox promoted a competitive advantage over the big three networks in its early years by successfully positioning itself as the network for young adults. ESPN has positioned itself as a leader in sports programming. CNN is widely recognized as a global news leader.

Positioning in the electronic media requires an objective analysis of many factors. Warner and Buchman (1991) suggest that positioning analysis should consider the market, the number of competitors and their marketing strategies, and a thorough internal analysis of all areas of station or system operation.

Branding Another way to describe a product's image in the marketplace, **branding** differentiates products, goods, and services (Murphy, 1987). In branding, both tangible and intangible values work together to create an image of a product in the mind of the consumer. For instance, many people do not think in terms of soap when they need to do laundry. Instead, they may think of products such as Tide, Cheer, or All. Any of the products will clean their laundry, yet most people would differentiate the quality of each product based simply on its brand name.

Branding triggers both emotive and rational responses in people. Brand image is influenced by many factors, including the product, packaging, name, price, advertising and promotion, and the method of distribution. To establish an effective brand image, managers must consider ways to make all these aspects work together.

Think for a minute how electronic media companies use branding. Radio stations identify their formats with phrases like "classic rock" and "jammin' oldies." Television stations use branding to distinguish their style of newscasts (Eyewitness News, Action News) and other programs. Cable services such as MTV, USA, TNT, and ESPN use distinctive logos and styles of presentation to create a brand for their channels. Branding is an important part of any marketing strategy.

The marketing strategies presented in this section—segmentation, positioning, and branding—form the basis of a complete marketing plan in any business. Segmentation requires analyzing a market to identify underserved audiences, while positioning fills audiences' needs. Branding establishes unique selling points for the audience to differentiate one entity from its competitors.

Sales versus Marketing

Electronic media companies have moved away from simply selling advertising time to clients. As competition for audiences has escalated, electronic media firms have recognized the need to emphasize marketing in order to attract advertising dollars. Therefore, before proceeding, you may find it helpful to learn the differences between sales and marketing.

Expanding Selling to Marketing

Until the 1970s, electronic media companies concentrated most of their efforts on selling advertising time to clients. Time was sold in 30- or 60-second units or as sponsorship of an entire program. Because there were relatively few choices, programs attracted larger shares of the audience, and advertisers eagerly purchased time.

As the number of stations and channels grew, competition for audiences intensified. Broadcasters could no longer just sell advertising time to waiting clients. To maintain a competitive position,

companies had to shift from a sales-oriented to a marketing-oriented philosophy.

Each industry established its own advertising bureau to help local stations and cable systems market themselves. The Radio Advertising Bureau (RAB), the Television Bureau of Advertising (TVB), the Cable Advertising Bureau (CAB), and the Internet Advertising Bureau (IAB) provide their members with many resources to aid local marketing efforts. Electronic media professionals keep abreast of the latest marketing techniques through seminars, conferences, and other educational opportunities.

The telecommunications industry also shifted to a marketing orientation. The 1984 breakup of AT&T created competition in the telephone industry, initially in the long-distance market. Now, carriers such as MCI/WorldCom, Sprint, AT&T, Verizon, and SBC fight for long-distance customers. Local markets are served by a minimum of two companies offering cellular service. Competition is moving into the area of local-exchange telephone service, as more carriers qualify to provide local service under the provisions of the 1996 Telecommunications Act. Further, many cable systems have begun offering telephony service. Internet telephony will also be a competitor, especially for long-distance services. Obviously, continuing emphasis will be placed on the role of marketing in the telecommunications industry.

Understanding Clients and Their Needs

One key difference between a selling and a marketing philosophy is the genuine recognition and goal of serving the client's needs. A sales-oriented approach focuses on the product (advertising time). A marketing-oriented approach is designed to help clients meet the goals and objectives of their business. To achieve this goal, many electronic media firms position their account executives as professional marketing consultants rather than as salespeople pitching packages of time units.

Recognizing the needs of clients requires a clear understanding of their business objectives. During the 1980s, the radio industry introduced consultancy interviews as a tool to learn about clients and their needs. The consultancy interview is designed to draw out information about the client's business, which is then used to formulate a marketing plan involving radio as part of the advertising mix. Consultative selling also occurs in television and cable.

Sales Management: GSM, Local, and National Sales

Role of the General Sales Manager (GSM)

The General Sales Manager oversees all operations of the sales department and reports to the General Manager. You will recall that two other supervisors—the LSM and the NSM—may assist the GSM. Some operations also employ someone charged with developing cooperative (or co-op) advertising that also reports to the GSM.

The GSM's primary responsibilities include the development of sales policies and objectives in conjunction with the GM. However, there are a number of other tasks, including coordinating sales with other departments in marketing the facility; maintaining budgets; supervising personnel; working with advertising clients at all levels (local, regional, and national); approving copy and contracts; where applicable, consulting with and selecting the national representative firm; and working with the business department on the credit, collections, and processing of various accounts. Given increasing industry consolidation, it is not uncommon for a GSM to supervise several stations (as in radio) or two television stations (in cases of LMA/duopoly). One of the most important managers in an electronic media facility, the GSM usually has several years of experience in sales. Many General Managers have prior experience as a GSM, whose success is a direct result of the sales efforts at the local and national level.

Local Advertising

The radio, television, and cable industries all depend on local advertising (see Table 9-1) as part of total revenues. Of the three, the radio industry depends most on local advertising, as local sales account for approximately 78 percent of total radio revenues. In television, local advertising sales account for approximately 33 percent of total industry revenues. Local sales account for 22 percent of total advertising revenues in the cable industry. Local advertising for radio, television, and cable totaled $28 million dollars in 1999 (Veronis, Shuler, & Associates, 2000).

The Local Sales Staff: Account Executives

In the radio, television, and cable industries, the local sales staff must generate new advertising business. Commonly referred to as **account executives**, AEs are supervised by either a local or a general sales manager. The size of the local staff varies according to market size. Larger markets tend to require larger, more specialized sales staffs than smaller markets.

TABLE 9-1

Local Electronic Media Advertising

	LOCAL ADVERTISING (IN MILLIONS)	PERCENT OF INDUSTRY TOTAL
Radio	$13,140	79%
Television	$12,595	33%
Cable	$2,546	22%

NOTE: 1999 industry data compiled by the author from various sources.

Regardless of market size, account executives regularly draw higher salaries because they often receive **commissions** paid as a percentage of advertising sales. Actual commission rates vary among stations and industries. For example, accounts serviced by an advertising agency will pay a low commission (3–5 percent) compared to new business development, which pays a higher rate (10–15 percent).

Local AEs concentrate most of their efforts on what Warner and Buchman (1991) refer to as *developmental selling,* which focuses on the customer rather than the product. Developmental selling integrates knowledge of the client's needs and business with creative approaches. In addition to finding and developing new accounts, local AEs prepare and present various types of sales presentations, provide service to existing clients, and often assist in preparing advertising copy.

Sales managers find the selection of new AEs a difficult task. Employers widely agree that AEs need experience, motivation, attention to detail, organizational ability, strong communication skills, professional appearance, integrity, creativity, imagination, and persistence. Unlike the situation in many other departments, part-time AE positions are uncommon. The sales assistant is one entry-level position that may lead to an AE job. A sales assistant helps prepare presentations, compile research, and service clients. Industry consolidation has displaced many former sales managers, returning many to the ranks of AEs.

Selling media advertising is a challenging profession, primarily due to the fact that salespeople experience a great deal of rejection. Turnover tends to be higher in sales, particularly among new AEs. Continuing education is a priority if one aspires to be an AE, not just to keep current with the industry but also to understand client needs. Electronic media firms attempt to counter AE turnover with careful

recruiting and selection, followed by rigorous training programs to orient and prepare new AEs for success in their career.

Role of the Local Sales Manager

The Local Sales Manager (LSM) is responsible for the performance of the local sales staff and reports directly to the General Sales Manager (GSM). In large markets, a single television station may employ several LSMs with each manager responsible for a small staff of AEs. Local Sales Managers typically have several years of successful experience as an AE. In addition to drawing relatively high salaries, LSMs often receive additional compensation in the form of an *override,* a term used to represent a commission on total sales achieved above monthly or quarterly goals.

The LSM's duties include administering all local sales activities, supervising local account executives, establishing individual projections and quotas for each AE, and evaluating unit performance. Local Sales Managers may also have their own list of clients with whom they maintain regular contact.

In conjunction with the GSM, the LSM establishes several important policies, such as setting revenue projections for the local sales staff and rates for advertising. In any broadcast station or cable system, the amount of advertising is limited to a certain degree and is affected by available supply, as well as demand by clients. In the radio industry, the amount of time available for advertising is referred to as **inventory;** in the television and cable industry, the term **availabilities** (or **avails**) is used as well. These terms are discussed in the following sections.

Radio Revenue Projections and Rates

Let's say a radio station has a policy of offering no more than 10 minutes of commercial matter per hour to maintain a steady flow of music to the audience. Broken into 30-second spots, inventory consists of 20 spots per hour, 480 spots per day (24 hours), or 3,360 spots per week. However, this figure is somewhat misleading in that stations rarely sell much advertising during the overnight time period (midnight to 5:00 A.M.) because the audience is small. Therefore, let's assume the station sells most of its advertising time between 6:00 A.M. and midnight, Monday through Sunday. With a maximum of 10 commercial minutes per hour, the total inventory declines to 2,520 spots.

Continuing this example, let's assume that about 20 percent of the station's inventory is reserved for national advertising (discussed

in the next section). This represents about 500 spots, leaving a weekly inventory of 2,020 spots for local advertising. The price for these spots will depend on the demand by advertisers. When demand is high, stations can charge premium rates for advertising. Conversely, when demand is low, stations may charge the minimum amount required per spot to break even. The cost of each spot is further affected by the quantity demanded by each advertiser (clients who buy more spots usually receive a lower cost per spot), competition, and local economic conditions.

Sales Managers know exactly how many spots must be sold at the minimum price to meet all the station's financial obligations (see break-even analysis, Chapter 5). But how does a sales manager determine a minimum price? Again, let's assume that the station must generate weekly revenue to cover approximately $50,000 of expenses. Managers always take into account a **sellout rate** for their particular station. Sellout rate refers to the actual percentage of inventory sold over a given time. Using a conservative sellout rate of 50 percent, the station can expect to sell 1,000 spots in a week. Therefore, the minimum amount the station can offer a single spot for is $50 ($50,000 divided by 1,000 spots = $50). In other words, selling spots consistently below $50 would have a negative impact on the station's bottom line, while selling spots consistently above the $50 minimum will increase the station's profits.

This example, however simplistic, gives you some idea of how sales managers determine revenue projections on a weekly, monthly, or annual basis. While rates for individual spots are almost always negotiable in markets of all sizes, supply and demand of inventory have the greatest impact on advertising prices. In major markets, advertising rates are likely to change by the hour during periods of peak demand.

Television Revenue Projections and Rates

Establishing rates and revenue projections for television stations requires a similar approach, although not as simple as for radio. Several factors make inventory much more variable in the television industry. First, the number of available spots varies according to day-part—prime-time programs will naturally draw more viewers (and advertisers) than early morning or late evening. Second, television spots are usually tied to ratings performance—stations guarantee that a certain estimated part of the audience will see the program. If

a station does not actually generate the promised audience, the station must provide a **makegood,** usually in the form of additional, free announcements as a supplement. Makegoods represent a cost to the station, not a benefit. When a station provides a makegood, it loses inventory that it could sell to other clients. A third factor is the reliance on barter in program acquisition. Recall from Chapter 8 that barter is used extensively in the licensing of syndicated television programs. Though barter may provide programs at a lower cost, it also limits the available inventory stations can sell.

Television and radio stations depend on their traffic departments to help the sales staff maintain control over available commercial inventory. Without coordination between traffic and sales, chaos would reign. Fortunately, software programs provide constant updates on the number of avails open for scheduling.

Cable Revenue Projections and Rates

The cable industry views local advertising in a different light, in that local advertising revenues have historically represented a smaller percentage of cable revenue streams. As such, local advertising on most cable systems ranks lower in priority than marketing monthly subscriptions, premium channels, pay-per-view events, and cable modems. Cable rates tend to be priced lower than radio and television spots, requiring little negotiation with clients. Finally, the quality of local cable advertising is notably lower on most systems than the quality of broadcast television advertising.

Inventory is also more limited in cable television. Local cable advertising is confined to 1 to 3 minutes per hour on most of the popular, advertiser-supported cable networks such as CNN, MTV, ESPN, and USA. Systems follow one of three options regarding local cable advertising. One is to employ a local marketing staff to call on clients in the same way that radio and television stations do. This option is usually the most expensive for local cable systems because of the cost of salaries and benefits for marketing personnel. Local sales staffs tend to be small.

A second option is to outsource advertising sales to a company that specializes in marketing insertion advertising to local businesses. Cable systems receive a set amount of money each month, and the company provides the necessary production and the actual tapes of all commercials sold on a weekly basis. Local clients can advertise on popular cable networks, usually at a rate comparable to that of local radio stations. Clients purchase insertion advertising for a number of

weeks at a time; spots are rotated among various cable networks on a random basis and air several times a day.

A third option involves the use of **interconnects.** According to the Cable Advertising Bureau, interconnects exist where two or more operators join together to distribute advertising simultaneously over their respective systems. Interconnects increase advertiser effectiveness by offering the efficiency of a multiple-system purchase and save time in that only one contract must be initiated. Interconnects are widely found across the cable industry in the United States.

Regardless of the method used, local cable advertising continues to grow on an annual basis. According to the Cable Advertising Bureau, local cable advertising reached $2 billion in 1998; by the year 2004, local cable advertising is projected to reach nearly $4.7 billion (Veronis, Suhler, & Associates, 2000).

National Advertising

National advertising is another important source of revenue for the broadcast and cable industries (see Table 9-2). National advertising also encompasses regional advertising. There are two categories of national advertising—**spot** and **network.** Spot advertising represents the local time, on a broadcast or cable outlet, sold to clients at the national level; this type of advertising is referred to as **national spot** or just *spot* for short. Network advertising represents the advertising dollars sold by the various broadcast and cable networks; these commercials are eventually presented during network programming.

Spot Advertising

To supplement national campaigns, clients at the national level advertise in local markets around the United States. Some of the more prominent national advertisers include soft drink companies (Coke,

TABLE 9-2

National and Network Electronic Media Advertising

	NATIONAL ADVERTISING (IN BILLIONS)	NETWORK ADVERTISING (IN BILLIONS)
Radio	$3,135	$.655
Television	$10,925	$15,043
Cable	$8,298	$.351[a]

[a] refers to advertising on regional sports networks

NOTE: 1999 industry data compiled by the author from various sources.

Pepsi), fast food franchises (McDonald's, Burger King), breweries (Anheuser Busch, Coors), airlines (American, Delta, United), and various other products (Procter and Gamble, American Home Products).

In radio, national spot accounts for approximately 20 percent of total revenues, while network advertising accounts for about 4 percent. In television, national spot sales account for approximately 28 percent of total revenues compared with 39 percent of network revenues. The cable industry commands a very small portion of national spot; most systems do not separate local sales from spot sales. Network advertising is the biggest category for the cable industry, accounting for 74 percent of all advertising revenues.

National Sales Staff

The national sales staff is smaller than the local sales staff. In some stations, the staff is limited to the National Sales Manager (NSM) and an assistant. To be promoted to the position of National Sales Manager, an individual usually needs several years of experience in the sales department as an AE or as an assistant to the NSM.

National sales tend to be concentrated in the top-50 markets. Because smaller markets receive limited national spot revenue, there is no need for a separate NSM. In such cases, national spot sales are coordinated by the GSM or the GM.

Role of the Rep Firm

National and regional sales are coordinated with a **National Representative Firm,** or National Rep for short. Most of the transactions for national advertising occur in major media centers such as New York, Los Angeles, Chicago, and Dallas, homes of the largest advertising agencies. Because each local station cannot afford an account executive in each city calling on the agencies to solicit national business, stations contract with a rep firm to handle national sales.

In representing local stations, the rep firm acts as an extension of the local sales force in the national and regional markets for advertising. Firms are usually contracted on an exclusive basis, meaning they will represent only one station owner in a market. Rep firms are compensated through a commission on all advertising placed on local stations. Rep commissions vary from a low of 2–5 percent in television to as much as 15–20 percent in radio.

Here is an idea of how the national sales process works. Reps call on agencies to solicit advertising for the stations they represent. Agencies specify the criteria they desire for a certain client. In some

cases, the "buy" for a client may demand a particular demographic group such as women 25–54, men 25–49, adults 18+, or teens. Or the buy may be based on quantitative requirements, such as a certain number of gross rating points or specific cost per thousand (discussed later in the chapter). The rep firm obtains a list of availabilities from each station able to meet the criteria desired by the client, then negotiates the individual transactions for each station it represents.

Besides contracting national advertising for individual stations, the rep firm may provide other services, such as audience research, assistance with sales and promotion strategies, revenue projections for individual markets, and advice on the purchase of television programming. Key rep firms in the radio industry include Interep Radio Store, Katz Radio Group, and CBS. In the television industry, the largest rep firms include Katz Television Group, Blair, Petry, Group W, Seltel, and Telerep.

Working with the Rep Firm

For both parties to accomplish their tasks, the rep firm and the National Sales Manager need close communication. To compete effectively for national ad dollars, rep firms need to be kept aware of any changes in the local station's market, programming, competition, and rate structures. An important partner in generating national sales, the rep firm should be consulted on all of the station's marketing planning and projections.

As in any business relationship, problems can occur between rep firms and stations. Either may switch affiliations at the end of a contract period if one is unhappy with the performance of the other. Because detail is important in coordinating national sales, sloppy work from either party can be frustrating for all concerned. Miscommunication, inaccurate information, and failure to follow up with needed paperwork are other common problems encountered in rep–station relations.

Cooperative (Co-op) Advertising

Cooperative or co-op advertising is another category of advertising revenue available to the electronic media, although it works differently than local and regional accounts. In **co-op advertising**, manufacturers share in the advertising costs with local retailers. For example, General Electric manufactures appliances available at many local retailers. If the local retailers meet the specific requirements of

the manufacturer's co-op plan, General Electric may reimburse them for part or all of their advertising costs.

The money available for co-op depends on the amount of **accruals,** or dollars credited for advertising for each retailer. Tied to the amount of products purchased by the retailer from the manufacturer, accruals are usually subject to a dollar limitation. A simple 3 percent/$3,000 co-op plan would indicate the local retailer could request advertising dollars based on 3 percent of the products purchased from the manufacturer, up to a total of $3,000. If the retailer bought $60,000 worth of products from the manufacturer, then the maximum available for co-op purposes would be $1,800 ($60,000 × .03 = $1,800).

It is estimated that millions of dollars of co-op advertising are left unused each year by retailers. You may wonder why this source of revenue is not used more often. Warner and Buchman (1991) cite three reasons. First, many retailers are not aware of co-op opportunities. Second, retailers tend to favor newspaper over broadcast and cable advertising. Third, retailers avoid the paperwork and bookkeeping required for co-op.

Because co-op plans vary among manufacturers, stations may employ a coordinator to work exclusively on co-op plans. The co-op coordinator works with retailers to set up the individual contracts, prepares paperwork required by the manufacturer, and sees that the copy adheres to all requirements set by the manufacturer.

Sales Terminology

A sales staff regularly uses audience research data to help market the station to advertisers. National sales are almost always structured around ratings performance, or selling by the numbers. Local sales may also be quantitatively driven, particularly in larger markets. Marketing professionals use many formulas to create an advantage over other competitors.

Common terms used in marketing media advertising include gross impressions (GI), gross rating points (GRP), reach, frequency, cost per thousand (CPM), and cost per point (CPP). Gross impressions, gross rating points, reach, and frequency all involve audience estimates and the number of commercial announcements in a schedule. Cost per thousand and cost per point are measures of efficiency that take into account price as well as audience estimates and com-

mercial load. Each of these terms is discussed in more detail as follows.

Gross impressions (GI) is a measure of the total media weight and refers to the total number of people reached by each commercial in a campaign. Though GIs can represent different time periods, they must always use the same demographic group. Primarily used in radio, GIs are calculated by multiplying AQH persons by the number of spots and summing for each daypart. The example shows the total GIs for women (W) 18–49 across three dayparts.

DAYPART	AQH	NO. OF SPOTS	GIs
6–10 A.M.	6,000	12	72,000
10–3 P.M.	2,400	6	14,400
3–7 P.M.	3,000	10	30,000
Total gross impressions			116,400

Note that you *cannot* add all the AQH estimates and multiply by the total number of spots to find the GIs; each daypart must be calculated separately as in the example.

Gross rating points (GRPs), another measure of media weight, is the sum of all rating points generated in an advertiser's schedule. The more rating points reached the better. GRPs are used in both radio and television, but as with GIs, the same audience base must be used. Radio GRPs are calculated by multiplying the total number of spots by the AQH rating. This example uses hypothetical data for men (M) 25–54.

DAYPART	AQH RTG	NO. OF SPOTS	GRPs
6–10 A.M.	9.5	12	114
10–3 P.M.	3.0	6	18
3–7 P.M.	5.2	10	52
Total gross rating points			184

Like GIs, GRPs must be calculated separately for each daypart. In television, GRPs are calculated by multiplying the rating for each program by the number of spots and summing the total. Again, the same audience base (M 25–54) must be used.

DAYPART	RTG	NO. OF SPOTS	GRPs
Monday Night Football	13.5	6	81
20/20	6.0	2	12
Dharma & Greg	10.0	2	20
Total gross rating points			113

Reach is a measure of how many different people are exposed to at least one commercial advertisement. Think of reach as a measure of width in a media plan. A radio station's cume audience is equal to the size of the station's reach. Different estimates can be used for reach, such as a rating or a cume.

Frequency, used in combination with reach, can be thought of as the depth in a media plan. Frequency refers to the number of times the average person (in radio) or household (in television) is exposed to the same advertisement. Reach, frequency, and GRPs are interrelated, as seen in the following example:

Reach × Frequency = GRPs
GRPs / Frequency = Reach
GRPs / Reach = Frequency

If 100 GRPs are purchased to reach an audience with an average frequency of 5, the reach will be 20.

Gross impressions, gross rating points, reach, and frequency all use audience estimates. The final terms discussed in this section, cost per thousand and cost per point, take into account the actual price paid for advertising as well as audience estimates.

Cost per thousand (CPM) describes the cost to reach 1,000 people; with it, one can compare competitors, advertising media, time periods, and so forth. (Note the abbreviation is CPM, not CPT. The M is derived from the Latin word for 1,000.) CPM is calculated by dividing the cost of the advertising plan by gross impressions (measured in thousands). For example, if the total cost of an ad campaign is $35,000, and the gross impressions total 700,000, then CPM equals $50.

$$CPM = \frac{Total\ Cost}{(Gross\ Impressions\ /\ 1,000)}$$

$$CPM = \frac{\$35,000}{700}$$

$$CPM = \$50.00$$

CPM is a comparison tool; a single CPM calculation tells a client nothing. In broadcast and cable selling, CPM is often used to compare advertising costs with costs of competitors as well as other media.

Cost per point (CPP), another measure of efficiency, is the cost of a single rating point. CPP is calculated by dividing the total cost of the ad plan by the total GRPs. Another useful comparison tool, CPP serves as a negotiating point in the sales process. In the following example, if the total cost of an advertising plan is $35,000 and the total number of GRPs equals 630, then CPP equals $55.55.

CPP is sensitive to the characteristics of a market. Advertisers expect to pay more money to buy rating points in Seattle or Denver

$$CPP = \frac{Total\ Cost}{Gross\ Rating\ Points}$$

$$CPP = \frac{\$35,000.00}{630}$$

$$CPP = \$55.55$$

than in Knoxville or Abilene. Again, CPP must be used as a comparison measure of cost estimates.

Do not be intimidated by all these formulas and calculations. Computer software generates many types of cost and audience analysis estimates for use in preparing client presentations. Understanding how to interpret the numbers is far more important than understanding how they are calculated.

Promotions as a Form of Marketing

The effective sales staff must have audiences to deliver to advertisers. Generating audiences is one of the primary functions of the promotions department. No radio, television, or cable system can become complacent about its share of the market; there are simply too many alternatives available to audiences. For the total marketing effort to succeed, companies need good promotional campaigns and strategies. Promotions have become strategically important to electronic media management as competition for audiences has intensified.

Promotion takes many forms, ranging from self-promotion via the Internet, through on-air activities, to paid promotion in the form of advertising. Promotional efforts maintain both audience and advertiser awareness. The size and budget allocated to the promotions department varies according to market size and revenues. Stand-alone promotions departments are most common in the top-50 markets; in smaller markets, other units may pick up the duties. On average, stations allocate 3–5 percent of revenues back to promotion budgets; in major markets, the budget can reach several million dollars.

Duties of the Promotion Manager

As a midlevel manager, the Promotion Manager supervises the activities of the department and reports directly to the General Manager. The Promotion Manager works closely with the programming and sales departments in planning and coordinating activities aimed at audiences and advertisers, as well as monitoring and evaluating all campaigns. Some stations use the term *creative services* in place of promotions.

The Promotion Manager is also responsible for managing personnel in the department, supervising the budget, allocating resources,

supervising graphics, evaluating research data, coordinating Internet (Web site) activities, and handling public promotional events. One of the most versatile managers in the electronic media, the Promotion Manager has knowledge of promotion, sales, marketing, research, technology, and regulatory policies concerning promotional activities.

Types of Promotion Promotion Managers use many types of activities to market an electronic media facility. Most promotional efforts are aimed at either audiences or advertisers. Some of the most common methods follow.

- *On-air promotion.* One of the most effective and efficient tools available for promotional activities, **on-air promotion** in radio includes simple things such as announcing the call letters, logo, and music coming up in the next segment. In television, promotional spots or **promos** are used to attract audiences to upcoming events, especially at the network level. Local stations center promotions on the news team. Both TV stations and cable channels use distinctive logos to maintain audience awareness. On-air promotion is not without cost; the time spent on promotional activities means time not available for advertisers. As consolidation has grown, cross-marketing promotional strategies are possible where an owner may include TV, radio, and even a newspaper as part of its holdings.

- *Web site.* Broadcasters and cable networks have devoted considerable resources to their Web pages for promotion and marketing purposes. Discussed more fully in Chapter 12, Web sites are used for everything from streaming media to providing an important source of audience feedback and participation. The primary challenge is finding the most efficient ways to use the Internet to develop additional revenue streams.

- *Publicity* refers to the free time and space made available by other media. Electronic media companies are very skilled at promoting events of interest to other media, such as newspapers. **Publicity** can range from simple activities, such as an electronic press release announcing the acquisition of a new program, to interviews or stories. Radio stations have been especially good at getting local television station newscasts to cover various contests and events. The key is to design events that other media will take interest in reporting.

- *Advertising*. In this context, advertising refers to paid promotional activities, or the time and space purchased by the electronic media facility in other media. Billboards, print advertisements, television commercials, radio commercials, Web site banner advertising, bumper stickers, and transit media placards (buses and taxis in urban areas) are vehicles for electronic media advertising.

- *Sales promotions*. In radio and television, sales promotions are designed to attract new advertisers to a station. Stations may offer seminars to potential advertisers on subjects such as the advantages of radio (or television) advertising. Other campaigns may be targeted toward existing advertisers. Cable companies gear most of their sales promotions to generating new subscribers or encouraging subscribers to try the next tier of service, a premium channel or a cable modem.

- *Community involvement*. Electronic media companies strive to promote goodwill in the communities they serve. Involvement with civic groups and nonprofit organizations on community projects establishes a positive image valuable to companies.

Evaluating Marketing Efforts

Media managers constantly execute and evaluate marketing strategies and campaigns. As such, they use many tangible measures of effectiveness. Advertising revenues, audience ratings, and research data all quantifiably indicate a particular marketing campaign's degree of success. Less tangible items, such as goodwill, phone calls, email messages, and letters from audiences and advertisers must also be considered when one evaluates marketing plans.

Technology also affects the ability to evaluate marketing in the electronic media. As you have seen, technology is providing increasingly efficient ways to measure consumers' use of individual products and services through database marketing and other innovations. At the same time, technology is also making marketing more challenging. How will marketing evolve when households are able to receive hundreds of channels of information and entertainment via their TV,

home computer, or PC/TV combination appliance? How will this affect the relationship with advertisers and audiences?

Though specific marketing tools may change, the goal of generating advertisers and audiences remains a significant challenge for electronic media managers in the 21st century.

Summary

Marketing knowledge is an essential skill needed by today's electronic media managers. In the electronic media, marketing is targeted toward advertisers and audiences. Marketing involves a range of responsibilities, including planning advertising and promotional campaigns and developing and maintaining the brand or identity of an operation.

Marketing strategies are an important part of any marketing plan. Segmentation, positioning, and branding are three common strategies used by businesses in marketing products and services.

The General Sales Manager and staff are responsible for generating advertisers. Over the years, advertising has evolved into a marketing orientation. Moving toward a marketing philosophy, companies emphasize meeting the needs of the client as opposed to selling time. Electronic media companies draw advertising revenues from local, regional, and national accounts, as well as through co-op advertising. Different formulas measure advertising weight, breadth, depth, and effectiveness.

The promotions or creative services department serves to generate audiences and audience awareness. Promotional activities may include on-air promotion, utilization of the Internet, publicity, and paid promotion (advertising). Other types of promotions include sales promotions and community projects.

Across the electronic media, marketing strategies undergo continual development and evaluation. Like many areas of the electronic media, technology impacts marketing techniques and challenges traditional assumptions, but the goal of generating audiences and advertisers remains the same.

| CASE STUDY | **Marketing a New Newscast** |

WKAR-TV is a Fox affiliate in a top-50 television market (125,000 TVHH), having signed on with Fox in 1988 after being an independent since it began broadcasting in the 1970s. There are four other stations in the market: affiliates for ABC, CBS, and NBC and a PBS station housed at a local university. Cable penetration is 58 percent.

WKAR has made a commitment to establish a local newscast and compete directly with other stations at 6:00 and 11:00 P.M. Until now, WKAR has been counterprogramming against its competitors, occasionally winning third place in both the 6:00 and 11:00 ratings with popular reruns of series such as *The Simpsons* and *Seinfeld.*

The ABC affiliate, WPAT-TV, has led the market for years, emphasizing a strong theme ("First for News"), well-established anchors, and a host of familiar news reporters and numerous community activities.

The CBS affiliate, WRMA-TV, has fought with the NBC affiliate, WWTC-TV, for second place at both the early and late newscasts. Most of the time, the difference in ratings between WRMA and WWTC has been a single point or two. WRMA uses a format replicated in several markets, calling its newscast "The NewsCenter." The WRMA NewsCenter features two anchors at all times (one male, one female); though they present the news in a serious manner, there is a lot of banter among the news, sports, and weather presenters.

WWTC emphasizes a fast-paced approach with its "Action News" format, which includes rotation among three anchors, regular investigative reporting featuring topics that border on titillation, and dramatic pictures of accidents, fires, and criminal activity.

As the Marketing Director of WKAR, your task is to come up with ideas for a marketing plan for the news venture. You must analyze the market and create a plan based on segmentation, positioning, and branding strategies. The final plan will be used in making decisions on the type of news personnel to hire, the format of the newscast, the design of the set, promotional strategies, and other criteria.

Note: Your instructor may wish to use your local television market in lieu of the hypothetical stations in this example. This case could also be applied to the national network newscasts, using the Fox, UPN, Warner Brothers, or Pax networks with plans to develop a national newscast to compete with ABC, NBC, and CBS News.

CASE STUDY	**The Tough Retailer**

Jim Robinson was the founder and owner of Robinson's Appliances, one of the largest appliance stores in the Northwest market of Rockport. Three months ago, Robinson retired, turning over the business to his daughter and son-in-law, Christine and David Applegate. Christine, who was raised in the family business, handles the sales staff, store layout, and customer relations. David, who has an MBA, carefully studies and analyzes all the business aspects of the store, including inventory, accounting and billing, taxes, and advertising.

Julie Hawkins, an account executive for KTLK-AM/KRCK-FM, has been calling on the Robinson account for nearly 5 years. Julie first convinced Mr. Robinson to try radio advertising through a co-op package with some of the brand names he carried in his store. Though Robinson was skeptical, the plan proved to be a winner. Convinced of the power of radio, Robinson purchased a small monthly package to supplement the co-op efforts. Over the 5 years, Robinson's Appliances has experienced growth in market share and revenues, thanks in part to successful radio advertising.

Hawkins knows that David Applegate will be the new contact for advertising at Robinson's Appliances, having met David on her regular call to the store last month. The two of them have decided to meet to discuss the account.

"How is everything going with the transition?" Julie asks.

"Overall, very well," says David. "We have a lot of work to do, but we are off to a smooth start. However, at the same time, the nature of doing business is changing, and we have to be very careful we are doing what we should be doing in all areas—including advertising."

Julie senses some concern in David's voice. "The past few years in working with Mr. Robinson, KTLK/KRCK has been very instrumental in establishing Robinson's Appliances as the premier appliance outlet in Rockport, and we want to continue to assist in that effort," she says.

David responds, "Yes, I know. But at the same time, I want to make sure your station will continue to be the best deal for the money. I don't see anything in the files and contracts with your station that says anything about the GRPs generated by the advertising, the cost per point, anything. If you want to keep this account, I will need that information in considering future advertising with your station."

Julie is flabbergasted. Mr. Robinson never asked about gross rating points or gross impressions. He simply wanted to position his business in the market and get customers to visit the store. Developmental selling had always worked with Mr. Robinson. But David, with his business background, wanted numbers to review.

Julie carefully considers her response. "David, the broadcast stations and newspaper in this market rarely find retailers who need or even understand the type of data you have asked for. However, if you feel such information will help you make informed decisions, I will be happy to generate a plan that includes these figures. I will get back to you later this week."

"That will be great. I am going to expect the same thing of your competitors, although the strength of your station in reaching our target audience of women 25–54 makes your operation and our business a good fit. Still, I want to see the numbers."

As Julie leaves the meeting, she makes some notes in her car. Few retailers in Rockport need the data Applegate wants, but if generating a media plan will maintain a strong client, then Julie has some work to do once she returns to the station.

Using data from the following table, construct a media plan she might present to Robinson's Appliances. In your plan, calculate the GIs, GRPs, CPM, and CPP for the retailer's target audience, women 25–54. Assume the station buys a package of 20 spots per week (:30 each), with 10 spots on the AM station and 10 on the FM station. Consider different placement of spots to determine the most efficient plan for a month.

	KTLK-AM (news/talk) W 25–54[a]			KRCK-FM (adult contemporary) W25–54[a]		
DAYPART	AQH[b]	AQH RTG	COST$	AQH[b]	AQH RTG	COST$
6–10 A.M.	4,300	4.1	$325	6,400	6.1	$550
10–3 P.M.	1,100	1.0	$150	3,350	3.2	$275
3–7 P.M.	2,700	2.6	$225	4,100	3.9	$450
7–12 A.M.	800	.01	$50	1,700	1.6	$100

[a]Total women 25–54 in the market is estimated at 105,000.
[b]AQH reflects actual estimates; do not add (00).

NOTE: $ refers to cost for a :30 spot.

 InfoTrac College Edition

For new information on the topic of marketing across the electronic media, use InfoTrac College Edition. Use the following terms for subject and keyword searches: marketing, branding, promotion, advertising, sales.

 Web World

The following Web sites offer useful information related to electronic
 media marketing:
National Association of Broadcasters (www.nab.org)
National Cable Television Association (www.ncta.com)
Radio Advertising Bureau (www.rab.com)
Television Advertising Bureau (www.tvb.com)
Cable Advertising Bureau (www.cabletvadbureau.com)
Internet Advertising Bureau (www.iab.com)
Cable & Telecommunications Association for Marketing (www.ctam.com)

References for Chapter 9

Albarran, A. B., & Pitts, G. G. (2001). *The radio broadcasting industry.* Boston: Allyn & Bacon.

Brandes, W. (1995, February 13). Black-oriented radio zeroes in on narrowly defined audiences. *The Wall Street Journal,* p. B8.

Cable TV Facts. (1999). Available online: http://www.cabletvadbureau.com.

David, M. (1980). *Making money with co-op.* New York: Radio Advertising Bureau.

Gerlin, A. (1993, July 14). Radio stations gain by going after Hispanics. *The Wall Street Journal,* pp. B1, B8.

Murphy, J. M. (1987). *Branding: A key marketing tool.* New York: McGraw-Hill.

Ries, A., & Trout, J. (1986a). *Marketing warfare.* New York: McGraw-Hill.

Ries, A., & Trout, J. (1986b). *Positioning: The battle for your mind* (Rev. ed.). New York: McGraw-Hill.

Runyon, K. (1980). *Consumer behavior and the practice of marketing* (2nd ed.). Columbus, OH: Merrill.

Scott, R. (1995, June 5). Radio direct marketing: Targeting the future. *Radio Ink,* 30–35.

Veronis, Shuler, and Associates. (2000). *Communications industry forecast.* New York: Author.

Warner, C., & Buchman, J. (1991). *Broadcast and cable selling* (2nd ed.). Belmont, CA: Wadsworth.

Yang, C. (2000, May 29). Turn on, tune in, interact. *Business Week,* 90–94.

News and News Management

In this chapter you will learn

- How news establishes a sense of localism
- How electronic media organizations use news as a form of programming
- How news departments are organized and staffed
- Key issues in news and newsroom management

The electronic media are visible in many ways to audiences and advertisers, but perhaps they are most visible in the delivery of news and news-related programming. Over the years, society has become increasingly dependent on the electronic media for news and information. For many Americans, the electronic media are their primary source for knowledge of national and international events.

News and news content are both ubiquitous and pervasive. Radio delivers much-needed traffic, weather, and local news to commuters during morning and afternoon drives. Local television stations may devote as much as one-third of their broadcast hours to news programming, beginning in early morning hours and extending to late night after prime time. Satellite-delivered news channels like CNN, MSNBC, and Fox News are representative of a number of 24-hour news channels available to cable and dish households 365 days a year. By mid-2000, a total of 30 regional and local all-news channels were available to cable and satellite households. In addition, the Internet, with its ability to stream and archive news content produced by electronic media organizations, represents yet another way for audiences to access local news and information.

Clearly, news is a key product of the electronic media. This chapter examines news and news management by focusing on several topics. These topics include the importance of news as an area of content, the organization of a news department, and issues in news management. While news can be examined on many levels of analysis, this chapter will center its discussion on news at the local level, consistent with the direction of this entire text. From a career standpoint, the local newsroom of a radio or television station is the logical starting point for entry into the field of broadcast journalism. Hence, an understanding of topics and issues related to local news management is applicable to most readers.

The Importance of News

Why is news so important to electronic media organizations? There are many possible ways to address this question. From a historical perspective, news has been intertwined with broadcasting since its beginnings. The first radio broadcasts to achieve notoriety were the election results of 1920, broadcast by KDKA, the nation's first licensed radio station (Albarran & Pitts, 2001). During the war years, radio news kept Americans informed of the campaigns in Europe and the Pacific Rim. The advent of television ushered in a new dimension for news with the capability of combining sound with moving pictures. Many broadcast historians feel the news coverage of the assassination and funeral of President John F. Kennedy in 1963 was a defining point for broadcast news, much in the same way CNN's coverage of the Gulf War in 1990 signified a new era of instantaneous global news coverage (Hatchen, 2000).

From a cultural perspective, news serves many areas of society. News not only provides information to improve learning and understanding but also aids in awareness of our societal norms, values, and beliefs. News enables listeners and viewers to experience and interact with cultures and peoples in other parts of the world. News and news content are aimed at different segments of the population, ranging from news that is feature oriented to news focusing on business and sports.

There are many ways one can examine news. In this section, we will center discussion on two important topics: localism and news as a form of programming.

Localism More than any other type of content, news establishes a sense of **localism** with both audiences and advertisers. In fact, listeners and viewers feel dependent on local news sources to help learn about topics and issues of concern. Critics may bemoan the fact that most Americans get their news from the electronic media as opposed to print media sources, but it is reality.

In fact, localism is the key feature that separates local and regional radio, television, and cable channels from their national and international counterparts. It is important to have access to the major networks and operations like CNN for key national and world events, but when people want to know what is happening locally that may impact them and the people closest to them, most will seek out local news operations.

Further, audiences identify with local news personalities, often regarding the news anchors or weathercasters as trusted sources and even friends. More viewers are aware of local news and news anchors than they are of which network the station may be affiliated with. Local news personalities tend to be visible in their local communities promoting and participating in various civic causes and events. This helps establish a sense of unity with the local electronic media, promoting greater loyalty among viewers and listeners.

As we move further toward a more saturated and competitive media environment, the concept of localism is the single biggest advantage the electronic media offer their audiences. For electronic media organizations, news is the manifestation of localism and the most tangible way to be a part of a community.

In addition to establishing a sense of localism, news also helps to build a definable brand in the mind of the audience. Logos such as "Eyewitness News," "Action News," and "News Center" are utilized in conjunction with on-air and external campaigns promoting news anchors and reporters. This branding of the news operations not only helps in generating awareness for audience ratings but also in marketing to advertisers. In the television industry, stations with a local news operation typically hold a strong competitive advantage over in-

dependent stations in terms of both audience ratings and revenues. News is the reason for this advantage.

News as Programming

News is critically important from a programming perspective, especially for television stations. The cost to produce a single news program would be very expensive, especially in terms of capital outlay to acquire talent, equipment, sets, and so forth. But by producing several hours of news, stations have a very economical form of programming. By programming multiple hours of local news, the overall costs drop considerably. This is especially true of stations in large and medium markets.

Content for the news comes from an internal system of assignments and reporting discussed later in the chapter, but other sources are used as well. Some stations are using Internet and phone polls to help select stories the audience is interested in. Town hall meetings have become popular as a way of generating community interest and helping identify the key issues on the minds of many local citizens.

Television news can be found in several dayparts. Early morning newscasts begin in some markets around 5:00 A.M. to 6:00 A.M. For network affiliates, local news is interspersed with morning programming like *Today* and *Good Morning America* (Eastman & Ferguson, 1997). The noon hour is another traditional time period for local news coverage. These earlier newscasts are among the most profitable hours of the television day. The programming is easy to sell, and talent costs are lower in the morning as this area represents a starting point for news talent.

Afternoon fringe time, beginning around 5:00 P.M., is the time when most stations will program their first evening news broadcast, followed by another local news block at 6:00 P.M. Late news appears directly after the conclusion of prime-time programming, at 11:00 P.M. in the eastern and Pacific time zones and at 10:00 P.M. in the central and mountain time zones. Many stations repeat their late-night news at some time slot during the overnight period and resell the advertising.

A growing trend among duopoly operations is to rebroadcast news on the sister station but at a different time period, thereby generating even larger reach and penetration in the market. It is not uncommon for news to represent 4 to 6 hours of the broadcast day for ABC, CBS, and NBC affiliates. Affiliates of Fox, WB, and UPN tend

to broadcast much less news; in fact, some affiliates may not even have a local news department, or they may buy news programs from other stations.

Local and regional television news coverage is growing rapidly across the United States. Some 30 local or regional 24-hour news channels now exist, with more in the planning stages. Audiences demand news more often, and advertisers prefer reaching news audiences who tend to be more loyal viewers with higher discretionary spending patterns.

In contrast to television programming, many radio stations have cut back on news coverage over the past decade. Still, most music stations offer a minimum of news headlines, local traffic, and weather reports during drive time hours (Albarran & Pitts, 2001). News and news/talk radio stations are found in just about all large and medium markets. Radio networks also offer news and other programming features to their affiliates.

Finally, the Internet has emerged as another important source of news distribution for electronic media companies. The ability to archive and expand existing news material via the Web offers new ways to increase the audience for news. Through the use of streaming media, stations can also provide news access to individuals outside of traditional listening and viewing hours. News content is usually repurposed for use on the Internet, rather than recreated for original news programming. However, as broadband access options for the audience increase, it will be possible to expand news offerings, and organizations may consider offering some original content on their Web site.

Organization of a News Department

News departments vary in size and composition from market to market and type of facility (e.g., radio or television) and depending on the commitment to news as a form of programming. In all cases, news is under the leadership of the News Director, who has responsibility for the unit and its performance. The News Director in most markets is an upper-level manager, reporting directly to the General Manager. Some operations in the top-10 markets may have a Vice President of News.

In most electronic media organizations, the News Director tends to be one of the higher paid members of the management team with several prior years of experience. News Directors usually work their way up through the ranks, with most having served as writers, reporters, and producers and having carried out general assignments. News Directors tend to have a degree in either journalism or a related field. In terms of salaries, television news directors earned an average of $70,000 in 1999, while their radio counterparts earned an average of $43,800 in 1999 (National Association of Broadcasters, 1999a, 1999b).

Staffing the News Department

The News Director is assisted by a number of personnel in the newsroom. Because of the variability in the size of the news department across markets, our discussion will center on the types of representative staff found at a local television station.

Assistant News Director The Assistant ND works closely with the News Director to manage the overall responsibility of the department. At some facilities, the Assistant ND may work an earlier time shift, with the News Director working later in the day. The Assistant ND will serve in a variety of roles, usually assisting producers and reporters as they progress on their individual stories. The Assistant ND will typically have input on hiring, newscast structure, and format.

Assignments Editor The Assignments Editor is responsible for assigning stories to be covered by the reporters. Some operations use a beat system of reporting, where a particular reporter will cover topics like education, city government, business, or the environment, while others will use a random-assignment approach. The reporters work with the Assignments Editor to determine the length of their **news package** and other criteria. The Assignments Editor seeks out story ideas by monitoring police scanners, reading newspapers and magazines, and keeping in touch with reporters and producers.

Operations Manager The Operations Manager may not be found in all news departments, but the responsibilities associated with this position are critical. The Operations Manager coordinates the technical

needs associated with covering stories and events, such as the use of satellite time, live trucks, helicopter coverage, and other logistics.

Executive Producers Executive producers are found in medium and larger markets, and are typically considered to be part of newsroom management. The Executive Producer often supervises a team of producers and will help write and rewrite all stories that eventually air. Executive Producers in the top-25 markets have the last word on what goes on the newscast.

Producers As a group, producers are responsible for ensuring that all elements of a newscast are properly put together and organized to provide a tight, coherent production. In theory this sounds easy, but in practice it can be extremely challenging, especially in situations involving breaking news stories that can totally disrupt the best-planned newscasts. As the newscast moves closer to air, producers keep in constant contact with all members of the department, including the reporters, anchors, and production staff.

Anchors Considered by many to have the most glamorous as well as most authoritative positions in the news department, anchors deliver the news by providing an introduction to stories gathered by reporters. They also help transition different segments of the newscast. The role of the anchor varies considerably; in some operations the anchor merely is the talent that delivers the news to the audience. In other operations, the anchor is directly involved in the production of the news department, perhaps even serving as a managing editor of the news in consultation with the News Director. In some cases a single anchor reports the news; in others multiple anchors share the anchor desk. Most anchors have roots in reporting, and they tend to be among the highest compensated positions in the newsroom. Anchors may also write or rewrite scripts used on-air.

Reporters Next to the anchors, the reporters are the most visible members of the news department because their work requires regular contact with the community they serve. Reporters handle a range of responsibilities, including writing their stories, working with the pro-

duction personnel in the shooting and editing of their package, and keeping in touch with the producers.

Photographers and Editors Production personnel are critical to the success of a news operation. On the television side, camera operators bring life to a news story with pictures of news events. In fact, anchors and reporters have very little on-camera time in most newscasts, because the pictures are what tell the stories. And news is about telling stories to audiences. Editors help in this process by editing together footage so packages are within their allocated time. In radio, reporters gather their own interviews and handle their own editing to produce **actualities,** or sound bites that add realism and interest to radio news stories.

Budgeting and the News Department

The News Director is responsible for maintaining the budget of the News Department. Like any department, the News Director negotiates the budget on an annual basis with the general manager and the controller. News directors normally manage two budgets—one budget to handle regular expenses (talent and other costs that cannot be amortized) and a capital budget for capital expenditures (equipment, vehicles, etc.).

News represents one of the more challenging areas of budgetary management, as the costs to cover live and unplanned news events can effectively kill an existing budget. The News Director is faced with the daily challenge of managing the resources for the news operation while at the same time working with other department heads to increase profitability.

Many professionals trained as journalists resent the fact that news is often expected to "pay its own way" in an electronic media facility. But as competition for audiences and advertisers has intensified, news personnel have come to grips with the realities of the marketplace and understand that ratings are critical in achieving success. By streamlining operations and cutting unnecessary costs, news managers attempt to meet economic objectives for the organization while preserving journalistic integrity. Still, it is important to recognize that this is a delicate balancing act to achieve. This is one reason why the news manager reports directly to the General Manager. To some extent, the news operation can be insulated from other departments in

TABLE 10-1

Average Salaries for Selected Categories of Television and Radio News Personnel

JOB TITLE	TELEVISION SALARY	RADIO SALARY
News Director	$79,200	$43,838
News Reporter	$33,730	$32,454
Sports Anchor/Director	$68,926	$52,513
News Producer	$29,270	N/A
News Photographer	$27,144	N/A
News Announcer	N/A	$40,996
Traffic Reporter	N/A	$40,785

NOTE: Salary information adapted from National Association of Broadcasters, 1999a and 1999b; data provided courtesy of Mark Fratrick, NAB Office of Research and Planning. Used with permission.

terms of its revenues and expenses and contribution to profitability (or loss).

The most expensive component in a news department is the personnel. News personnel salaries typically account for around 60 percent of the budget in a network affiliate television station, less for independents, and significantly less for radio stations. Average salaries for selected categories of television and radio news personnel are presented in Table 10-1. Equipment is the largest capital expense, with many operations converting to a nonlinear, digital world. News services in the form of wire services, syndicated news sources, and subscriptions represent another expense category.

There are other expenses that are either directly or indirectly tied to the news department. Overtime tends to be a common expense in the news department when news events require keeping personnel beyond normal working hours as events evolve. Travel and satellite time represent other common expenses. Research in the form of focus groups is often used as a qualitative measure to obtain audience feedback, while ratings services provide quantitative measures of demographic reach and viewing trends. Other types of expenses include such things as fuel and vehicles, tape, sets, office supplies, and telephone expenses.

Remember that news department budgets vary across the electronic media and market size, and the budgetary items discussed in this section may not be applicable to all news operations. Regardless of the type of market, one should realize that budgetary management of a news department represents a number of challenges, and the abil-

ity to utilize resources in the most effective way directly impacts the overall performance of the news department. Given this range of experiences, News Directors make excellent candidates for General Manager positions.

Issues in News Management

News Directors deal with a number of issues in the course of leading their news operations. This section focuses on some of the more salient issues managers confront on a daily basis, as opposed to logistical issues associated with breaking news events.

Erosion of the News Audience
With so many viewing options available for today's television viewers, audience levels for local television news have tended to decline in recent years. The decline in audience has placed even more pressure on news departments and news managers to reverse the ratings slide, before advertisers balk at paying increasingly higher prices to reach fewer and fewer audience members.

A national study of 500 adults conducted by NewsLab released in September 2000 found that viewers were not uninterested in local news, but they chose to get their news from sources other than television. Newspapers were identified as the primary source of local news by 43.2 percent of all respondents, with 20.6 percent ranking television second, followed by radio at 16.8 percent (Potter & Gantz, 2000).

In addition to getting their local news from some other source, respondents also cited being too busy, not at home when news is broadcast, too many crime stories, and not enough positive news as reasons they were not watching local news. In order to get the audience back to local television news, the authors identified several things viewers wanted to see in regards to local news. These items included more variety, greater depth of reporting, and better coverage of local news and events (Potter & Gantz, 2000).

This study illustrates the major challenge news management faces in many local markets: how to deliver a quality product that the audience finds interesting and informative, while at the same time attracting advertisers. The authors conclude that if news focuses more on news that matters to individuals as opposed to just crime and vi-

olence, the audience will respond more favorably toward local television news.

Negotiations with News Talent

News anchors and reporters often have detailed contracts specifying the terms of service, compensation, benefits, and personal services provided by the electronic media facility. An agent often represents talent in contractual negotiations in large and medium markets. News Directors usually are involved in negotiations for news contracts along with the General Manager.

Contracts serve to protect both parties. For the talent, the contract specifies the financial commitment the organization makes to the individual. In turn, the contract protects the electronic media facility from another entity in the market buying out an existing contract, leading to talent jumping from one operation to another. Many contracts contain what is referred to as a **non-compete clause** that specifies the length of time employees must remain off the air in the market if they leave their position. Some states have ruled that these clauses are unconstitutional, so it is important to understand state regulations regarding labor and employment.

Good talent is one of the keys to a successful news operation, so management tries to do whatever it can to maintain a positive relationship with its on-air talent. This can be especially challenging with local news departments, as individuals who do find success as news talent typically have many employment options, from moving to a larger market to making the jump to a network operation.

Ratings and Sweeps

Aside from the daily pressures of presenting news that is accurate, objective, and fair, the constant pressure associated with ratings looms over the newsroom. Everyone in the newsroom from the News Director down knows that the success of the news operation is not measured by how well the news is planned and presented but by how favorably the audience responds to the news via audience ratings.

Chapter 9 details the way ratings are gathered and analyzed. In this chapter, the focus is on how the ratings impact the presentation of local news.

In television news, sweeps is the critical time period for assessing viewing trends. The sweeps are held four times a year, during the months of February, May, July, and November, but adjustments to

this schedule may take place due to recurring events like the elections, the Olympics, or other significant events. During sweep periods, news departments devote a block of time to "special" reports on topics that run on consecutive days. Some news operations have been criticized for presenting what many feel are merely sensational stories dealing with sex, crime, and drugs. Other news operations have been lauded for presenting series that deal with important community issues regarding education, politics, health, and medicine, as well as investigative reports detailing fraud and corruption.

Determining the type of series and other strategies (e.g., a new news set or news theme) to unveil during sweeps requires months of advance planning on the part of the news management team. Trying to coordinate materials for a sweep period that is weeks or months away adds another layer to the responsibilities of news management personnel.

News Ethics Ethical issues, first discussed in Chapter 3, tend to have a recurring presence in the newsroom. Ethical confrontations can occur in several areas of news gathering and delivery, as illustrated in the following paragraphs.

Technology is one such area. The increasing use of helicopters in news operations, first designed for use in monitoring traffic problems and coverage of fires and other accidents, has expanded into an array of activities that confront news ethics. Most viewers can remember the infamous police chase of the white Bronco carrying O. J. Simpson that was carried out on national television. In recent years, TV helicopter crews have captured gunfights between the police and various suspects that often resulted in on-camera suicide or death.

Live shots have become a staple of local news, but they raise the question of whether live shots are needed or even desired by the audience. Knowing when to engage the live shot is more important than the ability to provide a live shot. Live shots also have the potential of endangering the news crew in certain situations such as demonstrations or violent conflict.

The use of hidden miniature cameras to collect material that traditional camera crews would be unable to obtain raises another set of questions regarding news ethics. There are some instances where the use of hidden cameras may in fact benefit the public, but news managers must know the proper time to invoke such a practice

(Steele, 1997). Regardless of their use, a portion of the public will always feel the use of hidden cameras in any situation is deceptive and unwarranted.

Presenting material fairly and accurately is a constant challenge for reporters. News Directors must demand accurate research, checking of facts, and corroboration of source material before stories are broadcast. Failing to do so violates any trust developed between the newsroom and the audience.

Finally, the use of video news releases (VNR) that are in reality videos produced by public relations departments should rarely be used as a news story. One publication calls the use of VNRs a "threat to the integrity of news programs" (Westin, 2000, p. 9).

Race and Ethnicity Issues

The Freedom Forum, a nonprofit organization funded by Gannett, released a report in 2000, "Best Practices for Television Journalists," authored by former ABC News Executive Av Westin. The handbook was based on anonymous interviews conducted with many news professionals at the local and network levels, across the United States.

The research surprisingly uncovered a lack of sensitivity in newsrooms towards race and ethnicity, which in turn influences story content and selection (Westin, 2000). News managers need to consider whom to assign to stories and need to assist in determining what footage to use in reports. The report calls for a system to create better balance in the presentation of news stories, as well as establishing in-house diversity councils to monitor and evaluate the production and presentation of the news.

Issues of race and ethnicity cannot be ignored, especially in the delivery of news programming. Media observers hope that the "Best Practices" report will provide greater awareness of the bias and insensitivity that exist in some newsrooms and will lead to solutions and training programs to prevent such problems from occurring.

Dealing with Unions

As discussed in Chapter 6, labor unions are prevalent in the electronic media industries and can be found in several representative areas related to the newsroom. While actual negotiations with unions are likely to be handled by the General Manager or perhaps an Operations Manager, News Directors may be involved because of the importance to the overall news operation.

One clear responsibility in unionized news operations is to make sure that people do not deviate from their job responsibilities. For example, camera operators are limited to their work with the camera, while the editors handle editing equipment, studio technicians handle the studio environment, and so forth. Management must be certain that duties are clearly defined and followed in accordance with guidelines agreed upon by management and the unions.

Summary

News serves a critical role for electronic media organizations and for society. For electronic media organizations, news establishes a sense of localism with audiences and advertisers and provides an important source of programming. For society, news programming helps individuals understand and interpret events that affect their lives in a local, national, and global context.

News and news programming is ubiquitous and pervasive. In addition to the local news presented by television and radio stations, there are local and regional news operations available to cable and satellite households, as well as national and international news services like CNN, Fox News, MSNBC, and CNBC. The Internet also delivers news to audiences in the form of text and graphics, as well as accessing video and audio streaming technologies.

News departments are under the direction of a News Director, who usually reports directly to the General Manager. The News Director manages the department along with the Assistant News Director and Assignments Editor. Producers, anchors, reporters, photographers, and editors round out the typical news staff. Salaries and duties vary across markets and type of facility (e.g., radio, television, or cable).

News Directors deal with a number of issues in the day-to-day management of the news department. Among the most prominent issues News Directors face are dealing with the erosion of the news audience, negotiating with talent, dealing with ratings and sweep periods, facing ethical issues and ethnic and gender bias, and dealing with unions.

CASE STUDY ## Live at 5:00 Takes a Twist

WDDD-TV is a VHF station located in a top-10 market. An ABC affiliate, WDDD has a strong local news presence in the market. The first afternoon newscast at 5:00 P.M., called "Live at 5:00," provides a mix of soft news, weather, and traffic information, with an occasional interview feature.

It is a typical Wednesday afternoon. The station's traffic reporter is inside the station's helicopter ready to appear live to give the first of three traffic updates to viewers. Just before going to air, the reporter observes a high-speed chase on the westbound side of a freeway involving a sports car and two police cars. The reporter goes to the first segment, with sirens obvious in the background.

Once the shot has switched back to the studio, the reporter asks the station's director through an internal feedback channel whether the chopper should follow the chase to see what is happening. Almost simultaneously, new information emerges. The police radio in the newsroom provides details of the car chase. Inside the car is a suspect, with a hostage taken in a carjacking. Several witnesses said the suspect was brandishing a gun. The victim of the carjacking has been identified via the license plate as a young mother who lives in a nearby suburb; it is possible there is a small child in the back seat.

As the News Director of the station, what do you tell your reporter and on-air team to do? Obviously the story has the potential to disrupt the entire newscast. Depending on what happens, the chopper cameras might witness a tragedy unfolding or a resolution to a dangerous situation. Clearly, you do not want the news helicopter to interfere with the work of the law enforcement officials, nor do you want to risk endangering any hostages trapped in the car.

The station newscast goes to a scheduled commercial break. The news will be back on the air in less than 90 seconds. A quick glance at the monitors in the newsroom tells you that none of the three local news competitors are on the story, at least from a "live" perspective. What do you do? Do you pursue the story? If so, what instructions will you forward to your reporter and production staff about how to cover this breaking news story?

CASE STUDY	**Anchor Woes**

Blessed with a strong but calming voice, Bill Powers has been anchoring television news in a top-20 market for the past 24 years. Many residents of the market associate Powers with the news, and for several years he dominated ratings at both 6:00 and 11:00 P.M. But over the past 2 years, the numbers have declined, in part due to the overall erosion of television news, and in part from intense competition from local competitors who offer a qualitatively different product to viewers.

Powers' 4-year contract is due to expire in 5 months, but the station has not reached an agreement with the anchor. Powers has been serving as his own representative. News Director Jennifer Scott, in meetings with the station's General Manager, John Craig, is well aware of the need to reduce expenditures for the news department and wants to hold down salaries. Powers has been offered a 3 percent salary increase and a 2-year contract extension; he wants an 8 percent raise and another 4-year deal.

The latest negotiating session has proved to be a nightmare for the station. Scott informed Powers that the station would offer a 4 percent salary increase for 2 years, and if ratings improved during the next 24 months, there would be incremental bonus money that would in effect add another 3 percent increase to his salary. Powers rejected the offer, claiming he was so upset with the station's offer that he intended to move to the station's primary competitor once his contract was up. In fact, he had already negotiated a new deal with the other station.

Scott was stunned. She knew that Powers did not have a non-compete clause in his contract, primarily because he had been considered a lifelong employee of the station. Legally, she could not keep him from going to work for another station. The question was what to do in the remaining 5 months of his contract.

Scott went to meet with the General Manager after the meeting to discuss options. There were really very few to consider. "He has got to go, now!" said Scott. "I don't want him on the air." Craig agreed that was probably the best thing to do, but how would the station handle the anchor chair? The weekend anchor was not an option for the full-time duties, and since Scott had been the lone anchor, there was no in-house replacement waiting in the wings. Further, the station was 2 weeks into a sweep period. The timing was awful from every possible angle: the effect on the news operation, the impact on the ratings, and the public relations problems this situation would create.

If you were the News Director, how would you handle this situation? What could you do to try to minimize the damage this situation might cause internally to the news operation, and externally to viewers and advertisers?

InfoTrac College Edition

For new information on news and the electronic media, use InfoTrac College Edition. Use the following terms for subject and keyword searches: broadcast journalism, electronic media, news, news management, news programming.

Web World

Here are some Web sites related to news and broadcast journalism:
Radio-Television News Directors Assoc. (www.rtnda.org)
The Poynter Institute (www.poynter.org)
American Journalism Review (www.ajr.org)
Don Fitzpatrick's ShopTalk (www.tvspy.com)
Investigative Reporters and Editors, Inc. (www.ire.org)
The Freedom Forum (www.thefreedomforum.com)
The News Lab (www.newslab.org)

References for Chapter 10

Albarran, A. B., & Pitts, G. G. (2001). *The radio broadcasting industry.* Boston: Allyn & Bacon.

Eastman, S. T., & Ferguson, D. A. (1997). *Broadcast/cable programming strategies and practices* (5th ed.). Belmont, CA: Wadsworth.

Hatchen, W. (2000). *The world news prism* (8th ed.). Ames, IA: Iowa State University Press.

National Association of Broadcasters. (1999a). *Radio station salaries.* Washington, DC: Author.

National Association of Broadcasters. (1999b). *Television employee compensation & fringe benefits report.* Washington, DC: Author.

Potter, D., & Gantz, W. (2000). *Bringing viewers back to local TV news: What could reverse the ratings slide?* Available online: www.newslab .org/bringback-1.htm [Accessed September 22, 2000].

Steele, B. (1997, September). Hidden cameras: High-powered and high-risk. *Communicator.* Available online: www.rtnda.org/prodev/articles/ hidden.htm [Accessed May 30, 2000].

Westin, A. (2000). *Best practices for television journalists.* New York: The Freedom Forum.

Reg...d
Ele...ment

he federal government

olicy

gulatory force in the electronic

ulations that affect the
mmunication industries
departments that influence

e on electronic media policy

regulatory forces that affect electronic me-
read about some of these influences in ear-
Chapter 6 referred to equal employment
olicies. Chapter 7 alluded to the licensing
d how it establishes the geographical as-
scussion of strategic alliances in Chapter 2
ions have removed barriers limiting com-
n this chapter, you will see a more detailed
analysis of regulation and policy.

By regulatory influences, I refer to institutional (e.g., govern-
mental) policies that affect the daily operation and management of an
electronic media facility. This chapter examines regulatory influences

[overlaid newspaper clipping text:]

half a second
business, said Mark Kowal-
y, "That's the
says. "And, of
czuk, president of the Payne-
ve Italian soups
Arcade Business Association.
"Dawkins is a very motivated,
good-hearted person, and she is
prepared enough to pull it off
successfully."

NICKNAME

nickname,
Greg Copeland, an East Side
eems apt for
activist who also chairs the
isn't been afraid
city's Republican Party Commit-
e status quo by
tee, says he supports many of
questions. The
her efforts but has had a run-in
s from her child-
or two over the years.
favorite nurs-
One involved her support for
ho put the over-
a bingo parlor on Payne.
rphy's chowder?
Copeland says he opposed risk-
ask louder, loud-
ing planning council funds on
the short-lived venture. "I am
s — pushing for
glad that this time she's invest-
her own money in serving
ing

places as Gary, Ind., or Me
phis, Tenn.

"Very often, people int
duce themselves (by) their j
'Hi, I am so and so, and I an
doctor,' " Dawkins says. "F
here, people will say: 'Hi, I am
and so, and I am from Railro
Island, or some other sm
neighborhood within the Pay
Avenue district. Together,
are East Siders."

With Kristin Dawkins,
always back to such first-pers
plural references.

She points to her Pay
Avenue work-in-progress ar
says: "It isn't just mine — it
everybody's."

ranging from agencies such as the Federal Communications Commission and the Federal Trade Commission to informal regulatory controls. Throughout, the chapter emphasizes how these regulatory influences affect electronic media managers.

Regulatory Influences: The Federal Government

Historically, the federal government has played a major role in shaping the present electronic media landscape in the United States. The federal government includes the president, the Congress, and the Supreme Court, representing the three branches of government—the executive, legislative, and judicial. Each of these branches plays a role in the regulation of the electronic media. Each of these areas is discussed in the following sections.

The Executive Branch

The executive branch of the government consists of the executive office of the president and other offices and councils, the departments whose heads form the president's cabinet, and several independent agencies. The president enforces the laws passed by Congress and makes appointments to agencies such as the Federal Communications Commission (FCC) with the Senate's approval.

By appointing the FCC chairman and other commissioners, the president directly influences electronic media policy. The FCC chairman and two other members of the commission represent the same political party as the president; the other party holds the other two seats.

The Legislative Branch

The legislative branch is made up of Congress and several administrative agencies. Congress consists of the United States Senate and the House of Representatives, politicians elected by the people they represent in various states and districts. Congress makes, repeals, and amends federal laws; levies taxes; and allocates funds for the entire government.

Media managers monitor congressional actions and administrative agency regulatory activities through several avenues, including trade associations such as the NAB, the NCTA, and the USTA (United States Telephone Association); Washington-based attorneys who rep-

resent electronic media owners; and trade publications. Most regulatory action in Congress that impacts the electronic media begins in the House with the Energy and Commerce Committees and the Telecommunications Subcommittee. In the Senate the Commerce Committee and Communications Subcommittee are often starting points for legislation.

The Judicial Branch The judicial branch of the government consists of the Supreme Court and other federal courts or district courts. The president appoints justices to the Supreme Court and federal judges, whom the Senate must approve. In both cases, the appointments are for life. The courts interpret the Constitution and federal laws.

There are approximately 95 federal district courts in the United States. Above the district courts are 13 courts of appeals designated as circuit courts. A decision at the district level may be appealed to a circuit court, and from the circuit court of appeals to the Supreme Court. Because it would be impossible for the Supreme Court to hear all appeals presented to it, the Court decides which cases to consider during each of its sessions. If the Supreme Court refuses to hear an appeal, the decision of the lower court stands.

Role of State and Local Law

The United States Constitution gives power to the federal government to make laws in areas of national concern, including matters pertaining to communications policy. However, state and local laws regulate certain aspects of electronic media policy, in coordination with national policies. Though this chapter focuses on federal policy, wherever state and local laws pertain to the topic (such as cable television and telecommunications regulation), their role is presented as well.

Role of the Federal Communications Commission

Though several federal agencies influence electronic media policy, the FCC exerts the greatest influence (Nadel, 1991). In examining this agency, we first consider the actions that led to its creation.

The FCC:
A Brief History

With the passage of the Wireless Ship Act of 1910, the government first recognized the importance of communication for both safety and commerce. Two years later, the Radio Act of 1912 established basic priorities for radio licenses. By the 1920s, radio was flourishing in the United States. Anyone could obtain a radio license through the secretary of commerce, whose office awarded licenses because radio communication crossed state boundaries. But chaos ensued when too many licenses were issued, resulting in overcrowding and technical interference.

Broadcasters attempted self-regulation through a series of national radio conferences held from 1922 to 1926, but they could not reach a consensus. In an unprecedented move, broadcasters asked the federal government to regulate the radio industry by establishing policies for station licensing and operation. Congress responded by passing the Radio Act of 1927, which created the Federal Radio Commission (FRC). Congress recognized the scarcity principle in its legislation—the idea that more people would want to engage in broadcasting than available frequencies would permit. The 1927 act introduced the PICON principle, which stated that all broadcast licensees had to "serve the public interest, convenience or necessity," a phrase borrowed from the Interstate Commerce Act (Le Duc, 1987). Because a broadcast license represented a scarce resource, the FRC was to ensure that licensees would serve the public interest.

Interestingly, though the FRC was not intended to be a permanent agency, it could not complete its mission in just 1 year as originally conceived. By the 1930s, with radio growing as a national medium and television in development, the need for a permanent agency became obvious to regulators. In 1934 Congress passed the Communications Act of 1934, which established the FCC to replace the FRC. The FCC became an independent agency with the power to regulate communication by wire and wireless—including radio, telephone, telegraph, and eventually television, as well as microwave and satellite transmission.

The Communications Act of 1934 was the cornerstone of electronic media regulation for 62 years. In February 1996, Congress passed a new Telecommunications Act that dramatically altered many regulatory policies affecting the broadcast, cable, and telecommunication industries. The act's primary goals were to promote competition and reduce regulation in order to provide lower prices and better services to consumers and to encourage the growth of new telecommunications technologies (Messere, 2000).

Among the many provisions of the act were several important changes. National ownership limits for radio were removed, while ownership limits for television were raised. Open competition between the cable and telephone industries was stimulated, along with a requirement that television manufacturers include a "V-chip" device in new receivers to allow blocking out of programs containing sex and violence. The 1996 act retains the FCC as the primary regulatory body for the electronic media.

The FCC Today

The FCC comprises five members, one of whom serves as chairman. Commissioners are appointed for 7 years and can be reappointed, although only a few commissioners have remained beyond their original term. The FCC continues its efforts to regulate telecommunications, although scholars question if this is possible given the rapid changes in the industry (Entman & Wildman, 1992).

Regardless of criticisms, the commission has responded to changes in the electronic media over the past 30 years. Beginning with the Carter administration in the late 1970s, the FCC entered a period of deregulation, eliminating a number of bureaucratic requirements for radio broadcasters under former chairman Charles Ferris. During the Reagan administration, chairmen Mark Fowler (1981–1987) and Dennis Patrick (1987–1989) further emphasized deregulation. Here are a few of the areas affected during this era.

- *Elimination of the Fairness Doctrine.* The Fairness Doctrine required broadcasters to present both sides of controversial issues (Aufderheide, 1990). Broadcasters for the most part argued that the Fairness Doctrine actually inhibited coverage of controversial topics and violated their First Amendment rights.

- *Community ascertainment requirements.* Broadcasters were once required to gather opinions from leaders in the community they served regarding issues of importance and were expected to offer specific programming (usually as news or public affairs) to address those issues. For broadcasters, ascertainment was a tedious and time-consuming requirement.

- *Programming quotas for news and public affairs.* The FCC eliminated quotas on the amount of news and public affairs programming for broadcast stations.

- *License renewal procedures.* License renewal procedures were greatly streamlined, with the length of license increased for radio and TV stations.

The Bush administration and FCC chairman Alfred Sikes (1989–1993) advocated further marketplace regulation with a number of additional changes:

- *Elimination of the fin-syn rules.* The financial interest–syndication rules (see Chapter 8) restricted the networks from having a financial interest in the programs they broadcast or from having syndication rights. The rules expired in November 1995.

- *New technology development.* The FCC began serious efforts to develop new communications technologies by encouraging the growth of digital television (formerly referred to widely as HDTV), digital audio broadcasting (DAB), and the participation of telephone companies in distributing video programming.

The Clinton administration took an entrepreneurial approach to communications regulation under chairmen Reed Hundt (1993–1998) and William Kennard (1998–2001). The FCC has dealt with a number of changes in the aftermath of the 1996 act, including review of mergers and acquisitions, the transition to digital television, authorization for television duopolies under certain market conditions, and growth and expansion of the Internet. At the same time, the Clinton-appointed FCC frustrated broadcasters with its traditional concerns over television violence, regulations on children's programming, changes in the EEO rules, and the refusal to further modify cross-media ownership of broadcast stations and newspapers.

The election of George W. Bush brought the Republican Party back into control of the White House and the FCC. Bush nominated commissioner Michael Powell to succeed Kennard as Chairman. The Powell FCC is expected to be more sensitive to the marketplace. Powell also intends to streamline the FCC to make the agency more efficient.

FCC Regulatory Policies: What the FCC Does

The FCC regulates many activities of electronic media companies by establishing and evaluating policies and procedures. It also has the power to levy fines and forfeitures against these companies. The Mass Media Bureau oversees regulatory activities for broadcasting, while

the Cable Services Bureau handles cable regulations. The Common Carrier Bureau oversees the telephone industry. Other offices and bureaus are presented in Figure 11-1. The following sections examine the role of the FCC in regulating the broadcast, cable, and telecommunication industries.

The FCC and Broadcasting

In the broadcast industry, the most visible and important actions of the FCC involve the licensing process. Why? Simply because a broadcast license is a valuable resource, as evidenced by the high prices paid to purchase radio and television stations. The price to purchase an electronic media facility in even small markets can be millions of dollars. Though actual equipment, land, and other assets do not warrant such high prices, the FCC license represents an invaluable asset to station owners. The license is the key asset owners acquire when they obtain a broadcast station (Bagdikian, 1997).

The FCC grants and renews licenses, but it also can take them away—something that has happened infrequently in broadcast history (see *KFKB Broadcasting Association, Inc. v. FRC*, 1931; Le Duc, 1987; *Office of Communication of the United Church of Christ [UCC] v. FCC*, 1966). The FCC also approves the transfer of a broadcast license—the actual sale of a radio or television station to a new owner. Here are some of the most important FCC licensing policies that managers need to be aware of.

- *Ownership limits.* Historically, the FCC has established limits on the number of stations an individual or company may own. The 1996 Telecommunications Act eliminated national ownership limits for radio. In local markets, the number of radio stations an individual or group may control is affected by the market size and by the number of television stations owned by the same individual or group. For the television industry, no individual or group may own stations that collectively reach more than 35 percent of the national audience. The 35 percent cap may be modified under the Powell FCC.

- *Duopoly rules.* In 1999, the commission approved common ownership of two television stations in the same market provided eight stations (commercial and noncommercial) remained post merger. Further, no duopoly is allowed among the top four stations in the market in terms of audience share. The duopoly rule also impacts

FIGURE 11-1 Federal Communications Commission Organization. From FCC Web site, www.fcc.gov.

cross-ownership of other media. If two television stations are owned in the same market, it reduces the number of radio stations the same owner may hold depending on the market size and the number of stations present (FCC revises, 1999).

- *Local marketing agreements (LMAs).* LMAs were first established during the early 1990s in radio and later spread to television. LMAs allowed one station to take over the programming and advertising sales for another station in the market without assuming ownership of the facility. The FCC made several minor changes to LMA policies in 1999, at the same time that it made changes in regulations regarding television duopolies. The most important change was that most existing LMAs would be allowed to become TV duopolies.

- *License renewal.* Broadcast licenses for both TV and radio stations were extended to 8 years under the 1996 act. The FCC also eliminated certain procedures for challenging a license renewal.

- *EEO guidelines.* New EEO guidelines adopted by the commission in January 2000 were subsequently thrown out by the courts in 2001 (see Chapter 6). At the time of publication, there are no EEO rules in place. Broadcasters and the FCC will attempt to develop new guidelines that will satisfy issues of constitutionality.

- *Cross-ownership rules.* The 1996 act allows broadcast stations to acquire cable systems, and cable operators may acquire broadcast stations but not broadcast networks. However, in March 2001 the Powell FCC decided to allow Viacom to own both CBS and UPN, which suggests that other small networks (e.g., WB, Paxnet) could be acquired by larger networks. The FCC is expected to further liberalize cross-ownership restrictions, especially in regards to newspaper-TV-radio cross-ownership. The 1996 act requires annual review of ownership policies to ensure they continue to meet the goals of the act.

- *Transition to digital television.* All existing analog stations must convert to digital transmission (DTV) and move to a new digital channel by 2006. Many stations in larger markets have already converted to digital equipment and transmit some limited programming on their digital channel. Many issues regarding DTV have not been resolved, especially regarding carriage of the new digital signals over cable television systems.

TABLE 11-1

TABLE 11-1

Public File Contents

Broadcast stations are required to maintain several types of information in the public file, in either paper or electronic form. The amount of time required to retain each item varies, depending on the length of the license term, except where indicated.

1. FCC applications, ownership documents, written agreements with community groups, annual employment reports (FCC Form 397 Statement of Compliance), and related EEO information.

2. The most recent version of the FCC publication *The Public and Broadcasting—A Procedure Manual.* Should be retained indefinitely.

3. Correspondence regarding requests for political time and information on any controversial programming.

4. A list of community issues and programs that have been afforded significant treatment by the station.

5. Letters and written comments from the public regarding station programming and other issues. Defamatory or obscene material should not be included, nor letters the authors have asked to be restricted from public access.

6. Quarterly report listing compliance with commercial limits on children's programming and a list of programs detailing the station's commitment to educational needs of children (FCC Form 398 for TV stations only).

NOTE: Adapted from *Electronic Media Management,* (4th ed.), by P. K. Pringle, M. F. Starr, and W. E. McCavitt, 1999, Boston: Focal Press; and Federal Communications Commission Web site (www.fcc.gov).

- *Public file.* All broadcast stations must maintain certain documents and information in a file available for public inspection during regular business hours. Stations must also handle telephone requests for information from the public file during regular business hours. Major documents required in the public file are listed in Table 11-1.

- *Operating and technical requirements.* As part of their license obligations, all broadcast stations must follow strict operating guidelines. The license specifies the channel of operation, transmitter power, hours of operation, maintenance of antenna and tower lights, proper station identification, and compliance with the nationwide Emergency Alert System (EAS). Failure to follow these standards can result in fines for the owner.

TABLE 11-2

**Voluntary
Programming
Code Ratings**

CONTENT RATINGS	
FV	Fantasy Violence
V	Violence
S	Sexual Situations
L	Coarse Language
D	Suggestive Dialogue
AGE RATINGS	
TV-Y	Programs Created Solely for Children
TV-Y7	Directed to Older Children
TV-G	General Audiences
TV-PG	Parental Guidance Suggested
TV-14	Parents Strongly Cautioned
TV-MA	Mature Audiences Only

- *V-chip requirements.* The 1996 act mandated that new television receivers must be equipped with a V-chip (short for violence chip) to be used in conjunction with a ratings system for television programming (see Table 11-2) that would give parents the option to block out unwanted programs. After years of deliberations on implementation and a timetable for production, the first sets equipped with the V-chip became available in January 2000.

**The FCC and
Programming
Policies**

Another visible area of FCC policy concerns broadcast programming. Although the FCC lets broadcasters determine what types of programming their local audiences will accept, the commission has adopted several policies that directly influence programming at local stations, such as the following:

- *Children's television programming.* The FCC has long been concerned with how broadcast programming meets the needs of children. Over the years the FCC has adopted several policies requiring broadcasters to provide responsible content. Congress passed the Children's Television Act (CTA) in 1991, with the commission adopting new rules in 1996 to strengthen enforcement (FCC adopts, 1996). The act requires broadcasters to provide at least 3 hours of core programming a week for children ages 12 and under.

The FCC defines core programming as any regularly scheduled weekly programming of at least 30 minutes, airing between 7:00 A.M. and 10:00 P.M., that has serving the "educational and informational needs of children as a significant purpose" (FCC adopts, 1996). Further, the rules require broadcasters to place quarterly programming reports in their public file on a quarterly basis, describing how they meet their obligations under the CTA. Stations are also required to file an annual Children's Television Programming Report (FCC Form 398).

The act also imposes limitations on the amount of commercial time in children's programming, 10½ minutes an hour on weekends and 12 minutes an hour on weekdays (Children's Television Act of 1990; Policies and Rules, 1993).

- *Television ratings system.* The prime-time television ratings system was established by the FCC following passage of the 1996 act. Networks were asked to voluntarily label their programs with codes for sex, violence, and dialogue (language) (see Table 11-2). News and sports programs are not rated. NBC has continually refused to participate in the voluntary ratings, the only network that does not label its programming.

- *Obscenity.* Broadcasting obscene material is against the law. But how does one define *obscene material?* Its definition comes from the *Miller v. California* (1973) decision by the Supreme Court. The material in question must meet three criteria: (1) The average person, applying contemporary community standards, finds that the work as a whole appeals to prurient interests; (2) the work depicts or describes in an offensive way sexual conduct specifically defined by the applicable state law; and (3) the work lacks serious literary, artistic, political, or scientific value (also called the LAPS test). By and large, broadcasters avoid any programming that one might consider obscene.

- *Indecency.* While indecent speech is protected under the First Amendment, it can be regulated. For many years, the *Pacifica* ruling regarding George Carlin's "seven dirty words" monologue served as the model of indecent speech (*FCC v. Pacifica Foundation,* 1978). In 1987, the FCC issued a new definition of indecent language: "language or material that depicts or describes, in terms patently offensive as measured by contemporary community standards for the broadcast medium, sexual or excretory activities or

organs" (New Indecency Enforcement Standards, 1987). The new standard became very controversial because it failed to clearly address the types of material that were prohibited, the hours the material could be broadcast, or the specific penalties for violation.

In the years following the *Pacifica* decision, the FCC adopted several provisions that permitted the airing of indecent programming during certain hours, a time period that became known as a "safe harbor." However, the courts repeatedly struck down the FCC limitations as unconstitutional. Resolution came in 1995 when the U.S. Court of Appeals ruled the commission could permit broadcasting of indecent material between the hours of 10:00 P.M. and 6:00 A.M. (*Action for Children's Television v. FCC*, 1995).

- *Equal time provisions (Section 315).* Section 315 of the 1934 Communications Act requires broadcasters to provide equal broadcast time for all legally qualified candidates for public office. Today, the rule primarily applies to political advertising. Participation by candidates in a newscast, politically sponsored debate, or other bona fide news event is exempt from the rule. The rule specifies that stations must sell political advertising at the lowest-unit-rate (LUR) charge to qualified candidates. Some networks and local broadcasters have voluntarily offered prime-time advertising (usually up to a 5-minute block) to legally qualified candidates for president. Other owners have refused to participate.

- *Broadcasting a hoax.* On-air hoaxes have long been associated with the radio industry, dating back to the 1938 CBS broadcast of "War of the Worlds," which caused panic among many listeners. In most cases, hoaxes have been presented with no harm intended. In 1992, the FCC issued new rules regarding on-air hoaxes (Broadcast Hoaxes, 1992). Essentially, the new rules forbid broadcasting of false information if three criteria apply: (1) The sender knows the information is false, (2) the broadcast of the hoax may cause public harm, and (3) broadcasting the information does in fact cause harm. Stations guilty of broadcasting a hoax can be fined up to $10,000.

- *Lotteries.* Broadcasters may not broadcast or sponsor a commercial lottery. Managers should be particularly concerned about promotional contests and campaigns that unintentionally carry the three elements that constitute a lottery—prize, chance, and consideration. Any contest or other activity that requires an individual

to pay some sort of fee (consideration) that provides an opportunity to be selected (chance) for some award of value (prize) constitutes an illegal lottery and is subject to a fine. The lone exception to broadcasting lotteries concerns those states with voter-approved lotteries, where licensees may carry announcements and advertisements for legal state lotteries.

The FCC and Cable Television

Regulation of the cable industry differs greatly from that of broadcasting. The FCC Cable Services Bureau oversees and enforces cable television regulation. However, cable operators do not obtain a license from the FCC; instead, they must obtain a **franchise** from a local governmental authority. The franchise agreement sets forth the requirements for each local cable system regarding fees, channels, and so forth. For many years, cable franchises were considered exclusive arrangements, giving cable operators monopolistic power. In passing the Cable Television Consumer Protection and Competition Act (1992), however, Congress eliminated exclusive franchising in the cable industry.

The 1992 Cable Act was designed to reregulate the cable industry in several specific areas, including rates for basic cable service (Johnson, 1994). Cable was effectively deregulated in 1984 with the passage of the Cable Television Communications Act. However, as cable rates soared and customer service declined under deregulation, citizens pressured Congress to act.

The 1996 Telecommunications Act also affected the cable industry. Among the major provisions were the following:

- *Rate regulation for basic cable.* National rate regulation for basic cable was eliminated in 1999. The cable operator establishes local rates, subject to the approval of the franchising authority. In many cases, the cable operator and the franchising authority end up negotiating rate increases.

- *Must carry/retransmission consent.* This provision gives broadcasters the right to negotiate with the cable operator for carriage of their station. TV stations now have one of two options. First, broadcasters can take **must carry,** which requires the cable operator to carry the television signal on the cable system at the channel's regular or mutually agreed-on channel position. Second, broadcasters may opt for **retransmission consent** in lieu of must carry and

thus negotiate individually with each cable system for compensation and channel position. The chosen option is to be renewed every 3 years. Most TV broadcasters have chosen must carry; very few stations have successfully negotiated retransmission consent. Must carry was challenged all the way to the Supreme Court, and the Court upheld the policy.

Broadcasters were hopeful that cable operators would be required to also carry their digital channels during the conversion period from analog to digital. The FCC has ruled that the cable operators are not required to carry both analog and digital channels under must carry.

- *Ownership provisions.* Previously, the FCC adopted a 30 percent audience reach cap, meaning a cable operator may serve no more than 30 percent of all multichannel households (defined as national cable and satellite TVHH). In March 2001, the courts ruled that the 30 percent cap was arbitrary and capricious and effectively eliminated any cap requirement for cable television ownership (Dreazen & Solomon, 2001). The decision also calls into question the role of the 35 percent audience reach cap for broadcast television.

- *Network exclusivity.* Cable operators may neither carry nor import network-affiliated programming that duplicates the same program on a local TV station. For example, a cable operator in Washington, D.C. may not import programming from a network affiliate in Baltimore; the station must provide the local network affiliates with program exclusivity.

- *Syndication exclusivity (syndex).* Local television stations pay high prices for syndicated programs; therefore, they want assurance that their programs will not be duplicated. The station must first engage in an exclusive market arrangement with the distributor. Once that contract is negotiated, the station must notify the cable operator, who must block out any programs in question. You may have observed this on local stations carrying sporting events; in the case where the local station has exclusive rights to the broadcast, the cable operator blacks out the signal from the other source and posts a message that the broadcast cannot be shown, because of federal regulations.

- *Program access channels.* The 1984 Cable Act established the right of franchising bodies to require that certain channels be designated

for public, educational, or governmental access. These PEG channels are not under the jurisdiction of the cable operator. In fact, because the operator may not censor or edit any of the material presented on the PEG channels, controversy has arisen in some communities. In 1995, a federal appeals court ruled that cable operators may place explicit public access programming on so-called "blocked" channels, which would require individual households to notify the cable operator if they wished to receive the programming (Pearl, 1995).

The FCC and Telephone Regulation

Telephone regulation is an extremely complicated process to address because of different jurisdictional boundaries and market segments. It involves interexchange (long-distance) service, local exchange service, and cellular and personal communication services regulated at both the state and national levels.

The long-distance or interexchange market is overseen by the FCC's Common Carrier Bureau. Most regulatory activity concerns rate regulation. Historically, telephone companies were regulated under a **rate-of-return (ROR)** framework, meaning that rates were set at levels needed to produce enough revenues to cover total costs. Over time, ROR regulations did little to encourage new products or expansion in the telecommunications industry, so the FCC began to use a different method, known as *price caps,* to regulate interexchange carriers (Shields, 1991).

First introduced in 1989, **price cap regulation** limits the prices companies can charge, rather than regulating profits. This change allows companies greater flexibility in dealing with competitors and promotes greater efficiency. To maximize profits, managers attempt to streamline production activities to lower costs below established prices. Price cap regulation has benefited consumers as the cost of long-distance service has declined over the past several years.

Local exchange providers (LECs) are regulated in tandem by the FCC and individual states. Because the LECs derive most of their revenues from intrastate services, most importance is placed at the state level. State **public utility commissions (PUCs)** or **public service commissions (PSCs)** oversee rate regulation of local telephone service within the 50 states, as well as the charges associated with ancillary services such as Caller ID. Some states use ROR regulation, while oth-

ers have adopted price caps. To raise tariffs and telephone rates, LECs must file requests with the appropriate state regulator for approval.

The 1996 act was designed to spur competition among local and long-distance carriers by allowing entry into each other's markets, and also to allow cable companies the opportunity to provide local telephone service. But the regulation empowered the FCC to formulate specific policies regarding market entry into competitive markets. Before local exchange carriers could provide long-distance services, they had to meet an exhaustive 14-point checklist that illustrated efforts to open the local market they served to competition.

Early in 2000, these goals were far from being realized. Bell Atlantic (now known as Verizon) was the first local carrier authorized to provide long-distance service. SBC has repeatedly sought permission to begin long-distance service but has been refused for not being in compliance with the commission's directives. Long-distance carriers have had difficulty in marketing local service. AT&T, Time Warner, and Cox have been the most successful cable companies to provide local phone service, but total telephone households served by cable operators will be slow to develop, reaching an estimated 30 million HH by 2002 (Cable Television Industry Overview 2000).

The Cable Act led to greater consolidation in the telecommunications sector. Since passage of the act, several mergers have occurred involving a number of firms. SBC Corporation and Bell Atlantic have been the most aggressive. SBC acquired Pacific Telesis, Ameritech, and Southern New England Telecommunications (SNET); Bell Atlantic acquired NYNEX and GTE and was renamed Verizon. U.S. West was acquired by Qwest Communications. WorldCom (formerly known as LDDS) merged with MCI, to become MCI/WorldCom.

The telecommunications sector will endure massive technological change as carriers try to become the dominant provider of communication-related services (voice, broadband, data wireless, and Internet telephony) for business and home. Telcos will compete with cable operators and terrestrial broadcasters, as well as with Internet Service Providers, to establish and build on market share. Regulating the changing and competitive telecommunications landscape will remain a challenge in the years ahead.

Other Federal Departments and Agencies

While the FCC is the federal agency that most affects electronic media policy and regulation, other federal departments and agencies also directly influence regulatory action (Nadel, 1991). This section offers an examination of other such departments and agencies.

Department of Justice

The Department of Justice (DOJ), through its Antitrust Division, is concerned with anticompetitive practices in American industries, including the electronic media. The DOJ has been called on several times in recent years to gauge the impact of mergers and acquisitions in the media industries, particularly to determine if such actions would be in the public interest.

For example, the Antitrust Division investigated the mergers of AT&T and TCI, as well as mergers involving Viacom and CBS and AOL and Time Warner. The agency gained considerable recognition with its high-profile lawsuit against Microsoft.

Because broadcast stations are federally licensed, the DOJ also has the power to prosecute violators of the Communications Act. The department concerns itself with flagrant violations rather than routine levies and fines, which the FCC administers.

Federal Trade Commission

The Federal Trade Commission (FTC) oversees advertising regulation in the United States. Because the electronic media depend on advertising for their survival, managers need an awareness of FTC duties and jurisdiction. Essentially, the FTC investigates false or deceptive advertising as well as unfair trade practices.

Advertising regulation also falls under the jurisdiction of other federal agencies and departments, including the Food and Drug Administration, the U.S. Postal Service, the FCC, and the Securities and Exchange Commission (Vivian, 1999). In addition, many states have laws pertaining to deceptive or false advertising. The FTC maintains a strong interest in advertising aimed at children and has been granted authority to oversee Internet advertising.

National Telecommunications and Information Administration

Operating within the Department of Commerce, the National Telecommunications and Information Administration (NTIA) serves primarily to advise the president on telecommunication issues. The NTIA was particularly active during the 1990s, recommending that

telephone companies be allowed to provide video services and pushing the development of high-definition television in the United States.

Federal Aviation Administration

Given the number of transmitting towers spread across the country and their potential risk to aviators, the Federal Aviation Administration (FAA) has a vested interest in the electronic media. Broadcast stations face tough fines for failure to maintain proper lighting of towers and antennas. Checking the tower light remains a daily operator function at all broadcast stations.

Informal Regulatory Forces

Through its various branches and agencies, the federal government is the primary regulatory body affecting the electronic media. State and local laws also play a role in regulation. In addition, informal regulatory forces also affect electronic media management. In this section, I examine three areas of regulatory influence that lie beyond governmental boundaries: citizen/consumer groups, self-regulation, and the press.

Citizen/Consumer Groups

Though the Communications Act of 1934 established the importance of serving the public interest, a landmark case was needed to demonstrate that the public has the right to participate in regulatory proceedings. During the early 1960s, WLBT-TV in Jackson, Mississippi, was accused of discriminating against Blacks in several areas, including refusing to sell political advertising to a local Black candidate for public office (Kahn, 1984). Local groups fought the station's license renewal with legal assistance from the United Church of Christ (*Office of Communication of the UCC v. FCC,* 1966). The case dragged on for over 20 years, with the circuit court of appeals ruling in favor of the UCC petition to deny WLBT's license. Ultimately, the case established the idea of *citizen's standing,* meaning the public had the right to challenge broadcasters at renewal proceedings.

The WLBT case spawned a period of activism by citizen groups toward broadcasters, not only in challenging license renewals but also in establishing media watchdog groups like Action for Children's Television (ACT) and Accuracy in Media (AIM). Other groups have

targeted certain types of programming, advertising, and employment practices in their protests and boycotts. Consumer groups regularly challenge rate increases for cable and telecommunication services. Electronic media managers are always concerned about the impact of consumer groups and the possibility of regulation by governmental bodies.

Self-Regulation

To prevent possible governmental involvement, the broadcast and cable industries have attempted various types of self-regulation. For many years, radio and television stations voluntarily operated under the NAB Codes, which specified various rules regarding programming, advertising, and promotional activities. The Justice Department challenged the codes in 1979, claiming they limited competition for advertising prices and other charges. In a 1982 settlement, the NAB Codes were eliminated.

For the most part, broadcasters and cable operators take rather conservative positions regarding material that could be deemed controversial or cause public concern. Stations routinely scrutinize advertising messages and have been known to refuse commercials considered controversial. At the network level, program standards and practices departments still serve as watchdogs over network advertising and programming.

Codes of ethics and conduct also influence self-regulation. These codes are discussed more fully in Chapter 3.

The Press

Most major newspapers in the United States employ at least one media critic who writes exclusively about the electronic media. Magazines, trade publications, the Internet, and newsletters also provide forums for such reviews. Criticism by the press and other agents not only helps to enlighten the public but also serves as a system of informal control.

Broadcast and cable operators are usually praised when they do something well, such as providing coverage of important news events or presenting programs that educate and enlighten the public. At the same time, critics admonish the media for promoting questionable or tasteless programming and violating ethical and journalistic responsibilities.

The critics applaud the way the media use their facilities to promote world unity, such as the celebration of the new millennium, the

fall of the Berlin Wall and the Olympic Games. They also remind us when the media falls short by providing inaccurate news stories, as CNN did in its 1996 Tailwind coverage, and by carrying programs that provide little more than innuendo and titillation.

Summary

Regulatory influences occur at many levels and take different forms among the electronic media. Through its executive, legislative, and judicial branches, the federal government provides the main sources of regulatory influence in various departments and agencies.

The greatest single source of regulatory influence is the Federal Communications Commission (FCC). Created by the Communications Act of 1934, the FCC regulates the broadcasting, cable, and telecommunications industries in coordination with state and local bodies. The FCC consists of five members appointed by the president of the United States.

In the broadcasting industry, the FCC specifies criteria for broadcast licensing and ownership, along with a variety of technical and operating requirements. It also deals with a number of programming policies, including provisions for children's programming, obscene and indecent language, equal time, prime-time access, financial interest and syndication, and broadcasting of hoaxes and lotteries.

In the cable industry, the FCC regulates rates for basic service, in tandem with local franchise authorities. The commission also oversees policies in regard to must carry/retransmission consent agreements, program and syndication exclusivity, and access channels.

The FCC and individual states regulate the telecommunications industry through public utility commissions (PUCs) or public service commissions (PSCs). Most regulatory action concerns rate regulation. Policy makers have used rate-of-return policies along with price caps to regulate the costs of telecommunication services. A growing list of potential services in the form of cellular, wireless, personal communication, and broadband complicates telecommunications regulation.

Aside from the FCC, other federal departments and agencies influence regulation. These include the Department of Justice's Antitrust Division, the Federal Trade Commission, the National Telecommunications and Information Administration, and the Federal Avia-

tion Administration, which is concerned with broadcast and cable towers and their potential threat to aviators.

Informal regulatory influences on electronic media policy come from citizen and consumer groups, self-regulatory efforts, and criticism in the press, the Internet, and other venues.

CASE STUDY	Is It a Hoax?

Doug Graves, Julie Morrow, and Tim Sanchez host the popular "morning crew" program airing on WBCV-FM, a top-20 urban radio station located in the Northeast. The morning crew's reputation for outrageous stunts and jokes on the audience and key figures was common throughout the market. Particularly adept at doing a range of impersonations, Graves would often call unsuspecting audience members and imitate politicians and well-known actors like Tom Cruise and Nicholas Cage.

With Halloween approaching, the morning crew decided on a skit, which later proved to be damaging to the station. The crew was scheduled to do a live evening broadcast on Halloween night at a downtown dance club's grand opening.

Violence was all too common in the city, so the morning crew decided to have Graves "seriously wounded" as a result of a drive-by gang shooting, to play a trick on the audience. The team decided not to tell the station's Program Director about their skit, so he would be part of the joke as well. A number of sound effects were recorded in advance along with sirens, crowd noise, and other techniques to provide a realistic incident for the listening audience.

Morrow and Sanchez would continue to broadcast live from the scene, reporting on other events following the "shooting." About 30 minutes later, they would interview a "police official," played by Graves. A series of questions would determine that the fake police officer was actually Graves, that there had in fact been no shooting, and that everyone was fine. WBCV listeners could then call in for a variety of "treats" to be given away on-air to wrap up the remote.

The incident went off as planned, with some unexpected consequences. Numerous listeners proceeded to the downtown area to get a firsthand look at the crime scene. Traffic jams occurred at several major intersections, and three people were injured in separate auto accidents directly related to the incident. Many listeners hearing about the "shooting" flooded

switchboards at the radio station, the police station, and local hospitals to try to find out information on Graves's condition. After it was over, the station received angry phone calls from listeners all night. The next day, several local officials threatened to notify the FCC. Only a handful of listeners found the broadcast amusing.

Is WBCV-FM guilty of playing a hoax on the audience? How would you, as the manager of the station, handle this problem? Would you report this incident to the FCC? Why or why not?

| **CASE STUDY** | **Political Advertising** |

A heated race for a congressional seat was coming to an end with the election less than 10 weeks away. Three legally qualified candidates, a Democrat (Kerry Childers), a Republican (Joe Welch), and an Independent (Bart Bergman) were bitterly divided on several issues, including gun control, education, and social security reform. But the major issue dividing the candidates—and voters—was abortion.

As the only female candidate, Childers unconditionally supported abortion rights for women and garnered support from all the pro-abortion groups. Welch believed in pro-choice but felt the local and national government should not be expected to fund abortions in any way. Bergman is a strong pro-life supporter, and his campaign had the support of all of the pro-life groups.

Five local stations serve the market, four network affiliates and one public station. You manage the smallest station, the former independent station in the market now affiliated with the WB network. The three other network affiliates garner the greatest share of political advertising, and they sold time to all three candidates. But there has been considerable controversy over the Bergman advertising, which featured gruesome pictures of aborted fetuses. Under the political advertising guidelines, the stations cannot censor the ads, regardless of how offensive they may be.

At a midday staff meeting, Sarah Turner, the General Sales Manager, informs the department heads the Bergman group has requested advertising time on the station. "What do we do?" said Turner. "Technically, we don't have to sell advertising to Bergman's campaign, as we have not sold any advertising to the other congressional candidates. Personally, I don't want to offend our viewers and other clients as the other stations in the market have done by showing these controversial spots."

Jason Margolies, the Program Manager spoke up. "But isn't this part of our public service responsibility—to help voters decide on who to vote for in the election? I think we have an obligation here, regardless of the concern over the content. How can we not run these ads?" Promotions manager Julie Lewis expressed fear that the ads would hurt the audience more than they would help. "What are we supposed to tell the parents who call the station complaining about the ads and their impact on their children?"

Ultimately, the department heads failed to reach a consensus. Take the role of the general manager in this case, carefully examine the issues and consequences, and make a decision as to whether or not your station will accept these controversial advertisements.

InfoTrac College Edition

For new information on regulatory policy and the electronic media, use InfoTrac College Edition. Use the following terms for subject and keyword searches: electronic media regulation, electronic media policy, Federal Communications Commission.

Web World

The following Web sites offer information related to electronic media policy and regulation:
Federal Communications Commission (www.fcc.gov)
National Association of Broadcasters (www.nab.com)
National Cable Television Association (www.ncta.com)
National Telecommunications and Information Administration (www.ntia.gov)

References for Chapter 11

Action for Children's Television v. Federal Communications Commission, 58 F.3d 654 (D.C. Cir. 1995).

Aufderheide, P. (1990). After the fairness doctrine: Controversial broadcast programming and the public interest. *Journal of Communication, 40*(3), 47–72.

Bagdikian, B. (1997). *The media monopoly* (5th ed.). Boston: Beacon Press.

Broadcast Hoaxes, 70 RR 2d 1383 (1992).

Cable Television Consumer Protection and Competition Act. 47 U.S.C.A. Sec. 521 et seq., 1992.

Cable Television Industry Overview 2000. Available online: http://www.ncta.com [Accessed May 21, 2000]

Children's Television Act of 1990, 47 U.S.C. Sec. 303 (a)-3(b) (Supp. II 1991).

Dreazen, Y. J., & Solomon, D. (2001, March 5). Court overturns FCC's ownership caps, in victory for AT&T, AOL, cable firms. *The Wall Street Journal,* A3, A10.

Entman, R. M., & Wildman, S. S. (1992). Reconciling economic and non-economic perspectives on media policy: Transcending the "market-place of ideas." *Journal of Communication, 40*(3), 47–72.

FCC adopts new children's TV rules. (1996, August 8). Available online: http://www.fcc.gov/Mass_Media/News_Releases/1996/nrmm6021.html [Accessed May 31, 2000]

FCC revises local television ownership rules. (1999, August 5). Available online: http://www.fcc.gov/Mass_Media/News_Releases/1999/nrmm9019.html [Accessed August 11, 1999]

Federal Communications Commission v. Pacifica Foundation, 438 U.S. 726 (1978).

Johnson, L. L. (1994). *Toward competition in cable television.* Cambridge, MA: MIT Press.

Kahn, F. (1984). *Documents of American broadcasting* (4th ed.). New York: Prentice Hall.

KFKB Broadcasting Association, Inc. v. Federal Radio Commission, 47 F.2d 670 (D.C. Cir. 1931).

Le Duc, D. (1987). *Beyond broadcasting: Patterns in policy and law* (2nd ed.). New York: Longman.

Messere, F. (2000, April). NAB Telecommunications Act 1996 update. A presentation to the Broadcast Education Association, Las Vegas, NV.

Miller v. California, 413 U.S. 15 (1973).

Nadel, M. S. (1991). U. S. communications policymaking: Who and where? *Comm/Ent Law Journal, 13*(2), 273–323.

New indecency enforcement standards to be applied to all broadcast and amateur radio licenses, 2 FCC Rcd. 2726, 1987.

Office of Communication of the United Church of Christ v. Federal Communications Commission, 359 F.2d 994 (D.C. Cir. 1966).

Pearl, D. (1995, June 7). Cable TV systems cleared to block "indecent" material. *The Wall Street Journal,* p. B4.

Policies and rules concerning children's television programming, FCC LEXIS 987 (1993).

Pringle, P. K., Starr, M. F., & McCavitt, W. E. (1999). *Electronic media management* (4th ed.). Boston: Focal Press.

Shields, P. (1991). The politics of the telecommunications policy process: The example of the FCC's price cap initiative. *Policy Studies Journal, 19*(3/4), 495–513.

Vivian, J. (1999). *The media of mass communication* (5th ed.). Needham Heights, MA: Allyn and Bacon.

12

The Internet and
Electronic Media Management

In this chapter you will learn

- Considerations electronic media managers face in utilization of the Web
- The primary functions of an electronic media company Web site
- Potential revenue streams associated with a Web site
- The primary management issues associated with an electronic media organization's Web site

The development and rapid diffusion of the World Wide Web during the 1990s brought a new appreciation and awareness of the Internet. Personal computer sales skyrocketed as thousands of households jumped into the online world to surf the net. It is safe to say that many traditional businesses, like broadcasting and cable, were unprepared for the revolution that would take place between 1995 and 2001 as the Internet phenomenon spread rapidly.

Electronic media organizations quickly realized that the Web would be a useful vehicle for marketing and promotional purposes (Owen, 1999). As radio and television stations and cable channels began to develop their own Web pages, they were confronted with very basic questions regarding the best way to utilize the Web, how their pages should be designed, and what type of content to showcase.

By 1997, the Web had emerged as a powerful tool across many industries, with an entire new language associated with business prac-

tices. **Electronic commerce,** or **e-commerce,** represented the buying and selling of products and services via the Internet among businesses and consumers. A number of cyber-based companies, or **dot-coms**—such as Amazon, eBay, Travelocity, and Priceline—proved it was possible to successfully conduct business over the net, despite the fact that few sites were profitable. **Search engines** (e.g., Yahoo!, Netscape, AltaVista, Excite) or **portals** emerged as sites that were visited frequently because they represented the critical entry point for people accessing the Web.

From an electronic media standpoint, perhaps the greatest revolution associated with the rapidly changing online world was the development of **streaming media.** The change started in radio with the introduction of AudioNet (later called Broadcast.com and today known as Yahoo! Broadcast Services). Electronic media companies can now deliver content over the Internet by sending streams of data to computers, rather than having the user download extremely large files that could quickly fill up hard drive space on a PC. The development of streaming media allowed electronic media companies to broadcast over the Internet, opening all sorts of new programming options. Further, users could access the material at any time they desired, from any location.

The advent of streaming media also fueled demand for high-speed Internet access, especially among consumers. With most home PC modems limited to download rates of 56 Kbps, users have been frustrated with the time needed to load Web pages. Transfers take even longer if the site utilizes streaming video or multimedia applications. By 2000, consumers could enter a high-speed, broadband world by using a cable modem, a digital subscriber line (DSL), or an ISDN line. Wireless technology, enabling Web access via a portable telephone, personal digital assistant (PDA), or other handheld devices will no doubt grow in usage during the next decade.

This final chapter examines the Internet from the perspective of electronic media management. A number of topics will be discussed, including utilization of the Internet, characteristics of Web departments, different functions of the Web, revenue streams, and key management issues associated with managing the Internet.

Utilization of the Internet

Exactly how electronic media firms utilize the Internet varies from company to company, but essentially management must decide between maintaining an internal unit or department responsible for Web management, and **outsourcing** the responsibilities to an outside vendor. There are advantages and disadvantages to each approach, as discussed in the following paragraphs.

Internal Department

By keeping Web operations in-house with an internal unit, management obtains greater control and access to the unit. Because many departments utilize the Web page, it is easier to coordinate activities and updates when the operation is internal. On the down side, having an internal department means hiring additional staff to handle Web design and updating, raising expenses for the operation.

With technology advancing so rapidly, the Web department staff must continually be engaged in their own professional development in order to keep up with the ever-changing Internet world. Finding qualified people with expertise is another challenge, as just about every business needs competent workers with information technology skills. Where many firms started with a single **webmaster**, today an electronic media Web department employs several people depending on the size of the market and the demands placed on the Web unit.

Outsourcing

Outsourcing is a common practice for Web page maintenance and design. Outsourcing is usually more cost effective than having an internal department since there are no salaries or benefits to pay to employees. But the primary advantage of outsourcing lies in tapping external expertise. If internally an organization lacks employees with the skills, knowledge, and time to be effective webmasters, then outsourcing becomes a logical option. Before selecting an outside vendor, management should seek references on vendors they are considering and be certain the vendor is capable of meeting the needs of the organization.

With outsourcing, management gives up a good deal of control to the outside vendor. Outsourcing can be costly, and it still requires at least one individual to maintain a liaison role with the vendor.

Management must regularly evaluate the relationship with the vendor, as well as monitor consumer and business usage (hits) of the company's Web sites. Further, because the vendor tends to work off-site, access can become an issue. Coordination on updating the site and regular communication are critical in working with an outsourcing vendor.

In addition to the Internet site available to the public, many electronic media organizations also utilize an internal **intranet,** which is a Web site that contains information available only for employees of the organization. Intranets are common at the corporate level, particularly for internal communication, personnel and benefit information, and internal forms and schedules. Access to an intranet usually requires a password available only to employees. Certain parts of the site can be open to all employees, while other areas can be restricted only to management.

Regardless of which type of utilization management initiates, the presence of the Internet represents yet another area demanding managerial planning and attention. Given the rate of change in technology, keeping pace with Internet issues and how they will impact electronic media organizations will remain a moving target for most managers. Changes in applications, as well as in Internet reception devices and technologies, mean an organization's Web strategy is constantly in a state of flux and transition.

The Web Department

Staffing and Reporting Structure

This section examines a typical internal department charged with maintaining an electronic media organization's Web site. The composition and reporting structure of the Web Department varies across organizations. Some organizations treat these activities as a separate unit, under an existing department head. In other organizations, Web responsibilities are encompassed in an existing department, such as Marketing and Promotions, Creative Services, Community Affairs, or Operations.

Television stations, especially those with a local news presence, tend to have a larger staff devoted to a Web department than do ra-

dio stations. Web sites in the cable industry vary dramatically, from simple sites to very complex, integrated sites. The Web department at a typical electronic media organization will likely consist of a minimum of two to three staff members, much larger if there is continuous 24-hour updating of the Web site as is typical in major markets. Web staff members should be familiar with hypertext language code, as well as the ability to produce scripts using Java code and other program languages. One member of the staff should also have formal training in graphic design so that sites can be designed that are both informative and visually appealing.

Qualifications and expertise among potential Web staff members can be quite variable. Different types of educational programs offer certificates and courses in multimedia, authoring and scripting, and Internet/intranet applications. Colleges and universities also offer courses and instruction related to Web design and multimedia application, but as yet nothing definitive has been created in the way of degree programs. These facts make hiring decisions somewhat difficult, as there are no recognized professional standards. As with any hiring opportunity, it is critical to seek out information from references, examine a portfolio of work created by the applicant, and ask lots of questions before making a decision.

Salary and Cost Structures

Salary information for Web professionals working in the electronic media is difficult to gauge. For example, the 1999 report on television employee compensation by the National Association of Broadcasters (1999b) does not identify any support staff positions with Web responsibilities. However, the 1999 NAB radio report (1999a) does list two related positions and average salaries. Based on national survey data, a radio station webmaster salary averaged $26,598 in 1999, while an Information Technology Administrator position averaged $44,214 in 1999.

Maintaining an internal Web department is expensive, an investment totaling thousands of dollars. Personnel costs tend to be higher than in other departments; professionals with Web-based skills are in great demand and thus command higher salaries. Further, the costs to maintain current servers, high-speed data lines, and other networking equipment to allow wide access by the public add to the expense of the Web department.

Web Functions and Management

While utilization and cost structures of the Web Department vary across electronic media organizations, the functions of the Web site tend to be more consistent. In a review of how traditional media organizations are adapting to the online world, Chan-Olmsted (2000) identified several Web functions. A few of these areas are discussed in more detail in the following paragraphs.

Brand Extension and Development

As discussed in Chapter 9, branding has become a critical strategy in maintaining an identity and building an image. The Web presents many ways to extend and further develop the existing brands of electronic media organizations. Perhaps most obvious as well as the most important, the Web gives electronic media organizations the opportunity to leverage their existing brands in order to expand their reach.

With the online audience growing daily, electronic media organizations have another tool to reach audiences and advertisers. Because the Web is accessible on a 24/7 basis, Internet usage allows users to consume media on their own schedule, instead of having to adhere to a fixed schedule. Early research indicates online usage tends to decrease the amount of time people spend with traditional media (see Americans Increase Internet Use, 2001; Online Users Watch Less TV, 1999). Having a strong online presence blunts some of the audience erosion while also providing a vehicle to reach new and expanded audiences.

Strong brands are vitally important to media organizations, but not all companies have been successful in translating their brands successfully to the Internet (Chan-Olmsted, 2000). For example, BBC Online has had difficulty with the development of their Internet presence, as have a number of radio companies. On the other hand, services like ESPN, CNN, and MTV have been very successful in using their Internet sites to complement their existing media operations.

One of the many challenges facing electronic media managers is determining the best way to use the Internet to enhance and expand on what they are already doing. Companies that are successful in strategically positioning their existing media with their online efforts

will maximize audience and advertiser potential, leading to a definite competitive advantage over other competitors.

Repurposing and Expansion of Content

Media organizations generate content, and the Web is a natural vehicle for repurposing and expanding existing content, in ways not possible with traditional media distribution. Audio and video streaming allows existing content to be located on the Web site, permitting access at any time by members of the audience. Further, "live" streaming enables access from anywhere in the world. This has allowed people in the military, business travelers, people living away from their homes, and vacationers to keep up with local news and events by simply connecting to the Internet. The proliferation of public Internet cafés and locations to access the Web means travelers don't even have to carry a laptop in order to log on.

Media organizations continue to experiment with content on their Web sites. Television stations and cable services offer a combination of text and graphics, streaming video, interactive features, and opportunities for email feedback. Radio stations primarily use text and graphics, along with different types of audio content. Radio stations are moving away from live streaming, due to concerns over the use of copyrighted material (music) on the Web sites. Clear Channel and Infinity, the two largest radio groups, no longer allow live streaming on their stations. Telecommunications services tend to use their sites for product-related information and expansion of marketing efforts.

The Web offers the opportunity to expand and enhance content. For example, a local television news department may run a week-long series on a public-interest topic such as drug abuse or recycling. The segments can be streamed (stored) on the Web site, with additional links set up to provide more detailed information on the subject matter. Where the clock and time pressures drive the traditional media world, the online world is nonlinear in nature, allowing for greater expansion and exposition of content.

Soon, interactive television will seamlessly blend traditional media channels with the Internet. Users will be able to move between Web sites while enjoying media content, simultaneously engaging in e-commerce, email, and other applications. Interactive television is

in development by many companies and business partners (Kersch-baumer, 2000). Among the more prominent players are AOL TV, Microsoft, Open TV, and PowerTV. As interactive television begins to diffuse in the early 2000s, electronic media organizations will have numerous opportunities to use the Internet to repurpose and extend content in ways never before imagined.

Audience Information and Research

The Web brings other opportunities for electronic media management in the form of audience research potential. Sites can be used for a number of different research initiatives. Among the more obvious are direct feedback from the audience via email and interactive surveys, the ability to collect database information from users in regards to demographics, lifestyle, and usage patterns, and the opportunity for market testing of different products and services.

Web-based audience research is becoming more refined as methods to access information from users improve. Media Metrix and Nielsen NetRatings are the two most prominent Internet research sites. Initially only information on the number of hits (visits to a particular site) was available. Now the opportunities to gather more information are present, whether through the use of Internet **cookies** (a small program tool that gathers information from the user's hard drive) or direct database questions.

Cookies raise questions and issues of privacy and security, but accessing Web sites without allowing a cookie to be stored on the drive has become almost impossible on many of the sites. In terms of database questions, many sites offer email distribution lists on topics of interest, as well as e-commerce opportunities, but to engage in these services the user must first offer basic information (name, email address, and other demographic data). The result is a constantly updated database of visitors to your site, many of whom are likely to utilize existing content or brands among traditional media channels.

Gathering audience research data is perhaps more efficient via the Internet, but it also more challenging to interpret. As Internet access methods proliferate (e.g., DSL, cable modems, and wireless technologies), managers will be confronted with data drawn from many different types of audience measurement methodologies (e.g., phone, online, news forms of "people meters," etc.). The ability to analyze, define, and understand how to utilize online data in conjunction with

traditional research sources will represent a continuing management challenge. Web logs accumulate data from hits to various Web pages; this information will be useful in comparing Internet surfing at work to surfing patterns at home.

Revenue Streams

The enormous potential of the Internet is often tempered by a recurring business question: How do you make money from the Internet? While many argue that the advent of the Internet will result in fundamental changes in the way our economy functions and the way business is conducted in a new information economy (Evans & Wurster, 2000), the reality is that many Web sites are not profitable. Indeed, the most successful sites in terms of revenues have been sites devoted to the selling of books and CDs, travel-related sites, and pornography.

Despite the widespread collapse of numerous dot-coms across different industries in 2000–2001, analysts remain bullish on the Web with its opportunities for multiple revenue streams. This section examines the most common revenue streams found on electronic media organization Web sites.

Advertising Advertising represents the most common form of revenue across electronic media organization Web sites. Because electronic media companies were already in the business of selling advertising, it is natural that this revenue stream evolved first for many media organizations.

Advertising primarily takes the form of **banner** advertisements, which typically run the width of a Web page and vary in length, although most are limited to about an inch of viewing space. Banner ads are sold on a rotating basis, meaning the banner will change as the page view changes. Some organizations have included banner advertising as a value-added benefit to a purchase of on-air advertising, while other organizations treat Web-based advertising as an entirely separate opportunity.

Most banner ads tend to be action oriented, in that a short visual message will encourage the user to click on the banner (also

known as a **click-through**), which will transport the user to another page for more information about a particular product or service. Here the user can usually request more information about a product or service, make a purchase, or simply disconnect.

Data on Internet advertising at the local and organizational level tends to be proprietary in nature, but figures for national Internet advertising are available. In 1999, online advertising totaled $4.6 billion, with projections to grow to $24 billion by 2004 (Veronis, Suhler, & Associates, 2000). The top advertisers consisted of computer and software companies, followed by financial services and catalog/e-commerce vendors. With Internet advertising poised to grow at an annual rate of nearly 39 percent, electronic media organizations need to aggressively target this revenue stream.

Do not be surprised to eventually see sponsorship of Internet-related tools like Web cameras and traffic cameras on electronic media Web sites. While the advertising revenue drawn from these activities may be small, it nevertheless represents revenue potential for broadcasters.

E-Commerce E-commerce–related activities, whether in the form of business-to-business transactions or business-to-consumer transactions, is changing the way companies and households do business. Business-to-business (B2B) commerce has utilized data networks for many years in the form of electronic data interchange (EDI). But the advent of the Web ushered in a new era, labeled by some as "webonomics" (Schwartz, 1997). The Web facilitates business transactions by enabling companies to engage in economies of scale, handle inventories in a more efficient manner, and ease distribution and marketing costs. The majority of e-commerce transactions (about 85 percent in 1999) represent B2B transactions.

At the household level another type of e-commerce is growing rapidly, that of business-to-consumer. Individuals can now buy just about anything on the Web that they would normally purchase at a bricks-and-mortar location. Airline tickets, concert tickets, books, CDs, clothing—even groceries and prescription drugs can be acquired over the Web. For many individuals, shopping for products or services over the Web (whether at home, school, or work) saves time, effort, and, in many cases, money.

E-commerce projections vary widely, ranging from an average of $360 billion to upwards of a trillion dollars by 2002 (Albarran, 2000). Veronis, Suhler, and Associates (2000) project B2B commerce will grow to $1.4 trillion by 2004, with consumer online spending reaching $65 billion the same year.

The question is how much of this revenue will make its way to electronic media organizations. At the national level, companies like AOL/Time Warner, Viacom/CBS, and the Walt Disney Company will certainly acquire their share of e-commerce dollars via their respective portal sites and their most popular brands (e.g., Netscape, MTVi, CBS Marketwatch.com, and ESPN, to mention a few). But how will local broadcast, cable, and telecommunications providers fare? To date, no clear successful business model has been introduced or emulated by electronic media companies. Herein lies another significant management challenge for the 21st century.

Local Portal Portals often represent the starting point for many users when they access the Internet. Advertisers certainly recognize this fact, with portals claiming approximately 49 percent of all Web advertising in 1999 (Veronis, Suhler, & Associates, 2000). But portals tend to be national in scope, offering the opportunity for users to specify types of information (e.g., local news and weather, financial information, and sports) to experience a local, customized version of the Web site.

Electronic media organizations, especially local broadcast television stations, are working on turning their Web sites into local information portals. Users can customize information to fit their own needs and lifestyles, and also access a variety of local information ranging from restaurant and movie reviews to ticket sales for local concerts and entertainment events. Further, local portals fit nicely with advertisers trying to reach local audiences, as well as with local businesses wanting to form partnerships and associate programs (discussed below).

Broadcasters face strong competition in their efforts to be a local portal. Other local broadcasters, newspapers, and general local portal sites like *Cityscape, Sidewalk,* and *Digital City* are all vying for the same eyes. Quality of service is an issue as well, as users expect their entry point to the Internet to always be up and running. Local media outlets that entered the online world early have the best poten-

tial to build a local portal presence; those that entered later are forced to play catch-up in a very competitive and crowded online world.

Associate Programs A small but steady form of revenue stream is available to media organizations through the use of associate programs. In an associate program, the Web site signs an agreement with an online vendor (such as Amazon.com). The main Web page carries a hot-link button or banner that, if clicked, will usually open the page of the vendor in a separate window. Then if the user makes a purchase through the vendor, the vendor returns a small percentage to the Web site on a monthly basis.

Associate programs will not by themselves make a Web site profitable, but they may generate revenue to supplement other online revenue streams. One problem with associate programs can be a cluttered Web site; too many programs at one time can be difficult to track and manage. Many local broadcasters are experimenting with associate programs to find vendors that are most compatible with their Web sites and that are financially good partners.

Key Management Issues

This final section examines the primary management issues associated with the evolving World Wide Web. As discussed earlier, the oversight of the Web unit, whether internal or via outsourcing, falls to a midlevel manager. However, the growing importance and significance of the Web in electronic media management embraces all units, forcing all management levels to place more time and effort on the Internet.

Finding the Business Model Despite the fact that several revenue streams are possible using the Internet, most media-related Web sites are far from profitable. Even at the network level, companies like NBC, Disney, and Time Warner have lost millions of dollars on their Web sites (The failure, 2000). Like many of the emerging dot-com companies, finding a lucrative business model that generates positive cash flow remains the major challenge associated with the Internet.

Part of the challenge is directly tied to technology. For most users, the Web is great for downloading text, graphics, and audio

(music). But video in its various forms (e.g., television, film, or cable programming) makes up the largest portion of the entertainment industry's profits (The failure, 2000). Until a significant number of U.S. households become broadband households, with the capability to move video either in real time or near real time, the technical limitations of the Web will severely limit how much households will spend on the Internet for entertainment. And broadband has a long road ahead. At the end of 1999, only about 1.5 million households had broadband access (The failure, 2000).

Until proven methods of making money on the Web evolve, media organizations will primarily use their Web sites for traditional functions like promotion, marketing, and research and will limit the amount of capital investment spent on the Internet.

Dealing with Change Technology will continue to impact the evolution of the Internet in many ways. From a distribution standpoint, consumers will have more and more ways to access the Internet beyond desktop computers. A growing number of industry analysts expect that wireless technology will emerge as the standard way to access the Internet, using cellular phones or various types of handheld devices (PDAs). Like the wireline telephone, the desktop computer will not totally disappear, but it may be used fewer hours per day as the primary way for households to access the Internet.

Innovations in hardware, software, and programming languages mean constant upgrading and retraining for technical employees. In the high-tech industry, Moore's Law states that processor speed doubles every 18 months, giving most desktop computers and servers a shelf life of 3 years or less (Evans & Wurster, 2000). Overall, this translates into still higher costs associated with maintaining a Web operation. Again, one can understand why outsourcing has become a popular option for many managers.

Where Does the Internet Fit? Where does the Internet fit?—this is a common question asked by many electronic media managers. There are still numerous questions as to how the Internet best complements existing broadcast, cable, and telecommunications operations. Consider the many topics discussed in this chapter. With a Web site, what business are electronic media companies engaged in? Is the Web site just for promotion and marketing? Should a Web site become a local information portal for

consumers? Is the purpose of a Web site to enhance the existing news operation? Should the site be devoted to making money through e-commerce and other revenue streams?

Answers to these questions ultimately depend on each organization's strategic use of the Internet. What is interesting is that so many different variations of how to utilize the Internet are possible. The Internet will continue to evolve and no doubt transform the media industries in many interesting ways. But the degree of transformation, and the impact on traditional media operations, remains unknown. In the final analysis, the Internet becomes yet another area where electronic media managers deal with a constantly changing environment.

Summary

This chapter examines the Internet and its relationship to electronic media management. The introduction of the World Wide Web created wide consumer and business interest in the Internet. Electronic media organizations immediately recognized the Web for its promotion and marketing potential, creating a rush to get Web sites up and running.

Electronic media organizations either function with an internal Web department, typically under the supervision of a midlevel manager, or they utilize outsourcing and have their Web site maintained by an outside vendor. In addition to an Internet Web site, many companies also utilize an internal Intranet available only to employees. Maintaining a Web operation is expensive, and few sites are profitable.

The Web site serves many functions across electronic media organizations, including but not limited to brand extension and development, content exhibition, audience research, and promotion. Media companies can also store audio and video clips on their Web sites. Live broadcasting via streaming applications are possible, but many radio stations have moved away from the practice. As more households adopt broadband technology, video streaming will become more accessible to the end user.

Media organizations are also attracted to the Web for its potential revenue streams. Advertising has been the most lucrative revenue

stream. Revenues can also be drawn from e-commerce activities, service as a local informational portal, and associate programs.

There are several pressing management issues associated with the Internet. Finding successful business models that enable the Web site to make stronger revenues is the biggest issue. Management must also be able to deal with constant change in terms of hardware and software and other technological innovations. Determining the best way to use the Internet to complement traditional media activities is another key concern of many electronic media managers.

The Internet is transforming many areas of society, and the media industries are certainly impacted by the growth and development of the Web. While it is not possible to predict the exact impact on electronic media organizations, managers will no doubt continue to deal with the challenges posed by the Internet and find the best way to successfully use the Internet to their competitive advantage.

CASE STUDY ° | Finding the Money

As a medium-market ABC affiliate, WTGG-TV has operated its own Web site since 1996, staffed with three people who work in the station's Promotion and Marketing Department. Primarily used to showcase the station's local news operation and provide local programming information, the site has steadily gained daily audience "hits," becoming one of the top three local sites in the market, based on the latest ratings available through outside research firms.

But like many local television sites, the Web site has failed to produce any sustainable revenue. At its weekly staff meeting, Promotion Manager Brian Falco pointed out that while the site was drawing lots of viewers, advertising only accounted for about 30 percent of the cost of maintaining the site. News Director Laurie Powers commented, "We know that most of the people visiting the site are checking weather, news headlines, and sports scores."

"That's true," said Falco. "But we are also attracting Internet users who are starting with our site to find local information on restaurants, entertainment, and community activities."

Station Manager Jim DeHaven spoke up. "We have achieved good traffic on the Web site. But we have had difficulty in transforming these hits into

any real revenue streams. There must be something more we can do. I want to put a task force together to try and solve this problem, and find some decent revenue sources. Brian, I want you to work with Laurie, Program Director Pat Meyers, and our Web team, and come up with a set of proposals we can consider at our next meeting. We are dealing with an unknown business model here, so think outside the box."

Taking the role of the station's promotion manager, work either individually or in teams to generate possible ideas to stimulate Web revenue streams for WTGG-TV.

CASE STUDY	**Problems with an Internal Hacker**

Radio stations KXVX-FM, KEZY-FM, and KRLY-FM are owned by a top-5 radio group operating in a West Coast city. The three stations share internal staffs in all areas except on-air programming. The Web sites for all the stations are housed in one office, with a webmaster assisted by a small staff of college interns.

Around 11:00 A.M. on Monday morning, all three stations began to receive calls from the public upset with the stations' respective Web sites. The calls varied about the problems encountered. On one site, clicking on a button to take the reader to a page with the week's top hits instead took the reader to a Web site for a vasectomy clinic. Another site's click-through took the reader to a pornography site, while yet another site instead linked the station to its primary competitor in the market.

Realizing that hackers had invaded all of the sites, General Manager Madison Winters ordered the servers shut down and taken off-line within 30 minutes. Working as quickly as possible, station personnel located webmaster Philip Reinhart at his home. Reinhart had been away from the stations for the weekend, leaving the sites under the control of the intern staff.

After spending nearly 2 hours on the servers, Reinhart called Winters in his office. "We've had a hacker hit all three sites," he said. "It's a mess. Whoever did this sabotaged most of the links, most of which can be reconfigured quickly. I think we can be back online within an hour or two." Winters asked, "How did this happen, Phil? I thought we had a pretty strong firewall in place to keep hackers out."

"That is the worst part of this situation," said Reinhart. "The attack was internal. It had to be someone on the intern staff who had access to

the server. I have an idea of who may have done this, but I don't know the motive. It is a shame, because I never thought something like this would happen internally. I am concerned about the impact on our Web audience, and the bad publicity this attack may bring, especially from our competitors."

Put yourself in the role of the station manager. How would you address the issues in this case? Among the issues to address are the problems of using a staff of interns to maintain a Web site, the bad publicity, the possible loss of goodwill generated by this situation, and the impact on your Internet audience. Discuss possible solutions in each of these areas.

InfoTrac College Edition

For new information on the Internet and electronic media management, use InfoTrac College Edition. Use the following terms for subject and keyword searches: Internet, management, e-commerce, portal, interactive media, digital media.

Web World

Here are some interesting categories of Web sites to examine:

Portals
www.altavista.com
www.excite.com
www.msn.com
www.yahoo.com

Popular Consumer E-Commerce Sites
www.amazon.com
www.ebay.com
www.travelocity.com
www.priceline.com

Streaming Media Web Sites
www.realnetworks.com
www.windowsmedia.com
www.playstream.com
www.broadcast.com (Yahoo! Broadcast Services)

Sites Related to Datacasting

www.spectrarep.com
www.iblast.com
www.wavexpress.com
www.skystream.com
www.dtvplus.com

References for Chapter 12

Albarran, A. B. (2000). Electronic commerce. In A. B. Albarran & D. H. Goff (Eds.), *Understanding the web: Social, political and economic dimensions of the Internet* (pp. 73–94). Ames, IA: Iowa State University Press.

Americans increase Internet use in 2000. (2001, February 21). Available Online: http://cyberatlas.internet.com/big_picture/geographics/article/0,1323,5911_594751,00.html [Accessed April 14, 2001].

Chan-Olmsted, S. (2000). Marketing mass media on the World Wide Web. In A. B. Albarran & D. H. Goff (Eds.), *Understanding the web: Social, political and economic dimensions of the Internet* (pp. 95–116). Ames, IA: Iowa State University Press.

Evans, P., & Wurster, T. S. (2000). *Blown to bits. How the new economics of information transforms strategy.* Boston: Harvard University Business School Press.

Kerschbaumer, K. (2000, July 10). Interactive television. Fulfilling the promise. *Broadcasting & Cable*, pp. 22–34.

National Association of Broadcasters. (1999a). *Radio station salaries.* Washington, DC: Author.

National Association of Broadcasters. (1999b). *Television employee compensation & fringe benefits report.* Washington, DC: Author.

Online users watch less TV. (1999, February 16). Available Online: http://cyberatlas.internet.com/big_picture/demographics/article/0,5901_150391,00.html [Accessed April 14, 2001].

Owen, B. M. (1999). *The Internet challenge to television.* Cambridge, MA: Harvard University Press.

Schwartz, E. (1997). *Webonomics.* New York: Broadway Books.

The failure of new media. (2000, August 19). *The Economist*, pp. 53–55.

Veronis, Suhler, & Associates. (2000). *Communications industry forecast.* New York: Author.

Glossary of Key Terms

Account Executives Electronic media professionals who sell advertising to clients at both the local and the national level.

accruals Used in co-op advertising; accruals refers to the dollars credited to local retailers for co-op plans.

actualities Term used to define audio clips used in radio news.

ad hoc networks Networks formed for certain broadcasts of television programming such as special events or sports.

affiliates Stations that carry network programs.

AM Amplitude modulation; a type of radio broadcasting.

amortization Method used in deducting the costs of intangible assets.

assets Items on a balance sheet that can be converted into cash. Examples of assets include cash, checking and savings accounts, accounts receivable, land, and equipment.

availabilities (avails) In television advertising, refers to the number of spots available for sale to advertising clients.

average quarter-hour (AQH) persons Estimates the number of people listening to a radio station for at least 5 minutes in any given quarter hour.

average quarter-hour rating The AQH persons expressed as a percentage of the total population.

average quarter-hour share The AQH persons expressed as a percentage of the total audience actually listening.

balance sheet Summarizes the financial condition of a firm at a particular point in time; used for comparison purposes. It consists of three sections: assets, liabilities, and owner's equity.

banner Refers to a common type of advertising on Web sites.

barriers to entry Normally thought of as obstacles new sellers must overcome before entering a particular market.

barter Used in selling programming; a barter program comes packaged with presold advertising.

bottom line Slang term used to represent the net profit or loss for a firm; taken from an income statement.

branding A commonly used marketing strategy whereby products, goods, or services are identified by their brand name. For example, customers often ask for a brand name such as Kleenex (instead of a tissue) or Coke (instead of a soft drink).

break-even analysis The amount of revenue needed to cover total costs in a business; how many units of a product must be sold in order to make a profit.

broadband delivery system The delivery of high-speed digital content via coaxial cable, a digital subscriber line, wireless service, or other high-capacity network.

bureaucracy A group with a hierarchical structure and a division of labor between workers and managers. Attributed to the German theorist Max Weber.

capital budgeting Process by which one determines major purchase decisions that cover more than one fiscal year.

clearance Occurs when a local affiliate accepts programming and advertising from its network; in most stations, clearance decisions are made by the Program Director in consultation with the GM. In return for clearing the program, the affiliate may receive compensation from the network.

clear channels Stations that have exclusive right to their assigned frequency at sunset. Clear channel radio stations can be heard over hundreds of miles and are considered valuable assets by managers.

click-through Occurs on a Web site when the user clicks on a banner or button that transports the user to another Web page.

clustering Movement across electronic media whereby larger firms acquire smaller firms in geographical groupings.

coaxial cable Primary means of distributing cable television signals. Coaxial cable is limited in capacity to about 120 channels.

collective bargaining The negotiation process between union and management over contracts.

commission In terms of sales, refers to the amount of compensation paid to account executives on advertising contracts. Industry standard is 15 percent.

compensation Refers to cash payments made by broadcast networks to affiliate stations for carrying or clearing network programs.

compounding The interest accumulated on money that is invested. For example, at an interest rate of 7 percent, a dollar invested will earn 7 cents in interest. Over time both the original dollar and the 7 cents in interest will earn interest, resulting in compounding of both the principal amount and the accumulated interest.

concentration Variable used in defining market structure; the number of producers or sellers in a given market.

convergence Combination and integration of the broadcast, cable, telecommunication, and computer industries to develop and market information and entertainment products.

cookies Information stored on a computer hard drive that is placed by the Web site to eliminate repetitive tasks such as logging in. Cookies also enable the Web site to read data from the hard drive, raising concerns over security and privacy for users.

cooperative advertising Also called *co-op advertising;* this type of advertising involves shared costs between local retailers and manufacturers.

cost per point (CPP) Calculated by dividing the total cost of the advertising plan by the number of rating points generated in a media buy, CPP is a comparison tool used to compare the cost per point of one radio station or one television program to another.

cost per thousand (CPM) The cost to reach 1,000 people; a comparison tool used in media buys.

cost structures The costs of production in a particular market.

counterprogramming Strategy in which one station or network offers alternative programming to attract audiences.

cume persons An estimate of the number of different listeners to a radio station for at least 5 minutes in any given quarter hour within an entire week.

cume rating An estimate of a station's reach; the cume persons expressed as a percentage of the total population for a given week.

current assets A group of assets that can be quickly converted into cash.

dayparts Time periods analyzed in audience research in both the radio and TV industries.

demographics Descriptive characteristics of the audience regarding age, sex, and time spent viewing/listening; used in audience research.

deontological ethics Field of ethics concerned with the process of making decisions based on established principles.

depreciation Method used in deducting the costs of tangible assets. Tax laws specify the various classes of assets and types of depreciation schedules that can be used in business.

Designated Market Area (DMA) Ratings term used to identify the heaviest concentration of audience members in a given market.

development The engagement of electronic media firms in creating and implementing new technological innovations.

digital audio broadcasting (DAB) Radio signals offering digital signals with compact-disc quality.

Digital Audio Radio Services (DARS) National subscription service delivering digital radio signals via satellite to automobiles equipped with a special receiver.

digital compression Converting an analog signal to binary code and then compressing the signal to allow several signals to be transmitted over a single channel.

direct broadcast satellite (DBS) Type of distribution system that delivers programming via satellite technology; leading DBS companies include DirectTV and EchoStar.

distribution A common activity of electronic media firms; distribution is concerned with linking different products to consumers.

dot-com The common term for commercial Internet Web sites.

downsizing The efforts by businesses to reduce expenses by eliminating excess personnel; also known as *flattening*.

dual product market A unique characteristic of many media industries. Media companies produce one product but offer the product to different markets. Most electronic media programming is targeted to two markets, advertisers, and audiences.

duopoly A type of ownership whereby one company can own two stations within the same geographical market; duopoly rules have been relaxed for both radio and TV.

e-commerce Also known as *electronic commerce;* the buying or selling of goods or services over the Internet.

economies of scale The decline in average cost that occurs as additional units of a product are produced.

economies of scope The overall decline in average costs that occurs as additional units of a product or service are created.

electronic media Used in this text to represent the radio, television, cable television, and telecommunication (telephone) industries.

Electronic Media Ratings Council (EMRC) A professional organization that examines the methodologies and procedures used in the collection of ratings data to ensure that the information is accurate and objective.

ethical codes Guidelines on behaviors and practices; many professional organizations adopt a formal code of ethics media practitioners are expected to follow.

exclusive cume rating An estimate of the percentage of the total population that listens to only one radio station over a period of time.

Executive Managers Also referred to as *General Managers,* people who monitor the entire organizational environment, identifying internal and external factors that affect their operation.

exhibition A common activity of electronic media firms whereby the consumer uses the product.

expenses Part of the operating statement that lists all relevant expenses for a firm.

feedback A concept of systems theory; information drawn from the environment in order to identify change and assess organizational goals.

financial management The planning, monitoring, and controlling of a firm's finances.

financial ratios Used in analyzing the financial status of a business, ratios compare many different characteristics such as liquidity, debt, growth, and performance.

first-run syndication Original television programming marketed directly to stations as opposed to being broadcast by a network.

fixed assets A group of assets usually held for a long time.

flattening Term used to describe elimination of managerial layers in an organization.

FM Frequency modulation; a type of radio broadcasting.

force field analysis Developed by Kurt Lewin as a diagnostic tool to determine the number of employees needed to complete a task effectively.

forecasting Projecting revenues and expenses; usually covers longer periods of time such as 3, 5, or 10 years.

format The programming of a radio station.

franchise In the cable industry, signifies the awarding of a geographical area to a cable operator by a local government for the purpose of providing cable television service.

frequency Used in advertising; refers to the number of times an individual is exposed to the same advertising message.

future value of money The value of a sum of money at some point in the future. The future value of money is affected by the number of time periods invested and the available interest rate.

General Managers See *Executive Managers.*

geodemographic Research that classifies neighborhoods with common characteristics by zip code; also incorporates demographic and psychographic information.

geographic market Commonly found in the electronic media; broadcast stations and cable systems operate in defined geographic markets.

goodwill An intangible asset; refers to a firm's public record in a community.

gross impressions (GI) A measure of media weight; refers to the total number of people reached by a media plan.

gross rating points The total of all rating points generated in an advertising plan; measure of media weight.

hammocking Programming strategy that places a new or weaker program between two established programs.

hardware Includes television and radio receivers, satellite dishes, and compact disc players.

Hawthorne effect Used to describe the impact of management attention on employee productivity; resulted from studies by Elton Mayo.

high definition television (HDTV) High-resolution, digitally enhanced TV. The FCC has ordered all stations to convert to digital capability by 2006.

hybrid fiber-coaxial system A distribution system that uses a combination of coaxial cable and fiber optics to deliver services to users.

hygiene factors Theorized by Herzberg to represent the working environment in an organization.

income statement Also called an *operating statement* or *profit and loss statement,* charts a firm's financial activities over a set period of time—usually a week, month, or quarter.

inputs In systems theory, refers to variables needed for processing (e.g., labor, capital, equipment).

insertion advertising Local advertising inserted into popular cable channels during commercial breaks.

intangible assets Programming and license agreements are examples of intangible assets. Intangible assets must be amortized instead of depreciated.

interconnects Separate cable systems banding together to market local advertising as a single unit.

interexchange carrier (IXC) A company engaged in providing long-distance telephone service.

Internet A collection of linked computer networks used for exchanging text, graphics, video, audio and other digital content. The most widely used part of the Internet is the World Wide Web (WWW).

intranet A Web site with restricted availability. Many companies set up an intranet to provide information to their employees and to handle repetitive business processes such as purchasing or human resource management.

inventory Advertising term used to denote the number of spots available for sale.

lead-in Program strategy in which the strongest program is placed at the beginning of the evening prime-time schedule.

liabilities Obligations to others, or what the firm owes.

liquidity ratios A set of tools used to measure the liquidity of an organization. Liquidity refers to the ability to quickly convert assets into cash.

local exchange carrier (LEC) Another name for a local telephone company.

localism Most important attribute of radio and television stations; many emphasize localism by presentation of local content such as news, sports, weather, and traffic.

local marketing agreement (LMA) Used in the broadcast industry; an LMA allows one station to take over marketing and programming of another station without taking control of ownership.

lower-level managers Those who mainly supervise others and monitor individual performance.

macro Focusing on the whole; taking a macro perspective requires looking at the entire organization, as in systems theory.

makegood When advertising fails to meet expected audience ratings, companies provide free spots or *makegoods* to make up the difference.

management A process in which individuals work with and through other people to accomplish organizational objectives.

Management by Objectives (MBO) Developed by Peter Drucker; MBO involves the interaction of managers with individual employees.

market A place where consumers and sellers interact with one another to determine the price and quantity of the goods produced.

market structure The characteristics of a market define its structure; the concentration of buyers and sellers (producers) in the market, the differentiation among the various products offered, barriers to entry for new competitors, cost structures, and vertical integration.

metro Used in audience research; the geographical area corresponding to the U.S. Office of Management and Budget's standard metropolitan statistical area (SMSA).

micro Focusing on individual units or people; a micro perspective centers on the individual rather than the organization as a whole.

middle managers Those who typically plan and allocate resources, and manage the performance of smaller groups.

mission statement Used by many electronic media organizations to communicate their purpose to internal and external publics.

monitoring Observing and evaluating performance of employees and the organization; an essential component of the process of management.

monopolistic competition Exists when there are many sellers offering products that are similar but not perfect substitutes for one another.

monopoly A market structure in which a product has only one seller.

motivators Theorized by Herzberg; involve aspects of the job itself, such as recognition, achievement, responsibility, and individual growth and development.

multiple ownership rules In the broadcast industry, refers to the limits imposed by the FCC on the number of stations in which an individual or group may hold ownership interests.

multiple system operator (MSO) A company that owns more than one cable system.

multipoint multichannel distribution services (MMDS) Also referred to as *wireless cable,* offers programming packages via microwave transmission.

must carry Regulations that require cable operators to carry all local broadcast stations.

National Representative Firm Or *Rep Firm;* works in conjunction with local stations in the sale of national advertising. Rep firms represent local stations in negotiating advertising.

national spot Category of media advertising.

net present value (NPV) Used in capital budgeting to determine which projects should be considered for adoption.

network In the broadcast industry, term used to describe a service that provides programming to affiliates. Also refers to a category of advertising.

news package Term used to describe a reporter's coverage of a story or event; usually includes file footage as well as a "stand-up" of the reporter at the story location.

Nielsen families Households selected to participate in the national Nielsen sample; these households determine the national ratings for the broadcast networks.

non-compete clause Routinely found in talent contracts; a non-compete clause prevents an employee from jumping from one station to another without a designated waiting period, usually 6 months to 1 year. Some states have ruled these clauses unconstitutional.

nonprobability sample Type of sample; every member of the population does not have an equal chance of being selected.

oligopoly A market structure that features more than one seller of a product. Products offered by the sellers may be either homogeneous or differentiated.

on-air promotion Promotional spots and other tools used by an electronic media company to promote programming and other activities; a form of self-promotion.

on-line promotion Using the Web site to reach audiences.

O & O Broadcast stations owned and operated by a network; O & O stations represent the most valuable broadcast stations and are usually located in major markets.

operating statement Another name for an income statement.

outputs From systems theory; refers to products, goods, and services.

outsourcing Describes having an outside vendor provide support services for an organization. Outsourcing can save an organization money, but it also creates job loss.

overnights Term used to describe ratings information gathered from the previous night of viewing from metered households; used to determine viewing estimates for the national audience and the top local television markets.

owner's equity Or *net worth;* refers to the financial interest of the firm's owners.

PEG channels Public, educational, and governmental channels found on cable television systems; usually required by the franchising authority.

perfect competition A market structure characterized by many sellers in which the product is homogeneous and no single firm or group of firms dominates the market.

performance review Usually conducted on an annual basis; allows employer and employee the opportunity to exchange feedback on job performance, expectations, and other criteria. Serves as the basis for merit and promotion in many organizations.

place One of the four Ps of marketing; refers to where the products of electronic media companies are available to audiences.

portal Term used to describe point of entry to the Internet/WWW.

positioning A marketing strategy developed by Ries and Trout. In positioning, the product or service must be clearly presented to the consumer. Used in the electronic media to help establish difference between competitors.

postings The recording of accounting data; may be completed using either a computer software system or manual entry.

present value Tool used in financial analysis to determine the value of cash flows.

price One of the four Ps of marketing; the amount paid for a product such as electronic media advertising or cable television service.

price cap regulation A form of pricing structure used in setting rates in the telecommunications industry. In using price caps, telecommunication carriers can charge only up to a set price for services; profits are generated when the company can provide the service at a lower internal cost.

process A series of actions or events marked by change. Management is often considered a process because of its ongoing state of operation.

product One of the four Ps of marketing; in the electronic media, usually refers to programming.

product differentiation Refers to the subtle differences (either real or imagined, perceived by buyers) that exist among products produced by sellers.

production A common activity of electronic media firms; consists of the manufacture of both hardware and software for the electronic media.

production processes The conversion of inputs into some type of product.

profit and loss (P & L) statement Another name for an income statement.

promos On-air promotional spots.

promotion One of the four Ps of marketing; consists of all activities (including advertising) designed to raise awareness of electronic media companies and their activities.

psychographics Type of research that focuses on consumer and lifestyle information.

publicity Free time and space afforded by another medium (such as a newspaper) in the promotion and marketing of an electronic media organization.

Public Utilities Commission (PUC) Or *Public Service Commission (PSC)*; at the state level the PUC or PSC regulates rates for local exchange carriers and other utilities.

random sample A type of probability sample; every member of the population has an equal chance of being selected.

rate-of-return (ROR) regulation A common way to regulate the rates of telecommunication companies for telephone services; ROR allows companies to earn a profitable rate of return as part of doing business.

rating An estimate of the number of people or households viewing or listening to a particular program, based on some universal estimate.

reach The number of different individuals reached in an advertising plan; a measure of media penetration.

regional Bell operating companies (RBOCs) The breakup of the Bell telephone system in 1984 created seven regional holding companies; over the years the number has been reduced to four companies.

retransmission consent The 1992 Cable Act gave broadcast stations the right to negotiate with cable operators for system carriage. This provision is known as retransmission consent, which means the cable operator can retransmit the broadcast signal only with the consent of the broadcaster, usually in return for some type of compensation.

revenues Money that flows into an organization through the sale of various products and services.

reverse compensation A new practice starting in the late 1990s in the TV industry; reverse compensation occurs when network affiliate stations pay the networks for their programming.

sample Audience research is based on a sample of the population; if the sample is chosen properly, the characteristics of the sample will reflect the larger population.

search engine Term used to describe Web sites that offer searching capability to users.

segmentation Marketing strategy used to identify specific target audiences and develop products and services to meet their needs.

sellout rate An estimate (expressed as a percentage) of how much available inventory will be sold to advertisers. Most broadcasters use an estimate of 70 to 80 percent as a sellout rate.

share Measures the percentage of the viewing or listening audience, based on the total number of viewers or listeners tuned in.

software The content goods, including such products as television and radio programs, recordings, and advertising messages.

spot A category of media advertising; also refers to individual commercial units.

stacking Placing programs of the same genre back to back in a program schedule, usually for a period of 1 to 2 hours.

standard error All samples are subject to error because of several factors; ratings must be interpreted within a given range of error, expressed as a percentage.

statement of cash flows A common financial statement used by management.

strategic alliance An association designed to provide benefits for each of its members; types of strategic alliances include mergers and acquisitions, joint ventures, and both formal and informal cooperative agreements.

streaming media Term used to describe the distribution of audio and video content over the Internet.

stunting Program strategy that in some way deviates from the regular presentation or schedule.

telecommunications Blanket term used to describe different components of the telephone industry; today the term is widely used to represent the integration of voice, data, and entertainment and informational materials.

teleological ethics Study of ethics concerned with actions or the consequences of making ethical decisions.

tent-poling Strategy used by programmers to place a strong program between two new or weaker programs.

Theory X Theorized by McGregor; managers use tactics such as control, threat, and coercion to motivate employees in a negative manner.

Theory Y Theorized by McGregor; managers integrate the individual needs of the workers and the needs of the organization. Employees exercise self-control and self-direction and develop their own sense of responsibility.

Theory Z Developed by William Ouchi; focuses on employee participation and individual development along with interpersonal relations between workers and managers. Management makes the key decisions in an organization, and a strong sense of authority must be maintained.

tiers Term used in the cable industry to denote different categories of service such as basic, expanded basic, and premium.

time spent listening (TSL) Estimates the amount of time the average person listens to radio.

time value of money Refers to the effect time has on the value of money. Over time, money invested may either grow or decrease in value, depending on many economic factors such as interest rates, the rate of inflation, and other economic indicators.

traffic Department in an electronic media organization that handles the placement and execution of advertising messages. Works closely with sales and marketing personnel as well as accounting personnel.

turnover An estimate of how many times the audience completely changes during a particular time period.

UHF Refers to ultrahigh frequency; those television stations that operate on channels 14–83.

V-chip Electronic device on future TV receivers allowing parents to block programs that contain excessive sex or violence.

vertical integration Occurs when a firm controls different aspects of production, distribution, and exhibition of its products.

VHF Refers to very high frequency; TV stations that operate on channels 2–13.

video compression Technology that allows compression of existing television signals to allow more expansion of channels; employs digital technology to compress signals.

video-on-demand (VOD) Delivering entertainment and information to users on demand; will work in conjunction with a set-top storage device to hold programming in memory for instant recall.

webmaster Person or department that maintains and updates Web pages for an organization.

Web site First referred to as a home page, Web sites are used by organizations and individuals to provide information and entertainment and to promote commerce.

wireless The transmission of information without the use of wires. The cellular industry was the first to engage wireless technology. Internet access is moving toward wireless distribution.

wireless cable Another term for MMDS services.

World Wide Web A part of the Internet of computer networks; allows for the integration of text, voice, and video data in the creation of various Web pages.

Index